T0388854

Suffering Sappho!

Suffering Sappho!

Suffering Sappho!

Lesbian Camp in American Popular Culture

BARBARA JANE BRICKMAN

Rutgers University Press
New Brunswick, Camden, and Newark, New Jersey
London and Oxford

Rutgers University Press is a department of Rutgers, The State University of New Jersey, one of the leading public research universities in the nation. By publishing worldwide, it furthers the University's mission of dedication to excellence in teaching, scholarship, research, and clinical care.

Library of Congress Cataloging-in-Publication Data

Names: Brickman, Barbara Jane, author.
Title: Suffering Sappho! : lesbian camp in American popular culture / Barbara Jane Brickman.
Description: New Brunswick : Rutgers University Press, 2023. | Includes bibliographical references and index.
Identifiers: LCCN 2023010300 | ISBN 9781978828254 (paperback) | ISBN 9781978828261 (hardback) | ISBN 9781978828278 (epub) | ISBN 9781978828292 (pdf)
Subjects: LCSH: Lesbians in popular culture. | Camp (Style) in popular culture. | Popular culture—United States—History.
Classification: LCC HQ75.5 .B75 2023 | DDC 306.76/63—dc23/eng/20230317
LC record available at https://lccn.loc.gov/2023010300

A British Cataloging-in-Publication record for this book is available from the British Library.

Copyright © 2024 by Barbara Jane Brickman
All rights reserved

No part of this book may be reproduced or utilized in any form or by any means, electronic or mechanical, or by any information storage and retrieval system, without written permission from the publisher. Please contact Rutgers University Press, 106 Somerset Street, New Brunswick, NJ 08901. The only exception to this prohibition is "fair use" as defined by U.S. copyright law.

References to internet websites (URLs) were accurate at the time of writing. Neither the author nor Rutgers University Press is responsible for URLs that may have expired or changed since the manuscript was prepared.

♾ The paper used in this publication meets the requirements of the American National Standard for Information Sciences—Permanence of Paper for Printed Library Materials, ANSI Z39.48-1992.

rutgersuniversitypress.org

For Lucy, Henry, and Maisie—
The best global pandemic companions a girl could ask for

Contents

	Introduction	1
1	The Big "Lesbian" Show in Postwar American Culture, a History	10
2	Voyage to Camp Lesbos: Pulp Fiction and the Shameful Lesbian "Sicko"	41
3	A Strange Desire That Never Dies: Monstrous Lesbian Camp at the Movies	66
4	Spinsters, Career Gals, and Butch Comedy in 1950s Television	90
5	Amazon Princesses and Sorority Queers, or the Golden Age(s) of Comic Lesbians	120
6	Sexual Outlaw: Disidentification, Race, and the Postwar Lesbian Rebel	148
	Epilogue	175
	Acknowledgments	179
	Notes	181
	Selected Filmography	227
	Index	229

Suffering Sappho!

Introduction

Accepted wisdom tells us that if you want to know what *camp* is, how it works, who (or what) it is upending or poking fun at, you should ask a gay man. Regardless of where we find it, parading in its most recognizable forms—from the superstars of *RuPaul's Drag Race* and the vicious collision of aging film icons Bette Davis and Joan Crawford to the miraculous disaster known as *Showgirls* (Verhoeven 1995)—camp is centered in the orbit of gay men, either performing it or recognizing it in all its wicked glory. David Halperin even goes so far as to call it a "gay male genre."[1] A natural corollary to this accepted notion, however—its inverted sister, if you will—is that lesbians just don't camp. They may pitch a tent and embrace the great outdoors, but lesbians apparently do not create or laughingly perceive that over-the-top performance or artificial "too much" of camp, which can so amuse us with its failed seriousness or pointed ironies. They may construct ironic juxtapositions, particularly ones that disrupt gender expectations, but, supposedly, the playful and biting humor and theatricality of camp not only elude lesbians themselves but are not even typically associated with popular representations of female same-sex desire. Yet, in the period following World War II, lesbian camp, I argue, simply flourished on the pages, stages, and screens of American popular culture, part of a wave of mass entertainment whose taboo and unsettling subject matter reflected the social changes brought by the war. Marking a watershed moment in media and queer history, a series of absurdly exaggerated, even monstrous, depictions of female same-sex desire and subversion, sometimes created by lesbians themselves, proliferated across popular discourses, camping out in what is often considered to be the most repressive and conservative era of the twentieth century.

While recent critical work on camp *has* attempted to make space for lesbians within our now more mainstream understanding of it, these few interventions

and claims for territory have yet to really get a foothold. Elly-Jean Nielsen, following on from Annamari Vänskä's case for a Eurovision lesbian camp triumph, has recently endeavored to define and classify established types of lesbian camp—(in her terms) *erotic*, *classic*, and *radical*—in order to "reveal a marginalized queer mode" that highlights "lesbian women's propensity to poke fun, to turn norms on their heads, to camp."[2] However, her examples for this overlooked practice and sensibility date, conspicuously, to after queer theory's revaluation and revision of camp in the 1990s, when crooner k.d. lang and the filmmakers of New Queer Cinema could exercise a postmodern parodic camp harnessed to blurring performativity and gender play rather than outmoded pre-Stonewall identities.[3] The guide for this liberatory practice of lesbian irony and denaturalization at the time was, of course, Sue-Ellen Case's infamous butch-femme "dynamic duo," who just might queer the "heterosexist cleavage of sexual difference," but other notable theorists asserted a place for a parodic camp as well, either accessible to all women, both straight and queer, or specifically created by lesbians of color in Muñoz's disidentifying practice of "self-enactment."[4] But despite Pamela Robertson's strong assertion of "oppositional modes of performance and reception" open to straight women and lesbians engaging in "feminist camp," more than twenty years after this queer blooming of camp possibilities the lesbian enactment of it still must be recovered and "unghosted" by recent critics like Nielsen.[5] Andrea Weiss may have once claimed that "as a product of the closet and the pre-Stonewall bar culture, camp is a tradition which belongs to women as well as men," yet very little critical work has truly established lesbians as long-standing camping subjects or camp readers of mainstream culture.[6] My goal here, then, is to create a historical (and theoretical) foothold for lesbian camp and camping, and I believe a turn to that pre-Stonewall culture and its compulsory closet is a key to consolidating it.

It would be absurd to deny that camp as a practice and a way of seeing and responding to a homophobic world was, particularly in the United States, primarily a product of gay male culture. Historians from Allan Bérubé to George Chauncey have amply documented the construction of "camp culture" and camp practices by gay men in the twentieth century, who combatted a "hostile society with humor and self-mockery" by using a "flamboyant" announcement, "vicious put-down," "secret coded language," double entendre, readings of popular culture and of gender or sexuality, parody, and their own ironic way to "interpret the world" as a "form of self-defense."[7] As Steven Cohan emphasizes, camping in pre-Stonewall, closeted gay male culture functioned as a strategy of wit, performance, ironic humor, and verbal play that was able to use the "ambiguity of straight discourse in order to articulate a queer perspective on social as well as sexual relations," becoming a "tactic of survival" and the means through which gay men created collective bonds and a common culture.[8] This particular response to the marginalized, stigmatized, and persecuted existence that necessitated the closet, of course, could hardly survive in its same form after liberation, pride, and

coming out irrevocably changed queer life and politics after Stonewall, but camp always seems to defy its own death knell and prove useful for successive generations of queer folk.[9] Therefore, if we are to understand its usefulness for lesbians (both then and now), then attending to its pre-Stonewall form and historical foundations is paramount.

Nevertheless, as already noted, recovering and rematerializing lesbian camp from a misty (and male dominated) queer past will not be easy. The defensive "style, language, and culture" that, for Richard Dyer, kept "a lot of gay men going" has so rarely been connected to lesbians before Stonewall, even by lesbian historians and camp theorists themselves.[10] Esther Newton, for example, distinguishing the camp from the drag queen in her defining early work *Mother Camp*, works from both Sontag's "Notes on 'Camp'" and her own study's informants not only to define *camp taste*, which she claims is "synonymous with homosexual taste," but also to elaborate on camp's three central characteristics, which for her are "incongruity, theatricality, and humor," both intentional and unintentional; yet, the figure of *the* camp, the exaggerated, theatrical wielder of b-tchy, even "hostile," camp humor—the "homosexual wit and clown"—seldom comes in a female form.[11] According to Newton, the lesbian camp remains "a very rare bird."[12] Despite notable efforts from other lesbian feminists such as Sue-Ellen Case, whose essay "Tracking the Vampire" and own butch "Memoir" assert the significance of *both* the "old dykes and gay male friends" who taught her the "subcultural discourse of camp" when she "lived in the ghetto of bars" in San Francisco in the 1960s, these "old dykes" are obscured in queer histories.[13] They do not appear, really, in Faderman's incredibly influential *Odd Girls and Twilight Lovers: A History of Lesbian Life in Twentieth-Century* (1991) and are categorically denied a "campy sense of humor" in Elizabeth Kennedy and Madeline Davis's landmark *Boots of Leather, Slippers of Gold: The History of a Lesbian Community* (1993).[14] Yet, as I endeavor to show, lesbian camp, both intentional and unintentional, has a significant role to play in queer history. In chapter 1, therefore, I begin by considering lesbian camp's conspicuous absence from gay and lesbian histories like Faderman's, particularly in their recounting of the Cold War period, but also by locating *the* lesbian camp in that era, in the final star turn of Tallulah Bankhead, not obscured from view but loudly taking up center stage.

Yet, Miss Tallulah is just the tip of the iceberg. Enunciated most commonly in five dominant types—the sicko, the monster, the spinster, the Amazon, and the rebel—lesbian camp, I argue, multiplied across media forms in the postwar era, from comics and pulp fiction to television sitcoms and exploitation films, offering both disruptive potential and repressive effects. Whether starring in popular TV comedies like *Our Miss Brooks* (CBS, 1952–1956) or cheap drive-in monster movies like *Daughter of Dr. Jekyll* (Ulmer 1957), or staring out from newsstands on the covers of queer pulps like Vin Packer's *Spring Fire* (1952) or the Silver Age *Wonder Woman*, a larger-than-life lesbian menace seemed to plague the postwar American landscape at a time when dominant culture was

most keen to control and contain female sexuality. Not coincidentally, at the same moment, there was a burgeoning queer community emerging from the shadows in the United States, creating not just a nascent sense of identity for themselves but also the mixed blessing of an increased visibility in public life, which brought the inevitable vicious and systematic persecution meant to suppress it. Amidst this apparent upheaval, I argue, lesbian camp worked simultaneously as a corrective attempt to manage the era's anxiety about female sexual liberation and queer sexuality *and* as an oversize failure to contain and control women's growing independence. In other words, the newly conspicuous visibility of lesbians camping it up in popular culture might have worked to discipline and control apparently monstrous sexual freedoms, but it also managed to disrupt through irony and humor and redefine female sexuality, working ultimately to enunciate, not silence, lesbian identities and desires.

In examining these multiple instances of lesbian camp across popular forms, I will necessarily need to employ expansive and diverse aspects of camp, a term notoriously difficult to pin down. The texts I engage with here will sometimes be produced by lesbian or other queer creators with an intention on their part "to camp"—to create and transform through exaggerated "incongruous juxtapositions," in Newton's terms, notions of gender and lesbian sexuality as a "tactic of survival" in the pre-Stonewall period.[15] These examples—from Tallulah Bankhead and pulp author Marijane Meaker to performers Gladys Bentley and Stormé DeLarverie—ultimately validate a camp sensibility for lesbian subjects, surely outnumbered by gay men but not as rare as we have been led to believe. Nevertheless, the following chapters will also raise instances of unintentional or "naïve" camp, where the object of study might not perceive or intend the particular exaggerated incongruity or "failed seriousness" that I attribute to it, yet I hope to avoid attributions of "purity," as Sontag would have it, for these campy manifestations of lesbian desire.[16] I am working to establish instead wide-ranging and varied forms of lesbian camp in the period after World War II as evidence of a remarkable new recognition of and intense concern about lesbian identities and communities in American public discourse. While I am not above appreciating what Isherwood might call the "Low Camp" of a lesbian camping it up for her friends (or audiences), the larger objective of the book is to establish a "camp sensibility" circulating around, as well as expressed by, lesbians in the period.[17] In the pre-Stonewall era, lesbians were certainly no strangers to the performance of self demanded by the closet, giving them a keen understanding of the ironic distance between appearance and supposed reality—or the theatricality of "Being-as-Playing-a-Role," to use Sontag's famous phrase—but they were also represented in absurdly exaggerated forms in mass media, producing a parodic and alarming effect, both intentionally and unintentionally.[18] The lesbian in the postwar period could be made awful and hilariously terrifying, as well as be the purveyor (and butt) of hostile jokes and double meanings made at her expense, but she was never not camp.

Beyond the overarching idea of camp as a "sensibility," coming so strongly from Sontag's influence, which manifests a love for the "unnatural," for artifice and exaggeration, and transforms it into a style and strategy—a wicked humor and way of being—there is the effect of this sensibility on the outside world.[19] For Philip Core, the second quality essential to camp is not just a "peculiar way of seeing things, affected by spiritual isolation," but a way of seeing things that is "strong enough to impose itself on others through acts and creations," remaking the (straight) world, particularly its cultural products.[20] Therein, the sensibility transforms into acts of creation or, perhaps more often, performance. In other words, as Chuck Kleinhaus puts it, camp is "a strategy for makers as well as for reception"—makers who frequently create a parody that "transforms" and "critiques" dominant culture.[21] In these acts of "camp writings," as he calls them, the creator merges love and shame, identification and mockery, pain and privileged sight, for camp effect, twisting popular culture, "shocking mainstream middle-class values," and expressing a sincere admiration for failure, even their own. In chapter 2, I examine the writings and camp tactics of just one such maker, pulp fiction author Marijane Meaker, who used the pulps' overheated, melodramatic, and formulaic mode to both reproduce the shameful lesbian "sicko" trope of the era and campily parody the authoritative discourses constructing psychologically "normal" sexuality for women after the war. A prominent example of that "very rare bird," the lesbian camp, this writer behind the well-known (and even notorious) lesbian pulp pseudonyms Vin Packer and Ann Aldrich represents an alternative queer voice and less affirmative model of lesbian subjectivity in the era, troubling the unashamed ideal championed by the emerging gay liberation movement. Moreover, the enormous popularity with lesbian readers of novels like Packer's *Spring Fire* or Aldrich's pseudo nonfiction exposés like *We Walk Alone* suggests a camp reception might have awaited makers like Marijane Meaker even in that most forbidding era.

As Core's "peculiar way of seeing things" suggests, possessing a camp sensibility amounts to a kind of second sight, a peculiar (and, in a way, privileged) point of view for taking in the dominant, normative world. This mode of "reception," which Kleinhaus summarizes as "camp as a strategy of reading," takes in objects, people, and (often) popular texts, many of which are devalued or even debased, and interprets them for camp pleasure—a reading process that often results in a kind of transgressive rewriting.[22] We can think here most obviously of the lists of "camp things" elevated by, particularly, gay male "taste," which Dyer, Core, and Sontag give us, or the canonical film texts—from *Sunset Boulevard* (Wilder 1950) and *The Women* (Cukor 1939) to *Valley of the Dolls* (Robson 1967) and *Mommie Dearest* (Perry 1981)—religiously revisited and adored by camp spectators and often productive of so-called "diva worship," which not only reads female stars with subversive (and often misogynistic) effects but also expands out into drag performance.[23] However, as Robertson argues, too often this reading and spectatorial practice—what Alexander Doty terms

"camping in culture"—has been denied to women, both queer and straight.[24] Focusing on the possibilities in "gender parody" in order to rectify this omission, Robertson argues for the centrality of a female "camp spectator," who can negotiate the terrain of "mass-produced objects that seem to support an oppressive patriarchal sexual regime" with both ironic critique and complicit consumption.[25] Likewise, in chapter 3, I work to extend "camp as a strategy of reading" to lesbian audiences, who might have found their own guilty pleasures in the deviant antics of the monstrous daughters of cheap horror films in the 1950s. In exploitation films such as Ulmer's *Daughter of Dr. Jekyll*, *Blood of Dracula* (Strock 1957), and *Frankenstein's Daughter* (Cunha 1958), these spectators would encounter deeply misogynistic and homophobic cautionary tales, meant to solicit fear, panic, and shame, but, I argue, the crudely imagined lesbian menace sensationalized in the films might also offer a different pleasure to these viewers, following sympathetic monstrous daughters as they campily roam the countryside, disrupting plots of inevitable hetero-maturation, and comically denaturalizing adjustment to the feminine role.

This might be a good moment to pause and address the elephant in the room. At the heart of this book is a simple question: What stops us from seeing lesbian camp? What is so difficult about imagining, for example, an audience of lesbians laughing to keep their tears at bay? It almost feels too obvious to state, but lesbians, in common imaginings, are just not funny. Despite ample evidence (and renowned comediennes) to the contrary, their gay brother is seen as the charming wicked wit, while they carry the weight of feminist responsibility around their straining necks like a millstone.[26] But then what are we to make of the male *and* female audiences clamoring for Gladys Bentley's ribald lesbian jokes in 1920s Harlem or the devoted lesbian radio audience for Tallulah's *Big Show* in 1950?[27] Are we to believe that no lesbians snickered at the snide comments of Thelma Ritter's Birdie in *All About Eve* (Mankiewicz 1950)? Or, who, indeed, is Audre Lorde talking about when she describes her "fat, and Black, and beautiful" friend Diane, whose "cruel tongue was used to great advantage, spilling out devastatingly uninhibited wit to demolish anyone who came too close to her; that is, when she wasn't busy deflowering the neighborhood's virgins," if not a lesbian camp?[28] Meaker might have elicited scorn from the Daughters of Bilitis (as I explore in chapter 2), but that should not preclude *other* lesbians from appreciating the bitter camp ironies of her pulp fictions. Therefore, when I turn to what I call the butch comedy of Eve Arden's *Our Miss Brooks* and Ann Sothern's *Private Secretary* (CBS, 1953-1957) in chapter 4, I have in my own mind a large television audience of lesbians, laughing through their tears at its camp delights. Although I have no intention of outing Arden or Sothern as closeted sapphists, I do contend that their wicked wit, expert lampooning of spinster frustrations, and "queer critiques of marriage" transform lesbian camp into sitcom gold.[29]

The complex affect and survival stratagem of camp have always pointed to a political promise intrinsic to its practice—but one too often corrupted from the

inside, hopelessly colluding with the enemy. Looking back from the 1970s, Jack Babuscio found the "bitter wit" of camp, the laughter ironically drenched in pain that is used as a strategy to undercut the rage from "dealing with a hostile environment," to be a "protopolitical phenomenon," repudiating "gay ghetto life" and subversively demonstrating "those cultural ambiguities and contradictions that oppress us all, gay and non-gay, and, in particular women."[30] While I am obviously invested in the historically and queerly specific political phenomenon of a camp rising out of "gay ghetto life" shared by lesbians and gay men after the war, I am at the same time wary of a parallel discourse to Babuscio's—the intransigent, circumscribed preservation of camp "as a *solely* queer discourse" and, for Meyer, an "oppositional critique embodied in the signifying practices that processually constitute queer identities."[31] A "gay [and lesbian] sensibility" is vital for the strategic camp I examine in this book, but I oppose confining it solely to gay- and lesbian-identified bodies, particularly because this obscures the straight use of campy representations in the postwar era to caution against and trouble lesbian sexuality but also because it tends to overstate the "progressive" power of camp.[32] Theorists from Dyer and Doty to Robertson have long cautioned against privileging camp's "radical/progressive potential" because camp reflects a sensibility "scarred" by oppression into "self-mockery" and self-hatred and too often colludes with the dominant culture's systems of oppression—for example, in reproducing stereotypes and objectifying women.[33] This "deep complicity with the dominant," as Robertson calls it, not only tends to reinforce patriarchal culture's misogyny but also, as I explore in chapter 5, ends up aligning camp with white supremacist notions of lesbian identity.[34] My examination in this chapter of the famed Amazon Princess of the *Wonder Woman* comics reveals both playful and serious manifestations of a clearly feminist lesbian camp, but these over-the-top representations of same-sex erotica and doomed heteronormativity also perpetuate the racist foundations for their feminist visions and reify the enduring equation of "lesbian" identity with whiteness in twentieth-century American culture.

Finally, and perhaps predictably, I offer a note about terminology. At the end of the previous paragraph, I placed the word "lesbian" in quotation marks, conspicuously before the term "identity." Much as I have done with the concept of camp, I hope here not to confine the term "lesbian" but rather pursue it, bewilderingly, along the many public paths and startling pronouncements where, I believe, it emerged so conspicuously in the second half of the twentieth century. Although, as I note above, this book details expressions of camp sensibility by lesbian-identified women, such as Marijane Meaker, the postwar "lesbian camp" of my title is not solely the product of women so identified or even of women. Within and through these various popular representations, I see the enunciation and elucidation, instead, of what Terry Castle has called "the lesbian idea," by which she means lesbianism as a "site of collective imaginative inquiry, as a topic of cultural conversation," and as a "rhetorical and cultural topos," not just a lived

experience for particular female-identified persons.[35] Like Castle, I recognize the frustrations and dangers of searching for "'authentic' lesbian-authored texts" when what truly concerns me is the way "sexual love between women has become eminently 'thinkable' in contemporary Western society," particularly in the twentieth century through its manifestation in popular culture—increasingly commanding the spotlight as a normalized, publicly recognized, even routine, "idea."[36] Significantly, my focus on this "coming out" of the lesbian idea in the postwar era immediately precedes Castle's symbolic moment for its triumphant "routinization," for its legitimate "entry into public discourse," which she identifies, unsurprisingly, at Stonewall.[37] With my sixth and final chapter, I single out the lives and performances of three African American entertainers, one of whom, Stormé DeLarverie, has reached almost legendary status owing to her participation in the Stonewall rebellion, in order to trouble this lesbian idea and its resolute whiteness. While none of these three figures (DeLarverie, Gladys Bentley, and Ethel Waters) identified as exclusively lesbian over their lifetimes, their disidentifying tactics for survival offer a model of camp defiance regrettably lost in the erasure of nonwhite voices and the experiences of queer women of color in feminist discourse.

So, for the sake of clarity at the end of an increasingly murky introduction, I offer a basic road map. We begin at the beginning with a reconsideration of gay and lesbian history's neglect of our lesbian camp, despite her attention-demanding presence in the 1950s as the star of the (Big) show—enter Tallulah Bankhead. Then, we proceed from one menacing pre-Stonewall queer figure to the next, across popular culture forms: we move from Meaker's pulp fiction sickos in chapter 2 through exploitation films' monstrous desiring daughters in chapter 3 to the camp comedy of Eve Arden's and Ann Sothern's queer spinsters in chapter 4; the lesbian separatist (and stubbornly white) Amazon is embodied in her most iconic form in chapter 5's camp Wonder Woman, while the Black performers of chapter 6, such as Stormé DeLarverie, suggest a rebellious disidentificatory practice of camp goes unacknowledged when we whitewash lesbian history. It is only left to the epilogue to unghost the lesbian camp one last time, as she flirts with discovery and rediscovery over the next fifty years.

Inevitably, with any historically bound study like this one, the author is presented with a question of reckoning: What happened to this camp who so shamelessly (and shamefully) asserted herself at midcentury? And, more pointedly for queer history, what became of her after Stonewall? My answer, again to invoke the voice of Terry Castle, is to say that she never disappeared; she is where she has always been, right "in the midst of things, as familiar and crucial as an old friend, as solid and sexy as the proverbial right-hand man, as intelligent and human and funny and real as Garbo."[38] In the repressive and punishing postwar period, camp served as perhaps the most felicitous yet painfully imperfect way for her to announce herself, to perform, advocate for, *and* humiliatingly denigrate an

Introduction • 9

identity, and to survive—laughing to keep from weeping. But she does not vanish after this moment. She demands our attention again and again, taking a star turn in the landmark gay liberation documentary *Word Is Out* (Adair, et al. 1977), for example, where ex–Women's Army Corps soldier and "All-American Dyke" Pat Bond transforms enlisting in pin-striped drag into a wickedly funny joke, or turning "butch" into an ironic commentary on lesbian politics as essayist Lorna Gufston did in 1980.[39] Or, one can simply marvel at the writings and pronouncements of "feminist butch colossus" Bertha Harris, who could condemn the vast majority of lesbian literature in a viciously economical phrase as "sheer winkieburger" and then just as cannily split all lesbian feminists into two tragic camps: the "tree worshippers on our west coast" versus the "ritualists who periodically burn their menstrual blood" everywhere else.[40] Muñoz finds her in the 1990s disidentificatory comedy of Cuban and Puerto Rican American lesbian artist Marga Gomez, and she even shows up on *The Golden Girls* (NBC, 1985–1992), although Bea Arthur's delicious butch comedy was perhaps never so brilliant as it was on *Maude* (CBS, 1972–1978).[41] Of course, on my own patch, I find it hard to ignore (or resist) the irrepressible, erudite camping of Sue-Ellen Case and, as should be painfully obvious, of the inimitable Terry Castle, whose essay on Sontag, "Desperately Seeking Susan," should be required reading for all young queers hoping to master camp.[42]

But if she is so omnipresent, so routine, so real, why would one even need to labor over a thick academic interrogation of her? (Why are we here?) Well, naturally, the answer sends us back to where we began. What seems so visible, so obvious, so present to me—the lesbian—has a nasty habit of dematerializing, being ghosted, or fading from view—upstaged, banished, or disappeared, even all this time after Stonewall, after her chic vogue in the queer 1990s, and through to today. I suppose my hope is that camp will help her to survive, once again, and bring her, chuckling with deep ironic laughter, back onto center stage.

1

The Big "Lesbian" Show in Postwar American Culture, a History

August 20, 1953. Anointed by the press as "K-Day," this momentous late-summer Thursday was heralded as carrying the potential impact of a sexual atomic bomb. Dr. Alfred C. Kinsey, Dr. Wardell Pomeroy, and the other staff of the Institute for Sex Research at Indiana University set this day as the prearranged release date for the press coverage on their long-awaited female follow-up to their first sensational study on male sexual behavior, commonly known as the "Kinsey Report." The national and international press, popular magazines, and cultural commentators from every arena played along with their publicity ploy, helping to set off what was already being dubbed the "K-Bomb" of *Sexual Behavior in the Human Female*'s publication even before the August 20th date, when, in a moment of seemingly staged coincidence, the competing lead story in most papers was the Soviets' announcement of their first successful test of a hydrogen bomb known as "Joe-4."[1]

What Kinsey biographer James Jones calls possibly "the biggest ballyhoo in the history of American publishing" was set in motion by a masterfully orchestrated plan wherein the world's most famous (and notorious) sex researcher invited international journalists and writers to Bloomington earlier in the summer for a heavily guarded and contractually restricted sneak peek at the new volume, with the shared agreement that not one word would be published on its contents until August 20, nearly a month before the book's publication date.[2] Anticipating (and simultaneously generating) a "major cultural earthquake" set

10

off by *Sexual Behavior in the Human Female*, Kinsey, the institute, and the publishers must have been initially pleased on K-Day as the success of their advance publicity gambit seemed realized: the upcoming publication of the book made front-page headlines in countless national newspapers that day, at least five of the biggest national magazines profiled both Kinsey and the book on newsstands the same week, and international coverage was almost equally as intense.[3]

Of course, the groundwork for these feverish expectations was established five years earlier by the unparalleled response to the first volume, *Sexual Behavior in the Human Male*. Essentially a dry, eight-hundred-page technical collection of findings, the first Kinsey report shocked the world by becoming a "national blockbuster," spending as many as forty-four weeks on national best-seller lists and selling nearly 250,000 copies.[4] Yet, it was the report's dissemination throughout popular culture that led to what Jones judges as the "most intense and high-level dialogue on human sexuality in the nation's history."[5] In 1948 and for years after, the report was debated and satirized in popular articles, on radio shows and television, by popular celebrities, and in newspaper cartoons, as everyone seemed to be discussing what Kinsey's report meant for the sexual norms of the country.[6] Simultaneously, the scientist at the center of the research became an internationally recognized celebrity or "brand name" for sexual revelation and revolution, mentioned in the same breath with Charles Darwin, Galileo, and Sigmund Freud.[7]

For good or ill, whether attacked or revered, Alfred Kinsey and his report became not just a publishing phenomenon but a cultural milestone. As John D'Emilio and Estelle Freedman argue, the report propelled "sex into the public eye in a way unlike any previous book or event had done," forcing a "nationwide examination of America's sexual habits and values."[8] Nevertheless, it must be acknowledged that this great sea change in public discourse about sexuality was predominantly the effect of the *first* volume on male behavior, while the 1953 female volume's reception and history are far more complicated. Originally anticipated for a second earth-shaking impact, the report on women ultimately landed with a bit of a thud, seemingly defused by lingering censorious decorum in the press around the subject of women's sexuality, as well as by an unquestionable conservative retrenchment on women's rights now notoriously associated with the era. The release strategy and reception of *Sexual Behavior in the Human Female* in fact might tell us more about the place and treatment of women in the Cold War era and the paradoxical attempts to manage and exploit female sexuality at the time than about Kinsey's influence. In other words, the report on women and the contradictory responses to it exhibit the postwar period's incongruous attitudes toward female sexuality that I am defining in this book as camp, with its "lesbian" iterations exposing the culture's most troubled ambivalences around gender and sexuality.

Greatly encouraged by the global response from his first volume on men, Kinsey was determined to protect the findings and, also, elevate the status of the

second volume on women, and so was born his publicity gambit of sequestering hundreds of journalists and obliging them to play by his book release rules. Yet, whether or not it succeeded in bringing about the changes he so desired, the dramatic release of *Sexual Behavior in the Human Female* did, arguably, approach the heights of camp. With its sequestered journalists, sound- and fireproofed laboratory vault, byzantine legal contracts demanding secrecy and obedience in reporting, and caricature-like bow-tied scientist emcee, the unveiling of information in the female report had all the theatricality and excess of an outlandish stage show, all the way down to its sensationally promoted opening night (or morning release).[9] Grace Naismith, reporting on the "Great Kinsey Hullabaloo!" for the *Los Angeles Times*, gave a fantastical and titillating account of her experience as part of a group of previewing journalists holed up in Bloomington during the midsummer heat, hoping to score the scoop of a lifetime—the "hottest secret in publishing history"—amid "strict cloak and dagger secrecy" and rooms at the Indiana Union so sweltering she had to write in her "bra and panties"; if the writers went out to eat, they were to lock their notes in suitcases, and while they were entertained and informed within the hallowed chambers of the institute itself (and by its indefatigable Svengali), they could never hope to examine the actual research interviews, which were furtively coded so that only four people on the planet could decipher them.[10] Like those thousands of sex records in "neat green files" that Naismith spies at the institute, teasing in their indecipherability, Kinsey was parading sex on the runway of mass culture and yet guarding his revelations with campy "locks and keys worthy of Los Alamos," standing in the closet doorway of what another reporter called his "office of sexual secrecy."[11]

Yet Kinsey himself was not only captivating as the maestro emcee and central performer in this audacious international peep show; he was also seriously working to manage an inevitable, but not entirely unwanted, hostile response.[12] Indeed, as the publicity-savvy "P. T. Barnum" of sex research, Kinsey must have partly welcomed the expected kneejerk reaction from austere moralists and cultural conservatives playing the démodé enemies of his sexual crusade.[13] A corollary of the camp spectacle (perhaps we can call it an aftershock) is surely found in conventional, priggish reactions to it—a predictable reception by shrill voices of sexual repression and moral rectitude. Accordingly, the Reverend Billy Graham took to the airwaves on September 13, 1953, and devoted his entire "Hour of Decision" to the "Bible and Dr. Kinsey," whose "obscene literature" was "going to teach our young people terrifying perversions that they have never even heard of before," while Pastor John Wimbish of Calvary Baptist Church in New York decried the female volume as "one of the most detrimental dissertations ever to be circulated among our people," finding it an "attack on our American way of life more overwhelming" than Pearl Harbor—nothing short of national cataclysm, where "home life would be crushed, our churches would be abolished," and "the very foundation of our freedom would be swept away."[14] Although

commentators such as Barnard president Millicent McIntosh were more circumspect, hyperbolic reactions like Wimbish's were not hard to find.[15] So, Kinsey's hysterical detractors, though in some respects strawmen, fittingly played their own (over the top) role.

In the end, however, the larger reception of the female volume went off not so much with a bang but a whimper. Guided most likely by an intractable propriety around the subject of female sexuality and the notorious double standards of the day, national newspapers and influential popular magazines assessed *Sexual Behavior in the Human Female* overall as enlightening but hardly the earth-shattering revelation that the initial Kinsey report on men produced in 1948—certainly not the cultural equivalent of a megaton bomb. If Kinsey's publicity gambit and public crusading can be viewed as a camp performance, then the relative *failure* of his efforts with the female volume represents the foregone, semitragic, ironic conclusion.

While *Newsweek* warned of a looming "controversy" surely to come, many news outlets presented their K-Day reviews as almost dull factual reportage rather than shock and awe, and, what's more, the female volume even elicited an unexpectedly approbative response from some quarters despite its critics, most notably in popular women's magazines.[16] To be sure, for example, Scheinfeld's critique in *Cosmopolitan* sought to undermine Kinsey's influence by ridiculing his sample as a "pretty small minority" of women, but this kind of reproach was often balanced by explicit endorsements such as Albert Deutsch's in *Women's Home Companion*, which asserted that the volume's revelations would "strengthen not shatter family ties" and improve marital relations through emphasis on "sexual compatibility."[17] For every complaint that the report suffered from a scientist's difficulty in "dealing precisely with the emotions of human beings," there would be equally compelling reassurances (from, for instance, a "woman doctor" writing with Deutsch) that increasing awareness of individual "needs" for both men and women could "strengthen many marriages" and offer welcome freedom and female "contentment."[18] In other words, the female volume could reassure, educate a little, or even be disregarded, but it would not shake the earth or stir a revolution in sexual behavior, norms, and civil rights—yet.

Partly driven by Kinsey's *own* arguments in the female volume that his findings would benefit heterosexual marriages by working toward compatibility and satisfaction for both partners, the sum of the reaction to the 1953 publication also evidenced a set of limiting contradictions about women and their sexuality that was characteristic of the period: sexual and gender norms were changing, but, paradoxically, women's purity and moral rectitude should be protected and preserved; women were increasingly granted agency and expanded freedoms, but they were also confined within traditional and restrictive old roles (as wife and mother); or, women deserved equal rights in certain areas, yet they were naturally different from men and so they should not be treated the same. Indeed, Kinsey biographer Jones attributes the downplaying and even censoring of the

female volume to the intransigency of these contradictions and the intense conservatism of the period around women's social roles. He concludes that, unlike with the release of the male volume, the "caution and blandness" typical of the national media's assessments steered clear of controversy and thereby produced "remarkably little soul searching"; although the female volume was obviously laying the groundwork for feminist calls for sexual liberation and gender equality, the press, for Jones, ignored or denied these "messages" and instead "rose to the defense of American womanhood," seizing on details that would support traditionalist ideas about the "moral superiority of women."[19] Finding it "nothing less than the domestication of Kinsey's message," the disavowal of and conflicted response to the female report that Jones identifies should, though, feel all too familiar.[20] As historians and cultural commentators have long argued, the postwar period was definitively marked by complex, paradoxical, and yet often disciplinary attitudes toward women's roles, desires, and changing status within the public sphere, and sexuality was, of course, a particularly fraught and prominent terrain for these conflicts.

It has become a historical truism—thanks in no small part to the influence of Elaine Tyler May's *Homeward Bound: American Families in the Cold War Era*—that the post–World War II period in the United States can be best characterized by a single word: *containment*. Accordingly, as May's thesis guides us, the Cold War era witnessed the ascension of a prevailing ideology of reactionary "domestic containment," where women (particularly white, middle-class ones) were sent homeward and reinscribed by a "family ideal" meant to confine and tame the freedoms, financial independence, and sexual activity unleashed during the disruptive war years.[21] Working in tandem with fears about containing Communist threats or nuclear energy was the conviction that the nation needed to be on a corresponding "moral alert" in order to rein in the "social and sexual fallout of the atomic age," so that the containment of female sexuality within the bounds of heterosexual marriage and family became synonymous with preserving the "American way of life."[22] Within this historical picture, then, it proves unsurprising that the national media might domesticate Kinsey's "message" on the potential sexual liberation and unsettling needs of American women, since it potentially threatened the body politic and, at the most reactionary, the future of the republic. Releasing the "destructive and disruptive force" of unbridled female sexuality could realize national anxieties of the atomic age, and so containment might appear preservative, yet the sexual emancipation for which Kinsey advocated was an energy nearly impossible to contain (in its domestic, suburban closet) because, in fact, it already contaminated nearly every aspect of the "American way of life."[23]

Indeed, subsequent work since May's foundational text cautions us to recognize a more complex and conflicted cultural moment, where, as Joanne Meyerowitz argues, rather than suffering under just one dominant narrative of containment, competing discourses were placed in an unsettling "tension."[24]

Capturing those conflicting discourses on female sexuality, then, Kinsey's female volume resembles something like an unexploded but not exactly defused bomb, one stifled by a sex-obsessed but puritanical country on moral alert but still, obviously, threatening. Set in motion by the contradictory messages communicated to women during the war—that their sexual availability might help the war effort, but, as Marilyn Hegarty shows, too much female sexual power, in the "victory girl" or "patriotute," endangered everyone—the postwar tensions could hardly be resolved by the plastic promise of a "domestic ideal."[25] The overgrown fears of female sexuality and empowerment that fueled moral campaigns to both "mobilize and contain" women during the war certainly did not disappear after it, as the tensions between sexual expression and external controls "continued to bedevil women" and, I would argue, the entire country, despite efforts at containment.[26] Finally, and most significantly for my argument, these postwar fears, conflicts, and disciplinary campaigns coalesced around a newly visible (or, as I will argue, often hypervisible) figure of disturbing female sexuality—the lesbian—whose status as a female figure unable to be contained within the confines of heterosexual marriage and the idealized nuclear family made her especially bedeviling.

Indeed, another commonly accepted thesis about the efforts to contain female sexuality in the Cold War era points to the persecution of queer Americans, specifically lesbians, as a means of defining and policing gender and sexual norms for women. Adroitly summarized by Donna Penn, the forces of containment needed a figure of female sexual deviance to "establish the boundaries of culturally sanctioned female heterosexuality," or, in other words, "to define, bind, and contain the so-called norm," and so the example of the prostitute joined with a newly visible lesbian predator to stand outside the limits of, and thereby define, the "parameters of prescribed gender and sexual behavior."[27] The increased attention to these two, often conflated, sexual outlaws signals, for Penn, postwar American culture's outsize fears of women's liberation and of a morally corrosive "uncontained female sexuality" endangering the nation, which accounts for the "uproar" at the publication of Kinsey's work, pointing to a changed perception of the lesbian not as an "asexual career woman" but as an ominous, sexually aggressive "threat."[28] However, as I have tried to show, *Sexual Behavior in the Human Female* was certainly met with less of an uproar than the male study, and, in fact, Kinsey's findings on female homosexuality were both less significant to his overall study *and* drastically less pronounced in the press coverage on its release, as compared with the enormous controversy caused by his earlier revelations about the prevalence of male homosexual activities in his sample.[29]

Kinsey's findings in the chapter "Homosexual Responses and Contacts" were thorough and exacting and considered a number of demographic factors (although, notably, not race) including age, marital status, religious background, and occupational class, as well as active incidence and frequency to orgasm, but in the end his conclusions about female homosexuality were predictably

underwhelming and unbalanced.[30] In sum, the report found the "incidences and frequencies of homosexual responses and contacts ... were much lower among the females in our sample than they were among the males on whom we have previously reported," with accumulative incidences of homosexual responses in women reaching only 28 percent, compared with 50 percent in the males.[31] These muted results concerning female homosexual acts were, not surprisingly, on the margins of most media coverage, if mentioned at all, and certainly took a back seat to the focus on heterosexual marriage that was underscored by troubling findings about age disparities between male and female sexual peaks and the recognition that women were not aroused by the same stimuli as men, causing confusion and disappointment for heterosexual partners.[32] If commentators were reluctant to sully the reputations of "American womanhood" with Kinsey's findings on premarital "petting" and extramarital affairs, then they were certainly not going to raise the profile of the lesbian sexual practices in the sample (perhaps most especially when they showed a much higher "frequency of orgasm" compared with "heterosexual marital coitus").[33] So, contrary to Penn, I recognize in the reception of Kinsey's volume a more conflicted and less open response to female sexual expression and, particularly, lesbian sexuality.

Nevertheless, Kinsey's impact on his gay and lesbian readers and admirers at the time should not be underestimated. He may have had less to say about female same-sex relations, but make no mistake, a lesbian audience was listening.[34] And what they heard was not condemnation or pathologization but scientific acknowledgment—not judgment and oppression but factual existence. The broader reception of *Sexual Behavior in the Human Female* in 1953 may have reflected the era's particularly conflicted response to female sexuality and emancipation, but Kinsey's influence and the acceptance of changing sexual norms could not be denied, even by the staunchest defenders of American "womanhood." Like Miriam Reumann, who finds both the reception and the aftereffects of its publication "complex and paradoxical" in offering "conflicting beliefs about female sexuality," I would argue the report influenced female sexual behavior as much as it documented it, establishing diverse sexual pleasures and extramarital sexual relations, even as Kinsey (and his detractors) tried to restrain women within heterosexual marital confines.[35] In other words, postwar Americans seemed to be in the thrall of a sexual identity crisis without a clear sense of its boundaries, provoking extreme and sometimes contradictory responses from dominant institutions like the state and medical establishment, as well as in popular culture. Yet, as Kinsey's example shows, there was no putting the genie back in the bottle, and certain figures most demonized by the forces of containment—like lesbians—became unsettling camp icons, whose megaton detonation often seemed only a moment away.

From a Monster to a Hero to a Sicko: A Cold War Queer Herstory

Only three short years after he released his K-Bomb, in August 1956, Alfred Kinsey succumbed to heart complications brought on by pneumonia and died with a series of future research publications left unfulfilled. His death, of course, was mourned in the national media, where even a critical *Time* magazine mentioned him in the same breath with sexual and cultural "prophets" like Freud and Havelock Ellis for using his vast statistics on sex to erase the stigma of the so-called abnormal; however, for an increasingly visible and vocal group of supposed sex perverts—the members of the two nascent homophile organizations in the United States—his death was experienced, in the words of his *ONE* magazine tribute, as an "immeasurable loss, deeply and personally felt."[36] Yet it was not just the predominantly gay male members of the Mattachine Society, whom Kinsey had met, interviewed, and advised on legal matters, who felt so "deeply indebted" to him for challenging "antiquated sex laws" and battling "prissy Victorian reservations" as well as a harmful psychiatric establishment.[37] Lesbians also expressed their sadness and gratitude. The very first issue of *The Ladder* in 1956, published by the recently formed Daughters of Bilitis, not only announced the formation and purpose of the "female homophile" organization but also included a brief "In Memoriam" for Kinsey, reprinting a tribute from the *San Francisco Examiner* to this "champion of human freedom and happiness," whose "grievous loss" might be cheered by the "powers of darkness and superstition," but whose work would continue through those "on the side of human progress."[38] Kinsey's own relatively small attention to female homosexuality and the press's minor recognition of his findings clearly did not prevent lesbians from absorbing or appreciating the potential effects of his destigmatizing and liberatory sexual message. They heard him, loud and clear.[39]

Indeed, Kinsey's reports on male and female sexual behavior have been recognized as one of the key catalysts in the postwar coming-out story for nascent queer communities finding a foothold in the period and for the civil rights movements they initiated. These two undeniable "cultural landmarks," for D'Emilio and Freedman, benefited the growing members of the "gay subculture" after the war by opening up "public discourse about sexuality," particularly through the male volume's "shocking" statistics on the pervasiveness of same-sex erotic experiences, which seemed to suggest that what was once a "deviant form of sexual behavior on the fringe of society" now "seemed to permeate American life."[40] Yet, historians like D'Emilio and Freedman typically temper the enthusiasm generated by this unprecedented opening up of sexual discourse with an immediate recognition of the ferocious *backlash* against the now more visible and vocal gay men and lesbians in the Cold War era; these individuals may have hoped for more opportunity, equality, and freedoms, but they were perceived and portrayed as a threat not just to national security but to the American way of life, unleashing "an irrational preoccupation with an alleged homosexual menace" that

18 • Suffering Sappho!

appeared to affect everything—from employment and military service to personal lives and popular culture.[41] Kinsey's work might have valiantly advanced the cause of those "on the side of human progress," but the forces of "darkness and superstition" would not be so easily vanquished, appearing to wield every lever of public power and state control against queer Americans during the period.

As I note above, the now familiar historical consensus on the pre-Stonewall period, established by major scholars such as Lillian Faderman, John D'Emilio, Allan Bérubé, and Estelle Freedman, argues for a crucial shift in gay and lesbian identity, cultural visibility, and subcultural consolidation in the wake of World War II, resulting, ultimately, in the gay civil rights movement. According to their defining scholarship, World War II acts as a watershed moment for gays and lesbians in the United States: first, the war disrupted the expected progress from familial home to matrimonial residence with geographic and ideological dislocation and relocation into sex-segregated military units or places of employment where independence, anonymity, and opportunity allowed for expression of previously proscribed desires; then, its end brought together newly freed men and women into urban communities (particularly in U.S. military port cities such as San Francisco, Los Angeles, and New York) where queer identities could flourish and a rights-oriented consciousness could take hold. What Allan Bérubé calls a "sexual revolution" for gay and lesbian veterans involved a seismic shift in social order brought on by the war that included not only close contact with the same sex away from the mores of one's local community but also, for women, opportunities for gender-nonconforming expression.[42] Military units such as the Women's Army Corps (WACs) and the Navy's Women Accepted for Voluntary Emergency Service (WAVES), as well as wartime employment in factories, offered women opportunities for financial independence and a space away from heterosexual (and gender) imperatives, particularly for working-class butch women who would appear "less unusual" in work attire and be subject to less hostility.[43] Then, with discharge policies that deposited queer servicemen and servicewomen at the closest U.S. port of call, the military seemed to inadvertently create urban enclaves where gay and lesbian communities thrived, and businesses, most significantly bars, sprung up to cater to this growing subculture, creating public spaces where queer communities might expand, develop a collective sense of "identity," and "come out" with political action to defend it.[44]

My goal here is not to discount the narrative of emerging lesbian and gay identities in the period or the historical consensus on the creation of an increasingly unified and politicized queer community as a result of the changes brought by the war, but instead to reevaluate the way in which American postwar culture offered a more ambiguous, incongruous, and contested idea of the newly visible *lesbian* subject within dominant culture and for the lesbian subject consuming representations of same-sex desire. Like Angela Weir and Elizabeth Wilson, who caution against reducing the historical moment of the 1950s and the lesbian

culture cultivated there into a "feminist folk myth" where "all women were pushed back into the home, all gays were persecuted," and "there was no chink of radical light at the end of tunnel," my concern is that the postwar period and our understanding of the "lesbians" found there not be pessimistically oversimplified in service of a prevailing progressive narrative.[45] As shown by the example of Kinsey's female report, this era that was consumed by changing and often confusing ideas about sexuality hardly appears monolithic in its conception of the lesbian. So, rather than accepting the effects of the period's "explosion of attention and rapid mass diffusion of information about same-sex sexuality" as "wholly negative," I concur with Reumann that the many discourses newly focusing on lesbian sexuality often offered "contradictory" or "more complex and ambivalent" meanings than the prevailing dark folk myth of feminist and queer histories allows.[46] At the very least, we might recognize competing narratives put in disturbing and incongruous tension, as with female sexuality more generally.

To be sure, the long-standing scholarly picture or folk myth of the postwar period, during which queer subcultural communities formed in urban centers, might be described as (at best) bleak. Taking into account the McCarthy-era witch hunts attacking gays and lesbians in governmental employment, the relentless police harassment of suspected "perverts," and the mainstream adoption of psychoanalytic theories of homosexual pathology, it seems unsurprising that the 1950s have grown to mythic, nightmarish proportions in queer histories—so much so that we almost come to expect hyperbolic claims, like Lillian Faderman's assertion that "the 1950s were perhaps the worst time in history for women to love women."[47] During what historian David Johnson has termed the "Lavender Scare," gays and lesbians and other "perverts" were linked to Communists and fellow travelers as both a disloyal, corrupting force in the government and as vulnerable to blackmail by foreign enemies, resulting in scrutiny, persecution, and attack as the "fear of homosexual infiltration" spread throughout the entire federal government and purges of employees multiplied precipitously—from the State Department and armed services down to state and municipal offices.[48] Moreover, these oppressive governmental policies and procedures encouraged local law enforcement to ramp up its own disciplinary practices in "unpredictable, brutal crackdowns" on bars as well as known gay cruising areas, leading to waves of arrests as well as moral panics like the one in Boise, Idaho, in 1955.[49] Finally, for Faderman, focusing particularly on "lesbian life," this "worst time in history" for queer women was strongly defined by its psychological persecution—betraying women who might have been sexual "monstrosities in the 1930s" but who found honor as service members and laborers during the war, only to be cast out again as "suddenly nothing but manifestations of illness" in a postwar period determined to renormalize women.[50] Transforming "from a monster to a hero to a sicko," the increasingly recognized and demonized lesbian in the postwar period became a sickness vital to be contained.

20 • Suffering Sappho!

Yet, not discounting the very real and very awful acts of persecution and oppression of sexual minorities in the postwar period, critics such as Robert Corber, Amy Villarejo, and Heather Love, nevertheless, ask what might be the motivation for and consequences of preserving the grim "contemporary myth dubbed 'pre-Stonewall.'"[51] What Corber questions as a historical picture becoming fixed and amplified into a sort of "Dark Ages of the lesbian and gay past," Villarejo more specifically challenges as a "myth" made to suit a contemporary liberatory and progressive narrative of queer identity politics.[52] For her, this pre-Stonewall history of "isolation and exclusion, marginalization and vulnerability, hidden pleasures and lurking dangers" works as a "cherished, melodramatic, and contradictory preservation" of a dark lesbian past beset by "shame" and oppression as the necessary (mythic) foundation for the movement to "pride" and social and civil rights progress.[53] More recently, Heather Love's work has joined this challenge to what she calls the "linear, triumphalist view" of queer history, where "utopian desires" and the need to fix or rescue the past has blinded us to the depth of experiences in that past and the way that past traumas, abjection, and shameful affect persevere into the present.[54] Rather than disavow, diminish, or repurpose the less palatable aspects of historical gay identities, such as despair, shame, alienation, and self-hatred, Love challenges the affirmative thrust of queer politics by asserting important "continuities between the bad gay past and the present," where undesirable pre-Stonewall feelings still persist in a post-Stonewall world, showing up the "inadequacies of queer narratives of progress" and "positive" representations.[55] I would argue, following Love, that the complex affect and representation produced both then and now by postwar popular culture has not been adequately addressed by queer critics and historians, who have been too quick to relegate their shameful and painful effects to the past, and that their continued appeal—for example, in the draw of the pulps—signals germane continuities between the postliberation lesbian subject and her dark pre-Stonewall sister. Finally, I want to insist that this Dark Ages pre-Stonewall sister is not nearly so sad and shamed and abject as she has been made out to be, nor should she be isolated in an ossified "bad gay past" devoid of the real possibilities of complexity and ambiguity or competing narratives within her own times.

Surely one of the most influential articulations of a specifically *lesbian* "narrative of progress" from a bad pre-Stonewall past to a liberated present is Faderman's already-cited landmark study, *Odd Girls and Twilight Lovers: A History of Lesbian Life in Twentieth-Century America*, published widely by Penguin in 1992. Beginning with the foundation provided by "romantic friendships" in the previous century, this exhaustive twentieth-century history finds its first firm identity footing in the lesbian "chic" of the swinging 1920s, with detailed considerations of two permissive "enclaves" in New York City—Harlem and Greenwich Village—which seemed to offer bohemian and nonconforming lesbians and bisexual women spaces where they could enjoy or at least try on "true sexual

rebellion and freedom."[56] However, the promise of the twenties, where clubs and parties in Harlem seem like a "refuge" in which a "homosexual consciousness" and sexual "outlaws" could coalesce, is quickly dashed in Faderman's "wasteland" of a Depression era, when the dire economic situation imprisons independent women in marriages of convenience or consigns them to the lonely isolation of a sexual otherness increasingly represented as "monstrous" by a powerful psycho-analytic (sexological) discourse.[57] Only the coming war and a widening recognition of sexologists' diagnoses of female same-sex love as "inevitably 'lesbian'" and "patently sexual" turns the story around, bringing women together in segregated settings where their intimate relationships might expand beyond innocent "friendship"; indeed, for many women, this was their very reason for signing up.[58] Moreover, because the war effort needed these heroes, female independence was encouraged, and love between women was not only "understood and undisturbed" but even "protected" at the highest levels, allowing organizations like the WAC and WAVES to run on "Armies of Lovers"—creating the largest subculture of lesbians in American history.[59]

Yet, as any student of the "Dark Ages" pre-Stonewall myth knows, the freedom, independence, and loves of wartime (and even the immediate postwar years) would come crashing down in the persecution, betrayal, and pathologization of the 1950s. When the war recedes from view and the discharged "Naked Amazons" of Eisenhower's Army collect back together at home, the reputedly darkest moment of the bad lesbian past arrives for Faderman, wherein a newly empowered psychiatric establishment defines "every aspect of same-sex love" as "sick" and McCarthy's witch hunts persecute those once considered heroes, purging them from their positions or confining them to a life of "secrecy," hiding, and distrust.[60] For those marginalized by the period's repressive sexual conformity, then, the defining feature of this conservative "age of authority" is, of course, fear—fear of unemployment, fear of arrest and public humiliation, fear of isolation and loneliness, fear of mental disorder and supposed abnormality, fear and internalized loathing of oneself, and even fear of each other.[61] Despite creating burgeoning communities around bars, private gatherings, and early homophile organizations, even the growing lesbian subcultures of the period documented by Faderman find themselves thwarted by an internecine "class war," where the largely young and working-class bar culture of butches and femmes cannot be reconciled with middle-class "kiki" lesbians who aspire "to integration" and "blending in."[62] The Cold War era is, here, nothing short of an unmitigated nightmare whose "legacy" can still clearly be felt even into the "more liberal times" of the book's publication.[63] Those more liberal times are, of course, ushered in by the lesbian and feminist "revolutions" and collectivizing of the late 1960s and post-Stonewall period.

To be sure, Faderman's comprehensive and eloquent work is a monument of gay and lesbian history, but it is also a deeply affective archive that hinges on the "triumphalist" narrative of queer progress challenged by theorists like Love and,

therefore, offers a grimly overdetermined view, I argue, of the postwar era. Her history presents moments of light and possibility within its noirish presentation of lesbian life in the 1950s and early 1960s, but, more often than not, Faderman discredits these competing narratives as "overstated" optimism or resituates them within the prevailing tale of fear, suspicion, and suffering.[64] In so doing, this queer legend of the sinister 1950s takes on the tenor of what I am tempted to call camp excess.

Yet, one does not have to *look back* on the Cold War era (ashamedly) to produce this excess. It was, in fact, always-already there. Faderman describes the persecution of the 1950s by "fanatical homophobes" as a kind of compulsive, intolerant articulation and twisting of the idea of lesbian sexuality, giving it "a name over and over again" so that a subculture of women came together and learned who they were, even if all they had were "hateful images of homosexuality" in their cultural mirror.[65] In other words, even though the homophobic society at large "would have preferred a conspiracy of silence with regard to lesbianism," it appears as though it just could not help itself, broadcasting and consuming a "widely disseminated" wave of titillating media accounts of "sick and subversive" gays and lesbians, which ultimately amounted to common knowledge of same-sex desire. Of course, it goes without saying that Kinsey has his own oversize role to play in this paradoxical story of a nation at once enthralled and repelled by, but surely no longer silent about, sexual behavior and changing sexual norms. Thanks to Kinsey, the popular press, the McCarthy-era witch hunts, and a handful of self-promoting and righteous neo-Freudian psychiatrists, the "lesbian" woman—yes, often as a monster, predator, or sicko—gained a place in common American discourse not only unprecedented in her history but beyond all rational or sensible measure. Compared with the past grave-like silence on female same-sex desire, the lesbian's full-voiced presence in postwar public discussion was startling. In her representations in popular culture, at times she verged on garish spectacle—a fifty-foot menace lurching through city streets, fixed on America's wives and daughters.

Whether as the deceptive lesbian wife, the evil predatory spinster, or the tragically deviant daughter, a popularized lesbian menace became the stuff of postwar nightmares, yet her signification and effects remained ambiguous at best. As Lauren Jae Gutterman shows in her recent scholarship on the era's wives who had extramarital sexual relationships with other women, even cautionary devils like the "lesbian wife," who cravenly sabotaged the nuclear family in psychoanalyst Frank Caprio's writings, prove complex figures with surprising agency in real life: amid the era's notorious conformity and marriage imperative, these women were often able to "balance" their sexual relationships with other women with their marriages and even engage with "an emerging gay and lesbian movement" from afar.[66] Additionally, in closely examining marital practices and divorce law, Gutterman further disrupts the queer narrative of progress by complicating the sense of the Cold War era as the "height" of state-sponsored

persecution of lesbians, finding clearer discrimination against lesbian mothers in divorce cases and custody battles of the 1970s and 1980s.[67] Notably, her work here parallels that of fellow historian Margot Canaday, who has also challenged the "accepted trajectory of gay and lesbian history" by questioning exactly *when* women became a focus of governmental attention and persecution, particularly in the armed forces where their lesbianism was often overlooked in favor of wartime exigencies.[68] Indeed, Faderman's Armies of Lovers prove a particularly resonant and complicated symbol of the wartime and postwar lesbian herstory, illustrating well the conflicted and evolving image of female same-sex desire throughout the tumultuous midcentury period.

Again, according to Faderman's account, lesbians who served in the armed forces during World War II were encouraged to view themselves as heroes only to be turned into persecuted pariahs or sickos after it, yet Canaday's intervention suggests a longer timeline and more of an evolving sense of lesbian identity and the public (and state-sponsored) uses for it. She insists, first, that we distinguish between the wartime experiences for gay men and those of lesbians, who, obviously, had different levels of participation in the armed services and who were understood and regulated differently by military authorities. As documented by Bérubé, the "history of invisibility" for lesbians translated into, initially, "no policies or procedures" to address their sexual "deviance" as they entered the U.S. military, resulting in few being screened out and only a small number, in comparison with gay men, receiving dishonorable discharges for homosexuality.[69] Likewise, Johnson finds a similar disparity in postwar purges of gay men and lesbians from the State Department, with women making up only a fraction of those fired.[70] Although Canaday goes on to show that this willful ignorance and queer invisibility would evaporate in the later postwar era as the state developed a permanent but subordinate place for women in the expanding armed services, during the war and immediately thereafter lesbians in some ways benefited from "government indifference" and a surprising lack of knowledge about them.[71] Indeed, she cites none other than Alfred Kinsey to establish how, at the time, the "relationship between the state and female homosexuality...was not a well-developed one." She notes that in *Sexual Behavior in the Human Female*, Kinsey exposes a legal, juridical, and even religious "history of invisibility" for lesbianism, as it moved from a total absence in ancient religious codes to ambiguous phrasing in U.S. sodomy laws that could allow for prosecuting female homosexual acts but almost never did so.[72] Therefore, at least until Canaday's well-documented acts of surveillance, harassment, and persecution in more permanent military positions after the war, the female Armies of Lovers and civil servants eluded some of the worst antihomosexual employment purges and prosecutions at the time.

Certainly, this is not to argue that lesbians wholly escaped persecution and harassment or that they were somehow blissfully free of the cruelty, paranoia, shame, and crippling fear that define the era in so many histories. Yet, the

privileged example of those women who chose to serve in the armed forces *does* suggest a more complicated discourse around lesbian sexuality at the midcentury—one that shifted and circled back between the extremes of invisibility and nightmarish spectacle. As I will show below, the lesbian servicewoman—most often represented in the figure of a WAC soldier—emerged as a legible sign of female same-sex desire throughout the war and into the postwar period, increasingly circulating in popular culture, the press, and institutional discourses as both a danger and a nervous joke. Coming out of the shadows of her history of invisibility yet still constrained by sexual norms and enduring conservative propriety, the lesbian in her military guise came to serve as a veiled warning *and* a coded, comic icon, making her a contested symbol of and identity marker for a coalescing lesbian subject in twentieth-century America. Rather than viewing this postwar history as a linear, progressive narrative—from monster to hero to sicko—I propose, instead, something more like a Möbius strip, with increasingly conspicuous manifestations of the "lesbian" circulating alongside one another, as, for example, when the lesbian servicewoman becomes increasingly visible as hero, monster, *and* sicko—and as the subject of a ribald, inside joke.

The Queer Spectacle of the Army's Lady Lovers

As both Allan Bérubé and Leisa Meyer establish, lesbian sexuality, while veiled in public discourse, was not invisible, unknown, or unimportant to the authorities developing women's auxiliary forces during World War II, and the danger posed by its exposure on military bases and in segregated all-female units necessitated a campaign of covert naming, education, increased scrutiny, and crisis management within military branches to avoid negative publicity and scandal. In the process, the lesbian became both more visible and more desperately concealed as the war progressed. Because World War II marked the first time that each military branch would create women's divisions, the branches were unprepared, according to Bérubé, to properly screen and assess the volunteer recruits, relying on existing procedures for men and neglecting to address female homosexuality directly. The need to recruit more personnel to meet higher quotas resulted in laxer standards and a willingness to turn a blind eye to disqualifying factors, even over, for example, WAC director Colonel Oveta Culp Hobby's expressed disapproval.[73]

Deeply concerned about the WAC's reputation and a common public perception of enlisted women as either sexually suspect "morale boosters" for male soldiers or "mannish" potentially queer women, Colonel Hobby repeatedly advocated for more stringent screening procedures, while also managing likely ruinous scandals such as the one at the WAC Training Center at Fort Oglethorpe, Georgia, which was initiated by a mother's accusation that the WAC was "full of homosexuals and sex maniacs."[74] By the end of 1942, Hobby's alarmed reports to higher-ups about lesbians and other "undesirable" women easily enlisting in the

corps resulted in some changes, including a confidential letter from the adjutant general to all commands ordering recruiters to scrutinize "undesirable habits and traits of character" such as "homosexual tendencies," as well as a revision to the recruiter's interview questions that asked if one of the applicant's motivations for joining was "to be with other girls." Nevertheless, many of these concerns and revisions, Bérubé finds, were largely ignored until the inspector general's investigation into the allegations at Fort Oglethorpe, which resulted in over a month of secret hearings on the prevalence of lesbians in the corps and, eventually, the release of a new technical bulletin in October 1944.[75] The new bulletin instructed medical examiners to use the psychiatric exam to screen out female homosexual applicants, although it included "no guidelines for identifying lesbian applicants," and at that point in the war, most of the recruiting had been completed.[76] Therefore, the military's approach to lesbian sexuality during the war proved conflicted and often contradictory, internally identifying it as a concern and seeking to conceal its potentially ruinous publication, while also downplaying its significance—even prohibiting "witchhunting" on bases—and tolerating it in service of the greater (wartime) good.[77]

Nevertheless, from the beginning, disassociating the female soldier from lesbian tendencies was always going to be a Sisyphean task. As Meyer argues in her history of the WAC, before World War II women's "non-medical military service" was typically divided between two chronicled bad-girl figures: the *camp follower*, who traveled with and provided needed services for armies such as cooking and sewing but whose duties might also include prostitution, and the *cross-dresser*, who represented a very long history of women passing as men in order to join military campaigns.[78] Indeed, the "slander campaign" that Meyer documents, which was directed against the very formation of a women's army auxiliary, relied heavily on the insinuation of these two specters of fallen or monstrous womanhood, with rumors and innuendo impugning and seeking to delegitimize the women who would serve by, for example, provocatively reporting on the War Department's distribution of "contraceptive and prophylactic equipment" to women in the corps or likening the Women's Army Auxiliary Corps (WAAC) enlistees to "naked Amazons . . . and the queer damozels of the Isle of Lesbos."[79] Despite an evolving psychiatric understanding of female homosexuality that was moving away from the nineteenth-century inversion hypothesis, the cross-dressing female soldier seemed to inevitably call up those mannish lesbians identified in Krafft-Ebing's *Psychopathia Sexualis* who suffered from a "psychic disorder" rooted in gender inversion and provoked by their investment in typically male occupations such as a military career.[80] Indeed, this sexual and gender deviant clearly haunted the women's branches of the armed forces during the war and received her fair share of thinly veiled press coverage and popular comic treatment.

Although certainly not to the degree that heterosexual wantonness and "morale boosting" were used to defame and undermine female soldiers during

the war, lesbian sexuality was used often enough as a scare tactic and means for devaluation and mockery. Meyers documents, for example, journalistic insinuations about the kind of "predilection" that would lead a woman to sign up for a man's army or that might enable her to "flourish in a martial environment," such as when one female reporter expressed surprise that a feminine woman like Colonel Hobby might lead the women's corps rather than "an unmarried woman with worlds of experience and a Gertrude Stein haircut."[81] Rumors and internal military handwringing about the kind of mannish women who would volunteer kept the lesbian more as part of a whisper campaign than an open panic, but, nevertheless, as army historian Mattie Treadwell admits, there was a "public impression that a women's corps was the ideal breeding ground" for female homosexuality, which the army had no choice but to refute.[82] Treadwell's official history in 1954, of course, denies this mistaken impression, insisting investigations found "very little evidence of homosexual practice"; but, the lingering popular idea that "any woman who was masculine in appearance" was sexually suspect plagued the WAC, not only shaping its policies but also failing spectacularly at keeping homosexual panic at bay.[83] Despite clear guidelines in a new enlistee's handbook that "mannish haircuts are taboo," the regulation hair style "above the collar" and the army's economic choice to base the pattern and sizes of the WAC uniforms on the male version turned out a conspicuously unfeminine female soldier, and the sexual connotations of this androgynous or even strongly masculinized appearance would form the basis for knowing comic pieces, although the jokes remained largely coded and allusive.[84]

Meyer documents one particularly salacious comic strip that was censored by the army, presumably for its open representation of postcoital lesbian confusion, but the comedic opportunity offered by 150,000 women with "Gertrude Stein" haircuts proved too enticing to stifle entirely. That censored 1944 comic, titled "Know Which Army You're In" and made for the popular comic strip "Male Call," dramatizes the morning-after revelation of its female protagonist, Miss Lace, who wakes up in her underclothes and is surprised to find she is sharing the sheets with a WAC private whose misleadingly ambiguous uniform hangs on a nearby chair, causing her to complain, ironically, "They should have more distinctive insignia on those WAC uniforms!"[85] Although this open recognition of same-sex desire for a woman in uniform was suppressed, the common perception of its possibility is in fact confirmed by a mainstream, popular version—a Bill O'Malley *Saturday Evening Post* cartoon from July 1943. In O'Malley's rendering, a convertible of cruising women approaches an open coupe that appears full of eligible conquests in uniform (signified by their dark shoulders and light caps, viewed from behind), but when the women pull alongside, waving gamely at their targets, the final panel hits home the same bawdy joke as that of "Male Call," showing three female capped heads turned to meet the femme pursuers' stunned gazes.[86] The cartoon has no caption, but "They should have more distinctive insignia on those WAC uniforms!" would surely fit the bill. Taken

together, these comics suggest not only the public impression that the women's corps attracted lesbians into its midst, but also that this "breeding ground" might attract other sexually adventurous women who found the masculine female soldier fairly irresistible in her uniform.

However, possibly the most popular cartoon femme soldier of the war (and postwar) period, Vic Herman's beloved Winnie the WAC, employed the mannish butch stereotype for an entirely different joke. Embodying what Meyer calls the "popular cultural stereotype of the mannish lesbian" attracted to the military, the butch WAC sergeant in Herman's comic works as the rigid, unattractive foil to Winnie's feminine antics, as our protagonist enacts the sexualized role of the "featherbrained Waac" used in both syndicated cartoons for male GIs and editorial pages to trivialize and belittle women's service.[87] In several of Herman's cartoons, with closely cropped hair and a husky figure filling out her regulation uniform (always with a tie even though Winnie can appear in an open-necked shirt accentuating her cleavage), the mannish sergeant hovers in the background, ridiculously staunch in her disapproval, with knitted eyebrows and meaty arms crossed as Winnie breaks dishes, shirks her duties, misses mealtime because she has slept in, and flirts with just about everyone.[88]

In one cartoon, as Winnie's equally girlish best friend (who also has a decidedly nonregulation length of well-styled hair) tries to wake her up with a bugle, Winnie slumbers alluringly in her bed while the cantankerous sergeant leans over both of them, thrusting her large, crossed arms into the back of the pleading and bending brunette friend. In another, not featuring the mannish commanding officer, a buxom MP with a suggestively placed erect nightstick catcalls behind Winnie that her "slip is showing!" In most instances, Winnie appears somewhat oblivious to these attempts to dominate her, as we are clearly supposed to sympathize with her natural lack of fit in a man's army, but her responses verge on the coquettish with fellow female soldiers, even with the butch sergeant, as she confides coyly to her friend in one cartoon, "I let her think she's my boss!" Her titillating pin-up pose here, thrusting her hip and rear in the direction of her mannish boss's gaze, performs well enough the inside joke that Colonel Hobby and other army officials were desperate to contain—that the WAC inevitably attracted and encouraged queer desires between all sorts of women, and sex-segregated barracks and common areas were indeed breeding grounds for a wide range of intimate relationships.

Furthermore, because of, rather than despite, the intensified persecution of gays and lesbians after the war, the premise undergirding these comic WAC intimacies—that the woman who actively desires other women exists at the heart of foundational American institutions—proved not only intransigent but increasingly iconic in the Cold War era, where she came to signify both sinister threat and ironic camp shorthand. In the chapters that follow, the woman in uniform, or even specifically the WAC or ex-WAC soldier, returns often as one of the postwar era's lesbian camp pop idols, setting off the lesbian pulp

28 • Suffering Sappho!

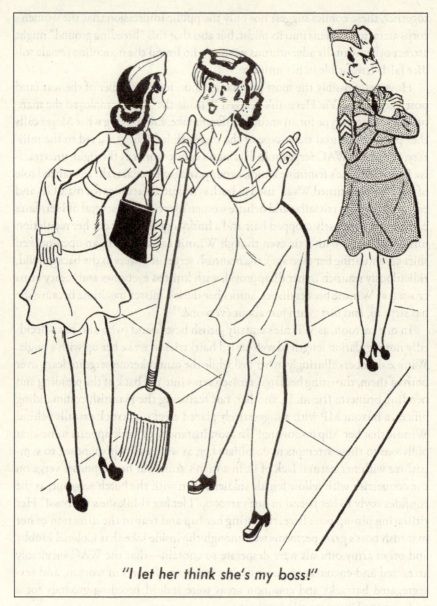

FIGURE 1 Winnie the WAC plays the coquette for her comically stern butch sergeant.

phenomenon and even finding her way onto national television. It is surely no accident that the novel typically viewed as the first lesbian pulp, Tereska Torrès's 1950 *Women's Barracks*, locates steamy lesbian assignations and demonic and tragic predation in the overly intimate military environment, or that the barely concealed queer splendor of William Marston's wartime Amazon,

The Big "Lesbian" Show • 29

Wonder Woman, infiltrates the WAC and chummily assists the WAVES, as one would expect of any daughter of the lesbian utopia Paradise Island, increasingly exclaiming "Suffering Sappho!" as the Cold War era wore on.[89] Even CBS's beloved spinster-teacher sitcom *Our Miss Brooks* makes self-conscious comic nods to "the almost quintessential lesbian institution" of the WAC—in one splendid instance encouraging Eve Arden to mug her way through yet another episode centering on her character's suspiciously unmarried status, this time sparked by a visit from two old WAC buddies who, it turns out, are not very surprised to find their ex-sergeant "Uncle Connie" still single ("Reunion," 1956).[90] These popular examples illustrate, then, how the lesbian increasingly preoccupied midcentury American culture through a set of competing discourses that appeared to wish for her silence and invisibility while simultaneously establishing her, sometimes through ironic humor, as an undeniable part of public life, campily allowing her to pass and gloriously fail to pass whenever her stereotyped menace reared its ugly head.

Nevertheless, in *Coming Out Under Fire* Allan Bérubé has to bracket off lesbians from the significant acts of wartime camping and army-sanctioned drag in musical comedy "soldier shows" like *This Is the Army*, which served as sources of refuge, camaraderie, and a means of defensive critique for gay men.[91] After some WAAC performers appeared in a handful of their own all-female musical comedies, the "leering comments" in the press about a female soldier "strip-tease" for male audiences convinced Colonel Hobby to restrict WAC participation in any revues, meaning some lesbian soldiers might have performed in drag but their performances were reframed in terms of heterosexual desirability, and there is essentially no documentation of their male impersonations.[92] Yet, the example of the comic WAC stereotype illustrated above suggests that, still, some camp effect *was* created by and attached to the lesbian soldier.

One of Bérubé's primary sources for accountings of WAC life, Pat Bond, who became a kind of celebrity chronicler of lesbian and gay life after her star turn in the defining 1977 documentary *Word Is Out: Stories of Some of Our Lives*, not only acts as a lesbian camp in her post-Stonewall remembrances but also suggests that the WAC experience and its lesbian signification played as camp even back then.[93] In her interview for *Word Is Out*, Bond contends that joining the WAC was "the thing to do" in the 1940s if you suspected you were a lesbian, which was amusingly confirmed for her by the "recruiting sergeant" who greeted her in Davenport, Iowa, dressed like one of her "old gym teachers in drag."[94] Insisting that "about 99 precent" of women in the corps were "gay," she goes on to make a joke of the recruiting process where many women she knew made their application in "drag," wearing "argyle socks and pin-striped suits and the hair cut just like a man's," and were allowed in by army psychiatrists who accepted every butch's absurd denial, "sitting there in your pin-striped suit," when asked "Have you ever been in love with a woman?"[95] Bond's

FIGURE 2 Pat Bond shares the joke of friends enlisting in drag in the landmark queer documentary *Word Is Out* (1977).

chuckling account both sends up the corps as a well-understood lesbian joke and presents it as a kind of refuge and camp performance similar to what Bérubé observed in the male soldier shows.

Yet, taken as a whole, Pat Bond's representation of her WAC experience offers a complex and emotionally fraught sense of the period. She can make the audience (and herself) laugh at the ironies of butch lesbians enlisting while in full drag, and she conveys the feeling of excitement in finding so many women "like" her in one place, yet she also turns quickly to the pain and injustices of the postwar purge of lesbians from her Tokyo base, where there was a barrage of "court martials and trials" at which women were encouraged to testify against their friends, making them "afraid of everything."[96] She presents exactly the sort of complicated picture of lesbian life at the midcentury that, I argue, allows for and highlights the pleasures, pains, *and* ironic critique of camp, where, as Steven Cohan maintains, its "recognition of incongruity" might not upend the "homologous boundaries of visible/straight/natural and invisible/queer/unnatural" but can at least put "one side of the polarity in direct tension with the other."[97] Although she is rarely represented for doing so, the lesbian camp can be especially brilliant at pointing up and parading this incongruity; she just needs the right venue to announce her critique and the star quality to carry it off. Enter Tallulah Bankhead.

"I'm a Lesbian. What Do You Do?" Tallulah Bankhead, the Lesbian Camp as Showstopper

On November 5, 1950, NBC premiered a new radio show meant to strike back at CBS's growing market share and its recent, devastating pilfering of the network's talent (although, of course, radio was exactly the wrong medium at this moment of television's ascent to accomplish such a comeback). This star-studded, ninety-minute variety program, *The Big Show*, brought together a crowded stage of guest talent on its opening night—from Fred Allen and Jimmy Durante to Ethel Merman and Danny Thomas—but the wild, immediate success of the show is largely attributed to the acerbic wit, self-deprecating asides, and dominating persona of its glamorous, scandalous mistress of ceremonies: stage, screen, and gossip-page legend, Tallulah Bankhead. Trading barbs with showbusiness friends and notable contemporaries like Merman and suffering her own slings at the hands of soon-to-be-regular foil Portland Hoffa, who that night initiated a running gag of the show where she and others point up Bankhead's gender and sexual nonconformity and smoky baritone by, of course, addressing her as "sir," Tallulah seems to effortlessly command *The Big Show* through force of personality and staggeringly felicitous wit alone. She could match her oversized comic persona with the likes of Groucho Marx and Fred Allen, while also shepherding the era's biggest stars of stage, screen, opera, and music through their numerous numbers. Armed with characteristically bawdy double entendre, caustic take-downs, cutting one-liners, and her own willingness to be the butt of the joke (greatly assisted by the best writers in the business, from Goodman Ace to Selma Diamond), Tallulah "darlings" her way into an intimate, if ironically distanced, relationship with what proved to be—at least for a year or two—a massive audience, showing that her brand of female camp had enormous currency at the time and not just with a small, knowing congregation of gay men.[98]

By 1950, Tallulah Bankhead had finally achieved the kind of fame she had maniacally pursued since her early teens, having conquered the West End as well as Broadway (if not quite Hollywood), while simultaneously constructing and earning an even greater reputation for her unrestrained personal life and outrageous pronouncements. In short, she had been, as one recent commentator notes, the "baddest, boldest, wildest woman of the acting world" across two continents, for nearly thirty years.[99] But after this period on *The Big Show* and following the success of her best-selling autobiography in 1952, Alabama's most notorious, hedonistic force of nature began the precipitous fall that her hard living and Faustian bargain surely portended, and so, her legendary camping transformed—perhaps predictably—into a tragicomic desperation and self-parody that an increasingly vocal gay male audience perceived and produced *as* camp. Indeed, by 1984, her transformation is all but complete when she joins Philip Core's pantheon of camp gods, goddesses, and sacred objects as the tragic, if brilliant, fallen star: imbued with a "manic aggression" motivated by

either "egoism or orgasm" that allowed her to reach great theatrical heights and coin legendary witticisms, Bankhead inevitably comes to "personif[y] camp" as the agent of her own undoing, unable to "stop being Tallulah" even "at the cost of her reputation," returning to "endless *double-entendre* jokes," living the debauched lifestyle of a bright young thing "far beyond the point where such behaviour was flattering," and coming to an unsavory end, rich but alone and "addicted to pre-scribed drugs."[100] Likewise, Denis Brian's 1980 biography, *Tallulah, Darling*, which profited from an impressive array of intimate interviews including an exclusive with the "grande dame herself," sings essentially the same sad refrain, promising (on its cover) to pull the curtain back on "Tallulah: A Glorious and Tragic Woman," who "wanted to be remembered, since she could not be loved," and opening with her infamous tragicomic final words, "Codeine—bourbon!"[101] She is at once admired, adored, pitied, and burlesqued—in other words, achieving the dizzying heights of a most revered camp object.

Yet, in the immediate postwar period, she is quite clearly still one of Ameri-can culture's most powerful camping *subjects*. Bérubé rightly cites gay men's self-defensive (and self-parodying) use of "Tallulah Bankhead's way of saying 'Darling!'" to exemplify their deployment of bits of popular culture to create "campy styles rich with irony, wit, artifice, theatricality, gender reversal, and sex-ual ambiguity," but his citation fails to recognize how Bankhead herself was a master of the "flamboyant and public announcement," the "vicious put-down used to attack pretentious closeted 'queens' and moralistic heterosexuals," and other play with "ironies in the realms of gender and sexuality" that define gay male camping for him.[102] Moreover, I would especially stress here that her well-rehearsed and well-lived camp persona (and camping acumen) was appreciated not just by gay men, either in the Cold War era or before. An almost throwaway line in Faderman's *Odd Girls and Twilight Lovers*—that the socializing of post-war kiki or middle-class lesbians might include dinner parties or private gather-ings centered on some communal event "such as listening to Tallulah Bankhead's weekly radio program"—points to a much larger revelation about the infamous actress-star: that she played to and was the object of queer *female* audience fervor from her earliest days on the New York stage.[103] Alluded to by Faderman and given voice in her source, Sasha Gregory Lewis's *Sunday's Women*, those lesbian fans who found security and community at gatherings (in groups of "thirty or forty"!) to listen to Tallulah, whom "everybody thought was gay," were as much a part of Bankhead's long-developed camp persona and personal history as the gay men she surrounded herself with and recognized in her later audiences.[104] Indeed, I would argue, a key to understanding the postwar period anew lies in the heretofore unrecognized significance of lesbian camp such as Bankhead's and the queer female audience for it, especially during what the kiki Tallulah fan in *Sunday's Women* calls "that terrible period."

Although she certainly produced enough critically acclaimed and influential performances to solidify her as one of the great American theatrical actresses of

the twentieth century, Tallulah Bankhead's star cast most of her (even more highly regarded) contemporaries into the shadows thanks to her colossal notoriety—and deliberately curated persona—as a sexual iconoclast and outrageous wit. With the indefatigable ambition and sense of entitlement befitting the indulged daughter of an Alabama political dynasty (her grandfather and uncle were U.S. senators and her father died as Speaker of the House), Tallulah hustled and commanded her way into great roles, from her early London star turn in Gerald du Maurier's *The Dancers* to her Broadway triumphs as the scheming southern matriarch Regina Giddens in Hellman's *The Little Foxes* and two defining roles in Wilder's *Skin of Our Teeth* and Noël Coward's *Private Lives*. But she also took on numerous inferior parts and substandard productions—including most of her film work apart from her restrained performance in Hitchcock's *Lifeboat* (1944), as well as many of her early stage appearances—because of either a self-defeating impatience (for stardom) or financial exigencies, or often both. All of which might have mattered if she had not been "Tallulah," the most notorious, foul-mouthed bad girl of American popular culture in the first half of the twentieth century.

Nearly synonymous with the sexual freedoms and libertine attitudes of the rebellious flappers of the 1920s, Tallulah used the star factory of studio Hollywood in the 1930s to propel her growing reputation as the most outrageous woman in show business to new heights. From her earliest days, she became infamous for her drug and alcohol use and sexual escapades with men and women, as well as for a penchant for shocking her costars, audiences, and fellow partygoers with habitual nudity and a disdain for underwear, but her notoriety and reputation were, significantly, of her own making. When she was not in the press for a cutting comment or popular riposte, she was offering up shocking publicity about *her own* exploits. Capping off her debauched adventures with the Bright Young Things of London by embroiling herself in a Scotland Yard–investigated incident with an underaged student at Eton, Tallulah came back to the United States in the 1930s with Hollywood in her sights, where she produced more controversy than winning performances, most notably earning the ire of the Hays Office for complaining in a *Motion Picture Story* interview that she had not "had an *affaire* for six months," insisting brazenly, "I WANT A MAN!"[105] Just at the fringes of tabloid printing she was even more capable of creating a stir, offering outrageous comments about fellow actors—referencing, for example, "divine" Gary Cooper's considerable "endowments" after she pursued a film role just for the chance to "f-ck" him—and audaciously joking about events that would have ruined most actresses' careers (and possibly killed them), such as her cosmetic surgeries, four abortions, and the emergency hysterectomy necessitated by an unchecked case of gonorrhea, most likely contracted from actor George Raft, not Cooper, as was rumored.[106]

This emergency surgery in November 1933, in fact, perfectly captures the legend of Tallulah's own making. With her collapse during a rehearsal of the

34 • Suffering Sappho!

original *Jezebel* stage production, doctors might have suspected one kind of self-inflicted crisis caused by the bottle of bourbon, sixty cigarettes, codeine, and minimal food she consumed daily but found instead an abdominal cavity "ravaged with gonorrhea," the removal of which nearly killed her and caused her weight to drop to a frightening seventy-three pounds; yet, even here, Tallulah was characteristically unrepentant, famously declaring to her doctor on her release, "Don't think this has taught me a lesson!"[107] Indeed, one might say the lesson that she had evidently learned, influencing so many controversial celebrities after her, was that any publicity was good publicity, or as she was fond of quipping, "I don't give a f-ck what people say about me so long as they say something!"[108] For a long time, in fact, many of the somethings said about her or offered in her own designed-to-shock pronouncements referenced her frequent affairs with other women.

Although her public declarations and shocking confessions typically pushed at but stayed within the bounds of publishing's restrictive heterosexual lines, her private life generated scandal and gossipy hints in the press, particularly in her twenties and thirties, for its queer fluidity and a strong element of sapphic devotions. It was not until much later biographies that we would learn of Tallulah's earliest queer inclinations, perhaps first glimpsed in her young teen obsession with a favored nun at the Mary Baldwin Seminary, but her sexual initiation in New York, with slightly older actress Eva Le Gallienne (who was followed by several other women), did not go unnoticed in the press.[109] The scandal-sheet *Broadway Brevities* latched on to young Tallulah's "close friendships" with several women, repeatedly alluding to her same-sex dalliances or associations with other queer actresses such as Le Gallienne and Blythe Daly; yet, this was, it seems, only the tip of the iceberg, as biographers now recognize many brief flings as well as more serious relationships with numerous women throughout her life—from the renowned such as Marlene Dietrich, Mercedes de Acosta, and comedienne Patsy Kelly to lesser-known girlfriends and companions such as Hope Williams, English actresses Monica Morrice and Beatrix Lehmann, and longtime caretaker Edie Smith.[110]

Perhaps equally significant during her early acting days, a number of prominent queer women in the theater helped steer and advance her career. The most important of these were bisexual actress Jobyna Howard and playwright and director Rachel Crothers, who not only nurtured and improved Tallulah's acting but eventually wrote roles specifically for her young, daring muse.[111] Indeed, Crothers's casting of Bankhead as the lead, Hallie Livingstone, in her successful 1921 play *Nice People* seems to have inspired key features of the emerging Tallulah persona: in the "beautiful, independent, wise-cracking flirt" Hallie, who was "treacherous and fashionably blasé about sex," Tallulah had a role she appeared born to play, superbly aided by Crothers's dialogue, which dripped with sexual innuendo and irony and repeated flapper aphorisms like "divine" and "dahling."[112] Moreover, even before she moved to London and was taken under the

wings (and into the homes) of a new set of powerful, mostly older, women, Tallulah began translating her same-sex intimacies and the lessons learned from her New York "flapper" roles into a provocative, public routine—a sapphic camp performance.[113]

Tallulah's early theatrical training and her rollicking but studied socializing in New York formed the foundation for her camp persona, which would only be further honed in London. The queer persona she crafted at such a young age was equal parts sexual shock tactics, coarse language, and culturally aware or sophisticated wit, all spoken with the air of a southern aristocrat and the timber of her dissolute baritone (deepening every year owing to nearly ceaseless smoking)—a combination she barely altered for the rest of her legendary life. Landing at the Algonquin Hotel when its fabled "Round Table" was just getting comfortable there, Bankhead studied and stole from Dorothy Parker herself and won invitations to the best theatrical parties with perfect imitations of her betters such as Ethel Barrymore. She took note of and adopted the "tough, abrasive style of New York conversations," which necessarily included frequent obscenities and slang, and did her best to approximate the "sly skewering banter and provocative cynicism" identified with Parker and the other intellectual glitterati of Manhattan, while also adding some of the best lines from her plays to her own unique witticisms.[114] In other words, Tallulah fashioned the language, provocativeness, and caustic wit of her public camp pronouncements and performances on the models provided by *female* iconoclasts like Parker and queer wordsmiths like Crothers, not just on the standards established by gay men. Similarly, one might argue that she learned a thing or two from frequent visits to the gender-bending and sexually outrageous performances of queer Harlem icons like Gladys Bentley (discussed in chapter 6), whose bawdy musical numbers and top hat and tails attracted many queer white women to the "anything goes" environment of Harlem cabarets in the 1920s.[115] Nevertheless, Tallulah's outrageous sexual liberties might be considered in a (lesbian) league all their own.

Determined to become notorious, Tallulah crafted an offstage persona of defiant sexual nonconformity associated with and appreciated by both the chic and humble lesbians of the liberated 1920s and 1930s. Rather than backing away from the baiting publicity that her relationships with women such as Le Gallienne and Crothers stirred up, Tallulah leaned in, often greeting fellow partygoers with the introduction, "Hello, my name is Tallulah Bankhead. I'm a lesbian. What do you do?" and becoming notorious for the quip, "My father warned me about men and booze, but he never mentioned women and cocaine."[116] In short, the young girl who supposedly modeled her first poses in the mirror on queer "doyenne" Alla Nazimova's "camp, over-the-top acting style" grew into her own camping persona similarly charged with a provocative, if not officially published, lesbian identity.[117] Bankhead may have bristled at the suggestion throughout her life that she was, in fact, a bona fide lesbian (and, certainly, her well-documented affairs with various men and women attest to something more akin to bisexuality or

36 • Suffering Sappho!

pansexuality), but the camp persona she developed at a young age could easily carry that term.[118]

Yet, again, I would emphasize that despite the debt she obviously owed to some of the most notable gay male camp stylists of the early twentieth century—from "Beautiful People" Noël Coward and Geoffrey Holmesdale in New York to the profligate, cross-dressing male "Bright Young Things" of London's costume balls and country weekends, most notably Cecil Beaton and her own beloved "Naps" (Honorable Napier Alington)—Tallulah's camp style was developed in concert with the queer women she knew (and admired), as well as those she performed for.[119] While she carried on with her sapphic alliances and dalliances offstage in England, apparently unamused by "London's more aggressively political sapphists" yet quite friendly with author Radclyffe Hall, Hall's lover Una Troubridge, and androgynous music hall comedian Gwen Farrar, publicly Bankhead camped across the West End stages for the riotous approval of her often queer, rabid female fans—her notorious following of "Gallery Girls."[120]

An alliance she had already cultivated and exploited in New York, Tallulah's relationship with and open playing to her fanatical female fans in the (cheap, elevated) gallery section of the theaters in London became almost as notorious as her outrageous pronouncements and dissolute exploits offstage.[121] Derided and bemoaned by theater critics, producers, and even fellow actors, Tallulah's cult of obsessive, largely working-class, female fans could derail a play with their shrieks and screams, thunderous applause, and well-organized call-outs to their idol, showering her curtain calls with flowers, undergarments, or even their own recently shorn locks of hair (in homage to Bankhead's controversial flapper bob)—all of which was reciprocated by the appreciative and publicity-savvy young star.[122] Tallulah took to acknowledging them first in her curtain calls by looking up to the gallery and blowing a kiss, and she even invited groups of her Gallery Girls, whose names she would remember and who would often queue for days just to see her, back to her dressing room or to her Farm Street home for drinks, small gifts, and snippets of wisdom.[123] They could make or break a play she was in (even the terrible ones), and a few of them became her trusted confidantes and presumed lovers. What seemed to drive their devotion and fervor, though, was not just Tallulah's renowned beauty and style but more her flouting of gender constraints and her sexual nonconformity, which so often mirrored their own.

On the London stage, Tallulah refined her exhibitionist persona as the female sexual outlaw, campily playing up her, ostensibly, heterosexual deviance for an enraptured and raucous audience of often lesbian or at least sexually nonconforming female (and male) fans. Two plays in particular, 1927's *Garden of Eden* and the following year's *Her Cardboard Lover*, made explicit the connection between her bold and sometimes crude performance of sexual daring and the ecstatic appreciation of her young queer fans. In the first, she plays a dancer who loses her job for rejecting the sexual advances from her female employer,

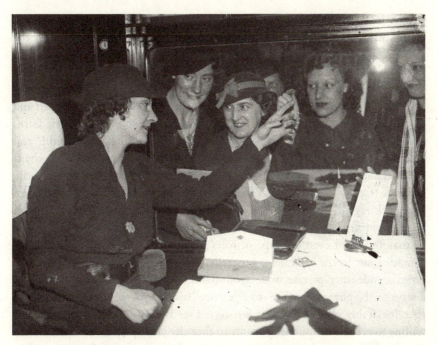

FIGURE 3 Members of the Tallulah cult of female fans crowd the train platform on her arrival back in England in 1934. (Photo credit: Smith Archive/Alamy.)

ultimately finding love ruined by her male beau's snobbish parent's disapproval. When she responds to this disappointment by tearing off her wedding dress, the shocking striptease (after a daring lesbian subplot) "drove her Gallery Girls into such a frenzy that the applause . . . lasted almost as long as the last act."[124] Then, opposite Leslie Howard a year later, Tallulah's appearance in the light lovetriangle romp *Her Cardboard Lover*, where she first appears onstage in silken pajamas, caused a near riot, with thousands of young women mobbing the Lyric Theater on opening night, almost overturning the arriving star's Bentley and requiring teams of police officers to rein in the melee.[125] Her gallery audience, predictably, devolved into paroxysms when she first appeared onstage in her pajamas, and a well-coordinated chant of "Tallulah, Hallelujah!" shouted down English stage favorite Howard's curtain call. By the time that her next play, *He's Mine*, appeared at the Lyric, her audience's queer makeup and deviant reputation (as well as her apparent encouragement of them) became so overwhelming that critics viewed it permissible territory for comment, as when one accused Tallulah of stripping down to her "lingerie" for the "benefit of the feminine element of the audience," who are derided with a final taunt, "Well, well, girls will be boys!"[126]

Not entirely unlike the World War II soldier shows detailed by Allan Bérubé, Tallulah's stage performances and her relationship (even camaraderie) with

certain female members of the audience evolved into what can only be called a camp spectacle, fueled both by the genius of her heterosexual drag and by the knowing pleasure in its queer reception. While there might have been Gallery Girls "of both sexes," as biographer Bret contends, the Tallulah "cult" at this time was less "mixed-gay" and more unadulterated lesbian.[127] The cult's undeniable "leader" was a "butch lesbian" known as Fat Sophie, who cross-dressed and employed her black umbrella to signal orchestrated responses from the Girls, such as when she opened it to begin the chants of "Tallulah, Hallelujah!" and who dictated cues for well-timed screams or swoons; she even devised the chant of "Sheep! Sheep!" for Tallulah's entrances, in reference to their idol's favorite perfume (Coty's *Chypre*), which the girls apparently used to sniff out her presence backstage.[128] Yet, this was certainly not a one-way relationship, as Tallulah took to consulting Fat Sophie regarding the success of a certain line of dialogue or mannerism or even the type of roles she would play, and the interchange extended out to the girls more generally, with whom the actress developed a series of codes or a "private, underground line of communication," such as using a wave or the phrase "bye-bye" to reference "beddy bye" (i.e., sex)—an allusion that inevitably elicited raucous self-conscious laughter.[129] Tallulah was even willing to orchestrate publicity stunts to cheekily play up (and down) their relationship.[130] In the end, she not only appreciated them and played to their campy spectatorial pleasures but took them sincerely into her life, inviting them into her home (especially Fat Sophie) and trusting them as longtime caretakers and friends; indeed, onetime Gallery Girl Edie Smith, whom Tallulah called "my confessor," became her secretary, personal assistant, and most trusted adviser for over a decade (and is most likely the real life inspiration for Thelma Ritter's Birdie character in *All About Eve*).[131]

Although the Gallery Girls may have faded from view as her career took different twists and turns in the 1930s and 1940s, the camp performance that Tallulah perfected for them on the stages of the West End merely solidified itself into what we now know as her central star persona—the sexually outrageous, exhibitionist, foul-mouthed but cutting wit who was asked to emcee NBC's last-gasp radio extravaganza, *The Big Show*, in 1950. In the increasingly conservative postwar environment, Tallulah's camping was, perhaps, less obviously lesbian, but at the same time the closeted atmosphere proved even more fertile ground for its ironic, audacious critique—a form of aggressive, gender-bending, and self-conscious humor that I call butch comedy and explore fully in chapter 4. While many examples might illustrate how *The Big Show* afforded Tallulah ample opportunity for her campy repartee, gender deviance, and deep-voiced double-entendre, the performance so beloved by those kiki lesbian fans gathered around their radios is encapsulated well enough by just one episode—the one on January 7, 1951, pitting her against (and with) that other foremost of queer female icons, Marlene Dietrich.

On its tenth episode, *The Big Show* delivered a queer dreamscape of Bette Davis jokes, self-conscious industry banter, Dorothy Parker monologues, and beloved torch songs, but it was obviously the irresistible pairing of Marlene and Tallulah that ensured its status as an instant camp classic. Opening with ironic references to Tallulah's influence on both Davis and the story of iconic b-tchy diatribe *All About Eve*, which Bankhead was fond of calling "All About Me," the show begins in familiar territory from the preceding episodes: Fred Allen wryly jokes about the impending death of radio, and several guests carry on the gender-bending gags inspired by Tallulah's voice "like any normal American boy," calling her "sir" or one of the "gentlemen" and referring to her toupee and wrestling skills. Described by Tallulah in her *Autobiography* as a show dedicated to the "comedy of insult," dripping with "venom" and "scornful allusions to my age, my thirst, my romantic bents and frustrations" countered by her own "scathing" rejoinders, *The Big Show*'s tenth episode reserves its best "ersatz venom" for the exchanges, threaded throughout the show, between the two sexually transgressive female superstars (and rumored lovers), Marlene and Tallulah.[132]

Their apparently venomous, but clearly companionable, husky-voiced banter hits on the highlights of the anticipated clash—their supposed rivalry, their advancing age, and their waning careers—but it also interjects a subtle erotic tension between them, rousing affective pangs of campy queer nostalgia. Tallulah may remind her rival that she is a "grandmother now," and Marlene may jab back that the *grande dame* has lowered herself to being "hidden" away "in radio," but there seems little on the program to equal Bankhead's smoky appreciation of Dietrich's "gorgeous legs" or the "divine" reprise of Marlene's signature torch song "Falling in Love Again," which Bankhead admits (only half-sardonically) made her die "a little" upon hearing it. Even though the episode ends with a trite "Anything You Can Do I Can Do Better" duet, the two old friends and rumored lovers give it a camp charm, entering a low-note competition that Tallulah wins with her sub-baritone final depths on the end of the word "beware" (from the well-worn sea shanty "Asleep in the Deep")—a virtuoso butch comic performance that elicits conspicuous female laughter from the audience. The show's "ersatz venom" proves, in the end, to manifest most winningly in another display of gender nonconformity—Tallulah growls deeply, "Step aside, buster," before delivering her final note—which a gratified audience cherishes, rewarded with the warm embrace of her "Goodnight, darlings" as the program draws to its close.

Recent Bankhead biographer Joel Lobenthal contends that episodes of *The Big Show* like the one described above were playing to "an urbane male homosexual audience" that was increasingly devoting itself to the star at the time but who would "foreclose Tallulah's theatrical career and reputation over the course of the 1950s," most notoriously in their vociferous reception of her performance in a 1956 revival of *A Streetcar Named Desire* when their ill-timed camp

40 • Suffering Sappho!

laughter disastrously disrupted the play.[133] Yet, the shrieks of laughter that rise above the audience response when Tallulah sinks to her winning low note at the end of the tenth episode sound evidently female, and it takes little imagination to guess that those lesbian friends documented in Lewis's *Sunday's Women* who gathered in listening parties of thirty to forty would have eaten up the flirtatious banter between Tallulah and Marlene, like Gallery Girls taken backstage to their idol's dressing room. By the end of her life, Bankhead clearly understood her status as a camp icon, particularly for young gay men—she is reported to have responded to the direction that she play up one of her final roles, in the infamous television camp classic *Batman*, with indignation, "Don't talk to me about camp, darling. I invented the word!"—but, in 1950, her camp performance and, more importantly, its reception were still in flux.[134] She may have abandoned some of her best "lesbian lines" from her youth and necessarily downplayed her relationships with women in her *Autobiography*, but her immediate postwar performances continued to play to, lean heavily on, and foster lesbian sexuality, commanding the stage with humorous, biting, and campily outrageous sexual iconoclasm and gender deviance.[135]

Recognizing her notorious reputation at the end of her memoirs, Tallulah Bankhead characteristically embraces her outrageousness. She might be "branded a harridan, a hussy, a rebel, a calculated trouble-maker" after enjoying "considerable dalliance" and "impromptu romances"—as she says, she "found no surprises in the Kinsey Report"—but she resolutely has "no regrets."[136] Her many affairs with women may be visible only between the lines of her canny confessions, but her boldfaced championing of "the heretics, the nonconformists, the iconoclasts" in the end, of course, flaunts her own legendary defiance of norms.[137] She may be hemmed in by the increasingly conformist and conservative tenor of the times and on the edge of a precipitous fall from the heights of stardom, but Tallulah's attitude and performances at this time are hardly the stuff of a paranoid, fear-drenched nightmare—certainly not the Dark Ages of a pre-Stonewall "bad gay past." She still brashly camps across the airwaves, and, as Faderman notes, communities of lesbians were listening and laughing. In fact, she is so well known to them that she appears in one of Ann Aldrich's pulp confessionals as a type: every lesbian bar, in the 1955 exposé, has a "poor people's Tallulah Bankhead," in dark glasses and a fur coat, "laughing raucously at her own jokes."[138] Indeed, as the next chapter will explore, the spectacle of the lesbian pulps at this time establishes well the contested and contradictory visions of the lesbian circulating in American culture, at once nightmarish, threatening, and harshly comic.

2

Voyage to Camp Lesbos

Pulp Fiction and the Shameful Lesbian "Sicko"

> According to the American Psychological Society, I was sick.
>
> According to the law, I was a criminal.
> —Katherine V. Forrest, introduction to *Lesbian Pulp Fiction: The Sexually Intrepid World of Lesbian Paperback Novels, 1950–1965*

In the opening essay to her entertaining and thorough historical overview of queer pulp fiction, Susan Stryker vividly defines, employing pulp's own overheated language, the sensational world created in the midcentury paperbacks—a world of "loose women and lost men who wandered in a moral twilight, a world of sin and sex and drugs and booze and every ugly thing human beings could do to one another."[1] It was a world in which its "ugly" human players quickly descended into an orgy of deviance as if perversion were a contagious disease—where "bisexual experimentation, like a single puff from a marijuana cigarette, often served as a first step on a long and sordid journey that tended toward heroin addiction, murder, homosexuality, the breakdown of gender distinctions, and the certain madness that lay beyond." But more to Stryker's point, the

41

42 • Suffering Sappho!

paperbacks constructed a world undeniably born of the era in which they thrived. The schizophrenic postwar period's hypocrisies and anxieties, obsessions with sexuality, voyeuristic puritanism, and paranoid suspicions found themselves cunningly reflected in those cheap shameful paperbacks. In other words, the pulps made manifest an entire culture's unconscious fears and basest desires: "Straight-laced America held a paperback mirror up to its face and found a queer reflection peering back." Yet as considerable personal reflection on and critical examination of the queer pulps has established, this is only half the story. As Stryker herself subsequently asserts, the audience for that queer reflection was not *only* the straight world. Particularly with the prolific lesbian paperback originals of the period, a lesbian readership was ardently consuming, contemplating, and sharing this pulp fiction perhaps not originally written or marketed with them in mind.

Like the one outlined above, the story of the unprecedented rise of lesbian pulp fiction at the midcentury has become (through repeated tellings) both a map for reading the anxieties and obsessions of the postwar era and, perhaps more importantly, a well-rehearsed origin tale for the dark pre-Stonewall lesbian identity and community explored in chapter 1. Delving into the twisted and sensational twilight world of *Strange Sisters* who walk *Through Lesbos' Lonely Groves* has become a method of scrutinizing the cultural moment after the dual shocks of World War II and Kinsey's *Sexual Behavior* bombs, but more often the pulps have been employed to chronicle how the emblematic scared, isolated, and persecuted queer women in the 1950s found themselves and each other and came out of the shadows to march on the streets. As Katherine Forrest describes it in the epigraph above, even though at the time the American Psychological Society labeled her "sick" and the law found her to be a criminal, the significance of the pulps for lesbian subjectivity in the twentieth century cannot be overstated, because despite their damning portrayals of lesbian life, they unified the community: "Because they told us about each other, they led us to look for and find each other, they led us to end the isolation that had divided and conquered us. And once we found each other, once we began to question the judgments made of us, our civil rights movement was born."[2] This origin story and accounting of the role the pulps played in lesbian self-recognition and, thereby, political awakening have been repeated in numerous critical articles on the pulps, in personal accounts of lesbian reading practices and cultural engagement, and in one notable documentary, *Forbidden Love: The Unashamed Stories of Lesbian Lives*, where a pulp storyline initiates and organizes its examination of lesbian lives in the 1950s.[3]

I would like to suggest, however, in my reading of the pulps—particularly by focusing on author Marijane Meaker—that there is another queer story to tell. Meaker, the writer behind the well-known (and even notorious) lesbian pulp pseudonyms Vin Packer and Ann Aldrich, offers an important example of an alternative queer voice and less affirmative model of lesbian subjectivity in the period as a lesbian camp who troubled the unashamed ideal championed by the

emerging gay liberation movement. For many, including the editors and readers of *The Ladder*—the first nationally distributed lesbian publication, produced by the Daughters of Bilitis (DOB)—the pulps appeared as a kind of pernicious blessing for the queer female audience hungrily consuming such unprecedented popular representations of same-sex desire, only to be reminded in seemingly every work of the culture's damning stereotypes and demonization of such doomed love. *The Ladder*, and particularly its central reviewer, Gene Damon (pseudonym of *Ladder* editor Barbara Grier), begrudgingly attended to the pulps, although often with strong cautions against the despicable publisher-mandated portrayals, and, as historian Martin Meeker chronicles, a favorite target of this conflicted attention was the controversial work of fellow lesbian writer Meaker, whom Damon at one point calls an "evil genius."[4]

Historian Meeker's meticulous recording of Meaker's public admonishment by the DOB in meetings, personal letters, and on the pages of *The Ladder* reveals a battle over the creation of a "politics of representation" for the emergent lesbian subject in American culture, with the DOB unsurprisingly arguing for more positive representations of lesbians and far fewer harmful stereotypes, such as those found in Meaker's "nonfiction" accounts of pre-Stonewall lesbian life: Aldrich's *We Walk Alone: Through Lesbos' Lonely Groves* (1955) and *We, Too, Must Love* (1958).[5] Professing to offer the stories of many different lesbians she knew or knew of in New York City, Aldrich's accounts, which the author claimed were meant to dispel the myth that there is one stereotypical lesbian—"She is any woman"—seemed instead to employ a bitter sense of humor fueled by internalized homophobia to create some of the worst stereotypes about lesbians while dispelling others.[6] For the DOB, an organization founded to promote the "integration of the homosexual into society" by helping the lesbian accept herself and by educating the greater public to break down "erroneous taboos and prejudices" about her, Meaker's portrayals too often reinforced these damning prejudices and too rarely presented the positive image necessary for encouraging gays and lesbians to identify themselves proudly, come together, and fight persecution.[7] Instead, I would argue, her work—not just the nonfiction but also her groundbreaking novel *Spring Fire*—is struck through with the increasingly shameful practice and sensibility of camp. Martin Meeker's account of this early dispute over the politics of lesbian identity certainly foregrounds a now familiar split between the piteous pre-Stonewall subject and the enlightened, proud post-liberation queer but does not consider how Meaker blurs that divide with a shameful but brilliant bit of camping. Focusing on her work as lesbian camp, then, not only presents an alternative queer possibility neglected by histories of the era but also encourages a revisiting of the pulps themselves for insight into the complex affect illustrated in them and experienced by lesbian readers of them—even, I would argue, today.

For sure, this is not to discount the role of pulps in the formation of lesbian identity and community after the war, but to complicate it. The estimated

thousands of lesbian-themed paperback originals of this period cannot be so easily divided between positive and negative portrayals for a starved lesbian readership willing to cling to any recognizable image of same-sex desire, and the pain roused by the narratives' inevitable homophobia, vilification, and hateful moralizing demanded by publishers and the obscenity laws constraining them cannot be so easily dismissed now as merely a trace of the dark days before triumphant liberation. The pulps, I argue, are more than bad objects of humiliation, despair, and vicious distortions smugly put in their place by postmodern irony and kitsch consumption. They still have an affective pull for contemporary readers that lies beyond irony, indeed beyond pleasure—at least partly in that same lowly realm of pain, self-loathing, and sad, traumatic alienation experienced by its original audience.[8] Therefore, even in this so-called enlightened and affirming moment, we need to revisit these texts for what they have to show us about this troubling affect and complex responses to it. Rooted in anger and self-loathing and yet productive of wicked pleasures, camp in the pre-Stonewall era remains one of the most notorious and powerful queer responses to the period's persecution and marginalization of sexual minorities—capable of brilliant critique and shameful betrayals. Therefore, I hold up the pulp fiction lesbian "sicko," rife with such contradictions, as a camp icon of her era, tragically enacting the trauma of the culture's gender norming and sexual containment of women as authorized by the psychoanalytic model of "normal" sexuality, while simultaneously mocking, denaturalizing, and subverting it.

In this chapter, by considering the pulps as lesbian camp, created as such in the pre-Stonewall era, I seek not only to suggest a more complicated emotional relationship between the pulps and their female readership before and after liberation but also to posit a rarely recognized form of queer critique performed by pre-Stonewall lesbians. The pulps were, of course, reissued and rebranded in the 1990s as "postmodern" campy gems from a (thankfully) bygone era, but my argument here aims to consider camp as a queer strategy of subversion for women, both writers and readers, *within* the pre-Stonewall closeted age.[9] As Chris Nealon has persuasively established, "ambivalence" is perhaps the term best suited to describe the relationship between the lesbian pulps and their latter-day readers, but I wonder how we might consider the feelings Nealon proposes for readers decades later—"camp pleasure and intense sadness"—as existing for some pulps, for some readers, all along.[10] To be sure, the ambivalence of more recent readers can be understood as an employment of camp ironies to manage the painful past from a remove, while also recognizing the place of the pulps as problematic "survival literature" for the coalescing pre-Stonewall community. Yet I would argue that this mixture of pleasure and sadness, ironic critique and shame, was also available to the pre-Stonewall lesbian, and this continuity indicates a subversive queerness within the Cold War–era lesbian, as well as the survival of her despair, marginalization, and internalized homophobia today.[11] Not unlike Robert Corber's Cold War "femme," whom he figures as a feminine

secret agent whose ability to pass poses as much of a threat to national security, national identity, and normative heterosexuality as the butch's refusal to pass, the lesbian camp of the era disrupts the typical postliberation historical narrative and offers a representative for queer critique from within the period itself.[12] This lesbian camp exposes contradictions and ambiguities within the governing pre-Stonewall discourses—particularly, in this case, psychoanalytic definitions of normality—opening the door for queer possibilities *and* pain in the earlier era, as well as today.

Specifically, in the examples I explore below, the scandalous and popular lesbian pulps not only construct what we would see now as campy worlds of "excess and exaggeration," but key works (such as those by Marijane Meaker) do so with a complex ironic humor specific to this painful closeted era that, in Doty's description of camp, "foregrounds straight cultural assumptions" and their "(per)version of reality," in this case the (per)version of reality offered by psychoanalytic authorities.[13] These works present a particularly powerful but seldom recognized performance of lesbian identity at the time, one that offers a tragically homophobic pathologization of female same-sex desire while simultaneously creating a parodic burlesque of the discourses and ruling ideologies authorizing this image, such as the psychiatric regulation of "normal" sexuality. As lesbian camp, their ironic representation highlights the contradictions and incongruities in these normative discourses, potentially blurring the boundaries between and, thereby, redefining oppositions such as hetero-homo, masculine-feminine, and normal-abnormal, while also reproducing some of the most hateful and shameful contemporary beliefs about lesbian sexuality and the female sicko who loves other women.

A Homophobic Phantasmagoria: The Lesbian Pulp and Psychoanalysis

Like Katherine V. Forrest, whose quote serves as the epigraph to this chapter, many gays and lesbians in the postwar period felt defined, as well as persecuted, by two key authoritative institutions regulating "normal" society: the law and the psychiatric establishment. These two institutions proscribed their actions with two damning labels: "sick" or "criminal." Yet, just as with the institutional forces of the government and law enforcement, which sought to regulate, ostracize, and control "sex perverts" in the period, the established (and seemingly universally accepted) psychiatric discourses were rife with queer ambiguities and contradictions and, thereby, vulnerable to camp critique—especially when reproduced in the works of lesbian pulp fiction, narratives where many critics feel these discourses were often relied on to create the kind of final condemnation of homosexuality that censors, and therefore publishers, required.[14] Indeed, from the very beginning—for example, in Tereska Torrès's *Women's Barracks*, the mass-market paperback vilified by the 1952 Congressional Select Committee on

Current Pornographic Materials for its obscenely lurid cover art and appeals to "sensuality, immorality, filth, perversion, and degeneracy"—the interdependence between publishing stories of perverted sexuality and apparently containing them through psychoanalytic explanation and pathologization was central, if not yet part of a queer critique.[15]

Published in 1950 and considered by many to be the "first" lesbian pulp, Torrès's semiautobiographical account of a group of female enlistees in the Free French forces, who live (and often have sex) together in a barracks in London, became the first groundbreaking lesbian success for paperback original publisher Fawcett in its Gold Medal imprint.[16] Clearly confirming the arguments of gay and lesbian historiographers *and* the fears of the era's antihomosexual witch hunts, the war creates for these young French women a period of geographic dislocation, social transformation, and independence, resulting in a sex-segregated barracks where autonomy and sexual freedom produce casual promiscuity and rampant lesbian "deviance" and predation. Ranging from Claude, the older, sophisticated bisexual who brings young innocent Ursula under her wicked spell of sexual bliss and wild rages, to the "true" lesbians like stereotypical inverts Ann and Petit, who were born with and "could not live without" their abnormal desires, the barracks at Down Street includes a cast of characters pushing the limits of (and rarely made happy by) sexual license.[17] Yet, perhaps more importantly and without irony, Torrès offers a predictably homophobic explanation for the causes and consequences of their perversion, one clearly influenced by older, established medical and psychiatric opinion.

With its tragically isolated inverts and feminine nymphomaniac seductresses, Torrès's novel establishes not exactly the version of "sick" lesbian types who will fill the many lesbian pulps to follow, but it does signal the way in which those types will be pathologized and diagnosed primarily in psychiatric terms. Urbane and debauched Claude plays at being a lesbian to fulfill her role as a "dangerous woman," where "love-making with women, opium-smoking, group love-making" are par for the course, unlike pathetic masculine women like Ann and Petit, who have spent a lifetime under censure for gender noncompliance and who wander from fruitless love to fruitless love without social acceptance or permanent companionship.[18] Although Claude does not escape her own psychiatric diagnosis (as a woman compensating for her lost chance at motherhood with a perverted maternal attraction to several girls in the barracks), the familiar designation of the doomed "congenital" invert, established by sexologists like Krafft-Ebing and Havelock Ellis at the end of the nineteenth century, prevails for the "real" lesbians or *gousses* of Torrès's novel, whose sad existence isolates them from the normal world in quasi-incestuous cloisters with each other and with only male "pederasts" as company.[19] While its psychological rationale might be "peculiarly out of date," as Kate Adams asserts, for the Freudian 1950s, its equation of lesbianism with terrifying and wretched pathology makes *Women's Barracks* doubly

significant as the "first," setting up the deference to psychoanalysis in so much subsequent lesbian pulp fiction.[20]

Following the stunning success of *Women's Barracks*, lesbian pulp fiction turns into a publishing phenomenon throughout the 1950s and early 1960s with thousands of titles and millions of copies sold, but the narratives consistently reproduce a clear pattern to appease censors wherein the lesbian characters must meet tragic ends such as suicide, madness, or other fantastic forms of debauched destruction. Often the route to these ends begins with a psychoanalytic explanation of the illness, directing these unfortunate women down the twisted path of homosexuality. In fact, Kate Adams goes so far as to argue that the fictionalized lesbian of the period *never* emerges without this pathologizing psychoanalytic perspective as her companion—without it, she is seemingly invisible: "Like a kind of postwar Cinderella, the lesbian's presence in society was strictly circumscribed by an explicatory 'godfather's' presence, who rendered her identifiable as a lesbian according to culturally sanctioned preconceptions."[21] These preconceptions are founded in the era's new psychoanalytic diagnoses of female homosexuality offered by popularizers of Freudian ideas such as Edmund Bergler and Frank Caprio, who found not congenital inversion but a childhood trauma or early abnormal turn as the origins of adult homosexuality, more often seen as a "profoundly abnormal but curable" neuroses or arrested development, rather than biological doom.[22] Like Adams, historian Donna Penn contends that this psychoanalytic discourse was central to the "national crusade" of the period to make the lesbian legible and, thereby, constrained, but it also worked through popular texts like pulp novels to demonize her as a "postwar sexual devil" in order to set up and police the boundaries of normal female sexuality.[23] In other words, the lesbian as a new type became suddenly visible in the postwar years as a sick other, and the force perhaps most responsible for her visibility—psychoanalysis— offered its own trusted expertise to clarify her deviance, all this in service of a containment effort aimed at all women after the war.

However, it is the nature of that visibility that I would like to examine. This sick "sexual devil" constructed through two intertwined discourses—popular pulp and scientific psychoanalysis—becomes, I would argue, *hyper*visible as lesbian camp, a larger-than-life figure with harmful effects *and* the potential to subvert the very authorities diagnosing her pathology.[24] Hinted at in Penn's fantastic descriptors, as "devil," "sexual demon," and even the center of "a homophobic phantasmagoria," the lesbian of popular psychology and pulp fiction in the postwar era seems to exceed any simple homophobic cautionary tale.[25] While shaming and vilifying with the same litany of psychoanalytic explanations, the representation of her as a sick pervert is also exaggerated by the extreme plots and forced endings of so many lesbian pulps, and the relentless, heavy-handed turn to that "explicatory 'godfather's' presence," in Adams's words, potentially makes a parody of the Freudian construction of this newly visible lesbian.

Adams's own discussion of one 1956 middlebrow work—*The Hearth and the Strangeness*, written by Beatrice Wright, division president of the American Psychological Association—points to both the damning stereotypes and excesses of the new psychoanalytically informed narratives about tragic queers.[26] In the novel, an "unorthodox home life" takes the Freudian blame for the ruinous end of two homosexual siblings, as the closeted and panicked brother murders his relatively well-adjusted lesbian sister, while her naked lover "looks helplessly on."[27] The novel clearly trades in the worst stereotypes and terrorizing fears about gays and lesbians—that they are sad, sick, psychotic, and ultimately doomed—but also presents what Adams calls a "sordid drama and Freudian hint-dropping," which she hesitates to term laughable because they were "so common in the fiction of the day." Yet, this, for me, is the most salient point—that the novel's "bad horror movie" of a "madman's panic, a grisly murder, and a nude lesbian's shrieking response to her blood-spattered bed" vilifies gays and lesbians but can also be viewed as darkly humorous, along with the "godfather's" explanations for it, *because* it is repeated so often in the fiction of the day.[28] Its potential absurdity is not only borne out in the excesses of its plotting and its not-so-subtle evocations of pop-Freudianism, but it is also grounded in the artificiality and ironic distance created through repetition, making it susceptible to criticism by writers and readers of the period. While, unquestionably, having themselves pathologized across various authoritative and popular discourses was experienced as traumatic and tormenting for lesbians in the period, this does not rule out the possibility of also reading against that grain, even without the distance enjoyed by contemporary readers who often feel superior to (badly) popularized Freudian ideas of the midcentury.

Indeed, the critique I am locating in these lesbian pulps at times resembles what Ellis Hanson has called the "Freudian camp" of lesbian vampire films and postwar female adjustment films like Litvak's *The Snake Pit* (1948). These novels might lack the visual impact of Olivia de Havilland's star turn, where schizophrenic progression out of the "snake pit" of the asylum to the bliss of correctly adjusted heteronormativity is achieved by savior-therapist Dr. Kik and his looming portrait of Freud, which hovers over her therapy sessions like a particularly resourceful "godfather's presence"; nevertheless, the tales of troubled women in them do provide some of the same "pop-psychoanalytic nonsense in the best 'You Freud, Me Jane' tradition" that Hanson describes, ambivalently stacking up conflicting psychoanalytic explanations and, at times, failing gloriously at the serious business of extinguishing lesbian desire.[29] Yet, the over-the-top excesses of Hanson's Freudian version do not capture the complex "archive of feelings," to borrow Ann Cvetkovich's phrase, that I locate in the lesbian camp of midcentury pulp fiction, which combines the painful, hateful distortions of the era with a complex ironic humor, using homophobic representations of the "sicko" lesbian to establish a subversion of dominant discourses.[30] Recently, David Halperin has described the particular affect produced and embraced by camp, where the

FIGURE 4 The assuring "godfather's presence" of Freud looms over Olivia de Havilland's adjusting therapy sessions in Litvak's *The Snake Pit* (1948).

practitioners "laugh at situations that are horrifying and tragic," but, importantly, the pain "does not cease when they laugh at it—it may, if anything, become sharper and more precise."[31] Camp works to mitigate that pain, to transform it through ironic critique and the "undoing of seriousness," which becomes a defiant, political act, but that pain still adheres and the stigma is not erased, even as it is shown up as constructed.[32] Like Halperin's description of camp, then, lesbian pulp fiction such as *Spring Fire* can "return to the scene of trauma and replay that trauma on a ludicrously amplified scale," without avoiding "the reality of the suffering that gives rise to tragedy," wedding pain and enduring sadness to laughter and biting ironies.[33]

While *Women's Barracks* might be considered the first lesbian pulp, Vin Packer's *Spring Fire* is most often cited as the novel that truly created the publishing phenomenon, by selling over a million copies in its first year of publication (1952)—more than the paperback edition of Erskine Caldwell's *God's Little Acre* or Cain's *The Postman Always Rings Twice*.[34] Perhaps not surprisingly, this book, whose astonishing success "started a whole new subgenre of original fiction," tells a fairly tame tale in comparison with the pulps that followed: two sorority girls at a midwestern university have a sexually impassioned affair that ends tragically, with one of them being scared straight while the other is scared, literally, out of

her mind.[35] Along with the requisite homophobic and punitive conclusion of "no happy ending," a renunciation of one girl's homosexuality, and the "sick or crazy" end for the other, Packer combines titillating sex scenes, ironic depictions of sorority life, deep despair and self-loathing, and a myriad of psychoanalytically informed explanations for their coed perversion.[36] Yet, it is not just in the proliferation of symptoms, root causes, and diagnoses where one finds lesbian camp at play, but more importantly in the way that these explanations contradict each other or the way their manifestations in the two lovers are queerly juxtaposed. Reminiscent of *Women's Barracks*, the novel contains both the older sexology model of the congenital "invert" and the new postwar psychoanalytic diagnoses, but by locating them in the same two lovers, Packer at times archly highlights the contradictions and ambiguities within the psychoanalytic discourse that was trying to pathologize and, thereby, circumscribe lesbian sexuality.

When Mitch, the masculine nickname for Susan Mitchell, and Leda Taylor first meet and throughout their affair, the more butch of the two, Mitch, is haunted by the idea of her own "natural" inversion, yet the novel queerly establishes in its conclusion that Leda, the exquisite sorority queen, has been the true lesbian all along.[37] From the opening pages, the "not lovely and dainty and pretty" Mitch is self-conscious of her strong, tall body, her big feet, her limp hair, and simple clothes.[38] In short, she feels overly masculine, especially for a girl pledging Tri Epsilon, where the other sorority members somehow read her gender deviance before they even see her. Indeed, Leda herself initially cautions (or hopes?) that they might be pledging a "muscle-bound amazon" but is overruled by opportunistic sorority members who covet Mitch's father's millions.[39] Once she is involved with Leda romantically and sexually, Mitch becomes quite concerned about her own in-born perversion seemingly rooted in a queer masculinity. Learning the word "lesbian" from Leda and conferring with medical texts, Mitch begins to fear others can actually see her physiological abnormality, legible on her masculine body—the "congenital trend" visible, for example, in her appearance after swimming, with a mannish slicked-back bob "like that of a young boy."[40] Until nearly the end, the novel also spuriously associates her fascination with Leda and her growing skill, domination, and masculine aggression in their lovemaking with a "natural" lesbian sexuality.[41] Nevertheless, it is the beautiful, femme "campus queen" Leda who is ultimately driven mad by the recognition of her lesbianism, which has seduced and infected a supposedly innocent Mitch, who discovers at last that "she had never really loved" Leda.[42] In a queerly ambiguous inversion of its own, Packer's text performs a similar disruption of homophobic stereotypes that Corber recognizes in the era's concern over the "Cold War femme," whose ability to pass disconcertingly dislodges gender from sexuality, emphasizing performativity over biology. And if the inversion model cannot hold, what other psychoanalytic models might collapse under the weight of their contradictory conclusions or their hasty generalizations drawn from a handful of case studies?

As feminist critics have noted, the new postwar model for lesbianism moved away from biology in favor of a psychosocial etiology, in a Freud-inspired assertion of pathology found in developmental missteps and environmental causes, which resulted in arrested development or a diversion away from normal sexuality. As would be expected in such a psychoanalytic context, the root causes for lesbianism often could be found in "parental influences," as Frank Caprio euphemistically calls it, or in traumas resulting in psychic disturbances, such as a debilitating fear of sex with men.[43] *Spring Fire* juxtaposes several of these inconsistent diagnoses within the same two women, one of whom is judged "normal" by the psychiatrist in the end, resulting in the camp effect of disrupting the definition of abnormality and exposing the fiction of a normal female sexuality. Both Leda and Mitch have suffered sexual trauma at the hands of men, while the former had the additional trauma of the abuse being sanctioned by her perverse mother.

Echoing the sickness theories of writers such as Caprio and Wilhelm Stekel, where some trauma, such as violence, abuse, or early sexual assault, results in frigidity and/or homosexuality in women, *Spring Fire* wastes very little time in placing freshman pledge Mitch in a situation of near date rape during her first double date with Leda—an assault she fends off once but cannot escape the second time Bud Roberts attacks her. Rather than receive sympathy from Leda, Mitch is told in no uncertain terms to get used to this male violence, as Leda has had to since she was assaulted at age ten by her mother's boyfriend. It is surely no coincidence that after making this revelation, Leda initiates their physical relationship. The connection between heterosexual trauma and homosexual consequences is solidified when after the rape Mitch seeks out comfort with Leda, who offers the safety of her bed, where the two women have sex with "lightly" moving fingers, gentle undressing, and "soft" sighs.[44] The novel suggests here that tender lesbian sex could be an understandable response to trauma caused by violent, perverse men, but its ending establishing Mitch's normality also serves as a painful reproach—that only abnormal women respond to this kind of trauma with lifelong homosexuality. Still, as the novel proceeds to offer different psychosocial explanations without a definitive diagnosis, the implication also becomes either that there is no way to know why a woman turns queer or, more subversively, that *any* woman is a potential lesbian.

Not surprisingly for the time in which it was written, the other significant psychogenic theory of homosexuality offered in *Spring Fire* places the blame for the pathology squarely at the feet of another woman: dear old mom. Freud's own foundational "Psychogenesis of a Case of Female Homosexuality," of course, proposes his lesbian patient's return to the mother as love object after rejection or disappointment by the father, but the postwar psychiatric discourse that followed (in the work of Edward Strecker and Vincent Lathbury, for example) more specifically exemplifies the era's anxieties about "the horrors of momism," where oppressive, dominating mothers could ruin daughters, turning them "against

heterosexuality by describing it as repulsive," offering "too much or not enough affection," or even encouraging latent lesbian daughters by fostering their "prolonged attachment" and nurturing their immaturity and masculinity complexes.[45] Mitch and Leda offer the opposite extremes of this diagnostic favorite: Mitch has no mother and a distant father, and Leda has no father and too much mother, and the wrong sort. On the one hand, Mitch's lack of a mother and identification with the father might potentially lead to her abnormal masculinity, but initially, anyway, it leads to her "fragile want to be nurtured and cared for, as Leda had then in bed."[46] Incongruously, she begins as the motherless child whom Leda protects, but then plays the role of the masculine aggressor in their lovemaking, which suggests paternal identification and pursuit of a mother substitute—a Freudian scenario that depends on a primary pre-Oedipal attachment to a *present* mother, who according to psychoanalysts would be fueling the flames.

The latter scenario—the contemporaneous, dreaded momism—better fits Leda's situation, with her perverse, controlling mother Jan, who initiates and clearly dominates Leda's sexual desires, yet the symptomology becomes even more confusing in her case. Is Leda looking for a surrogate to provide something like her mother's perverse affections, or is she modeling her own activities on Jan's behavior and corrupting a version of herself? Like a daughter-lover, she seems to hang on Jan's every word and pathologically fears her disapproval—even dreaming that her sexual partner transforms from romantic snow-covered Mitch into a shocked, condemning Jan—but she also behaves almost like a nurturing mother with Mitch, although one who infects her with sexual desire.[47] Lesbians are made, apparently, by "too much or not enough" maternal affection, and *Spring Fire* both replicates this condemning diagnosis and highlights the double bind of the psychoanalytic impasse—damned if you do, damned if you don't—and in the tormenting confusion of who wants to be nurtured and who nurtures, who is the aggressor and who is the submissive, one is left with pain *and* the ironies of inconsistency in the authoritative discourse meant to be explaining away the sickness.

The final stroke of this camp critique, the "lie that tells the truth" of the whole charade (to borrow Cocteau's famous phrase), comes fittingly enough with the publisher-mandated ending, where one girl meets a tragic end and the other abandons her homosexual desires or denies that they ever existed. In a series of awful events that critic Michelle Ann Abate finds "outrageous," "ridiculous," and preposterous, Leda's climactic betrayal of Mitch leads her to a guilt-stricken, drunken, confessional car wreck, after which she has a nervous breakdown of Medean proportions, and Mitch discovers, with the help of a kind, pipe-toting psychiatrist, that she "never really loved" the queen of sorority row.[48] Despite being convinced earlier by "a thick volume on the psychology shelf" that she is abnormal, as it reminds her of "awful emotional orgies" with girls at boarding school, her fixations on certain female teachers, her lack of interest in boys, and

the "pulsing" of her whole body in "sweet pain" and "glory" with Leda, Mitch is swiftly pronounced "normal" by the male psychiatrist Dr. Peters (pun intended, I think) and seems to develop an opportune case of amnesia as she enacts his miraculous diagnosis in her last meeting with "sick" Leda.[49] Truly, how can we interpret this ending as anything but farce, as Mitch herself admits she was convinced that she was "a genuine Lesbian type" and the novel has consistently supported this identification from the moment that her first "fixed look" at Leda across the Tri Ep living room is met with a grin and a cruising stare, allowing "something familiar" to pass between them?[50] Surely, the reader has little reason to doubt Mitch's original conviction when the wild abandon of the sexual embrace that leads to their disastrous outing finds Mitch coming to Leda with "the arrogance of a master," digging her nails into her lover as she tears her clothes off.[51] Even with her "normal" bill of health, it is no wonder Mitch thereafter avoids the sorority, where fellow sisters discovered her rapaciously in flagrante with Leda.

With these scenes and confessions in mind, the good doctor's confidence in Mitch's normality ("there's no question") seems as ridiculous as Leda's B-movie madhouse breakdown and as absurd as his diagnosis of temporary contagion: despite mountains of evidence to the contrary, Mitch has just "caught some of that sickness" present in Leda and will be "all right" now.[52] The instability of his authority and of all the psychosocial theories of female homosexuality evoked in the book culminates in this obvious fiction. How can they claim with a straight face that she will be "all right" if homosexuality is essentially airborne and all you have to do is stand across the sorority living room from a sultry carrier? In other words, the fact that there is now "no question" about *Mitch's* normality means, as the author slyly has Peters admit in the very next line, that "it could have happened to almost any lonely, helpless, and naïve child."[53] And if almost any lonely, helpless, and naive girl is susceptible to this sickness, then abnormality exists potentially in almost every girl.

Packer's novel establishes an unsettling camp ambiguity at the heart of female same-sex desire, which queerly slips away from our understanding once we think we have grasped it and leads perversely back to normality even as its monstrous otherness parades before our eyes. Bastions of phobic heteronormativity, then, like the sorority, become easy targets for this disturbing and humorous camp subversion with their girl-on-girl final dances, glossy promotional materials featuring Leda Taylor (which poor Mitch, alone in her room, cannot help but stroke), and sly opportunities for convenient rooming situations. This amusing queer coloring of normal college life creates doubts similar to those expressed by the dour and (of course) unmarried dean of women, who is right to suspect Mitch's miraculous recovery.[54] Simply, these doubts and ambiguities unsettle the very foundations of normality or, worse, represent it as a hypocritical closet-case tempting young girls with her "campus queen" good looks and cloistered sisterly love, but delivering only heartache and a string of lies.

54 • Suffering Sappho!

Indeed, the workings of the closet, in 1950s American culture and through the sanction of psychoanalytic discourse, receive the final and most pointed jab of *Spring Fire*'s affecting camp critique. Leda is, of course, consumed by panic that she will be outed and goes to great lengths to conceal her true desires, most centrally by promiscuously performing as, in her own words, every "fraternity man's little damn darling."[55] And in the end, it is her guilt and strain over the extreme measures she must take to keep up the charade (such as betraying Mitch) that drive her mad. But, significantly, instead of treating this obvious root cause of her breakdown, psychiatry steps in to perpetuate the illness, implying of course that it has done so all along. Dr. Peters persuades both Leda's sorority sisters and Mitch to reconstruct the lie of the closet—"She'll be attempting to live the lie, and you've got to help her live it"—and not surprisingly, all of them prove to be excellent actresses, convincing Leda that no one suspects her lesbianism.[56] In this ironic, painful moment, the author stresses both the cruel sadness of the agreed-upon lie of the closet and the campy theatricality of it for everyone, including her "straight" sorority sisters.

Yet, by underscoring the doctor's enforcement, the novel also reveals the role of psychiatric authorities in constructing compulsory, performative heterosexuality. Leda suffers the anguish of trying to live the lie of heteronormativity, and rather than get rid of that corrosive lie (the other irreconcilable self), the doctor appallingly asks Mitch to preserve it, which she interprets correctly as mad confusion—"tell her, don't tell her, say, don't say, all jumbled up and crazy in her mind"—and as morally questionable.[57] At perhaps its most subversive moment, the novel suggests here that pathology is fashioned and *preserved* by psychoanalytic or psychiatric discourse, just as normality and the closet are. Leda is sick not only because she fits some of the (contradictory) psychosocial theories for female homosexuality but also because the falsehood of normal heterosexuality must be maintained, and Mitch is normal because the same discourse says it is so, despite ample evidence to the contrary.

Through Lesbos' Lonely Groves

I have performed this close reading of Packer's *Spring Fire* to illustrate a fairly straightforward point: that the author behind the pseudonym, Marijane Meaker, created her own version of lesbian camp through Mitch and Leda to play up not only their particular pulp melodrama but also the vexing, painful, and darkly humorous experience of closeted queer life in 1950s America. The novel reproduces and complicitly engages in the era's ugly, homophobic pathologization of lesbians, yet also works as a camp critique of normative values, juxtaposing competing narratives and highlighting contradictions to denaturalize the straight world, particularly its authoritative psychoanalytic discourses. In other words, rather than enacting an empowering postmodern play with essentialist discourses and the phallus, as Sue-Ellen Case's lesbian camps do, Mitch and Leda

have more in common with those earlier relics of the closet—the compromised and flagrant camp of pre-Stonewall gay culture who, George Melly notes, is viewed in recent progressive gay culture as the "Stepin Fetchit of the leather bars, the Auntie Tom of the denim discos."[58] After the ascent of gay liberation and identity politics in the 1970s, camp, such as the kind I am arguing Meaker creates, necessarily carries with it what Cohan calls "the stigma of the closet's oppressiveness," and it is difficult to deny that figures like mad Leda in *Spring Fire* brandish that shame.[59] Furthermore, many of the reminiscences by lesbians who read the pulps in the 1950s and 1960s are permeated with shame at their own enjoyment of such "miserable" and hateful portrayals.[60] Yet, more recent theorizations of affect have encouraged scholars not to dismiss, reject, or hide queer shame but to reevaluate it and recognize productive avenues opened up by its enactment.[61]

While many women furtively buying and enjoying these novels felt humiliation at their own need for and pleasure in the distorted mirror held up to them, and one can argue, certainly, that the lesbian author of such works, Meaker, projected her own reprehensible self-loathing and homophobia onto the page, we do a disservice to these texts and to pre-Stonewall lesbians if we delimit their complex and troubling affective engagement with the pulps as solely shameful and sad or relegated to what Love calls the "bad gay past." Interestingly, in a 2005 interview, author Marijane Meaker herself performs this exact sort of disavowal, clearly influenced by the post-Stonewall liberation narrative, while she simultaneously, in so many words, admits to her own provocative camping. She confesses that before she "got more pride," her works "made some jokes or pointed out some things that might have been true but maybe weren't kind," which she associates with gay men she knew who made "nelly jokes and made fun of themselves" but began to "clean up their act" after the 1960s, abandoning nonsense like calling "everybody 'auntie'" and other such "fool[ing] around," in the name of "progress."[62] This "metamorphosis" was shared by lesbians like herself, she says, who realized that they were "entitled to the same things other people had; instead of laughing it off we began to get angrier about it." In other words, with the coming of "pride," gay men and lesbians who made cruel, shameful, and often self-deprecatory jokes (i.e., camps) grew up, grew a political consciousness based in equality, and transformed themselves in the name of "progress." Yet, even in this clear self-indictment, Meaker shows resistance to abject shame about her own camping, hedging her self-criticism with a "maybe," still asserting the truth of her representations, and focusing on "anger" instead of regret. The sense of humor she shares with her "nelly" friends must be recast as discreditable and pre- or even antipolitical, but there is something about this camping that eludes total censure.

What Meaker hints at here, under the cover of postliberation contriteness, is a parallel, and perhaps counter, affect to the shame she is supposed to feel about her own camp creations and her own camping—humor, defiance, and maybe

56 • Suffering Sappho!

even a bit of pride in the truths she was able to offer. While we must recognize the shame she expresses now and probably felt then, the pleasure also produced by that laughter and insight should not be denied. In fact, in an interview with NPR in 2003, Meaker reasserts a place for this complex humor, contending that she found the publisher-mandated "unhappy endings" forced on paperbacks like *Spring Fire* "hilarious."[63] Certainly, pre-Stonewall camp is the product of indignities, internalized homophobia, and marginalization, but its angry bending of the straight world can also produce a pleasurable affect not just in the dark laughter it evokes but also in the act of critique and subversion by what Steven Cohan calls a "dissident identity": a significant "queer pleasure" in camp's "perceiving if not causing category dissonance," particularly for the values and founding oppositions so dear to dominant culture.[64] Her lesbian camp, then, can be seen as both shameful and part of a pleasurable, "dissident" queer project aimed at perceiving and causing "category dissonance" for notions of gender, sexuality, and psychoanalytically defined normality. Consequently, the affective experience of it is not an amused engagement with pain at an ironic (later) distance, but an immediate pleasure entwined with pain, laughter entwined with shame. To take Meaker's camp on its own terms is to confront queer defiance *and* the use of grotesque lesbian stereotypes, insightful critique *and* homophobic horrors, sharp jokes at normative culture's expense *and* the pain and suffering of rejection, alienation, and self-loathing.

Importantly, one must add Marijane Meaker's nonfiction pulp works, under the pseudonym Ann Aldrich, to this body of lesbian camp that she was so shamefully but effectively producing in the period. Like *Spring Fire*, *We Walk Alone: Through Lesbos' Lonely Groves* (1955), the first of her Aldrich nonfiction works, offers some of the most reprehensible stereotypes of female same-sex desire in its moments of stinging ridicule of lesbian life, but it similarly performs a pointed critique of psychosocial explanations for lesbian sexuality, presenting the worst opinions and then countering them with disruptive contradictions and common sense, ultimately blurring the lines again between normal and abnormal by aligning the lesbian with "any normal woman."[65] Yet, Meaker proclaims in her introduction to the Feminist Press's reprinting of her foundational nonfiction work *We Walk Alone* that she "hoped, too, that Ann Aldrich wouldn't lack a sense of humor" and that the journey she and many others like her took to New York City to find company and a place to "thrive" resulted in "many tears, and much *laughter*: ironies and epiphanies."[66] In presenting the many different lesbians she knew or knew of in New York City—*We Walk Alone* is her apparent reportage of the lesbian scene she personally experienced—her sense of humor and internalized homophobia as Aldrich offer some of the worst stereotypes of lesbians alongside her dispelling of others, all with an ironic eye and a humorous acerbic wit.

As Stephanie Foote argues in her afterword to the recent reprint of *We Walk Alone*, Aldrich/Meaker endeavors in this unique nonfiction work to present

"many lesbian cultures" as a defense against easy categorization or debasing myths, borrowing formal elements from pulp fiction, autobiography, and journalism to develop her own queer style comfortable with paradox and ambivalence and remarkable for its "deft manipulation of sometimes contradictory ways of understanding sexuality."[67] But Foote also finds a very particular authorial voice, one characterized by a "sharp-eyed humor" that produces often "biting" remarks or observations—a voice both off-putting and "assured, wry, world-weary, and acutely observant."[68] In other words, without identifying it as such, Foote recognizes the complex affective experience of being *and* encountering the lesbian camp as I am defining her: Aldrich creates "sometimes cruel jabs" at other lesbians' expense and demeans lesbian experiences while also sympathizing with the social alienation, emotional confusion, and material constraints experienced by them. Defined by her "contradictions"—for example, seeming to agree with pathologizing discourses of the time while simultaneously defying and muddying those expert opinions—Aldrich becomes "an agent provocateur," for Foote, at least partly driven by a desire "to critique what we might call a social as well as a psychological method of diagnosing all women and their sexuality."[69] Reading these Aldrich works provokes questions in queer readers (both then and now) as to why this professed lesbian expert seems at times to treat her fellow lesbians with such disdain, disgust, or even scorn—for example, in her discussions of the butch partner in butch-femme couples—which signals a painful self-loathing on her part; but, Aldrich simultaneously becomes that provocateur in her defiant refusal to limit lesbian identity or accede to any one authoritative explanation for lesbian subjectivity and, especially, in the biting sense of humor that so frequently underlies her authorial voice and her depictions of lesbian life.

Clearly stating that "one factor alone can never suffice to explain the lesbian's character, any more than any single bad experience can suffice to cause lesbianism in a woman," this nonfiction work plays with the idea that lesbianism is a pathology in search of a cure via the lens of her "sharp-eyed humor," as Foote calls it.[70] From its very first chapter, "Who Is She?," Aldrich uses that cruel wit to set the book apart from outsider examinations of lesbian life and intimacy, opening with a mocking depiction of a "young Yale man" she meets in a Greenwich Village bar who fancies himself a "student of psychology" and offers his expert opinion on the "lessie," which if correct, she says doubtingly, would give him "the edge on every student of psychology, psychiatry, and sociology, from Freud to Henry to Kinsey."[71] Then despite asserting (in opposition to the condescending Yalie) that "lesbianism cannot be accurately defined, nor can the lesbian's personality traits be lumped into any category that will include all of her characteristics," Aldrich herself begins to offer a litany of stereotypes and cuttingly comic scenes—observing "professional 'butches' in all the Greenwich Villages from Los Angeles to Paris" and a bewildering variety of precisely described gay bar patrons: the "wholesome-looking, twentyish blonde, swathed in a creamy polo coat," buying drinks for her "sullen-faced, boyish brunette" and

admonishing her "darling" for calling her at home where "mother and father" might find out about them; the lonely-heart, "haggard, middle-aged teletype operator in the pin-striped women's suit" listening to music and "nursing" her beer; and, of course, the "studious college seniors who claim to be there only in the interests of research, their hands touching gently under the table."[72] She professes to have seen them all—"the good, the frightened, the beautiful, the bad, the ignorant, the confident, the uncertain, the intelligent, and the mean"—but then in the next breath undercuts her own cruel typing: "I have seen them, and I am one of them; yet I have never been able to pick a lesbian out of a crowd."[73] It may be difficult to remember at times when she seems to be uncritically reproducing the most damaging diagnoses of lesbian abnormality offered by the psychologists, sociologists, and other "experts," but Aldrich seems intent here on using her humor to assert again and again that the lesbian can be recognized in certain types and yet is "any woman."

Still, this patently political assertion does not stop her from employing the freedom of *We Walk Alone*'s semiautobiographical, documentary reportage to wickedly reprise the camp ironies of *Spring Fire*—for example, in its coed catastrophe. In the very next chapter, "How Did She Get That Way?," which begins with etiology and symptomology from the likes of Helene Deutsch, Freud, and Adler, with their predictable turns to penis envy and arrested development, Aldrich acerbically skips through sketches from her own boarding school experience, where a cloistered same-sex environment breeds lesbian relationships "as a swamp breeds mosquitoes" and intimate schoolgirl crushes are as much a part of campus life as "soccer, 'sings', chaperoned trips to town, pillow fights, secret midnight feasts, and finals."[74] The author may write in the language of pulpified psychological discourse about the "less fortunate sisters" who cannot "fight off the blight" of lifelong homosexual object choice after the phase of adolescent dabbling—"For them, heterosexuality was finished in finishing school"—but, as the previous quip attests, she also relishes the chance to describe the scene of "half the student body" and half the female teachers "paired off in abnormal relationships." From her droll perspective, the "'Love that cannot speak its name!' was screaming its name in that fine old finishing school," where students witnessed female teachers courting each other in their apartments or having lover's spats with vases and jealous accusations thrown down dormitory halls, and the students themselves overlooked "passionate love notes" passing between them or their classmates' nightly visits to other girls' bedrooms, while they breathlessly attended "dance hour" on Saturday afternoon where they could waltz with favorite female partners "dreamy-eyed to the lyrics of 'All or Nothing at All.'" Although in her second nonfiction work, *We, Too, Must Love* (1958), Aldrich uses her experiences at her New England boarding school to elicit understanding and perhaps pity for the true lesbian couples first finding love on their dormitory hallway, as well as offering an unusual moment of sincere self-reproach and examination, in *We Walk Alone* the snapshot she gives plays as high camp, right down

to the senior student opportunistically charging five cents to view the congress between their gym teacher and music teacher through opera glasses.[75]

Leading the reader through glimpses at the bar experience, private parties in apartments, and the small-town controversy of a lesbian wife, Aldrich interweaves her sharp-eyed observations with summaries of expert opinion in *We Walk Alone*, and while she does not openly contradict the various psychological explanations and conclusions about lesbian "abnormality," she does offer moments of subtle critique. Particularly, in one of the last chapters, "Can a Lesbian Be Cured?," she takes her jabs at the psychiatric establishment and answers the titular question with a kind of question of her own: What does she need to be cured of? She opens the chapter with the accounts of three acquaintances who are in what she calls "serious and intensive analysis," in distinction from the many lesbians she has met who have only "flirted" with analysis due to its lack of results.[76] After ironically detailing exactly how much analysis is costing each woman and the frequency of the visits—from three sessions a week at $180 a month to $450 a month for six visits a week—Aldrich connects the expense of the analysis to the possibility of a "cure," revealing not only the socioeconomic constraints on queer women in the period but also the transactional nature of psychological treatment.

In contrast to Lou, for example, who is a beautiful, young model gifted analysis by her wealthy married boyfriend, Millie, the oldest of the three and a manager of a bookshop, stands the best chance for a cure because she seeks it out despite its incredible strain on her finances. Lou laughingly describes her analysis as "the greatest thing since the talkies," but Millie has been so unhappy in her lesbian relationships that she will pay whatever the price.[77] Poignant, incisive, and subtly critical of a field that profits from its diagnosis of abnormal sexuality, Aldrich concludes with a sarcastic rejoinder, dismissing much interest in a cure: "If it is true that a lesbian can be cured once she sincerely desires cure, it is probably not true that there are very many lesbians who seek treatment."[78] Not only does she propose here that many lesbians at the time were content with their nonconforming sexual desires, but this statement also follows a telling example from Helene Deutsch's *Psychology of Women*, wherein the groundbreaking female psychoanalyst actually adjusts a patient *to* lesbianism, finding her patient unable to "renounce homosexuality" as her analyst hoped but yet able (in a "compromise" with the therapist) to shed her deep unhappiness and suicidal thoughts once she achieved "tenderness and sexual gratification" with a female partner.[79] Describing the patient as being "liberated from a condemnation of her homosexuality," Aldrich clearly suggests that it is social stigma, the guilt and internalized homophobia of the closet, and psychological judgment that lead to mental illness, not an inborn condition or childhood trauma.

Her second nonfiction work, *We, Too, Must Love*, expands on these ironic glimpses into lesbian lives in response to hundreds of letters Aldrich received from women all over the country, many of whom cared less about the expert

60 • Suffering Sappho!

opinion offered in the first volume and more about the nascent primer on queer life in New York City. Promising in her foreword to write "the facets and foibles of homosexual life as I have known it in New York City" in response to letter writers, this "reporter within her own group" focuses on three sets of lesbians in the city: the more Bohemian, younger group in Greenwich Village; the wealthier uptown group on the Upper East Side; and the working-class butch-femme couples, who receive less attention yet harsher treatment from the author.[80] We get to know a collection of characters, typically as couples, in each group and follow them through their relationship dramas and to their typical haunts, like a Village bar called The Dock, a catered party and art opening for the "uptown Lesbians" in their thirties, and even summer retreats like Fire Island, the Hamptons, and Riis Park. We see them fall in love, drink to excess, struggle to maintain relationships, trade partners within their small incestuous circles (a stereotypical lesbian practice Aldrich refers to bitingly as "Hands-Around"), and even interact with their male friends and *beards*, who are usually gay men. These much more detailed vignettes enable the author to expand on her sharp-eyed observations and cutting quips—"To the uptown gay girl, being chic is paramount. The foreign car, the unlisted phone, the poodle, and the East Side address are essential"—and introduce readers to common, if harshly exaggerated, features of queer life in New York in the 1950s.[81] Meaker, through Aldrich, even paints a quick portrait of the gay male camp, describing Andrius from across the East Side apartment hallway as "the gay of the gay" who always "camps": "a straight-faced comedian of gay patter, with the slight lisp, the arched eyebrow, and the certain tilt to the head that are the accompanying dressing."[82] Perhaps, it takes one to know one.

As I indicated in the opening to this chapter, Marijane Meaker's portrayal of the expanding queer community in 1950s New York upset many of her readers, particularly those individuals working toward acceptance and civil rights. As historian Martin Meeker summarizes, the DOB in particular reacted very strongly to the Aldrich portrayals, openly criticizing her work for an imbalance between her "demystifying" and "pathologizing" and demanding more examples of lesbians as "useful productive citizens."[83] Yet, as Stephanie Foote contends in her afterword to the reissue of Aldrich's second work, Meaker's divergence from the well-rehearsed story of persecuted queer life in the Cold War era and the progression toward a liberatory identity politics should not be ignored. Indeed, Foote argues strongly for a renewed recognition of Meaker as an atypical but key voice of dissent in the era: "Aldrich's work explodes views of the 1950s as timid, apolitical, or sexually phobic. Aldrich also shatters the consensus that pre-Stonewall gay politics must have been tentative, assimilationist, or strategically ameliorative."[84] Agreeing wholeheartedly with Foote, I simply want to consider how the way she "queers our idea of what it meant to live as a lesbian in the fifties" can be productively understood as camp.

At once calling her a "dissenter" and an "agitator" who, by airing dirty laundry and exposing internal conflicts and contradictions, seemed to betray other lesbians who were fighting for civil rights, Foote describes Meaker in terms quite similar to Cohan's definition of the camp's shameful but dissident identity with which I began this section.[85] Meaker's camp revels in troubling contradictions while embodying (in her characters) the worst stereotypes of lesbians and other queer women, exposing norms and practices *within* the subculture itself that could be "both nourishing and destructive" and finding productive "friction" in her dissent from those norms or even in suspending the normative through contradiction.[86] Mindful of Kaye Mitchell's warning that we not "rush to embrace works . . . as 'queer'" based on contemporary reading practices that seek to "valorize sexual ambiguities; forms of textual and sexual unintelligibility; and feelings of loss, shame, and trauma" from a postliberation perspective, I do still want to argue that Meaker's dissent was deliberate and subversive, while being simultaneously conflicted, ashamed, and imbued with hateful pathologization.[87] Moreover, this form of deliberate, humorous dissent has too often been neglected in gay and lesbian histories of the period. Similar to Amanda Littauer's call for "plurality, possibility, and fruitful alternatives" in accounts of lesbian identities in the mid-twentieth century, I offer the lesbian camp as one such important possibility—a powerful one capable of both nourishment and destruction.[88]

We Do Not Walk Alone

Ultimately, I believe that the continued relevance and draw of the pulps (both fiction and nonfiction examples) can be attributed to the complex affective experience of 1950s camp and its continued resonance for queer audiences gaining victories and attaining major civil rights within a persistently homophobic world. One of Meaker's earliest readers, Lee Lynch, describes the dizzying experience (in the bad old days) of reading works like those by Vin Packer and Ann Bannon, or even Radclyffe Hall, as a foolish and misplaced love: she "devoured the books, loved the characters, identified completely" but in liberated retrospect realizes her "mistake," as these toxic lovers devastated her "incipient pride."[89] Yet even in her moment of postliberation regret, I have to wonder where that totalizing identification and devouring love went. Surely it cannot have disappeared entirely. The contemporary reader of the pulps may never have this same experience, since *incipient* pride is supposed to be a thing of the past, but love and identification, I would argue, still occur and their object continues to possess and produce pain and shame, as well as pleasure.[90] In her critical challenge to the "call of gay normalization," Heather Love argues for a gay identity that "cannot be uncoupled from violence, suffering, and loss" because the "structures of inequality" that produce such suffering endure into the present.[91] Instead of wishing these painful "continuities" between past and present away, queer critics

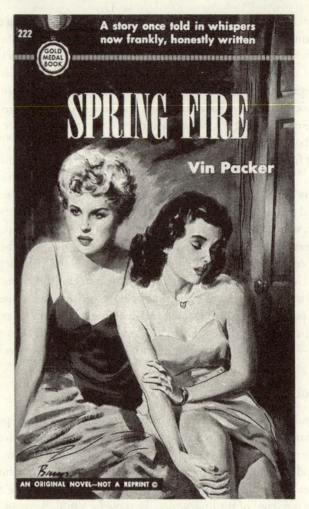

FIGURE 5 Alluring covers like this one for Packer's *Spring Fire* drew in lesbian readers who shamefully "devoured the books" in the 1950s.

might "follow the trace of violence and marginalization" right up to the present, where it still has much to impart about queer subjectivity and social exclusion.[92] The pain, self-hatred, and shame of the pulps, then, must be recognized as alive in the present moment, yet the complex affect produced by the camp of writers like Meaker does not end in pain, though its pleasure is never divorced from it.

At the risk of sounding like one of those queer critics whom Love chastises for attempting to rescue the past, I do want to reconsider how lesbian camp disrupts the shameful legacy attached to the pulps and behind them the lesbian subject in the pre-Stonewall period.[93] As I have examined it in Meaker's works, camp does not deny the "trace of violence and marginalization," but at the same time, it does exploit that violence to produce critique. Moreover, a denial of that

critique in favor of a narrative of the dark gay past does its own disservice to the complexities of queer history. Not fitting into the feminist folk myth of the pre-Stonewall period where "all gays were persecuted" and where pulps seemed to serve one purpose for a besieged but coalescing community of lesbians, a camp like Marijane Meaker represents the possibility of a different version of lesbian identity in the era—one that finds humorous pleasure in disturbing the vilest of homophobic beliefs without entirely disengaging from those beliefs and also without conforming to positive identity politics.[94]

Like the various lesbians she describes in her Aldrich nonfiction works, the pre-Stonewall lesbian should, for her, defy oversimplification. Despite her post-liberation contriteness, Meaker still insists on this diversity contrary to the particular lesbian identity the DOB wanted to construct, which she feels was not "representative . . . of the vast majority of the women I knew," encouraging Martin Meeker to label her an "iconoclast" who troubled the emerging DOB definition of "lesbian culture."[95] However, I would stress, as her comments maintain, that she was not alone in this challenge—that she voiced the concerns of many lesbians, like her onetime lover and fellow author Patricia Highsmith, who also bristled at the constraints of gay liberation's emerging identity politics.[96] Or, as historian Littauer documents, lesbians of the time did not need to be famous writers to voice this same challenge: for example, Littauer quotes a working-class butch contributor to the GLBT Historical Society's oral history project, Reba Hudson, who confidently asserts her difference from the DOB, whom she found lacking "an ounce of respect or a smile on their face."[97] In other words, Meaker's form of critique, favoring the painful ironies of camp over an emerging identity politics, might have been exceptional, but I do not believe she was a lesbian exception in the queer story of the 1950s.

Indeed, Meaker was not camping alone in the postwar period. Had I more time and space, I would compare her camping in pulp with the creative work and influential figure of Bertha Harris, whose "Notes Toward Defining the Nature of Lesbian Literature" begins with a stated misappropriation of and play with Oscar Wilde and, as I noted in the introduction, goes on to argue that most recent lesbian literature is "sheer winkieburger."[98] Although Harris moved to New York at the end of the 1950s and her first novel, *Catching Saradove* (1969), was published as Meaker's notoriety as the controversial Aldrich was fading (the final book in the nonfiction series was published in 1972), she could be offered as a significant substantiating figure for the type of lesbian camp I am proposing here.[99]

With the publication of *The Lover*, her most influential work, in the mid-1970s, Harris emerged as a lesbian force within the women's and gay rights movements of the post-Stonewall era, but it is the description of her by other lesbian authors and critics, as well as her own view of her work, that signals the camp is at play. Fellow southerner and author Dorothy Allison describes Harris in a memoir in 1994 as "outrageous, complicated, fascinating, uncompromising"—an

irresistible "force of nature" teaching a writing class at the Sagaris feminist institute in 1975 where Allison fell in awe of her "completely twisted sense of humor" and "wry irony" as she implored the students not to write "cock-sucking literature, her voice edged with absolute contempt."[100] Without referring to it in exactly those terms, Sue-Ellen Case then takes up this view of Harris and crystallizes her into a lesbian camp icon for the ages, "standing feet apart, like a butch colossus, overseeing the divide between the tradition of feminism and its *All About Eve* successor—the queer dyke"—transforming Allison's Harris into "a kind of *Night of the Living Dead*, starring brain-eating butch writers teaching at a 1970s feminist institute."[101] Allison, and then Case, re-creates that complex affect that I have argued the lesbian camp produces—laughter, fear, awe, and contempt, as well as a bit of nostalgia—but perhaps Harris's own description of her writing illustrates their recognition best. With the kind of outrageous humor and incisive candor familiar from the other descriptions of her, Harris describes her own major postmodern lesbian classic *The Lover* (in her introduction to the 1993 reissue) as a kind of "performance" that is "rife with the movie stars and movies of my childhood and adolescence," with a "perverted, effeminate *Hamlet*" and "tap-dancing and singing, disguise, sleights of hand, mirror illusions, quick-change acts, and drag."[102] Likening her own major work to the atmosphere of "*very* small-time vaudeville" performed with her father in insane asylums as a child, Harris embraces and performs the humor, absurdity, pain, and defiant critique of the camp, an "agent provocateur" in line with Meaker and similarly at odds with positive identity politics.[103]

One might also argue that Meaker's camp practice contributed to a larger tradition engaged in even by less queer contributors, who regardless felt her influence. One could take, for example, her campy impact on the body of original paperback works known as *pulp sexology*, as detailed by critic Annamarie Jagose.[104] For example, W. D. Sprague's *The Lesbian in Our Society: Detailed Case Histories of the Third Sex* from 1962—brought to readers by the associate director of the purely fictional "Psychological Assistance Foundation"—seems hardly possible without the path laid out by Aldrich's works. A masterwork of campy chronicling by pulp writers Bela and Sylvia von Block, this pseudo-nonfiction pulp, based in "files" and supposedly real case histories, as well as citations of actual and made-up scientific studies, gives a ribald and brief "History of Lesbianism" before a tongue-in-cheek cataloging of "Major Types"—from "Dykes and Dolls" to "The Part-Time Lesbian" and then moving on to "Special and Specific" types such as the infamous "Homosexual Housewife." (Aldrich's *We Walk Alone* contains more than one reference to this particular 1950s phenomenon and has an entire chapter devoted to marriages of convenience within the queer community entitled "Here Comes the Bride.") The sensational depictions and fantastic details from the case histories really must be read to be believed. The case of the bored housewives in suburbia who frequently turn to exciting trysts with other housewives because of conformist husbands who are often "unsatisfactory—or

at least unsatisfying" in bed is perhaps the funniest of the mocking examples, which, of course, share the pages with a litany of the most serious, damning views of lesbian sexuality in any era.[105]

Ultimately, these examples and the success of Meaker's novels and nonfiction, both then and now, not only queer the established idea of the lesbian subject in the pre-Stonewall era but also suggest that more than a few lesbians were and are drawn to this affective experience and share this form of "gay sensibility." Rather than seeing her creative brew of exaggeration, critique, nasty jokes, and shrewd rereadings of the medical discourse as just a strange, embarrassing artifact of the closeted era or as a limit case for queer challenges to affirmative gay politics, I see Meaker's camp as representative of a persistent, but neglected, line in lesbian history and cultural practice. A different sort of pre-Stonewall lesbian subject did not "walk alone" through lonely groves but announced herself in a deeply affecting way and attracted others to her, in both the past and the present, even as her shameful camping seemed to sidestep the march toward pride and progress.

3

A Strange Desire That Never Dies

Monstrous Lesbian Camp at the Movies

> Lesbians are sharks, vampires, creatures from the deep lagoon, godzillas, hydrogen bombs, inventions of the laboratory, werewolves—all of whom stalk Beverly Hills by night. Christopher Lee, in drag, in the Hammer Films middle period, is my ideal lesbian.
> —Bertha Harris, "What Is a Lesbian?"

In one of the climactic scenes of Roger Corman's teen exploitation gem *Sorority Girl* (1957), the mommy-deprived bad-girl villain, Sabra, takes her cruel exploits of Chi Sigma pledges to their predictable, titillating conclusion, as she paddles her favorite flunky Ellie over a plush ottoman in the center of her bedroom. Prominently referenced in the promotional materials featuring Sabra with her Chi Sigma paddle, this brief scene, which begins with Sabra's irresistible come-on line, "Feeling limber enough?," sutures the viewer into a bit of rough sapphic sorority fun by cutting back and forth between each girl's point of view—a high angle shot of a cowering Ellie followed by a reverse angle view of her sadistic tor-mentor, paddle raised in the air. Although the scene ends with Ellie in tears

66

FIGURE 6 Promotional materials for Corman's *Sorority Girl* (1957) prominently featured the paddle-wielding, sapphic sadism of its sorority bad girl, Sabra.

after receiving the "discipline" Sabra feels she deserves, earlier moments in the film suggest that the young pledge is more than a willing participant: she is shown trying to comfort the unpopular Sabra, lighting the older girl's cigarette, and stroking the hair at the nape of her neck—overtures that are initially rejected but eventually lead to repeated "little sessions" in Sabra's room meant to improve Ellie's physical conditioning. Opening the film fearful of living a "nightmare" of being "hated the way people hate me" yet unabashedly cruising her "sisters" in a hot new convertible Thunderbird, sorority sadist Sabra seems to drive straight off the pages of one of Vin Packer's lesbian pulps. With her wicked urges and fantastic cruelties combined with a regret drenched in self-loathing, the film makes a halfhearted attempt to earn sympathy for Sabra, but for the most part it just revels in the camp pleasures of her exploits and the overwrought emotional nightmares she orchestrates.[1]

Typically, however, when we think of camp icons or classical camp objects of pleasure, the "sexual kinkiness" of the "paddling, forced underwear duty, [and] implied *lesbianism*" of Corman's film rarely has a starring role.[2] For many critics, the abusive queer sorority girl or the monstrous lesbian predator of exploitation horror film seldom delights as a fabulous and humorous camp figure (Bertha Harris's epigraph aside); instead, she is taken quite seriously as a negative

stereotype, a damning cautionary tale, and a lethal source of shame and self-loathing. Nevertheless, in exploitation films of the 1950s, like *Sorority Girl* and, most centrally for this chapter, monster horror pics like Edgar Ulmer's *Daughter of Dr. Jekyll* (1957), the crypto-lesbians there both caution against and camp up a crudely figured sexual menace.

Her presence in these films provokes for me some fundamental questions. What might be the *purpose* for this camping up of lesbian desire in the media culture of the 1950s—at a time when lesbian visibility was on the rise, as were, of course, the vicious attempts to discipline, contain, and even excise gays and lesbians from public life? But then, also, what might be the consequences of letting her run amok on-screen, especially considering that the era's she-monster films, particularly—like *Daughter of Dr. Jekyll*, *Blood of Dracula* (Strock 1957), and *Frankenstein's Daughter* (Cunha 1958)—were intended for a *female* adolescent audience? In other words, how is this lesbian camp supposed to be functioning in/for dominant culture, but also how might she exceed that intended purpose for a variety of viewers? In this chapter, predominantly through a close reading of Ulmer's *Daughter of Dr. Jekyll*, I address these questions by demonstrating that this camp lesbian figure both serves a predictable misogynistic and homophobic purpose in these films—an attempt to contain female sexuality in the age of conformity—and has the potential to denaturalize and make comic the compulsory heterosexuality that was imposing itself on young women of the period from seemingly every quarter. Ultimately, as in Bertha Harris's description of her campy ideal lesbian with her atomic threat and Hammer horror magnificence, I show how deadly serious and seriously funny these lesbian figures can be—prowling the streets of normative 1950s culture with haunting and disturbing effects.

As I established in the introduction, in the considerable critical discussion about camp since the publication of Sontag's influential and contentious essay "Notes on 'Camp,'" work on lesbians as objects of camp, camping subjects, or practitioners of camp readings has been largely overshadowed by the central understanding of camp sensibility and camping as a gay male subcultural practice, at least historically.[3] Within film studies particularly, despite work by writers such as Andrea Weiss, who makes an explicit call in *Vampire and Violets* for recognition of camp's relevance for female spectators—especially lesbians, for whom "camp is a frequent component" of their viewing practices—examinations of the relationship between lesbians and camp have been far too few or too limited.[4] Indeed, Weiss's work is symptomatic of tension between possibility and foreclosure that occurs in analyses of lesbian camp: despite her strong claim that "camp is a tradition which belongs to women as well as men," she makes little use of the concept in her wide-ranging history of lesbians in film, merely concluding her "Vampire Lovers" chapter with a brief mention of lesbian irony and subversive camp humor.[5] Similarly, while Bonnie Zimmerman finds that Delphine Seyrig's

role in *Daughters of Darkness* (Kümel 1971) lends itself to "a camp interpretation" offered to lesbian viewers who might find the film's ending "amusing, almost charming," her overall analysis of cinematic lesbian vampires focuses on the hostility and antifeminist tenor of the films.[6]

In sum, camp reading practices, what Alexander Doty has called "camping in culture," have been claimed for lesbians by critics like Weiss but rarely performed, and even common objects of classic camp readings have failed to be examined in terms of their *lesbian* signification—the example of Marlene Dietrich immediately springs to mind.[7] Two notable exceptions would be, of course, Doty, who has argued quite powerfully for a queer appreciation of camp lesbians on-screen—from lesbian fantasy as coming of age in *The Wizard of Oz* (Fleming 1939) to the "tomboys/dykes" and campy femmes in *Pee-Wee's Playhouse* (1986-1991)—and Ellis Hanson, whose reading of "Lesbians Who Bite" takes to task several lesbian critics who fail to exploit the camp potential in female vampire films where he finds not only "Gothic" and "Freudian" camp but also the run-of-the-mill classic camp of lesbian vampires like *Dracula's Daughter* (Hillyer 1936).[8] There are the occasional considerations, such as Yvonne Tasker's work suggesting that camp can help define a "lesbian cinema" with room for the pleasurable consumption of the Pussy Galores of popular film or articles devoted to musical icons like k.d. lang and Dusty Springfield, which do specifically link the camp object and her viewing pleasures to a lesbian sensibility and sexuality, but seemingly just as often lesbian film criticism resists the connection.[9]

Indeed, despite repeatedly returning to gay male audience favorites like Bette Davis, Greta Garbo, and Dietrich and to moments like Dietrich's iconic cross-dressing performance in *Morocco* (von Sternberg 1930), lesbian film criticism has at times rejected wholesale the idea of lesbian camps or camp reading practices. Patricia White somewhat sarcastically offers an explanation for avoiding this "vigorous tradition of claiming the movies" through *male* cultural practices like camp, in that "to include lesbians under gay male cultural rubrics makes almost as little sense with regard to cinema as it does with regard to sex."[10] However, recognizing, as White does, that lesbian audience members still can and do share in the "spectacular subculture of gay male camp," Paula Graham's work attempts to persuade them to *stop*. I will not belabor the many points Graham marshals against the proposition of lesbian camp and the value of camp reading strategies for lesbian spectators, but in sum she warns that "transgressive" practices and pleasures for gay *men* cannot offer the same subversive potential for *women* under patriarchy, and, moreover, while many camp classics parody male authority, they also "confirm the illegitimacy of female authority" by demonizing female power, sometimes through the figure of the lesbian.[11] In other words, she offers a seemingly straightforward feminist response to the question of whether lesbian camp exists: if you want to know about lesbian cultural practices, why not look at the "discursive practices" of *lesbians* (not gay men) and investigate "among what multiple and historically specific

70 • Suffering Sappho!

power-relations" lesbians construct themselves (or a self).[12] For these critics, lesbians live a political reality that supersedes all else, and irony and parody offer negligible benefit.[13] Still, those like White, Tasker, and Weiss, despite their reservations, do recognize that lesbian audiences have enjoyed film for its camp pleasures.

In considering exploitation films from the 1950s, I am focusing here on the relation between a series of camp objects and the apparent consumption and uses of them, and I am less interested in establishing one person, say the director Edgar Ulmer or one particular star, as their source. Instead, I explore lesbian camp as a cultural construct or idea representative of a particular historical moment and social context. Nevertheless, it is true that *my own* reading employs what Sontag defines as the mode of perception, which revels in the "exaggerated, the 'off', of things-being-what-they-are-not" in order to suggest how disruptive a campy lesbian might be, especially if lesbian viewers might have shared this camp consumption in the 1950s.[14] In the following play with Ulmer's *Daughter of Dr. Jekyll*, I hope to show, then, how one might perform such a camp reading, mindful of the warnings I heed in the introduction (raised by the likes of Pamela Robertson) that the politics of camp are not simple or stable, changing from reader to reader, scene to scene, and even character to character.

Daughter Camp

In the opening pre-credit moments of Ulmer's lesser-known monster film *Daughter of Dr. Jekyll*, the viewer comes face-to-face with a smiling fiend who emerges from an absurdly dense veil of fog—not the titular daughter but a father figure. At first appearing in profile as the embodiment of the backstory being offered, this shrouded male creature sits among scientific paraphernalia, including beakers and test tubes, while the narration conjures a legend of the "strange experiment" that transformed the good Dr. Jekyll in Robert Louis Stevenson's famous work of terror into Hyde, "a human werewolf." Clearly taking a bit of license with Stevenson's narrative, the pre-credit scene transitions from the silhouetted doctor figure into a close-up of a monster, with sparse, werewolf-like hair covering much of his face and vampire fangs protruding from his impishly grinning mouth. When the authoritative voiceover promises that the evil will be vanquished in the end, this ghoulish grinning figure squeals out to the audience from within the diegesis, "Are you *sure*?" and, with high-pitched giggles, fades back into the fog. Critic Gary Morris has called this moment one of the genre's "most memorably campy," within a film that is marked by "sheer weirdness" and a "paranoia about what women were capable of in a postnuclear era."[15] While I agree with Morris that this moment's knowing artificiality and wonderful incongruities—including the inexact dubbing with the actor's mouth movements and the return of the same scene at the end of the film but with a different voice actor—exemplify the film's camp style, *Daughter of Dr. Jekyll*

offers many more moments of campy splendor, the majority of which center on exactly what some women might be "capable of" in the postwar era. Indeed, those scenes of the *daughter's* queer transformations and apparent attacks on young women of the village should be considered a realization of the promise of this opening delight, offering the campy consummation of the film's "fabulously weird" world.[16]

True to its generic cycle—a so-called "weirdie" within the larger teenxploitation films of the 1950s—*Daughter of Dr. Jekyll* contains a whole host of campy pleasures and horrors, from its promotional materials to its over-the-top drama. While the tagline focuses on the hereditary monstrosity—promising the "Blood Hungry Spawn" of Jekyll—other promotional items, including the trailer, flirt with a queer desire closeted within a young woman as the force behind the horrors. The "hidden" danger (or open yet ambiguous secret) on a lobby card warning of a "Bestial Fiend Hidden in a Woman's Sensuous Body!" is more clearly the theme of the trailer, which is punctuated with ever-more desperate and dangerous questions (with lurid phrases placed in all caps) that fly across the screen: "Is there a RAVAGING BEAST Hidden in Her Body? Is there a STRANGE DESIRE that Never Dies . . . But prowls the earth LUSTING FOR BLOOD?" Obviously, as Hyde was the evil hidden within Dr. Jekyll, one wonders what this "strange desire that never dies" might be in his daughter. But, to be honest, can it really be much of a mystery considering that the combination of strange female desires and beastly vampirism has signaled lesbian sexuality since at least the infamous tales of the Countess Elizabeth Bathory and her virginal victims in sixteenth-century Hungary? Yet the trailer goes on to dutifully answer the question, repeatedly showing the daughter, Janet, writhing in bed or even screaming in bed, and when the title asking "Is there a STRANGE DESIRE that Never Dies" comes onto the screen, we see the daughter in medium close-up, lying back with an anticipatory look on her face seemingly awaiting a lover's advance. Although the film is, of course, never going to come out and actually name Janet's terror and desire as lesbian panic, the exaggeration of "strange" perversions suggesting female vampirism, interrupting heteronormative union, and, finally, taking only other young women as victims creates the campy open secret with which the narrative frequently plays.

Such sensational promotional tactics were typical of the "weirdie" cycle to which the film belongs—the evocative (and enormously popular) hybrids of melodramatic teenpics and horror films—but, significantly, so were their queerly figured representations of teenage sexuality. The low-budget "weirdies" incorporated many fantastic elements, from Gothic horror to science experiments gone awry, just so long as the sensational product could be churned out quickly and its outrageousness would attract a teen audience.[17] While *I Was a Teenage Werewolf* (Fowler, Jr. 1957) or *The Creature from the Black Lagoon* (Arnold 1954) might be the best known of these films, their numbers and variety seem to match an insatiable desire at the time for such fare.[18] More significantly for this

72 • Suffering Sappho!

discussion, the weirdie cycle gets its name through a primary connection between their so-called weirdness and sexuality. As Thomas Doherty describes them, these "offbeat" films that "knew no bounds or shame" joined fanciful content with a thematic focus on a strange sexuality at their core: "In one shape or another, sex is the open secret of every weirdie, the intrinsic perversity, or weirdness, of a ripe desire for sexual congress mingled with a virginal dread of closure."[19] By definition, it would seem, these films are *queer*—a point confirmed by how often their monsters interrupt the "1950s couple necking in a parked car," a force disrupting, attacking, or clearly other to the normal heterosexual teens. What I would add, though, is that the weirdies—as exploitation films that by definition should be sensational, low budget, and exploitative of subject matter and audience—are clearly tailor-made for a camp sensibility. They "know no bounds or shame," have at their core an "open secret" about sex, and are sure to contain exaggeration, a failed seriousness (in, for example, the B-grade acting), and the inappropriateness of "too much." Some, like *Daughter of Dr. Jekyll* or Strock's *Blood of Dracula*, I would argue, specifically dramatize a campy "open secret" of lesbian desire and the social and personal responses to it.

Ulmer's *Daughter* sets the stage for this weird discourse on female sexuality by placing it within a carnival camp-ground of excesses and cinematic delights. Its "fabulously weird" world, in Morris's terms, befits the director dubbed a "King of the Bs" for his Poverty Row masterpieces like *Detour* (1946) and *The Black Cat* (1934) because for audiences and auteur theorists alike, beginning with his canonization by Cahiers du Cinéma in the 1950s, Ulmer's cult status largely comes from his facility with and penchant for audacious visual experimentation and nightmarish psychological or existential crucibles. Yet, I would argue, by the time of the production of *Daughter of Dr. Jekyll*, Ulmer's career is at a stage where ironic self-consciousness has crept in, sending up either his own work or the vaunted tradition from which he arose. Famously getting his foothold in the industry as assistant and set designer for silent cinema giant F. W. Murnau, working on *The Last Laugh* (1924), *Sunrise* (1927), and *Tabu* (1931), Ulmer claimed a role in the making of seemingly every masterwork of early German filmmaking—from building and designing sets for *Golem* (Wegener 1915) and *The Cabinet of Dr. Caligari* (Wiene 1920) and Pabst's *Joyless Street* in 1925 to being production designer for Lang's *Metropolis* (1927) and *Die Nibelungen* (1924). Yet, once one considers his career as a whole, this incredible cinematic apprenticeship begins to look like the early reward in a Faustian bargain after which he descends into the murky film industry backwaters of Poverty Row and beyond.[20]

And in some respects, *Daughter of Dr. Jekyll* plays up or along with this biographical mythos, referencing the set design and mood of Universal horror films, which, like his own minor classic *Black Cat*, have their foundations in the German Expressionist filmmaking he helped design—all for a 1950s audience that would have just seen these early films lambasted in the Abbot and Costello

comedies only a few years before.[21] The mood created by the absurdly dense fog pervading the film and by the detailed miniatures of the Jekyll manor anachronistically evokes another age of cinema, in which a film's world could powerfully mirror the haunted minds of its characters or when it was revolutionary that, as one critic describes Ulmer's best work, the "décor echoes the dark, abstract forces" at the center of the film.[22] Yet, cast with hammy character actors and earnest leads who have fallen on hard times, *Daughter* rings wonderfully false and feels generically tired, even as some of the actors insist on playing it straight. Indeed, as the theremin soundtrack vibrates with stock horror creepiness and the clouds obscure yet another shot of the moon, the film suggests nothing so much as an episode of Hanna-Barbera's classic (and campy in its own right) *Scooby Doo, Where Are You!*—a program that I now suspect of using Ulmer's film as direct source material.

From Dr. Lomas's various English country tweed costume changes, including a Sherlock-homage Inverness cape coat (minus the deerstalker hat), to the conspicuously omnipresent bust of William Shakespeare on the mansion's second-floor landing, one can find camp details in possibly every frame. (Some viewers might be disappointed, as I was, to watch the entire film and never see the Bard's bronze head pushed back to open a secret passageway.) Yet *Daughter of Dr. Jekyll* would not be fitting for a camp reading if there were not a seriousness that fails. The daughter Janet quite sincerely and at times movingly struggles with what seem to be *her* "unnatural" actions and desires, and as her nightmares grow more intense and she more involved, the recognition of what she might be turning into drives her to consider suicide. The plot of the film follows Janet and her fiancé George as they return to her ancestral home on the eve of her twenty-first birthday, when her guardian Dr. Lomas informs her that she will inherit the Jekyll estate but also other "birthrights." Once Janet learns of her monstrous family history, she calls the wedding off. Although at first George refuses to countenance the local superstitions about transformations and Jekyll-family werewolves (even after Janet wakes up from a vivid nightmare where she attacks and kills maid Maggie, who is later discovered dead), he ultimately realizes that they must leave for her mental stability and safety. Once the female bodies start piling up, the torch-toting villagers immediately know who to blame, demanding punishment of the demon daughter. But just in the nick of time, Janet is saved by a deus ex machina of sorts in the revelation of the true fiend: kind Dr. Lomas turns out to be a hypnotizing villain who transforms into Hyde and frames Janet for his crimes.

In recounting the fantastic plot of the film, one is reminded of the numerous camp pleasures and splendid individual performances in it that denaturalize and depend on the seriousness of Janet's ordeal, and while it would be tempting, for example, to devote an entire lengthy section of my analysis just to Irish character actor Arthur Shields, who plays Dr. Lomas with a self-conscious giddiness that often appears just on the verge of turning and winking at the audience, I

74 • Suffering Sappho!

want to keep focused here on the film's stunning evocation of *lesbian* camp. With its ending, the film works to defang the young woman's nightmarish "strange desires" by transferring them from her to the (more acceptable) mesmerizing male letch, yet the central conflict of the film, or the fulcrum around which its campy pleasures revolve, remains resolutely Janet's. The two actual nightmares, in which we see the atavistic Hyde version of Janet attack two other young women, comprise the central dramatic horror of the first three-quarters of the film, giving us a remarkable opportunity to see a lesbian camp at work (and play).

For the first half hour or so, the film works to set up Janet as a wholesome, likable young woman burdened with a terrible family legacy, but it also amusingly underscores her preoccupation with young women, particularly Maggie, her young maidservant who is also her peer in age if not class position. Preparing for dinner on her first night at the mansion, Janet seems overly concerned about the blonde maidservant's sleeping arrangements; as Maggie helps her pull on an off-the-shoulder dress over her silk underwear, bustier, and heels, she twice wonders out loud why her maidservant would prefer to walk home alone instead of sleeping at the house. Maggie rebuffs the offer to sleep there, but one can find in this early attraction some grounds for Dr. Lomas's subsequent confusion when Janet announces that she and George are soon to be wed. Even her own fiancé expects the doctor's reaction of surprise at their announcement, providing an early opportunity for Arthur Shields's self-conscious excess in a saucy, "Yes, rather!" Her titillating interest in Maggie, which continues through the next day and night (meeting again in Janet's bedroom), might further color not only the surprise wedding announcement but also the ensuing not-so-shocking declaration that Janet wants to call the wedding off. Although the film gives Janet a spectacular reason not to marry George—the announcement of her family history of "strange" experiments, madness, and genetic werewolf inheritance—up until the moment he actually sees Henry Jekyll's tomb, George believes there must be some other reason why Janet calls the wedding off. He first assumes that she does not love him and then becomes increasingly frustrated with all the "mysteries" surrounding her. As the following night's bedroom scene and nightmare attack on Maggie establish, the "secret," as the doctor calls it, at the heart of Janet's mysteries might be both her apparent family legacy (monstrosity) and her troubling relationship to other young women.

Between the wide-eyed mugging and the over-the-top handwringing of Arthur Shields and the wooden (to the point of petrification) performance of John Agar as George, whose strongman roles in prestige Westerns and war films had dried up by this time owing to his problems with alcohol and subsequent divorce from child superstar Shirley Temple, it is Gloria Talbott's Janet who carries the weight of the film's mysteries and grounds the film's camp pleasures.[23] Centrally, she contains the incongruous pairing of victimized, feminine hetero-monogamy and aggressive, lusting lesbian monstrosity, which finds its full evocation in the first nightmare attack and its aftermath. On her second night in

FIGURE 7 The transitional superimposition weds the anguished Janet writhing in bed with the over-the-top "sexy" lesbian predator of her she-Hyde dreams.

the mansion and on the eve of her now desperately rushed nuptials, Janet has another intimate bedside chat with Maggie before falling into a drug- and hypnosis-induced slumber during which her innermost desires seem to take corporeal, monstrous form. The scene follows Maggie's departure into the nighttime fog with a portentous dissolve from a shot of the full moon (accompanied by the self-consciously spooky theremin score) to a shot of Janet writhing in her sleep, associatively connecting her tossing and turning with Maggie's departure and whatever feelings it might have stirred up. This shot of Janet's troubled sleep quickly blurs and dissolves into a superimposition of two shots: one of Janet writhing in bed and one of a Hyde-Janet emerging from Jekyll's tomb with ghoulishly unplucked eyebrows and a flowing white chiffon gown, a costume choice that certainly harkens back to common imagery of the vampire bride. This evil from within Janet is played by another actress, which does complicate the relay of desire in this scene, as if Janet's psyche is not quite prepared to see her own face on the horrific lesbian. However, this mysterious Hyde-Janet not only plays up one of the film's central indeterminacies (is she or isn't she turning into a monster) but also clearly offers an over-the-top representation of the predatory lesbian, right down to the unplucked eyebrows, twilight cruising, and aggressive sexual advances.[24]

Even if we accept the film's ultimate explanation for these attacks (as Dr. Lomas's actions and false memory implantation), it is hard not to read this scene as a fairly undisguised masturbatory fantasy for Janet, with the screaming orgasm timed right with the kill, but her reaction to it is where we find lesbian camp most clearly articulated. As the final assault on Maggie occurs from behind (an image again superimposed on Janet's face) and she screams, the

"indisputable sexual feeling" recognized in this scene by critic Robert Singer shows not only on Janet's face but also in her subsequent guilt-fueled reaction.[25] Although help comes in the form of Dr. Lomas, George, and the housekeeper, Janet's first question gives her away, "Is Maggie alright?" and this panting question is enough to peak even staid fiancé George's suspicions about why she keeps "asking about Maggie." Once left alone, she rises out of bed and discovers blood on her hands and on her nightgown. Slowly recognizing her potential guilt as the possessor of the desires and, seemingly, the actions of the "dream," Janet goes over to her mirror and sees there the waking reality of the fantasy: the superimposed figure of the she-Hyde in the moment of attack overlaid on her own worried face and frame. In this moment, Janet's vision of herself is clearly camp—she is both the terrified victim and the sexy lesbian predator, the passive bride-to-be and possessor of the transgressive wish—and, in that incongruous juxtaposition, both identities are joined but also become less determined or clearly differentiated, much as the superimposition disrupts the clarity of both images. When the scene ends with a hold on Janet's concerned and teary-eyed expression, the spectator is meant to experience her fear and remorse, but it is hard to forget the provocative romp that has come before, especially since we have just seen its hyperbolic representative superimposed over Janet's body. And the longer Janet's nightmares continue and the more extreme her responses become (and exaggerated "Scream Queen" Talbott's acting becomes), the funnier and more absurd this sexual panic appears. Was that really remorse we saw on her face at the end of the scene or an awakening thrill? The attack scenes are both sexy and hilariously exaggerated, undermining Janet's fearful response by juxtaposing pleasure or attraction and revulsion in the way camp can join antithetical qualities, values, or emotions.

Of course, this attack sequence and the one that follows it the next night are also functioning as part of a 1950s homophobic and misogynistic disciplinary discourse, wherein female sexuality is pictured as always-already potentially monstrous and, therefore, in need of control, adjustment, and surveillance.[26] Janet's panic can obviously be read as a sign of that disciplinary discourse working well enough, encouraging her (and, by extension, the female audience member) to castigate herself, repress her desires, and ultimately prefer death to the unleashing of these perverse cravings. One might be amused on the third night by the delicious double entendre in Dr. Lomas's promise that after some hot milk, drugs, and a good night's sleep, Janet will "feel like another girl," to which Janet responds, "Lock me in!" or, by Talbott's teeth-gnashing, clothes-rending reaction to George's suspicious reading of *Witch, Warlock, and Werewolf,* "If you love me, please *kill* me!" Ultimately, though, one should not forget the gravity of Janet's situation: the McCarthy-era FBI surveillance of and attacks on gays and lesbians, not to mention the nationwide moral panic about homosexuality, has after all been fittingly termed a "witch hunt." Yet despite, or indeed because of, the significance of this disciplinary discourse (for the preservation of

heteronormative patriarchy), it becomes even more imperative to consider how the presence of camp might denaturalize or put into critical relief its foundational precepts. In this regard, one of the most significant casualties of lesbian camp's subversive presence in this film is the heteronormative and cisgender male hero George, played to artless perfection by the earnest and (previously) A-film actor John Agar. Pitching on these camp grounds, normative masculinity and compulsory heterosexuality are shown to be working very hard indeed to maintain authority and validity as natural or normal.

From the opening scene of the film, George's (and Agar's) performance of normative masculinity both parodies itself through its ridiculous staginess and two-dimensionality and manages to fail fantastically at key dramatic moments. It is not just that George looks ridiculous the first morning in his hasty adoption of a striped regatta blazer now that he is the soon-to-be laird of an English manor house; it is also that he begins his previous night's conversation with Dr. Lomas by playing the part of the proud, assertive fiancé who refuses to take the guardian's money but then ends it by blithely accepting his new place as the kept man for a very wealthy heiress. As the ubiquitous suit of armor seems to keep reminding us (often sharing the frame with George, looming behind him), George's masculinity is only a suit he wears, a role he plays, and not very convincingly. Indeed, George's failure to enact the power of normative masculinity is key in dislodging it from its natural position *and* in illuminating the extreme tactics of a patriarchy desperate to control female sexuality and agency in this era. In other words, because George is so bad at performing normative masculinity, the audience can see gender as artifice and patriarchy as struggling to maintain dominance, and because Janet's "strange desires" raise the specter (vampire/werewolf) of lesbian sexuality, it is the machinations of compulsory heterosexuality that perhaps come most into question.

Played (and read) straight, George's role in the events of the film and his care and concern for Janet would reveal an upstanding young man from (sometime in) twentieth-century America wanting to take control of a difficult situation, protect his young fiancé, and make an honest woman of her. But, thankfully, so little in *Daughter of Dr. Jekyll* is convincingly played straight or sans a strong comic vein of failed gravitas. Agar's broad-shouldered physique and perfect posture probably served him well in the air force and in earlier Westerns, but here it makes him appear uncomfortably stiff and out of place as soon as he walks into the fantastical world of the Jekyll mansion—with its anachronistic mix of medieval candelabras and suits of armor, family mausoleums and busts of Shakespeare, and Victorian touches like the early phone, push-button light switches, and the Edison Standard Phonograph (not to mention the 1950s cars visible through the dining room window). When placed next to a series of delicious camp figures—the stock buxom housekeeper from Liverpool, Mrs. Merchant, or Shields's laughing leprechaun of a doctor, or the paranoid, scowling, stooped caretaker Jacob—it is Agar's respectable George who seems odd. And, as the film

goes on, the strangeness of his male normalcy is at least partly explained by his failure to perform dominant masculinity; in other words, it was all a desperate act to cover a crisis of impotency. At pivotal moments, when George's chivalric masculinity should be rescuing the damsel, he is complicit in the increasingly harsh and violent restraints Dr. Lomas puts on Janet, failing to see the doctor's evil designs. He also hides from the doctor when he hypnotizes Janet and transforms into Hyde. And finally, he loses a physical altercation with the much older man and then has another ridiculous fight with him at the film's climax, during which he seems to get the upper hand but needs Jacob to finally dispatch the fiend with a stake to heart.

This campy juxtaposition of macho performance and miserable failure is perhaps best illustrated in the scene of Janet's second nightmare attack and its aftermath. Despite the rapid decline in Janet's emotional stability after Maggie's death and Jacob's allegation of Janet's monstrosity, George, once again sporting his striped boating blazer, goes along with the doctor's plan to drug Janet and lock her in her bedroom (in retrospect the room she probably should have been locked *out* of), and he allows Lomas to keep vigil across from her door when *he* should have been her guardian. Janet's sensational dream/nightmare unfolds uninterrupted—this time with the sexy she-Hyde pouncing on a coed in the woods who has just spurned her male lover's advances—and only her screams when she awakens with blood on her hands bring George to her door, where his loud, forceful banging and yelling give the show of a strong, physical masculinity. Yet, he completely misses the doctor's clever accusatory aside, admitting to dropping off for a "few moments" or just long enough for Janet to do her worst, and cannot manage to hear what Janet is confessing to. He brushes off her passionate revelation, "I crept up like some animal and then I had my hands around her throat and I . . . ," shaking her by the shoulders and offering a classic misreading, dismissal, and repression of female desire: "Janet, be quiet. We have to be sensible. This is all nerves!" Ignoring Janet's irritated recognition of his trite male silencing and pathologization of woman ("nerves?"), George is incandescent in a moment of self-righteous, patronizing indignation that punctuates one of the funniest scenes in the film. Caught in medium close-up over Janet's shoulder and offering his most impassioned acting, Agar as George (all business in his mock turtleneck) delivers the appropriate response to campy werewolf killers and Scooby-Doo mysteries, but obviously, in this world, his straightness becomes the joke. As he opines, "This is ridiculous. We're living in the twentieth century. This is an age of reason, not superstition!" and exhorts everyone to "look at this calmly," his male rationality and correctness, that everything "has a reasonable explanation," threatens to dampen all the fun and rings hollow coming from a man who leaves the fox in charge of the henhouse. With his masculinity increasingly proven a sham, these lines lack any validity and become absurd parodies, and his über-serious delivery camps up the mastery, control, and rationalizations of dominant patriarchal culture.

What's more, the strangeness, miscues, and stagey excesses of this performance of masculinity disrupt and denaturalize the foundation of patriarchal culture: heterosexual union. As the figure of heteronormativity must work harder and harder to battle the "superstitions," "strange desires," and unknowns of this diegetic world, the more compulsory his project appears. The presence of lesbian camp disturbs normative male masculinity, with the predictable effect of challenging the naturalness of heterosexuality: it sets into motion both a gender parody in the figure of George and a parody of compulsory heterosexuality in his reactions to Janet's strange desires. In the process, one might argue, heteronormativity becomes less assured and more of a masquerade, or just more farcical in the lengths to which it will go to reinforce its imperative. Particularly in this period, as Pamela Robertson has established with Nicolas Ray's *Johnny Guitar* (1954), female camp has the potential to act as "both an enactment and critique of the suppression of women and excess," chiefly in terms of female sexuality and attempts to contain it.[27] For example, George and Janet might enter the house like equal partners, but the secrets and disturbances of her unfolding strange narrative seem to lead George into playing a more domineering role, a force for containment. Janet is suddenly dismissed as "you little idiot" for calling off the wedding, and with every passing moment in the house, the date of their impending nuptials must be hurriedly moved up: for George, "The sooner we're out of here and married, the better!" Although he frantically moves the wedding up to the very next day, promising to travel to London and get married that morning, Maggie's dead body intervenes, and the suspicions of both the villagers and Janet herself—that she's a "monster," not a 1950s housewife—make him so anxious to complete the heterosexual plot that he is willing to abduct his fiancée, or at least forcibly remove a drugged Janet from the house. Despite all the signs telling him that Janet might not fit the story to which he is clinging, he is even willing to be in league with the disturbed doctor to manufacture the "correct" heterosexual resolution.

In other words, one of the most significant consequences of lesbian camp's centrality to the cinematic narrative here is that it disrupts and denaturalizes the heterosexual marriage plot, causing the male lead to grow absurdly desperate to reach what should be its inevitable conclusion. But even more interesting for the period, her story also highlights his complicity (possibly against his own better judgment) with one of the era's most insidious means of ensuring female consent: adjustment therapy. Janet's adjustment, not coincidentally, begins on the same night that she tries to call off the wedding because of the secret of her hereditary monstrosity. To ensure her "rest" on what has now become the eve before her hurried wedding, the doctor prescribes a sleeping draft and George promises a trip to the minister first thing. Clearly, this drugging serves a key function in the final resolution of the plot (the doctor's scheme to incriminate Janet for his transgressions), yet it also becomes a point to which the film obsessively returns and which the narrative uses to implicate George as complicit with the

80 • Suffering Sappho!

doctor's mistreatment of Janet. Because the drugging and matrimony are so clearly joined here, the realization of this heterosexual union finally seems to depend on the doctor's adjustment of Janet, which, similar to my discussion in chapter 2, uses camp to impugn the medical profession's normalizing discourse around female sexuality at the time.

Indeed, evocative of psychiatry's coercive role at the pulp climax of Vin Packer's *Strange Fire*, the doctor-prescribed pills, sleeping drafts, and use of hypnosis here not only signal desperation and campy excess in their proliferation and compounding but also become vital in the adjustment of Janet's plot back to supposed heterosexual normalcy. On the first night, the doctor drugs her and hypnotizes her; on the second night he needs hot milk, brandy, *and* his "special ingredient"; and by the third night, it is George imploring Janet to take her pills and aiding in their administration. With Janet drawn to Jekyll's tomb despite their efforts, the doctor and George must work together (with Janet's panicked agreement) to give her enough drugs to "put an elephant to sleep" and nail the windows shut in her room, all to keep her from prowling away from her intended path. The ironic pleasure one might get from seeing the lengths to which George will go is equally matched by the wretchedness of Janet's fearful complicity ("I want to be completely unconscious, unable to *move*"), punctuated by his tragicomic parting words, "Goodnight, princess." It is all so sad and so funny. It can only be camp. So, the lesbian camp story proceeds accordingly: this self-loathing princess will be awakened from her slumber, not by the prince with true love's kiss, but by the evil, predatory father-surrogate doctor, with whom the prince has conspired to drug her and for whom the prince proves no match. To be sure, one would need to be "adjusted" to endure such a horrific situation.

For me, then, Janet's drama is both humorous and transgressive because of its deconstructive burlesque of the idea that lesbians are predatory monsters *and* because its camp excesses denaturalize the era's cultural norms of gender and heteronormativity. Yet, it is impossible to overlook that the film simultaneously enacts the torment of recognizing shameful desires in oneself that one's culture deems so monstrous it must violently adjust them away, and that the narrative, therefore, works equally well as a homophobic discourse warning against and regulating same-sex desires, which are portrayed as violent, destructive, pitiable, and nightmarish (if strangely sexy). Lesbian desires, in fact, prove so awful that the film must erase their grounding in reality and attempt to deny them entirely through the climactic revelation that a male monster has been behind the crimes of attacking women all along. Taken all together, these competing narratives articulate a powerful and not unexpected allegory: Janet's story in its entirety becomes a meditation on how to make the closet work for a queer young woman in the 1950s. Foretold by the trailer, the film seems to desperately ask, What can be done to hide Janet's perverse desires and stop them from coming to light? Might she, too, make use of a "secret room" like the one she discovers in the mansion where her father performed his clandestine experiments—a discovery that

leads to the revelations of Janet's own supposed secrets and then to her refusal to marry? The transfer of desires and murderous intent to Dr. Lomas could be seen as an attempt to close once and for all that particular closet door. Yet, I am tempted to ask archly, as the film's final moment does, "Are you sure?" Are we so sure that the resolution adequately eliminates the lesbian (and camp) from the scene?

One could certainly argue that through its ending, which asserts Dr. Lomas as the true villain of the film—hypnotizing Janet, placing ideas in her head, allowing her to sleepwalk, and even bloodying her hands to direct blame away from himself—the film forecloses the possibility of authentic lesbian desires in Janet's experiences and feelings of guilt. Indeed, it would not be much of a stretch to propose a heterosexual man as the source for this girl-on-girl fantasy. Yet this, for me, is the moment when the film's lesbian camp potentially becomes its most subversive. In the final attack scene with its overt voyeurism, the audience witnesses the presence of Dr. Lomas now transformed into werewolf Hyde, but the visuals send us right back to Janet's visions. The scene proceeds from a shot of the foggy mausoleum, to a tracking shot of the cloud-covered moon through dark trees, and then a foggy establishing shot of the new girl's location. An almost identical pattern of shots precedes both of the she-Hyde attacks, and, therefore, I would argue, the viewer has been trained to understand these shots as belonging to Janet's consciousness. We may now see a reaction shot of the devilish Hyde smiling at the pinup figure of the blonde final victim putting on her stockings and perfume as he watches, but the film has already connected this type of subjective point-of-view shot with the she-Hyde. Janet's visions, then, take primacy owing to their placement in the plot, their duration, and repetition so that even though we are shown the real Hyde, the two points of view become connected and the line between them blurred. Even more significantly, the film denies us visual proof of the young blonde's actual attacker, as a Nosferatu-type shadow stands in for the monster at the moment of attack. Dr. Lomas's Hyde, then, could be another exaggerated enactment of Janet's desires, allowing her to be both victim and perpetrator once again.

Robert Singer points to this same ambiguity when he proposes Ulmer's modern fairy tale as enigmatic in its emphasis on the "persecuted heroine" Janet *and* on an obscured monstrosity. For him the film raises a troublesome question indeed, "Which monster is the real monster in Ulmer's horror film: the grinning werewolf (who does exist), or the hysterical Ms. Hyde (who does not exist)?"[28] As his question implies, *Daughter* offers the possibility that the monstrosity in the film has belonged to Janet all along, despite the neat resolution that absolves her of the feverish desires and safely returns her to the embrace of George and heteronormativity. And, interestingly, Janet's not-so-hidden guilt is even reflected in the critic's phrasing when he names the "hysterical Ms. Hyde (who does not exist)" as one of the monsters, clearly eliding the young, troubled heiress and the female double she envisions in her dreams—one being the

hysterical dreamer who *does* exist and the other being the she-Hyde who supposedly exists only in Janet's unconscious. Unfortunately not pursuing the sexual confusion at the center of the girl's monstrosity and persecution, Singer at once establishes "Janet's hysteria-into-madness" as one of the ways that the film offers a feminist criticism of patriarchal control and its consequences for the minds and bodies of women, yet he sees her "sexually predatory nightmares" as merely a gender role reversal, not as her sexual desire for other women.[29]

On the contrary, I suggest we let Janet's desire out of the closet. Why not see Dr. Lomas's Hyde as a powerful evocation of lesbian desire, but in drag—like Bertha Harris's "ideal lesbian" with whom I began this chapter, a Christopher-Lee-drag-king werewolf who "stalk[s] Beverly Hills by night."[30] In other words, isn't it possible to view the monstrous Lomas in this penultimate scene as Janet's camp vision of herself, so that both the she-Hyde and the he-Hyde act as embodiments of her desires, just in two different forms? This reading offers these scenarios as Janet's fantasy evocations (and rehearsing) of two paths for lesbian sexuality, echoing Doty's reading of *The Wizard of Oz* as the "fantasy of a teenaged girl on the road to dykedom" where Dorothy is caught between Glinda and the Wicked Witch of the West, a "division of lesbianism into the good femme-inine and the bad butch, or the model potentially 'invisible' femme and the threateningly obvious butch."[31] Unlike with Dorothy Gale, though, while the attractive femme monster is obviously preferable to the "real" killer butch for Janet, both remain cause for panic and shame. And one should not forget the frighteningly reactionary and conservative function Lomas's Hyde can then serve, arguing for a monstrous butch lurking below the crimes of Janet's predatory femme, predictably returning to traditional alignments of female masculinity, violence, and criminality.[32] Or in yet another view, one might also read this penultimate scene as a splendidly camp send-up of a heterosexual male's hijacking of lesbian sexual desire for his own ends, restaging Janet's transgressive pleasures for his own gratification.

Once we open up the film (and Janet's closet) to a camp reading and embrace its effects, the pleasures and politics of the narrative become slippery indeed. The final coda of the film, where Hyde mockingly returns to tease the viewer as he did in the film's opening moment, asking "Are you sure?," suggests to me the subversive potential in the indeterminacy and dislocation of the film's monstrosity. In the end, even as the film demonizes, disappears, rationalizes, and, of course, heterosexualizes it, the narrative is also unable to extinguish the enticement of lesbian desire. It persists in the film—a "Strange Desire that Never Dies!" As Philip Core reminds us, "Camp is a lie that tells the truth," and in *Daughter of Dr. Jekyll*, both Janet and the two Hyde creatures are the lies that tell the truth of one of the central desires or pleasures of the film, which for me is distinctly lesbian.[33]

Guilty Lesbian Pleasures

In the introduction, I heeded Alexander Doty's advice not to assume a progressive politics for camp. Camp, for Doty and others, always eludes attempts to contain its meaning: it can be "reactionary, liberal, or radical."[34] In this vein, while I might stress the subversive potential in Dr. Lomas's campy Hyde, who can be read as a lesbian in drag or as an indictment of heterosexual male exploitation of lesbian sexuality, this figure also has the ability to reinforce ideas of lesbian monstrosity, particularly in regard to butch lesbians whose female masculinity and desires have so often been vilified as inherently perverse, violent, predatory, and yet pathetic imitations of "real" men.[35] Along similar lines, visually uniting Dr. Lomas's Hyde with Janet's consciousness, as I argue the film does, connects his grotesque voyeurism and violence (a disgusting sadistic gaze at the window in the final attack) to the scopic practices and pleasures of lesbian spectatorship. In other words, by seeing Lomas as a lesbian in drag, my reading at least partly presents the idea of lesbian spectatorship as monstrous and degraded or as a repellent enactment of Laura Mulvey's famous formulation of the female spectator shifting "restlessly in [her] borrowed transvestite clothes," trapped in the regressive masculinity Freud was so fond of locating in lesbian desire.[36] Yet, as with a progressive reading, this reactionary one remains just that—one possible reading—and if one considers the film as a whole, a more complicated picture of female viewing pleasures emerges, by turns guilty, reactionary, and radical.

To illustrate this complexity and the film's seeming preoccupation with female viewing practices, I return to the second nightmare sequence, during which the film plainly links Janet's she-Hyde to the disruption of normal heterosexual romance (a couple kissing in the park) and again to her predilection for female victims. Locked in her room for the second night at the manor, Janet is drugged, and her subsequent vision/dream/fantasy/implanted memory echoes the previous night's, opening with the same superimposition of Janet's troubled sleep and her monstrous self prowling through the fog. But through a shift in point of view, this second she-Hyde sequence draws the viewer in for a more subjective experience of monstrous predation. As Janet's anguished face disappears, we are left with an unobstructed view of the she-Hyde's progress through the woods and her discovery of a young heterosexual couple cuddled together, bringing us into proximity to the monster's actions and suggesting that Janet is beginning to identify herself with the monster. Yet even more provocatively, at the moment when the monster witnesses the young couple's broken embrace (as the young woman spurns his advances), the viewer is granted a subjective point-of-view shot from the she-Hyde's position. It surely cannot be a coincidence that the one moment when both Janet and the viewer are given this privileged and monstrous point of view is the moment of disruption of heterosexual romance and an opening for a woman on the make. Even though the scene returns to a more objective perspective of the young girl's flight and the female Hyde's rapid and

eager chase after her, the scene does not return to its original superimposition for an extended period of time. Janet and the viewer have plunged entirely into the world of the depraved she-Hyde and conceivably can both enjoy and dread the pleasures found there.[37]

As if to offer the spectator a lingering view of these excessive and ecstatic pleasures, we follow the monster on her journey through the woods and then see her lunging in for the kill again, but this time the embrace is heightened and prolonged. The camera goes in for a medium close-up with a clear view of the attack, despite the superimposition of Janet's anguished face, and the moment is sustained long enough for the viewer to see the she-Hyde pinning her female victim's arms back and moving in on the open neck. While we later learn the truth of these killings, at this point in the film, and exaggerated by the camera-work and editing, the desires and, as far as we know, the actions are Janet's (and possibly ours through subjective camera), and her dramatic postnightmare revelation re-emphasizes this first-person viewpoint: "*I* killed her. *I* crept up like some animal and then *I* had my hands around her throat and *I*—." Met with fiancé George's aforementioned wooden performance of masculinity and his patronizing attempts to interject some "reason" into the situation, Janet's personal claiming of the nightmare's actions and our shared experience with her give much more affective weight and ironic force to this scene of spectating, desire, and violence.

While the film is surely creating a camp effect by juxtaposing George-Agar's cardboard-cutout manliness to Janet-Talbott's over-the-top hysterics, there is also an ambivalent gesture toward and meaningful evocation of a lesbian spectatorship. We watch as Janet envisions or watches the female Hyde watching the young couple, before we are taken into the very spectatorial position of the she-monster on the prowl. At first, we are outside spectators to and then actually share in the monstrous lesbian's cruising of the park at night—a prolonged experience that draws us in emotionally and prepares us to sympathize with Janet's waking confusion and breathless turmoil. In some respects, we should be ashamed and disgusted, as Janet's guilt-drenched hysterics model for us, but the scene's pleasures and identificatory gestures exceed this. Unlike in the final attack scene with Lomas's Hyde where the reverse angle unambiguously pictures a salivating, lascivious peeping tom at the window, this representation of spectatorship and desire lacks the other's moralizing simplicity. Or, to put it in strictly filmic terms, one could say it trades the conclusive reaction shot for the blurring of superimposition. Ambiguously mixing anguish and disciplinary shame with sympathy, titillating excitement, and a hilarious lampooning of killjoy George's censuring authority, this presentation of lesbian spectatorship might be monstrous, but it is also much more.

In other words, *Daughter* does not simply demonize lesbian desire by inextricably linking it to aggression, violence, and sadistic voyeurism in order to police nonnormative sexuality and gender expression and encourage female subjects,

in turn, to police themselves. In a contradictory vein, we are likewise given a thrilling experience of cruising—the subjective camera at the moment of discovery and the following shot of the chase through the fog—by filmmakers who were concerned with making their she-creature "sexy," and if we look long enough through Janet's superimposed face of anguish, we are even allowed to come up to the moment of contact. In this late Code-era horror, we cannot be shown the gore of the attack, only the pinning of the victim's arms above her head and the monster lunging toward her neck before the dissolve, which allows for an enticing queer ambiguity in terms of what happens next.

Perhaps more importantly, this thrilling, suggestive, and disturbing attack occurs in a film or subgenre of films intended largely for a *female* teen audience, who had a number of examples to choose from. As part of profitable "weirdie" double bills for companies like AIP, exploitation producers often paired female monster films with the male versions to create a female audience half of the double bill, attempting to capture "male and female interests" in films like *Daughter of Dr. Jekyll*, but also other notable examples such as *Blood of Dracula* and *Frankenstein's Daughter*.[38] The first of these, *Blood of Dracula*—with its setting of an all-girl's boarding school run by none other than Mrs. Thorn*dyke* and its narrative conflict between power-hungry chemistry teacher Miss Branding and her "special" girl Nancy, whom she hypnotizes and turns into an obedient, murderous vampire—obviously replays the monstrous stereotypes of lesbian desire and predation contemporaneously offered in *Daughter of Dr. Jekyll*.

Recognized by Bonnie Zimmerman and Harry Benshoff as a lesser-known lesbian vampire film, one also employing the "classic stereotype" of the "schoolgirl-teacher lesbian representation," *Blood of Dracula* places troubled teen Nancy in a single-sex den of partying girl cliques, schoolgirl rivalries over teachers' attentions, and a butch staff of faculty led by feminist, antinuke madwoman Miss Branding, whom the trailer warns has been "stimulating young girls beyond any reasonable control" and "transforming a young girl's love into terrifying blood lust!"[39] Although he minimizes the influence of this female vampire teenpic, justifying his focus on two male monster films, *I Was a Teenage Frankenstein* (Strock 1957) and *How to Make a Monster* (Strock 1958), by arguing that "lesbianism was far less prominent in popular culture of the 1950s than was male homosexuality," Benshoff does recognize its repetition of the "homosexuality-as-pederasty model of the era," as well as its queer ability, as I find in *Daughter of Dr. Jekyll*, to disrupt heterosexual normality through its monstrous desires.[40] Clearly, however, I dispute his assessment of the paucity of popular lesbian variations on this theme.

As in Corman's *Sorority Girl*, which opened this chapter, *Blood of Dracula* makes a "weirdie" out of the campy boarding school / sorority girl pulp fiction fascinations of the era. Announced by its promotional poster, the film contaminates a wholesome tableau of teenage girls socializing in a school common room with warnings of "nightmares forever" therein, which are figured in a framing

86 • Suffering Sappho!

image to the left of a vampire attack posed in a fashion remarkably similar to the cover art for lesbian pulps like Ann Bannon's classic *Odd Girl Out*, published the same year.[41] Moreover, as Benshoff notes, the film follows a barely disguised "homosexuality-as-pederasty" plot where domineering *Miss* Branding is looking for "a special kind of girl" to place under her amulet's spell, and the "disturbed" and later disparaged "cold fish" Nancy seems only too willing at first; however, once she has committed her bushy eyebrowed attacks, she questions the "nightmare" she is living where, like Janet in *Dr. Jekyll*, a "horrible urge comes over" her: "I feel a strength that's almost frightening! It takes possession of me!" Expressed in language and scenarios so familiar from the pulps, even though she feels that what Miss Branding "make[s]" her do is "wrong," she appears unable to control herself until her near attack on her boyfriend Glen gives her the strength to break free from the older woman's spell ("I know who you are and what you've done to me!") and end their "horrible" experiment. Campily, it is Mrs. Thorndyke at the end who provides the ironic commentary on what might as well be the publisher's mandated traumatic ending for "those who twist and pervert knowledge," assuring that not even the notes from the "evil" experiment survive to reproduce it.

Nevertheless, produced in 1958, a year after *Daughter of Dr. Jekyll* and *Blood of Dracula*, *Frankenstein's Daughter* perhaps puts a lie to Mrs. Thorndyke's reassuring conclusions. This next installment demonstrates the growing presence of "evil" lesbian camp in the exploitation teenpics, and, furthermore, its monster once more dramatizes the possibility of a queer female spectatorship. The opening scene in fact replays exactly the scenario from Janet's second nightmare, just without the fog. We see a teenage couple seemingly concluding their date with a kiss on the sidewalk in front of the girl's house. Again, the (blonde) female half of the couple abruptly ends their intimacy and pushes her date away. Immediately following his departure, the buxom blonde turns around and sees the ghoulish figure of what we assume is Frankenstein's daughter coming down the sidewalk toward her. The blonde's scream and terrified reaction shot are, of course, followed by another shot of her female attacker, who is wearing a fairly delicate cotton negligee but whose face has a similar atavistic look to the she-Hyde, with excessively bushy eyebrows and large protruding teeth. Pronounced *Frankenstein's Daughter* by the title superimposed over her face, this teen monster surveils and then seeks out female victims and is revealed in the following scene to be another innocent heroine who wakes up after a fitful sleep with memories of a nightmare that "seemed so real, as though it actually happened." Since our heroine Trudy is dressed in the same negligee as the monster, we must assume this film begins where *Daughter of Dr. Jekyll* left off, with another young woman wrestling with the "strange desires" inside her.

Although in the end the transformed Trudy is not the traditional creature manufactured by the film's Dr. Frankenstein (Dr. Oliver "Frank") who goes on to dominate the majority of the narrative, her early attacks create a queer female

turmoil at the center of the film's construction. Oliver Frank, the devious assistant to Trudy's scientist uncle, initially uses her as a side experiment to test a drug that he plans to use to preserve the cells in his true creation—the monstrous life formed from human parts—and so Trudy's monstrous queer desires are somewhat neglected in the second half of the film when the new creature is born. Still, while the film works to refigure Trudy as the normal, heterosexual teen heroine in contrast to the new genderqueer monstrous creation, the viewer can hardly be expected to forget her earlier transformation or the attacks, specifically on women. Furthermore, she and her friend Suzie, her blonde victim in the opening attack scene, re-emphasize this queerness by battling over their privileged knowledge of the monster in, at times, passionate confrontations. When Trudy overhears Suzie telling her boyfriend about the monster who came "flying" at her the night before, she recognizes the figure of her dreams and fears her exposure as the creature who menaced Suzie. This monster, whom Suzie describes as "just awful," stopping at the description of "her mouth," is for Trudy "too real to be a dream" and too closely associated with Suzie. Trudy assumes the two of them share "exactly the same dream," and this idea brings her dangerously close to the monster and the lesbian desires the monster acts out.

Provocatively, after Frank's fruit punch causes Trudy to transform once again, her bathing-suited escapades are jealously championed by Suzie, who seems to want the monster all to herself. Both women wish to claim a singular knowledge of the "terrible looking creature in a bathing suit," who was nearly caught creeping into yet another woman's apartment, but Suzie's jealousy seems strangely out of proportion. Pointing to newspaper headlines that read "Woman Monster Menaces City," Suzie claims vindication for her earlier stories of a female assailant that were doubted by her male companions, but then Trudy does her one better, sounding a great deal like *Dr. Jekyll's* Janet: "Somehow I think *I* was that creature. I can see her running through the streets. Her body was mine, but the face . . . I'm sure it was me!" Neither girl seems to recognize that Trudy's confession exposes her monstrous nighttime attraction to Suzie, yet, I would stress, the film does in this moment emphasize the visual pleasure of this repeated cruising scenario: "I can see her." In response, the less refined, bleach-blonde Suzie bristles at losing any ground to her wholesome competition and replies to Trudy's confession with a queerly possessive statement, again centralizing spectatorship: "I saw that monster woman first." Although the scene concludes with the sense that Suzie distrusts and dislikes Trudy because of her success with boys like Johnny, their interest in the female monster results in a lingering intimacy between the two teen girls. And as the film turns to the creation of the second she-monster—Suzie's brain in a demonstrably male body—the emphasis on the homoerotic relationship between the teenage girls is at once masked by the focus on the heterosexual couple's defense of the home but also reinforced by the use of Suzie's brain to create the new "daughter," who yet again raises the specter of the lesbian monster in drag, as she is played by a male actor hastily made up with

88 • Suffering Sappho!

lipstick and mascara—campily upending gender by contrasting the outwardly femme but assertive Trudy with the physically imposing (and hairy) yet obedient she-creature.[42]

Surely, the disastrous drag of this monstrous (second) *Frankenstein's Daughter* could appeal to the "queer spectator" whom Benshoff imagines might "revel in the joys of monstrous rampages that overthrow heterosexist presumption," in this case about gender, yet the critic does not himself imagine this campily amused spectator as female.[43] Nevertheless, teen film scholars like Doherty assert a female audience for the second half of these monster movie double bills. How are we, then, to imagine the young female audience receiving these monstrous daughter films, which, at one and the same time, manage to titillate with, caution against, and camp up female same-sex desire, gender play, cruising, and violence? How are the scenes just detailed hailing these spectators and to what end? It is easy enough to suggest a male audience for these monstrous daughters, either exploiting lesbian sexuality for their own erotic pleasure or reveling in the many excesses to embrace the B-movie camp delights of these films, but in fact films like these had a sizable female audience, brought to theaters and drive-ins by producers targeting them. Therefore, I would argue that the "fabulously weird" world, as Morris calls it, of films like *Daughter of Dr. Jekyll*, which is centered on lesbian camp, creates an instability and irony that open up for a *female* spectator both the pleasure and fear, thrill and amusement, disgust and shame at viewing this parody of queer female monstrosity on-screen. That is, these films offer these female spectators, who are not typically associated with it, a camp mode of reception with all the "contradictory pleasures" that Robertson warns us to heed in her conceptualization of feminist camp, containing both subversive (queer) laughter and an "affirmation of the dominant order."[44]

Regrettably, this particular form of reading practice or set of contradictory viewing pleasures has too rarely been associated with lesbian spectators and too often neglected in critical accounts of lesbian spectatorship. Despite recognition by leading voices in lesbian film criticism—from Andrea Weiss and Judith Mayne to Sue-Ellen Case and Patricia White—that lesbian viewers have historically enjoyed films for their camp pleasures and participated in camp practices alongside gay men, the critical discourse has eschewed this model of spectatorship for psychoanalytically informed theorizations and subsequent reactions to them, a divide that Mayne describes as major "competing claims of film spectatorship—as a function of an apparatus, as a means of ideological control, on the one hand, and as a series of discontinuous, heterogeneous, and sometimes empowering responses, on the other" (the latter informed by cultural studies and ethnographic or historical approaches).[45] Too often the paradigm set up by early feminist film theory in the wake of Mulvey's landmark essay "Visual Pleasure and Narrative Cinema" seemed to dictate the terms of the debate, focusing on "identification" and/or "desire" either in revising the psychoanalytic model or in opposing it, with lesbian film theorists again and again intervening to complicate the rigid binary

of sexual difference seemingly unavoidable within the psychoanalytic framework and to expose the heterosexism underpinning so much of the most influential feminist criticism.[46] Yet this (at times) contentious debate left little room for other imaginings of the lesbian spectator—for example, one who performs a camp reading or approaches the text with irony, humor, or play.[47]

To redress this absence, I am advocating here for a broader understanding of lesbian spectatorship and female consumption practices in the Cold War era. Along the lines of Judith Mayne's concept of "critical spectatorship," we might imagine the "*shared* pleasures in camp" as a significant aspect of cinema's role in constituting "the very notion of gay/lesbian identity."[48] While I am mindful of Mayne's warning not to equate a "critical" audience with a "politicized" one or to hold up an "essentialist" notion of some monolithic queer audience that identifies in the same way or has an innate ability to "read against the grain," I do want to argue for a more sustained and thorough recognition of how lesbian spectatorship might be potentially "contestatory" and "radical" *and* ironic through its adoption of camp reading practices and their complex pleasures.[49]

At several points in this chapter, I have referenced the high camp delight of Arthur Shields's Hyde figure opening and closing *Daughter of Dr. Jekyll* with his giggling challenge to narrative closure and containment of the monstrous elements within it. Are we so *sure* that the monster has been vanquished, that the "evil thing" will never "prowl the dark again," or that we even know the nature of the monstrosity? No. And what's more, the daughter's "strange desire that never dies . . . but prowls the earth" is not even contained within this one film. From *Sorority Girl* and girl gang films to the girls' school lust of *Blood of Dracula* and the suburban she-monster attacks of *Frankenstein's Daughter*, other female-centered exploitation films of the period unleash it again and again and camp up lesbian desire in their own ways. What these repeated occurrences show me is that there is a disturbing presence of lesbian camp in 1950s popular culture, which exposes not only a major anxiety of the era—fears about the inability to contain female sexuality—but also the complexities and contradictions of trying to control it. You can use popular film to demonize sexual deviants, but in so doing, you might just let the monster out of the closet and project her campy splendor onto a fifty-foot screen.

4

Spinsters, Career Gals, and Butch Comedy in 1950s Television

For all the concern generated by the monstrous daughters of teen cinema in the 1950s whom I examine in the previous chapter, their plots *would* ultimately be resolved through the predictable conventions of the era. They either find wholeness in heterosexual union or, as true monsters, are removed or destroyed by the final frame. In the end, despite Dr. Lomas's/Hyde's cackling laughter and unsettling question, our apparently innocent and confused heroine in *Daughter of Dr. Jekyll* does end up in the arms of her fiancé in the final moments, although he has gloriously failed once again to defeat the male monster in their last mano a mano tussle. Similarly, with the she-monster engulfed in flames after a clumsy run-in with a Bunsen burner, Trudy and Johnny of *Frankenstein's Daughter* also escape into a poolside romantic clutch in the final scene; in it, Johnny facetiously proposes, "Do you promise to love, honor, obey, and always dry my back?"—an assurance of calming matrimony somewhat ironically (dis)confirmed by their friend Don, who announces, "I now pronounce you 'boy' and 'girl,'" reminding us, subversively, that at one point this distinction of gender was not definitively established. In contrast, true to the Universal horror tradition to which these exploitation films so often refer, the irredeemable convert Nancy and her teacher-seductress in *Blood of Dracula* ultimately "belong dead," as the creature in Whale's queer classic *Bride of Frankenstein* (1935) would say. She ghoulishly chokes Miss Branding and then accidentally impales herself on a broken table leg after admitting that she had to flee her boyfriend's embrace. Nevertheless,

like the other two films, *Blood of Dracula* does not conclude without some irony, giving the tweedy, butch headmistress Mrs. Thorndyke the final tongue-in-cheek verdict about "those who twist and pervert knowledge for evil," with a closing hold on the destroyed Branding manuscript, charred and alarmingly vulvic in its appearance. Another way to view these resolutions, however, would be to say that with either ending at least these daughters do avoid the most feared monstrosity of all: the life of an unmarried woman, or, in other words, ending their days as a twisted and perverted spinster schoolmarm like Miss Branding.

An easily recognizable caricature by the 1950s, the concept of the "spinster" or old maid had followed, however, a somewhat complicated path over the previous one hundred years before her shadow would loom over these she-monster drive-in classics, and it would continue to evolve as late twentieth-century feminist interventions took up (or rejected) the figure. The old maid or unmarried and childless woman certainly captivated the cultural imagination of Britain and America before the Victorian period: for example, Nina Auerbach identifies her comic grotesque as being already iconic by the time of Defoe's *Appleby's Journal* of the late eighteenth century. Yet, historians posit the establishment of the (at times) viciously negative *modern* stereotype of the spinster around the middle of the nineteenth century when a dramatic "surplus" of women created a kind of panic around the figure of the unattached, educated, middle-class, white woman.[1] Alternately embraced and disparaged by proceeding waves of feminists and advocates for women's suffrage in the twentieth century, the spinster figure made a portentous return after World War II, at once the cautionary handmaiden of the conservative drive to redomesticate middle-class women and aggrandize the white, suburban nuclear family and yet also a troubling figure gesturing toward the demands for financial and sexual independence that would come to define Second Wave Feminism. As the spinster began to transform into the single "career gal" throughout the 1960s, her conceptual framework became increasingly ambivalent and conflicted, an affective archive that continues even today. At once closeted as a shameful reminder of patriarchal control (at the height of the Second Wave) and wielded as a cudgel against working women at the end of the twentieth century, she has come roaring back in recent years as a feminist heroine for the great unmarried masses of millennial women in the United States, who see in the spinsters of yore a "radical act" and imaginative state of blissful independence and self-sufficiency now powerfully shared by both "all the single ladies" and even some married ones.[2]

Expectedly, as her impact and relevance have shifted and her image has repeatedly served as a repository for competing ideological positions on women's independence, the spinster's or old maid's fictional representations have likewise performed a disciplinary function and simultaneously manifested the contradictions inherent in changing notions of gender and sexuality. As documented, for example, in Laura Doan's influential collection *Old Maids to Radical Spinsters: Unmarried Women in the Twentieth-Century Novel* (1991), the notable Victorian

old maids and literary heroines such as those in Elizabeth Gaskell's *Cranford* or Barbara Pym's spinster novels were clearly enlarged in the popular imagination by spinster star turns in Classical Hollywood of the 1930s and 1940s by Katharine Hepburn, Bette Davis, Joan Crawford, Barbara Stanwyck, and other notable supporting actresses like Eve Arden, who is central to this chapter's argument.

Further, arguably serving as the more "domestic" mass media of the mid-twentieth century, American broadcast radio and television might have lacked the impact and star power of a Bette Davis settling for "the stars" in *Now Voyager* (1942) or a Katharine Hepburn primly teaming up with Bogart in *The African Queen* (1951), but their many variety shows and domestic comedies did allow room for a few notable spinster or career gal headliners, such as Eve Arden in her long run on radio and television as the title character of *Our Miss Brooks* (CBS Radio, 1948–1957; CBS Television, 1952–1956) and Ann Sothern as everyone's favorite secretary, Susie MacNamara, in *Private Secretary*, also on CBS from 1953 to 1957. There was briefly even room for a multitalented, leading Black performer like Ethel Waters—already a major star as a singer and Broadway and film actress—to feature on a network comedy, *Beulah*, as the unmarried sage of the kitchen, although her tenure within a white supremacist industry, as the first African American woman to star in a television series, would predictably be short (barely more than one season on ABC, beginning in 1950). Throughout the 1960s and 1970s, of course, the single career gal matured into a less negative stereotype, with Mary Tyler Moore's Mary Richards winning the hearts, minds, and Emmy Awards of a large popular audience (CBS, 1970–1977), and even the old maid was brought into the embrace of the family with the genteel and quirky Baldwin sisters adding humor and sophistication to the Mountain on the beloved nostalgic drama *The Waltons* (CBS, 1972–1981).[3] While one could surely follow this broadcast trajectory through the Ally McBeals and Designing Women or Golden Girls of the 1980s and 1990s to, naturally, the quasi-romantic friendships of single New Yorkers Samantha, Charlotte, and Miranda in *Sex in the City* (HBO, 1998–2004), for the purposes of this book, the notable spinsters and comedic working girls of television's first Golden Age will remain the primary focus.

Here, I consider the influence of lesbian camp in the guise of the wisecracking, typically white, spinster who headlined several of early television's biggest hits. In this era, a number of comedic, female supporting actresses from Hollywood became leading ladies on television, with their own enormously popular shows and often their own production companies. Lucille Ball is, of course, the most famous of these early television superstars, but the list of performers who went from "sidekicks," to use Judith Roof's term, to stars includes, most notably, Eve Arden and Ann Sothern.[4] Positioned as a headliner in the newly ascendant situation comedy format, a popular radio personality like Arden could transform from a supporting Hollywood player to a lead on the new televisual

medium, where comediennes' strong personalities and repeated or identifiable comic signatures made for television hits. Engaging a huge fan base eager to return every week to see these female stars, shows like *Our Miss Brooks* made the working spinster an icon of the early TV era, propelled by Arden's signature double takes and witty and, often biting, retorts. Yet, contrary to major feminist historians of television like Lynn Spigel, who argues that these sitcom comediennes failed ultimately to disturb the status quo because they were disciplined within domestic scenarios as daughters, wives, or devoted subordinates, I contend in this chapter that two foremost examples—Arden's spinster teacher Miss Brooks and Sothern's single working-gal secretary Susie McNamara—created more disruption and critique than critics have fully recognized.[5] With their perpetually unhitched or even defiantly single, sardonic working women of 1950s TV, these actresses create what I term "butch comedy," transforming previous roles as a comic film sidekick into the lesbian camp as sitcom star. No longer supporting characters or comic exceptions, these female purveyors of biting and gender-bending comedy campily elevate the queerly coded spinster into the beloved star of the show.

The Spinster: A Queer Fish

In some respects, the spinster has always evoked a decidedly conflicted response: pitied and ridiculed but also admired and feared. Since at least the middle of the nineteenth century in Europe and North America, her (usually white) figure has garnered anxious attention, largely negative, as a troubling excess created by modern industrialization, urbanization, and the concomitant division of gendered spheres of influence. Neither situated normally in the domestic realm of the bourgeois family home nor allowed to flourish in the public sphere of male work and institutions, the iconic spinster—identified by historians as, characteristically, a white, middle-class, unmarried, and childless woman—stands apart and disturbingly lacks definition. Indeed, Auerbach's reflection on her conventional rendering in the Victorian age distinguishes *lack* as her central, pitiable characteristic: "Victorian spinsters were defined by what they could not have. Work and love, those two engrossing components of adult life, were forbidden or allowed only second hand."[6] The work that the increasing number of middle-class, single white women found at the time was poorly paid and rarely included professional advancement or authority, and their unconventional place in the family home frequently left them with the onerous care of elderly parents or their siblings' small children. Seemingly without romantic attachment or defining purpose, their lives were portrayed as not just pitiable but even horrible or grotesque: conservative writer W. R. Greg, who in an infamous 1862 article recommended expatriating the nearly 750,000 single British women over thirty to Canada, Australia, and the United States, where men were in the majority, found these spinsters almost gruesome, "wretched and deteriorating, their

minds narrowing, and their hearts withering, because they have nothing to do, and none to love, cherish, and obey."[7] Yet the feminist historians and critics who have held up the Victorian spinster as an ambiguous and even radical figure contend that these vilifying and shaming representations reveal a deep underlying fear of the threat that unattached women pose to patriarchy and its domestic ideology of the white, heteronormative, male-dominated family so central to Victorian mythos (and, indeed, as this chapter argues, to postwar American culture).

Of course, it is this exact threat to the ideological hold of the white patriarchal family and the defining roles of womanhood within it that transforms the unattached woman or spinster into a heroic figure for those invested in women's liberation. In her introduction to *Old Maids to Radical Spinsters*, Laura Doan ties the difficulty of disentangling the spinster from deeply entrenched "negative connotations" to a calculated defense martialed against women's independence: "Society has deliberately deemed her pathetic to mask its fear of the unmarried woman. The image of the old-fashioned genteel schoolmarm or the prying town gossip effectively cloaks the more dangerous threat of an autonomous woman."[8] Evading a defining relationship to a man, whether father or husband, within the nuclear family and, thereby, freer to define her self, the spinster disturbs as a liminal figure, or third term. Outside of patriarchy's "relational schemas," she becomes the "self-identified and autonomous single woman," who is such a threat to the symbolic order that she is deemed "unnatural" by a "controlling myth" meant to allay her threat.[9] Yet women depicted as monstrous demons or unnatural witches have long attracted feminist admiration for the disruptive power and well-founded patriarchal terror they so clearly expose.[10]

Moreover, as the work of historians such as Martha Vicinus and Sheila Jeffreys has shown, the burgeoning communities of unmarried women in the late nineteenth and early twentieth centuries legitimately did pose a challenging, if still small, alternative to dominant male institutions, heteronormative sexuality, and the nuclear family, while serving a significant and, apparently, morally superior social role. In hospitals, church communities like Deaconess's Houses and Sisterhoods, women's colleges, and settlement houses for the poor, unmarried independent women of the period created their own refuges but ones that uplifted marginalized or vulnerable members of the community, earning many of these women great respect and reverence. Often devoted to serving, sacrificing for, or ministering to others, the single women in these institutions gained "dignity and independence" in the "morally redeeming power of work," all the while creating "new occupations, new living conditions, and new public roles" for women.[11] In the celebrated figure of Florence Nightingale, these women found a larger-than-life heroine and model to counter the criticism and suspicion of their subversive existence outside the boundaries of matrimony and the bourgeois family. Still, even beyond the iconic Nightingale and her small band of nurses, whose spinsterhood presented perhaps "the most outspoken defiance we have of the Victorian family," Auerbach locates a number of other

"transcendent" and "grandiose" examples of spinster heroines—from independent artists like Christina Rossetti and George Eliot to those "majestic pioneers of Victorian female education," Dorothea Beale and Frances Buss, who founded and headed their schools with the "solitary authority of queens."[12] Predictably, however, as Jeffreys documents, suspicion and eventual intolerance of their "unnatural" sexuality, whether in the form of celibacy or ambiguously defined and often romantic or sexually intimate female partnerships, turned these heroines back into pariahs, as "vigorous attack[s]" on spinsters were revived in the 1920s and 1930s.[13] Furthermore, these early twentieth-century attacks on the spinster and sexology's emerging categorization of "lesbian" sexual identity illuminate a key connection, particularly for my discussion, between the spinster and queer female sexuality and gender presentation.

In short, the spinster or old maid has always been, in the words of *Mrs. Dalloway's* bitterly critical Peter Walsh, a "queer fish."[14] In examining the high-minded celibacy of nineteenth-century spinster feminists, as well as the passionate same-sex friendships and intimate relationships between women often forged in single-sex communities of the period, Jeffreys explicitly ties the attacks on spinsterhood in the early twentieth century to its nonnormative or even counternormative queerness, specifically its correlation with lesbianism in the wake of sexologists' classification of sexual behavior, particularly through the work of Havelock Ellis; casting suspicion on or labeling any women who live independently of heterosexual relationships as abnormal, perverse sexual others—stigmatized, for example, within the psychosexual category "lesbian"—could serve, for Jeffreys, "to undermine" the relational bonds between women and "dilute their potential strength" as autonomous economic and political forces.[15] The powerful spinsters of the women's rights and suffrage movements, strengthened by their close involvement with each other, could be disempowered, then, by this "scientific" recasting of unattached and, thereby, nonnormative women as perverse or sick. For just one specific example, Alison Oram documents how the growing awareness and sexological classification of female homosexuality was integral to the calculated attacks on "spinster teachers" in the interwar period, particularly in the 1930s, when the stereotype of the spinster as "an embittered, thwarted, sexually frustrated or deviant woman," and/or suspected lesbian, was employed to counter the increasing economic and political power of unmarried female teachers, who at the time dominated the profession in the UK and the United States and were advocating for collective rights such as equal pay.[16] As the twentieth century wore on, this persecutorial association between perverse sexual and gender identity and the unmarried female teacher who might prey on and corrupt children would serve to turn what Blount calls the "spinster's profession" into a nightmare of post-McCarthy-era witch hunts and highly publicized purges of suspected queers in the teaching profession.[17] Not just in this one highly visible public role, it would appear, by midcentury the spinster and the lesbian had become inextricably linked.

96 • Suffering Sappho!

In sum, as Sheila Jeffreys has argued, the unequivocal identification of the spinster with female same-sex desire has taken hold since the beginning of the twentieth century when the sexological category of the "lesbian" was used to undermine women's relationships with each other and feminist political gains, so much so that she can conclude, simply, "any attack on the spinster is inevitably an attack on the lesbian."[18] Yet, none of the historians cited above closely examines this queer spinster in the period *following* World War II.[19] While we have been assured that the spinster will inevitably carry with her the taint of sexual abnormality and ridicule for her pathetic, withering isolation, she nevertheless, I argue, subverts her debasement during the postwar period with her troublingly ambivalent and contentious contradictions.

Clearly running counter to the dominant ideology of "domestic containment" and reification of the patriarchal "family ideal" that I discussed in chapter 1, the single woman appears as both hopelessly out of place in the era, even anachronistic, and a radical vision of what might have been, and might still be: female autonomy, self-definition, and sexual freedom. Amidst the "most marrying generation on record" in the United States, producing the biggest boom of babies the nation had ever known, the spinster would be a queer fish indeed.[20] Yet, as Elaine Tyler May and many other historians have noted, the family ideal and dramatic postwar containment of women were hardly smooth, totalizing, or without disruption or discontentment. Many (particularly white, middle-class) women were induced into the domestic space, or "homeward bound," but this did not erase the empowerment, financial self-sufficiency of steady wage labor, and educational attainment they had enjoyed during and after the war. In fact, as Joanne Meyerowitz has shown, it is more accurate to view the Cold War era less as one of totalizing "containment" and more as one of unsettled tensions between the conflicting narratives for women of "domestic ideals" and "an ethos of individual achievement."[21]

In other words, the Cold War era was not all *Father Knows Best* and a demoralizing "feminine mystique" for certain working women. Examining hundreds of nonfiction articles in popular magazines of the era, Meyerowitz finds what she calls a "significant counterpoint to the 'feminine mystique'" in numerous pieces about the benefits of wage work, civic participation, and other admirable public achievements for women, suggesting another powerful "morality tale" at play, which "honored" careers for women and held up "heroic women of striving and worth" as paragons of the mythically American virtue of "individual achievement."[22] Perhaps more significantly for my own argument, she also discovers that over one-third of the articles on individual women "featured unmarried women, divorced women, or women of unmentioned marital status," and even those articles focused specifically on the apparent "domestic ideal" of motherhood and married life often stressed the toil of housework and even marital strife, establishing "ample references to housewife's discontent."[23] Therefore, it might be more accurate to view the spinster or single woman as a particularly

fraught and contentious queer fish of the period, providing an alternative to the "familism" of the "domestic ideal" narrative—one that could stress "individual achievement"—but also standing in conflict with the era's steadfast reinforcement of traditional gender roles and accepted female behavior.[24] As in the past, then, the spinster functioned in the postwar era as a troubling liminal figure who could queerly expose the paradoxes and competing narratives imposing themselves on women at the time, as well as point to imminent social change coming on the horizon, when the single career gal of the 1960s and 1970s emerges amid Second Wave Feminism to assert self-reliance, self-identification, and autonomy for women, at work, at home, and over their own gender and sexuality.

The Wrong Mrs. Boynton: Our Miss Brooks as Lesbian Camp

Supporting her identification of a "post-World War II domestic explosion," May refers us to the census statistics for the marriage rate per 1,000 unmarried females from 1920 to 2004, where in 1945 the rate approached almost 100 percent, followed by nearly 90 percent in 1950.[25] Since 1950, unsurprisingly, the rate has been falling steadily to a stunning low of 40 percent in 2004. Yet, amid this marriage and baby explosion with its supposed "reaffirmation of domesticity," two of the most popular television programs of the early 1950s elevated a beloved spinster teacher and a resolutely single career gal to national acclaim and star status. Although never a match for top-rated Lucille Ball's comedic housewife antics, *Our Miss Brooks* earned massive shares of audience attention in the 1952–1953 and 1953–1954 seasons (and in syndication), with its high point at fourteenth overall according to Nielsen's ratings, and Ann Sothern's *Private Secretary* was a stalwart in early television ratings, remaining in the top twenty-five programs for four seasons between 1953 and 1957.[26]

Although the end of the decade would arguably witness the ascension of May's domestic ideal on television with CBS's patriarchal family homily *Father Knows Best* (1954–1960) consistently hovering around the top-ten highest-rated shows, the first half of the decade gave an alarming number of spinsters and unmarried career gals center stage.[27] Arden's Connie Brooks and Sothern's Susie MacNamara may have been the most popular and influential, but single working women abounded in early television, particularly on CBS, although every network had at least one. Twentieth Century-Fox's "Queen of the Bs" Lynn Bari played *Boss Lady* Gwen Allen, owner of the Hillendale Homes Construction Company, on the DuMont Network and then on NBC from 1951 to 1954.[28] CBS added another popular radio program to its television lineup the same year as *Our Miss Brooks*'s debut (1952) with the highly successful *My Friend Irma*, pairing once again the titular ditzy blonde secretary (Marie Wilson) with her wisecracking best friend and roommate, Jane Stacey (played by a droll Cathy Lewis)—an urban working conceit shared by many programs including another Manhattan secretary, Millie Bronson, in *Meet Millie* on

CBS that same year.[29] Additionally, NBC tried a slightly different formula in 1954 with *So This Is Hollywood*, pairing two single roommates as aspiring female performers in Tinseltown, one a typical young starlet (played by Virginia Gibson) and the other a more wizened stunt woman (Mitzi Green), while *How to Marry a Millionaire* (1957–1959) turned Hollywood fare into first-run syndication for three Manhattan secretaries, launching the career of *I Dream of Jeannie*'s Barbara Eden.[30] By the 1961–1962 season, even Lucy had divorced Desi and returned to television with *The Lucy Show*, now playing Lucy Carmichael, a widow with two kids but still palling around with her best friend Vivian, a divorcée not coincidentally played by Vivian Vance, who had already served nearly ten years as her partner in crime, Ethel Mertz.[31] Mothers and wives were certainly not absent in this early Golden Age of television, but the prevalence of single working women suggests a competing narrative at play: the popular, if often comic, situation of the spinster teacher heroine and her single secretary sisters.

Surely, it is hard to deny the popularity of everyone's favorite English teacher, Connie Brooks, played by Eve Arden on radio and television for CBS from 1948 to 1957. Offered to Arden as the broadcast radio version of a star vehicle by CBS chairman William Paley, this most successful of early workplace situation comedies, centered on Connie's fruitless pursuit of fellow teacher Philip Boynton and her comic battles with Gale Gordon's blustering Principal Osgood Conklin, was an immediate hit for the radio network in its 1948 Sunday night lineup. Praised by reviewers and fans alike for Arden's unrivaled comic performance and for its warmhearted and yet sardonic depiction of the teaching profession—as one reviewer put it, finally presenting a teacher as "something other than a boring, sexless, freak of nature"—*Our Miss Brooks* became, according to radio historians, "one of CBS's most universally beloved comedies," making it an obvious choice to take to the network's television lineup.[32]

Indeed, following the smash success of Arden's friend and fellow film comedienne Lucille Ball's revolutionary comedy *I Love Lucy* in 1951, a transition to television seemed almost a foregone conclusion for *Our Miss Brooks*, although the radio program would continue to be broadcast simultaneously throughout the television run of the show. Developed for CBS by Ball and her husband Desi Arnaz's company, Desilu Productions, which had overnight become a major player in the industry with its groundbreaking changes to television production, *Our Miss Brooks* benefited enormously from the quality and style of the innovative Desilu formal techniques, which included recording on film in front of a live studio audience, with multiple (usually three) 35mm cameras to capture different angles of the performance, while maintaining the energy and comic timing promised by a live audience.[33] Having performed expertly in film and onstage for years, Arden would thrive in this format, now commonly known as the multicam mode of production, and Desilu would benefit from the cost-saving measures of shooting two similar shows back-to-back with the

same equipment and much of the same crew, even sharing Ball's favored cine-matographer, Karl Freund, and technician Al Simon, who are often credited with developing this mode of television sitcom production.[34] With almost the entire radio cast intact for the transition to television (leading man Jeff Chandler was replaced by Robert Rockwell in the role of love interest Mr. Boynton), the quality of *Our Miss Brooks* was unmistakable on its premiere for CBS television in 1952: even if reviewers like Jack Gould initially lamented the "pathetic contrivance and incredibly obviousness" of its slapstick gags and broad situational humor, they could not deny the show's revelation of the "sophisti-cated comic artistry of Eve Arden" (although Gould felt it was wasted on such puerile material).[35] Dubbed by one historian as "the thinking man's Lucy," Arden's spinster teacher was the central draw for one of CBS-TV's biggest hit shows of the early 1950s, earning great ratings and Arden herself an Emmy for Best Female Star of a Regular Series that same year, when she even beat out her friend and boss Lucille Ball for the honor.[36]

To be sure, in the program's first season, Arden's comedic artistry was focused relentlessly on a sardonic assessment of the plight and repeated failures of her character's spinster condition. From its opening episode, "Trying to Pick a Fight," which aired on October 3, 1952, the series establishes the crux of her dilemma— that pathologically shy and implausibly clueless biology teacher Philip Boynton fails over and over again to take Connie's less-than-subtle hints that she would like their relationship to be both more physical and more serious, eventually lead-ing to blissful matrimony. Although she and "Mr. Boynton" (as she still calls him) have been "going steady" for over four years, Connie complains to her land-lady and confidant Mrs. Davis that he seems more interested in his pet frog McDougall than in her, which student Walter Denton confirms by judging he will "never make a move." She spends the remainder of the episode unsuccess-fully trying to get a rise out of him, concluding in comic exasperation to the cam-era, "I may have to bite him!" Now, clearly, as director and writer Al Lewis asserted at the time, if Connie Brooks ever got her man, it would destroy the founding premise, tension, and even the very "format" of the show, transform-ing it into a "kind of family show" instead of the comic situation it had nearly perfected, and fans seemed eager to keep it that way, happy with its "matrimo-nial mirage" and expressing in letters, according to Lewis, "that they appreciate Miss Brooks' frustration."[37] Although this *TV Guide* piece with Lewis's appraisal guaranteed "No Mrs. For This Miss," the show relentlessly teased viewers with one "matrimonial mirage" after another throughout its run but particularly in its first season when as many as four episodes offered the illusionary prospect of marriage ultimately denied Connie Brooks, creating in the repetition a camp parody of her spinster desperation.

From its fifth episode, "The Wrong Mrs. Boynton," *Our Miss Brooks*, in fact, seemed to be making a cruel queer joke of dangled marriage prospects being ripped away from the beleaguered spinster teacher. Gamely agreeing to be

"Mrs. Boynton" for her biology beau's interview with a prospective employer, Connie even misses her chance to *play act* as Philip Boynton's wife in this episode since he has actually cast her in the role of his live-in mother, which creates the opening for a few risqué Oedipal jokes from Connie (and queers Boynton's now maternally defined bachelorhood) but brings her no closer to marriage. Then, in several proceeding episodes, the series makes clear that although Miss Brooks might hope to quit her job and start a family, her comic spinsterhood is too fine a material to pass up: in episode twenty-three, "Conklin's Love Nest," she expects a proposal, but Philip Boynton moves in with fellow male teacher Maurice La Blanche instead; in episode thirty-four, "Mrs. Davis Reads the Tea Leaves," a teacup prediction and confusion about a summer camp lead Connie to hope once again for a proposal, but her false chance to be a June bride evaporates; and in the season's final episode, actually titled "June Bride," she agrees to help colleague Monsieur La Blanche by serving as a proxy bride for his marriage to a delayed French girlfriend (in a white dress and veil no less), yet even this sham marriage falls through.

Signaling its significance for our understanding of Miss Brooks's fantastic plight, this proxy bride conceit, which incredibly surfaces again in season 4, is featured in the *TV Guide* article above with a full-page photo offering the punishing caption, "But the Miss missed again."[38] In other words, so much of the comedy of *Our Miss Brooks* depends not only on her conspicuous and oft-recognized spinster condition but also on the absurd lengths she will go to in order to resolve it, which, the show insists, must always remain queerly unsuccessful, resulting in a parody of the era's heteronormative obligation to marry. Therefore, in the audience's pleasure with her spectacular frustration, I argue, we find the affective draw of lesbian camp—the spinster teacher seems pathetic and is cruelly foiled in her desperate attempts at normalcy, and yet, in the expert hands of Eve Arden, she makes parodic hay of her conundrum *and* the men around her, puncturing conventionality and heteronormativity with her queer irony and wise, conspiratorial side-eyes at the audience.

As mentioned in the opening to this chapter, in this period Eve Arden eschewed more work in Hollywood as a particular type of comedic, female supporting actress—what Judith Roof calls a comic "sidekick" or "second"—to become a headliner on television.[39] Of course, never achieving the superstar status of fellow Hollywood supporting actress Lucille Ball, Arden flourished in the situation comedy form nonetheless to become a leading figure on the burgeoning televisual medium, where (for Roof) the "idiosyncratic personalities" and repeated "humorous behaviors" of female comedians, such as Arden's signature "double take and snide rejoinder," made for early hits.[40] Yet, contrary to television historians like Spigel, who finds independent women like Arden's Brooks not "threatening" but instead "tamed" by their shows back into "charming housewives" and "in the working-girl formula, devoted teachers . . . and faithful secretaries," my argument here focuses on the subversive potential carried over

from their "female comic second" roles in film.[41] Arden's supporting role as Ida Corwin in camp classic *Mildred Pierce* (Curtiz 1945) stands out as exemplary here, with critics often citing her notorious renunciation of motherhood as representative not only of the cinematic sidekick's "sarcastic, unromantic, and sensible" commentary on the female lead's plight but also of her essential queerness.[42] Referring specifically to Arden's Ida, Roof connects her detachment and keen "ironic observation" to the sidekick's distance from traditional femininity and her queer or ambiguous sexuality, always "unattached or unworried about mating" and, therefore, necessarily disappeared by the end of the main (hetero) romance plot.[43] Contrary to Michael Bronski, who insists that female "sidekicks were never played as lesbians, just 'old maids,'" I agree with Roof (and Patricia White) that these typically unattached women, who in the case of Arden signal masculinity by being "taller and brasher" than their more normative leading lady confidants, can be read as not only queer but specifically lesbian.[44] Although White stops short of identifying the perpetual spinster "our Miss Brooks" as iconically lesbian as Agnes Moorehead's campy turn in 1960s television's *Bewitched* (ABC, 1964–1972), I would argue that Arden's frustrated single schoolmarm did create an uproarious ironic commentary on the compulsory heterosexuality of her era, often connecting the old maid to the possibility of a lesbian alternative.[45]

To be sure, I am not the first to suggest this queer potential, particularly for Arden, although most prominent histories of gays and lesbians on television fail to read Connie Brooks or any other unattached women of the early period as a specifically lesbian type.[46] Particularly, I am perhaps most indebted here to Amy Villarejo's *Ethereal Queer*, where she performs a rare queer reading of *Our Miss Brooks*, specifically, in her examination of the "Christmas Show" episode from its first season. Within the episode's situation of gifts being returned and exchanged at a local department store because Connie and her colleagues cannot afford Christmas gifts for each other, Villarejo focuses particularly on the interactions between Connie and the officious and decidedly "butch" Mrs. Carney, who runs the gift exchange office and whom the critic labels as instant "gender and sexual trouble," with her short hair, tortoise-shell glasses, tailored suit jacket, and gruff demeanor, *and* as a catalyst for Eve Arden's own "queer significations."[47] In their first exchange of dialogue (accompanied by Arden's signature double takes for the camera), Mrs. Carney reframes Connie's returning of perfume as gender trouble, suggesting that it might be "too feminine" for such a "self-reliant" and "rugged" type, and then expresses her own surprise when Connie plays with the suggestion, asserting her wish to exchange the perfume for the more masculine pipe, just a short step away from the phallic "cigars" that Connie jokes she needs to "cut down" on. Villarejo reads this scene, rightly I think, as *both* women "traffick[ing] in innuendo" that "casts suspicion on Arden's character" and ultimately ties this gender play to lesbian stereotypes, a connection that she further supports with analysis of the second exchange between Miss

102 • Suffering Sappho!

Brooks and Carney, where their examples of gift swapping move quickly from perfume to "daybeds" and then to "loveseats," which Villarejo labels "a tongue-in-cheek itinerary of a lesbian relationship" where, "as the joke goes, the second date is with U-Haul."[48] Not only do I agree that this type of rapid-fire trafficking in "recognition and innuendo" has the potential to give a "lesbian resonance" to Arden's character, as she asserts, but I would offer that this Christmas episode represents just *one* instance of the television program's play with gender and sexuality that, as the series continues, becomes more pronounced, moving from a "resonance" to the bolder, campy display of an open secret.[49]

Yet, even within this single episode, Villarejo is able to establish a myriad of ways that queerness seems to "permeate" the show—with a running gag using Santa's "beard" as a queer disguise from Mrs. Carney and a prolonged joke about Miss Brooks's gifts and then herself being "in the closet"—resulting in a "chain of queer significations" that rely on innuendo, double entendre, slang, and gay and lesbian coding.[50] What is remarkable about the series, I would argue, is that this bewildering chain of queer significations is not confined to this one episode but weaves through episode after episode until it reaches its campy peak in the final, troubled (and least popular) season of *Our Miss Brooks*, where the coded and, surely by now, suspect spinster is undeniably presented as lesbian camp. In fact, the repetition of the very same chain of queer signifiers can be found in the next year's Christmas episode, entitled "The Magic Tree," which places Connie Brooks alone on Christmas Eve with only her landlady's cat Minerva to keep her company. In what amounts to a twenty-seven-minute camp send-up of an old maid schoolteacher, the episode begins with Arden sarcastically assuring her landlady that she will have a "gay" time on her own, but it moves quickly into a dream sequence involving a "magic tree" and its ability to upend normalcy as the show has defined it, making her miraculously irresistible to all men.[51]

In the dream sequence set off when Connie falls asleep in her (iconically old-maid) rocking chair clinging to the troublesome cat Minerva, the jokes about her advanced age, her abnormal femininity, her "claustrophobia," and her comic desperation for a partner propel the action toward its supernatural solution, when the perpetually indifferent (and sexually suspect) Mr. Boynton suddenly shows virile interest in Connie and passionately kisses her under the mistletoe.[52] Tinged with the pathos and comic cruelty central to the program's treatment of the spinster schoolteacher, her desperation and loneliness are absurdly exaggerated by the sprigs of mistletoe attached to every corner of her apartment for Boynton, yet the episode plays as an ironic romp where a mere touch of the magic tree inverts the three central men in Connie's life, making the dream sequence a heterosexual "mirage" that we are encouraged to discount. Beginning with Connie in dressed-down vacation mode, where her closely cropped blonde hair, heavy eyebrow penciling, black pedal-pushers, and dark, open-necked button-down appear more downtown hip than uptight teacher, the episode establishes the kind of "aberrant femininity," or one might even say stylish butchness, that Christine

Becker attributes to Arden and the other "working girl sitcom stars" marginalized in Hollywood owing to their failure to "conform to bourgeois standards of femininity."[53] Indeed, the repetitions in this second Christmas episode pose an extended and pointed critique of the sexism, ageism, and homophobia directed at unmarried bourgeois women of a certain age—Miss Brooks is revealed to be in her thirties during the series, while Arden herself was forty-four when CBS-TV's *Our Miss Brooks* debuted—complete with a barrage of age slights from the unwitting student visitor Walter and a consistent thread of cat jokes.[54] Connie's desperate singlehood is raised to absurd heights here, and the more ridiculous her machinations, failures, and Boynton's rejections become, the campier her version of spinsterhood appears.

Yet even more meaningfully, the episode seems to take parodic aim at the performance of gender itself, as well as the attendant queer sexual connotations of Connie's aberrant femininity. Connie may change into a version of normative femininity in her black evening dress, choker, and earrings to greet her guests, but she announces this move to compulsory femininity sardonically, "I'd feel better if I slipped into something *uncomfortable*," and thereby sends up the theatricality and artificiality of gender. Then, having recognized the drag performance of her female impersonation, one cannot help but view her over-the-top desperation for Boynton and the absurdity of his continued indifference (represented here by his ridiculous turn to pet guinea pigs when Connie makes an advance) as queerly disturbing camp. In response to the double entendre of her aggressive romantic overtures—that she is "cooking" for him—he blurts out awkwardly, "Don't cook for me. I couldn't eat a thing!" punctuating a running joke of the episode that the two central men in Connie's life, Boynton and her nemesis, Principal Conklin, are both allergic to mistletoe and, therefore, shun heterosexual contact. In fact, over the span of the series, Robert Rockwell so perfects this reserved, impossibly naive, and pinched performance as confirmed bachelor Boynton, with his repeated ignorance, avoidance, and even refusal of Connie's advances, that by the middle of the second season his troubled claims to heteronormative masculinity can be openly lampooned by the magic tree, whose touch transposes him into a hypermasculine, deep-voiced paramour who campily groans, "Come here, baby!" and plunges a shocked and confused Connie for a dramatic kiss. We are clearly supposed to be in on the joke of this parody of over-the-top hetero-manhood campily played for laughs, but we are also encouraged to balk at its normative resolution as the episode ultimately returns us to the comfortable certainty of the queer spinster waking up with her arms around her roommate's cat. As the episode ends, Connie may wish for the ridiculous "miracle" that another ten trees could provide, but even this overkill, we know, will not give her the straight Boynton of her dream, nor perhaps (and more to the point) are we supposed to believe in the sincerity of that wish.

In fact, one could argue that the relationship between Connie and Philip Boynton works throughout the series as the central normative mirage—or camp

104 • Suffering Sappho!

lie—meant to thinly (and humorously) disguise the queer truth parading before us. In other words, Connie and Philip are acting as each other's beards. Yet, the series' near obsession with masquerade, costumes, and just plain drag also obviously highlights this camped-up impersonation of normativity. Numerous episodes feature or are narratively based around masquerade balls, dances, and stolen or exchanged clothing, with four such instances in season 1 alone. "The Embezzled Dress" (episode 3) offers just our *first* glimpse of Mr. Boynton in drag, receiving wolf whistles from student Walter Denton and ribbing from Connie: "Oh, you've never had a prettier dress in your whole life!" Then, providing an opportunity for perhaps the campiest of Connie's female impersonations, "Madison Country Club" allows her to send up and perform an imitation of none other than Tallulah Bankhead, right down to the cigarette holder and "Hello, darling!" A masquerade ball in "Madame Brooks Du Barry" encourages Miss Brooks's landlady to dress convincingly as a rugged Teddy Roosevelt and make a pass at Connie, while "The Stolen Wardrobe" finds Walter, Boynton, and Principal Conklin in drag, punctuated by jokes about living at the YWCA. Moreover, the impact of these masquerades on heteronormativity and the era's "domestic ideal" of matrimony and the nuclear family finds fruition in episodes like the season-ending "June Bride," where Connie's bridal gown and veil for the proxy wedding become just another farcical costume, or particularly in the stunning proposal of marriage Connie makes to Mrs. Davis in perhaps the first season's queerest episode, "Conklin's Love Nest."

Beginning with the premise that the principal's spare apartment might provide Connie with an excuse to lure her notoriously cheap Mr. Boynton into a marriage of financial convenience, "Conklin's Love Nest" offers a veritable bounty of "queer significations" that shift lesbian "resonance," in Villarejo's terms, to the campy display of lesbian commitment. The episode hinges on yet another absurd plan to elicit a marriage proposal out of the "bashful biologist," but because of a number of sitcom-induced misunderstandings, the plans to make him jealous with French teacher LaBlanche or woo him with the cost savings of marital bliss result in a queer mix-up indeed. The confused Frenchman switches his attentions to his bachelor colleague, unwittingly propositioning him to move in together since "two can live as cheaply as one," while an embarrassed Connie tries to deflect her landlady's "crude" hints about newlyweds saving money with a gender inversion that sends the episode into a shockingly queer burlesque.

After Mrs. Davis suggests that she tell Mr. Boynton about "Joe and Lorraine," a pair of frugal newlyweds they know, Connie avoids being so direct with him by changing Joe and Lorraine to "two very nice girls"—friends of hers who are sisters—creating the setup for an interplay of ironic sexual reversals. Missing Connie's gender switch, Mrs. Davis comes back into the room and raises the stakes initiated by the queer miscommunication, announcing cheerily how the couple "just had the cutest baby," the "image of Joe," at which point Boynton underscores the lesbian signification by literally spitting out his coffee. Refusing

to veer away from the queer innuendo, the series instead doubles down, concluding the setup with Connie's sardonic punch line: "If you think *you're* confused, you should have seen Joe." Then, however pained and confused, Boynton does seem to take the hint and announces his own queer coupling: as foreshadowed by the episode's industry in-joke about "Rochester" hiding another confirmed bachelor in "Jack Benny's vault," Boynton (once again) deflates her hopes of marriage by taking Mr. LaBlanche up on his offer for a "happy" life in their new apartment together.[55] Mr. Conklin's "Love Nest," it would appear, has just been waiting for two frugal confirmed bachelors to fill it, but of course Connie already has a long-time companion and housemate, the "eccentric" Mrs. Davis, who might be too old for lesbian parenthood, but who, at the very least, has earned a promise of commitment. As the episode concludes, astonishingly, with Connie's exasperated proposal to her, "If you're not busy tomorrow, you and I are getting married," the light (and perhaps anxious) laughter of the studio audience belies the stunning impact of viewing this moment today. While obviously the supposed ridiculousness of this gesture—Mrs. Davis is, after all, an aged, doddering widow—underscores the inherent heterosexism of the culture and television industry at the time, it also manifests the queer connotations running through not only this episode but so many in the series, which are so often lesbian in all but name.

Only occasionally casting doubt on Mr. Boynton's sexual normalcy, it would appear that after the first successful season capitalizing on the spectacle of her outrageous matrimonial failures and mix-ups, the series focused its comedy on the inevitable punch line to be drawn from those failures—that there is something wrong with the spinster, no matter how beloved the teacher-star might be.[56] Over the next few seasons, double entendre and repeated queer coding, such as toying with the nature of Connie's relationship with her eccentric housemate and landlady (and their cat), are often articulated as a satiric discourse confronting the closet and its debilitating effects on queer Americans in the Cold War era. Throughout the 1950s, as Steven Cohan reminds us, camp was "the code and custom of the closet," performing the "double function" of the closet as a "style and a strategy of passing," a cultural practice that both recognized and challenged "the imperative to pass as straight" through its particular language, coded signs, and play with mainstream culture.[57] In this vein, Connie's spinster predicament, lacking the matrimonial bona fides to secure her heterosexual place, is dramatized through the workings of the closet—the ambiguous queer space of passing and repeatedly failing to pass as straight, which becomes a heightened force of anxious tension and humor in the series—a generative camp humor and sitcom practice uncomfortably taking aim at normative constraints while also following them. In season 3's "The Citizen's League," for example, the series powerfully evokes the closet itself for a camp send-up of nothing so central to the era's normalizing project as McCarthyite persecutions of gays and lesbians.[58]

Mocking and yet poignantly enacting the cruel and destructive censure of McCarthyite accusations, harassment, and silencing, the episode comically

106 • Suffering Sappho!

implicates nearly the entire cast in shameful complicity and self-destroying phobia as members of a "civic pride" group whose pamphlet, "Road to Good Citizenship," read aloud in full by different characters, opens with an ominous charge: "Every adult, without exception, has some dark secret in his life, something of which he would be mortally ashamed were his neighbors to learn of it," perhaps an act that occurred on "some gay holiday" like Christmas or the Fourth of July. At the mention of the most patriotic of "gay" holidays, the members of the Citizen's League (Connie, Boynton, and the Conklins) visibly panic and flee. Failing to hear Mrs. Davis's reassuring, queer-positive conclusion, which encourages a release from shame, "not to dwell on your dark secret," they pack their bags and head to the bus station for a one-way ticket out of town. Self-described "miserable creature[s]" in a situation comedy, however, they do of course find laughable release in the end through "confession" of their farcical crimes (having prevented the officious Mrs. Dumfree from playing the organ at the governor's wedding), yet Connie is able to turn her reprehensible queer condition—the guilt of *her* offending sewing needle suggestively jabbed into Mrs. Dumfree's rear end—into an affecting challenge to persecution as well as a comedic complaint brimming with gay innuendo: "I have so much bottled up inside me, my conscience feels like Phil Harris' closet."[59] Despite this reference to male indiscretion and effeminate, closeted performance (again, involving *The Jack Benny Show*), it remains *Connie's* queer conscience and quasi-sexual secrets we are uneasily laughing about and that serve as a continued critique of the era's treatment of queer Americans.

Furthermore, season 4 proceeds to campily ratchet up this critique through Connie's arrest by the vice squad ("Connie and Bonnie"), followed by the "Skeleton in the Closet" episode involving years of blackmail, and, eventually, a get-together with her WAC buddies where she is called "Uncle Connie" and besieged by a troupe of ridiculous male suitors in hypermasculine drag ("Reunion"). That several actual closets feature in these later episodes—such as when Connie hides her blackmailer and then herself in a closet to conclude the "Skeleton" episode—should be of no surprise, although the entrance, in the middle of the final season, of actress Nancy Kulp rehearsing the queer spinster role she will perfect in *The Beverly Hillbillies* (1962–1971) seems the kind of magical gift only a queer scholar could dream up.[60]

In other words, over four seasons, CBS-TV's *Our Miss Brooks* produces what one is tempted to call bumper-to-bumper "traffic" in lesbian "recognition and innuendo" like the kind Villarejo recognizes in the show's first "Christmas" episode, making a parodic spectacle of the perverse position of the spinster schoolmarm through the unfeminine wit and wicked precision of Eve Arden's masterful camp performance. We are supposed to pity the lonely schoolmarm with her desperate frustrations and shriveled opportunities, but, principally, we love our acerbic Miss Brooks as she encourages us to laugh at (and long for) one ridiculous heteronormative mirage after another. Contrary to expectations, I would

argue, she often prevails as the self-defined, autonomous, and beloved spinster heroine—able to counter the "family ideal" of the postwar period with a queer allure all her own. Not unlike Jack Benny, through many turns of double entendre, coded references to queer life, and gendered masquerades, Eve Arden's spinster camp winks at us and lets us in on the joke through her conspiratorial looks, her biting but hilarious observations, and, simply, her irrepressible charm. What I am proposing below as her style of butch comedy, then, allows Arden to "get away with it" as it were—to pass—and, significantly, she is joined by a few similarly humorous spinster heroines both at that time and since.

Butch Comedy and the Spinster Wit

Similar to other broadcast television histories cited above, such as Tropiano's *The Prime Time Closet*, Steven Capsuto's *Alternate Channels: The Uncensored Story of Gay and Lesbian Images on Radio and Television* references the industry's network rules that prohibited scripts about "sex abnormalities" in order to explain why homosexuality "remained virtually invisible on television through the mid-1960s," even going so far as to assert that radio throughout this period did not produce even one "implicit lesbian" character to rival the "male sissy" (such as the ones associated with Jack Benny).[61] Despite then citing examples of "stereotyped 'bulldykes'" or "grotesque butch women," some of whom "turned up on several comedy shows" where they were portrayed as plain, "man-crazy girls" and, therefore, "were not gay at all," Capsuto confidently insists that "lesbian listeners heard no echoes of themselves on the air."[62] With its bewildering claim that the coded "fairy" characters of radio reveal the limitation of comedians' "homo gags" on the "radio drag" of programs like *The Jack Benny Show* but "stereotyped 'bulldykes'" are somehow "not gay at all" and *certainly* not drag, this critical position reveals not only the obvious sexism permeating these histories but also the intractable refusal to acknowledge female camp when it is literally calling out through the airwaves.[63] In a recent groundbreaking work, however, Quinlan Miller sets out to rewrite this history through a "trans gender queer" exploration of camp TV beginning in the exact period of early television considered in this chapter, when numerous sitcoms, for the critic, "debut as camp" rather than appear "only camp in retrospect," opening the concept up to representations such as those "man-crazy" and "grotesque butch women" dismissed by Capsuto.[64] Obviously, the claims and episode readings of the previous section amply resound Miller's revisionary critique with the camp TV of one of CBS's biggest hits of the early 1950s, *Our Miss Brooks*.

Although Miller briefly recognizes *Our Miss Brooks* as part of the camp TV of the era and identifies Eve Arden's performance as one of the unmarried "career women" whose "queer meaning" signified "nonstraightness," the book predominantly directs its attention to supporting characters and guest stars, not headliners, and often less recognized (or even available) programs, yet almost all the

fundamental features of camp TV outlined therein are obviously present in *Our Miss Brooks*.[65] At the show's core, one could argue, we find Miller's notion of the "ironic coupling" scenario of Connie and Philip, which subverts the institution of marriage through "ambiguously believable romantic interest and sexual devotion," creating the kind of "high concept marital camp" that Miller explores in the queer "heterosexual front[s]" of *The Bob Cummings Show* (1955-1959).[66] Whether through repeated use of "proxy" and other sham or fake marriages as I explored in season 1's "The Wrong Mrs. Boynton" or "June Bride," or in later instances of the "partnering of gender nonconforming partners," such as season 4's pairing of Bob Sweeney's confirmed bachelor Oliver Munsey with Nancy Kulp's queer secretary Miss Lucretia Hannibal (in "Connie and Frankie" and especially "24 Hours"), *Our Miss Brooks* performs a powerful camp TV critique of marriage developed directly from its hyperbolic treatment of the queer spinster condition.[67] Further, as the mention of Kulp indicates, the show's producers were not immune to the charms of the era's queer guest stars or character actors singled out by Miller as camp "icons" of "trans gender queer expression" in sitcoms, although I would argue that Connie Brooks herself more clearly parallels Rose Marie's Sal of *The Dick Van Dyke Show* (1961–1966), whose spinster character's ridiculous dates and sarcastic commentary were able at times to create a "camp approach to marriage" critiquing "conventional coupling."[68] While *Our Miss Brooks*, of course, also offers instances of drag, sexualized double entendre and wordplay, queer codes, and other excesses central to *Camp TV* as defined by Miller, it is the form of its camp, what I am calling butch comedy, that extends and builds on this significant recent critical work.

In other words, it is vital, I believe, to examine closely *how* the barbed humor of Arden's spinster heroine works to both amuse and unsettle us, as well as upend broadcast television's gendered comic conventions. As I noted above, Arden's performance as Connie Brooks received almost unanimous critical praise at the time, but she was also clearly distinguished from other contemporary female comic performers. Arden's Miss Brooks was not a ditzy blonde punch line like Marie Wilson's Irma or an absurdist comic wife like Gracie Allen; she was most certainly an "unruly woman," but not exactly in the vein of the destructive genius of Lucille Ball.[69] Jack Gould's distinguishing of Arden from other "Top Comediennes" at the time was typical: Arden led with her "brittle, caustic style and stinging delivery of a wisecrack," not through the "inspired farce" of a Lucille Ball or the "pratfall" and "harum-scarum bedlam" of a Joan Davis.[70] Having seemingly perfected her "brassy," sardonic, unattached "sidekick" femme in the movies, Arden is credited with infusing that caustic, tough dame with the charm and warmth she felt the Brooks role could possess; although Gerard Jones insists that "no other TV woman was as combative," Arden manages, for him and others, to combine "nurturing" maternal qualities with a wisecracking "self-assurance" that makes her the equal of her male adversaries on the show and, therefore, "no Lucy."[71] As radio historian Gerald Nachman

Spinsters, Career Gals, and Butch Comedy • 109

describes it, the key to her unique "thinking man's Lucy" is the rare (paradoxical) combination of the "acerbic and nice"—the "smart-mouthed gal," who is "a master of the dry aside, sidelong look, and permanently arched eyebrows" and a "feminist before it was in fashion," through her obvious equality with or even superiority over the men around her, and yet she is beloved and charming.[72] Combative and acerbic, "tart-tongued" and smart-mouthed, Arden's Connie Brooks retains that tough, assertive, wisecracking cynicism of her earlier Ida Corwin-esque roles, yet somehow she becomes our softened, beloved spinster confidante, our likable working-gal emcee—a "thinking man's Lucy" but, perhaps more to the point, the thinking woman's George (Burns).[73]

If there is one signature feature of Arden's comic style in the series, besides her sidelong look and arched eyebrows, which in fact often just serve to punctuate them, it is undoubtedly her sarcastic comic asides or wisecracking one-liners, often spoken under her breath as if to the audience, that make up the heart of what I am calling her "butch comedy." Indeed, this kind of verbal play and wit is what distinguished the camp of this period from the drag queen, for example, as their sensibility was communicated through humor, in the form of "the snappy retort or putdown, the coded innuendo, the double-barreled pun, the misleading pronoun . . . the pilfered and then twisted cultural allusion."[74] For just one example outlined above, consider the deliciously queer moment when Connie is caught in her "Joe and Lorraine" couple mix-up in "Conklin's Love Nest" and wisecracks with sly innuendo, "If you think *you're* confused, you should have seen Joe." Ostensibly, of course, she is speaking this line to Philip Boynton, who has just been shown in medium close-up choking on his coffee, but in the two-shot of her and Mrs. Davis, to which the scene reverts, the audience has full view of Arden's notorious sidelong look at her landlady (as she digs the hole deeper for Connie, adding that the baby was "just the image of Joe"), as well as her glance at Boynton as she intones the punch line, but we also see her milk the studio audience's laugh with shifting eyes and reactions, looking down at the table, off-camera, and once directly into the camera, while Morgan's Mrs. Davis shows no reaction to the line. These "tart-tongued" comic asides, in other words, often revolving around sexual innuendo directed at her male love interest but rarely acknowledged by him, are repeatedly signaled as *for* the audience's pleasure, as we are taken into Arden's knowing and bemused confidence, and also *at the expense* of her unwitting fellow characters, often the men on the show. For instance, in a different vein, many of her most biting quips are directed at (or adjacent to) Gale Gordon's wonderfully boorish Principal Osgood Conklin, who, to be fair, can give as good as he gets.

Certainly, though, not all these sarcastic one-liners are at someone else's expense. Particularly in relation to her failed romantic overtures, Arden's asides are often self-deprecating and even punishing. For example, doubting and undercutting the supposed envy that her visiting, married WAC buddies have for her independent single life (in "Reunion"), Connie responds first to her friend Ellie's

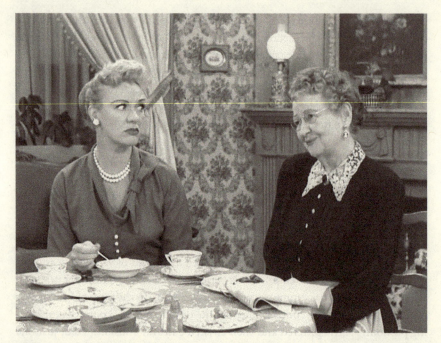

FIGURE 8 Eve Arden gives one of her notorious sidelong looks at Jane Morgan's meddling Mrs. Davis in season 1's "Conklin's Love Nest."

son calling her "Uncle Connie" with a side-eye reaction shot and the queer retort, "If he met me, he'd be even more confused," and then returns to this gender trouble later in the episode to pointedly ridicule her own spinsterhood, "If something doesn't happen fast, Uncle Connie is going to be known as Grandma Brooks" and to bristle at Gayle's husband's assumption that her ex-sergeant Brooks must "drive a truck."[75] Nevertheless, she is always in knowing, ironic command and driving whatever sharply observant critique (of fellow characters, of repressive social conventions, and even of herself) that piques the scene or the episode. Her verbal and expressive mastery extends not only over the diegesis of *Our Miss Brooks* but also out to us, less often through clear direct address than through those trademark comic dry asides and in-camera looks—a modified version of the audience address and familiarity that George Burns supposedly "perfected" in the early television era.[76] In fact, her biting asides, double entendre, and knowing quips evoke not just George Burns but a number of male contemporaries who came up through vaudeville, even Groucho Marx.[77]

For sure, Arden's Miss Brooks character and her wicked one-liners signal early television sitcom and radio comedy's roots in vaudeville, but her female comic performance challenges the gendered conventions of those established comedic forms. While most broadcast historians view the rise of the situation comedy as a conservative domestication of the unrulier aspects of "loud, urban, unrestrained" vaudeville and stand-up, where comedians "could create characters

that were often more contemptible than admirable . . . and still win the love of a large audience," aspects (and major performers) of vaudeville were still integral to early television comedy.[78] For instance, George Burns and *The Burns and Allen Show* (1950-1958), along with Jack Benny, are often credited with bringing some of those unruly aspects of vaudeville routines into the domestic space and situations of early television, where Burns, for instance, continued his direct address to the audience begun during his vaudeville stage career and even moved between "extra-diegetic" and diegetic spaces on his television show, crossing the "proscenium threshold" to re-enter a scene after commenting on its action.[79] Eve Arden was never a vaudeville performer (like her costar Jane Morgan or co–head writer Joe Quillan), but her facility with a gag or well-timed punch line rises to this tradition; and although she does in some ways resemble Mary Livingstone's "heckler secretary," who used sarcastic wisecracks to "needle" and belittle Benny, Arden's Miss Brooks is the star of the show, not just a supporting sidekick—able, like her male comedic contemporaries, to dominate the narrative world, at times even inhabiting diegetic and extra-diegetic space as she looks out at us and directs her sardonic asides to the audience.[80]

Yet perhaps nothing confirms this privileged comedic narrative position better than the program's frequent granting of the last word or final absurd unresolvable deed to our Miss Brooks. From the first episode, where her barbs and comically exasperated expression take their final shot at an oblivious Boynton, Arden/Brooks almost always has the conclusive role as the comic arbiter of the action or the absurd disrupter who perpetuates the unsettled situation into its next weekly iteration. In the episodes discussed above—"The Wrong Mrs. Boynton," "Magic Tree," and "Conklin's Love Nest," for instance—it is Connie's final punch line, such as "You and I are getting married," and Arden's beleaguered, bemused, or sardonic expression and double take that bring the comedy to a close. In other episodes, Connie takes part in a partial resolution of the comic misunderstanding, miscommunication, or hijinks set in motion by one of her (or another character's) schemes, yet often she does not resolve the fundamental issue at hand but instead avoids it through an absurd action, performance, or escape that serves to undermine male authority, typically represented by Conklin or Boynton. A characteristic example of her evasion can be found at the end of "The Citizen's League" episode, where Conklin, not Connie, becomes the target of Mrs. Dumfree's revenge, and she subsequently flies away from his angry confrontation, sprinting off stage right to bring the show to a close.

Rather than grant authority and dominion to Conklin or truly allow for Connie's punishment and domestication—as would be typical, for example, on *I Love Lucy*, where Lucy's scheme for the week would come crashing down on her and she would be compelled to return to Ricky's understanding (paternalistic) embrace—*Our Miss Brooks* typically ends with *her* critical word and countenance or with an unresolvable action, such as fleeing from Conklin or performing a comic number, gag, or pointed song. For instance, she sings "Sonny

Boy" to Boynton, patting her knee, at the end of "The Wrong Mrs. Boynton," square dances at the end of "June Bride," and threatens to go "on the road with *The Desert Song*," accompanied by her ridiculously macho paramours in "Reunion."[81] Indeed, there is no small element of the carnivalesque on display at the end of many episodes, where magic, fantasy, and costumed masquerades are raised up in the closing moments, such as in early favorites like "Dem Golden Slippers" and "Just Remember the Red River Valley," where Connie leads her fellow costumed "fugitives from Tobacco Road" in a reprise of their song as they rhythmically abscond offstage.

In other words, Arden's Connie Brooks is ultimately not a source of domestic resolution or bourgeois consensus at this early point in the sitcom's televisual development, and her position as the controlling force for the program's narrative and its comedic commentary was remarkably unusual for female performers at this time. As my references to Lucille Ball and George Burns indicate, my theorization of Arden/Brooks's unusual position here certainly relies on Patricia Mellencamp's influential essay "Situation Comedy, Feminism, and Freud: Discourses of Gracie and Lucy," which examines the work of Allen and Ball to understand how early television comedy served as a successful "machinery for familial containment" while also employing the genius of "idiosyncratically powerful female stars."[82] In the figure of Gracie Allen, she finds the "bewildering non sequiturs" and deconstructive logic of this female half of the vaunted "husband and wife" vaudeville sketch team to be disruptive to patriarchal law, while Lucille Ball creates perhaps even more subversive tension with her weekly expressions of housewifely "discontent and ambition," pitting her "dissatisfaction" and performative star power against the show's final containment through her failures and "the happy endings of hug/kiss."[83] Although the unsettling ditz Gracie might temporarily escape or defy order (but never George's controlling gaze) and Ball might get the last look or close-up to upstage every other performer, especially her humiliated husband, neither female comedian, for Mellencamp, "escaped confinement," despite Ball's nearly unrivaled mastery of "the male domain of physical comedy."[84] Eve Arden, on the other hand, as I have established above, stands apart from these two female comedy stars in her combination of Ball's centralized female complaint and George Burns's (male) authority over comic speech and the narrative world. Never truly happy or content, Arden's Miss Brooks is also not contained in the domestic sphere, and, through her butch comedy, she announces herself as a transgressive comic woman with the witticism, voice, and position of the "thinking man."[85]

Within Mellencamp's figuration, that "thinking man" is, of course, represented by Gracie Allen's perpetual straight man and husband, George Burns. Gracie may have at times appeared outside of male control, but, as already noted above, ultimately George has dominion, reigning "over the show with benign resignation, a wry smile, and narrative 'logic'" firmly on his side: he is "center-framed in the mise-en-scène and by the moving camera"; he looms over other

characters; and he has "access to the audience via his direct looks at the camera," his nods to us, or with "sidelong collusive glances at us," as well as simply through "direct monologues to the audience."[86] Like Burns, Arden clearly enjoys the show's last "controlling look and laugh," possessing a powerful ability to manage and persuade the audience as our intimate and as the "wielder of authoritatively funny speech."[87] Indeed, mindful of how comediennes in this formulation are rarely the subject speaking and not just enduring jokes, one is struck by the astonishing achievement of Arden's (and the producers') comedic creation. She is a match for one of the greatest male comedians of her time, performing the husband's role in the "husband and wife" sketch with a clueless Boynton and no marriage in sight and leading us through its circular comic situation from a decidedly queer place where the heterosexual front of her relationships and pursuit of Boynton are never resolved, *and* she retains until the very end the male comedian's conventional position as "wielder of authoritatively funny speech" and controller of narrative logic, not to mention us.

The female-identified actress's performance in this typically male character position with its familiar features of normative masculinity—including physical domination of space, critical and logical narrative superiority, bold and assertive verbal authority, and even aggression—forms the backbone of the "butch" in what I am calling butch comedy. Still employing the softness and warmth that Arden professed to want to bring to the role of Connie Brooks, her headlining star protagonist and quasi narrator for the show effectively wields the masculine traits enumerated above: listed at five feet seven inches in height, Arden is often taller than or on par with every other performer in the scene, at times noticeably looming over Gordon's Conklin and only really exceeded by Rockwell's Boynton; her knowledge of story content and her direct relationship with the audience grant her superiority over others in the story world; her verbal battles with other characters, erotic banter, and decisive wisecracks make her the masculinized "wielder of authoritatively funny speech"; and she can be physically, and is certainly verbally, aggressive. As television historian Gerard Jones asserts, "No other TV woman was as combative."[88] Despite her sympathetic benevolence, feminine attractiveness (often mentioned by male critics and historians), and "soft" Brooks wardrobe, Arden wields unmistakably masculine force and command.[89] In other words, she queers gender in a performance blending the feminine and masculine, comedically asserting herself while never abandoning the feminine entirely.

For further evidence of this comic style, one might consider how Arden's voice serves as a significant site for its genderqueer presentation. Described by one contemporary reviewer as "gravelly" and "resigned," Arden's "unforgettable voice" does often sink into lower registers, particularly when delivering one of her wisecracking asides, and is notably contrasted with Richard Crenna's trademark Denton squeak, the high-pitched nasal tone used by the actor to brand his numerous teenager roles well into his twenties.[90] Her version of comedy, her

114 • Suffering Sappho!

place within early television sitcom conventions, and her dominating performance evoke masculinity and male prerogatives, but she does not abandon effeminacy; rather, she reinforces it through her physical appearance and makeup, costuming, and nurturing gestures toward others, thereby queering the lot.

In its recent examination of camp TV, Quinlan Miller's work provides context and precedent for how Arden's form of butch comedy should be viewed *not* as unusual but on a continuum of challenging gender expressions during this early period of broadcast television.[91] Attempting to intervene in media histories of the period viewed as "skewed to favor straight and cis 'readings,'" Miller makes room for the "queer gender production" present in other programs, such as *Our Miss Brooks*.[92] Therefore, I argue that the lesbian camp present within early television's working-gal sitcoms relies on a kind of queer humor employed by headliner stars identified as female wherein they take up the male comedian's position, exhibit and sometimes even parody effeminacy, and dominate space, other characters, and the comic voice in a way typically deemed masculine. In early broadcast television, in other words, camp makes itself heard through the lead comediennes' butch comedy.

The Working Spinster Type

In perhaps the campiest episode of certainly its campiest season (*Our Miss Brooks*'s last), Connie finds herself scooped up in a vice raid at a "gambling joint" after apparently following another woman down a dark corridor to what she thought was the ladies' restroom. Fortunately, she discovers the next morning that the police blotter in the newspaper has misprinted her name as "Bonnie Brooks," and so, setting up a classic sitcom predicament, she fabricates an "unmentionable" bad twin sister in order to avoid the inevitable firing that would await any teacher caught in such a raid. Following colleague Mr. Munsey's advice that since no one believes the truth, "what you need is a great big fat white lie," she enters a hidden compartment in Principal Conklin's office closet and crosses back and forth between her supposedly "clean-living, wholesome" schoolmarm self and an over-the-top female impersonation of her "burlesque queen" twin, wearing an outlandish zebra-print coat from her landlady's "Follies" days, topped with a large feather hat, and loudly chewing gum. In the end, the big fat lie she constructs in Conklin's closet succeeds, as her boss cannot unveil Connie's charade and so he must keep her on. But even her friends fail to believe her halfhearted protestations of innocence. Every time she denies gambling, the other characters respond by asking, "How much did you win?" Replete with references to Jack Benny, ribald humor, and trademark Arden asides and beleaguered expressions, the episode concludes with characteristic irresolution: Connie apparently will keep her job, but in the final moments Conklin emerges from the closet dressed in Connie's drag, forcing her to run back in after wildly announcing, "He's not

Mr. Conklin. She's his twin sister, Mrs. Bonklin!" This might be exactly the sort of ridiculous predicament and broad humor that so disappointed critics and many fans in the show's final season, but it is also, unmistakably, camp.

In short, the episode is saturated with queer innuendo, drag, and campy parody as it begins with what could surely be reference to the notorious vice raids of gay and lesbian bars during this period of McCarthyite persecution and then revolves around the central conceit of dual identities and closeted indiscretions.[93] Representative of the midcentury shift, described by Steven Cohan, from the "denotative marking of queerness as a gender inversion" to the "more covert encoding of a gay subculture through connotation," *Our Miss Brooks* here layers joke after joke and gag after gag to create a "semiotics of queerness," spelling out lesbian camp.[94] Once again we have "guilty" spinster schoolteacher Connie Brooks caught in the act—in a women's restroom no less—but camping her way out of it through over-the-top gender play, winking double entendre, and a lot of bad acting. Indeed, her terrible performance as the streetwise, tough-talking Bonnie is duly mocked by Conklin even as he realizes he cannot overcome her queer machinations. Moreover, her failed burlesque as the tacky femme Bonnie just serves as a reinforcement of the butch flare subtly signaled by Connie's own towering figure and floppy bowties, and, of course, Arden provides the butch comedy here to suit. The episode never takes its attention away from her driving narrative actions, she delivers ironic commentary asides to us at moments of highest tension, and, naturally, she has the last (queer) word, changing Conklin's pronoun and beckoning us into her well-used comic closet.

Although with little space left to explore it, I would insist, moreover, that Arden's and *Our Miss Brooks*'s use of butch comedy to produce lesbian camp is not an isolated incident—not a token queer eruption. Certainly, a brief look at Ann Sothern's role as "heckler-secretary" extraordinaire, Susie McNamara, on *Private Secretary* seems warranted here. In fact, following her consideration of Arden's unconventional "narrative agency" and "verbal license" as a working woman empowered with "wit and intelligence" to control most situations, Christine Becker offers a longer discussion of Sothern's groundbreaking role as producer *and* star—able to create a comedy lead in Susie who "operated outside of the domestic sphere with an independent no-nonsense attitude."[95] As the executive secretary for Manhattan talent agent Peter Sands (played by Don Porter), Susie represents more the "professional career woman" and single gal, who will become much more familiar in the 1960s and 1970s, than the spinster schoolmarm of *Our Miss Brooks*, but her unconventionality, singlehood, and attitude as a "brassy, resourceful, independent, outspoken," and droll female lead character unmistakably mirrors Arden's famous part and verbal comic dominance.[96] Moreover, Sothern's contented, career-focused secretary (as well as her followup role as hotel manager Katy O'Connor in *The Ann Sothern Show* [1958-1961]) similarly demonstrated the acceptance and popularity of nondomestic roles for female headliners on television during this period, as she, like Arden, won over

a legion of female fans, many of whom were working women (and often secretaries) themselves.[97]

Yet Sothern perhaps more than Arden personally embodied this assertive independence for women outside the domestic sphere because her status as producer, story editor, and star (as well as a single divorcée) was well documented in *Private Secretary*'s publicity and thereby intertwined with her portrayal of the independent and commanding Susie. Bringing her newly formed company, Vincent Productions, into a deal with TV producer Jack Chertok to produce the show, Sothern not only took the headlining part but also had control over much of the production, approving and even editing scripts, as well as involving herself in casting and larger financial decisions, such as those about syndication. In fact, her refusal to cede power over the show and her own multiple roles brought the program to a premature end in 1957 when a contract dispute with Chertok over her rights as performer and producer ended in her exit.[98] Nevertheless, it was not just her admirable working-gal independence but also her brand of brassy and assertive wit that both made the show a hit and aligns her with the butch comedy mastered by Eve Arden.

Although Sothern surely has a less caustic comic style and the show's scripts provide less sexual verbal play and use of double entendre, her role as Susie McNamara offers significant parallels to the butch comedy of Arden's Miss Brooks. Possibly more of an A-list star of stage and screen than a supporting actress like Arden, Sothern still also gravitated to powerful opportunities in television in her forties, where she could revive the enormous success of her "Maisie" series for MGM, whose title character, a "brassy, cheerful showgirl," figured her way out of various predicaments and into the arms of her male lead in the end.[99] This "saucy," independent "Maisie" persona carried over easily to her Susie McNamara performance, where she not only ran the office and solved any problem her boss Mr. Sands could throw at her but also dominated the comic situations with her quick "sharp-tongued" wit, verbal play, and knowing reactions.[100] Imbued with what Jack Gould calls her "blond glamour," Sothern's performance as Susie perhaps exhibits less traditionally masculine traits than Arden's Connie—Sothern was also less imposing at five feet one and had more of a curvy figure—particularly after her life-threatening bout with hepatitis—yet her comic success is likewise achieved primarily through narrative superiority and verbal acuity, which David Tucker extols as "her rich voice wrapping itself around a variety of sardonic and beguiling lines."[101] She also takes the lead role in handling the narrative action as well as commenting on it and other characters.

With Susie, Sothern may have been less acerbic than Arden's Connie, but she still balanced what Becker calls her "warm, down-to-earth performance style" with a stream of punishing wisecracks and sardonic one-liners throughout each episode, often made at the expense of her boss or her other adversaries.[102] For example, in season 5's "Her Best Enemy," Susie takes on archnemesis and competing agent Cagey Calhoun (played by Jesse White), whose desire to sneak a

peek at a client's contract encourages him to try subterfuge to get around the "brutal" and "tough" secretary guarding its secrets. Our favorite office doyenne, whom he calls "Foxy," calmly relies on her intelligence and control to head off each of his attempts—from speaking French to literally putting out office fires and exposing his ridiculous drag performance as his own "old, ancient mother" paying an office visit—but she also fires off a string of insults and sarcastic commentaries in the process, cracking jokes about his intemperance, his expected place in front of a "parole board," and his basic duplicity: she greets his first entrance into the office with the crack, "Lock up all the silverware and send him in." In a wonderfully absurd bit of camp TV, she finally exposes the goal of his scheme by dissembling his mother drag on a "vibrating pony" exercise machine, taking "mother" for "a little ride" by increasing the speed and offering both wicked verbal critique and knowing looks in medium-range reaction shots, which are typical companions to her one-liners, adding a knowing smile and even eye rolls to her ironic commentary on the scenes.

Moreover, while it clearly lacks the strong element of marital camp that grounds so many of *Our Miss Brooks*'s storylines (Susie has a boyfriend but expresses little interest in marriage, focusing instead on her career), *Private Secretary* does put Sothern's style of biting comedy to use as fuel for lesbian camp. Broadly speaking, not just Susie's unconventional singlehood but also the spinster status of her best friend and office mate Vi Praskins (played with complementary nervous ditziness by Ann Tyrell) signal the lesbian possibility of their queer nonconformity to the domestic imperative. Indeed, the series takes advantage of this trope of queer singlehood through the women's close relationship—further emphasized in the continuation of Sothern's career gal persona on *The Ann Sothern Show* for which Ann Tyrell repeated her intimate part as Katy O'Connor's secretary, best friend, and *roommate*—as well as in episode plotting. For example, in season 4's "Cat in a Hot Tin File" the two women protect and care for a stray cat that wanders into the office, referencing again the queer tie between spinster women and their felines (as well as Tennessee Williams's queer distinction). Furthermore, with its share of show business in-jokes and core self-reflexivity on the entertainment world (as a show about a talent agency), *Private Secretary* offered itself up for almost weekly camp readings.[103] To this point, from the beginning the series was intimately tied to *The Jack Benny Show*, for example, as the two programs alternated weeks in their Sunday evening time slot (7:30 P.M.) on CBS, and Benny was even the topic of an episode in season 1, "Where There Is a Will." However, the episode that perhaps best represents the "lesbian" in *Private Secretary*'s lesbian camp TV must be season 4's "Elusive," which aired in June 1956 and played broadly with the queer iconicity of none other than Greta Garbo.

The setup for the episode's dramatic action makes little secret of its campy intertextual reference to Garbo. The "shy and sensitive" retreated star of the silver screen, Inga Kovar (played by German actress Fay Wall), who conceals

118 • Suffering Sappho!

herself in a trench coat, black hat, and dark sunglasses and demands "absolute privacy," is wooed out of retirement by Susie to sign with International Artists. (At one point, Inga introduces herself with the pseudonym "Gloria Green," prompting knowing laughter from the studio audience.) That this seduction must be performed by a woman is made abundantly clear when Susie's required "woman's approach" to the problem involves subterfuge and two different disguises to break into the "Fort Knox" of Kovar's apartment, which her male boss knows he has no hope of entering. Donning her own coat, black hat, and glasses, Susie first disguises herself as a worker for the Census Bureau and then as an officer in the police department's "Special Bureau of Investigation" in order to con her way into Kovar's apartment, where she meets Maud, Kovar's maid, who herself serves as a double for Kovar when she seeks to confound prying strangers disguised as her own domestic.

The camp potential for an episode premised on Garbo's notorious reclusiveness and reliant on a funhouse mirror of doubling and tripling identities is hard to ignore, but so is its grounding in a closeted play with female same-sex desire. Not only is Kovar's ill-fated first visit to the office punctuated by the adoration and titillation of specifically female fans, most centrally spinster receptionist Vi, but her attraction for women continues throughout, with Vi dreamily imagining Kovar might be interested in her, another "shy and retiring" type, and Susie making her most risqué wisecrack of the episode at the mention of the actress being a "vegetarian," offering herself up as Kovar's next meal: "If I were a carrot, I'd be in business." While Garbo's queer desires as a "vegetarian" would have been mostly unconfirmed rumors in the mid-1950s, the lesbian camp of Susie's successful pickup of Kovar/Garbo by the Central Park reservoir makes the actress's susceptibility to female wiles quite plain.[104] Susie's lakeside ruse as a fellow "lost soul" in need of Kovar's inspiration brings the actress "back to life" and, perhaps more importantly, back in front of the cameras, but this kind of witty "miracle" is par for the course for Sothern's secretary, who camped her way through several hit seasons well into the late 1950s.

Although Garbo might have preferred the term "bachelor," the figure that she and Sothern call forth is, of course, the aging spinster, queerly unattached to any man and without children—a sign of dangerous female surplus in the mid-nineteenth century and seemingly anathema to the domestic family ideal of postwar American culture. To be sure, this figure is typically white and middle class in almost all representations, as the rare example of *Beulah* shows, where its African American "Queen of the Kitchen" remained uncommitted to her hapless boyfriend Bill but barely lasted three seasons within a white supremacist television industry. Indeed, partly due to its racist caricatures, Ethel Waters, about whom I will have more to say in chapter 6, left the show after one season, yet her incisive comedic observations certainly fit the mold of the butch comedy examined in this chapter. The white wisecracking spinster, on the other hand, was so prevalent in this early period of broadcast television that

one would be hard-pressed to find another era in which she held such sway—at least until very recently, when spinster chic and single-gal comedy seems to be expressing a particular resonance for millennial women. Yet, the union of lesbian camp and butch comedy was, rather, a product of this particular moment when queer sexuality, female independence, and the patriarchal family came into fierce yet richly ironic, even comedic, collision.

5

Amazon Princesses and Sorority Queers, or the Golden Age(s) of Comic Lesbians

In 1954, professional comic book Cassandra Dr. Fredric Wertham not only published his major diatribe against the moral depravity and terrifying influence of the crime comics, *Seduction of the Innocent*, but also made his dramatic star turn in front of Estes Kefauver's Senate Subcommittee on Juvenile Delinquency. Punctuated by shocking exhibits of crime comics' most lurid content, the hearings proved decisive in the postwar moral panic focused on the comics and other youth-consumed popular culture, as well as validating psychiatrist Wertham's long-standing, and at times almost paranoid, crusade against the corrupting influence of mass culture on the young.[1] Playing to the crowd with his campily over-the-top exposé of one issue of EC Comics where men play baseball with a corpse's head, Wertham used the momentous stage of his Senate testimony to rehearse his central criticisms of the comics' corrupting influences on children—that they encouraged horrific violence, degraded women, advanced racist ideology, and inspired sexual deviance. While the hearings ultimately resulted in the adoption of the industry's self-censoring Comics Code and the relatively swift end to horror and crime comics, Wertham's legacy remains problematic at best, with some of his claims exposing justifiable concerns (about racism, for example), while others were defended with scant evidence, anecdotal support from just a few of his juvenile patients, and even misrepresentations of

key examples. Yet, in one notorious example, I would argue that Wertham's suspicions about the subversive intentions of comics creators were no cry of paranoid delusion. He was, for all intents and purposes, absolutely right about the midcentury's most famous Amazon and her author's appreciation for sapphic sisterhoods, as well as his racist beliefs.

Wertham, without ever mentioning him by name, offered a direct challenge to the radical sexual revolution championed by *Wonder Woman*'s creator William Moulton Marston. Establishing a significant concern in *Seduction* for the way comics could serve to "fixate homoerotic tendencies," Wertham notoriously set his sights on superhero comics, most notably DC flagship *Batman*, offering a multipage description of the many ways Batman and Robin (or Bruce Wayne and his ward Dick) show the unmistakable signs of their "Ganymede-Zeus type of love-relationship," evidenced in their "idyllic life" at home—a "wish dream of two homosexuals living together."[2] For him, the obvious "Lesbian" counterpart to the "homosexual and anti-feminine" atmosphere of Batman was, of course, Wonder Woman.[3] As a "morbid ideal" for the girls reading the comic, *Wonder Woman* communicated "unmistakable" homosexual lessons, not the least of which was the comics' supposed portrayal of "extremely sadistic hatred of all males in a framework which is plainly Lesbian."[4] (Clearly, this conclusion, which he quotes from an uncited editorial in *Psychiatric Quarterly*, willfully ignores that pathetic beard Steve Trevor, like so many of us with "morbid" pleasure in Wonder Woman have always done.)[5]

His primary proof for this sapphism is not, however, the Amazon Princess's supposed all-consuming man loathing, or her *actual* exclamation in the comic, "Suffering Sappho!" Instead, it is Wonder Woman's very own queer "female following," the Holliday Girls, whom Wertham drains of all pleasure with his plodding, painfully literal decoding, "i.e. the holiday girls, the gay party girls, the gay girls."[6] This group of (Beeta Lambda) sorority gals, whom Wonder Woman calls "my girls," are apparently callous and yet coy, "like sweet little girls," but also suspiciously into a bit of "mutual rescuing" and other such "adventures" with the princess. Connecting them to a horrifying comics type—the "Superwoman (Wonder Woman)" who "tortures men, has her own female following, and is the cruel, 'phallic' woman"—Wertham nevertheless chooses not to follow these gay party-girl antics to potentially the most frightening setting of all, Paradise Island, with its feminist separatist ways and its Amazonian pedigree.[7] But, he does briefly shine the spotlight on the sorority girls' lesbian camp queen, quoting in full one of Etta Candy's trademark pleas, "Honest, I'd give the last piece of candy in the world to bring her back!"[8]

As ringleader of the Holliday Girls and quite frequently leaned on as Wonder Woman's wartime right-hand man, Etta Candy can often be found directly in the center of William Marston's subversive, and for him liberatory, games of sexual dominance and submission, providing wry commentary from behind her box of bon-bons when she is not outright joining in. Perhaps the paradigmatic

figure of absurd callousness and coy playfulness, Etta Candy, more than Wonder Woman herself, stands as the obvious "Lesbian counterpart" to Wertham's lavender Batman and Robin, undeniably camping her way through the Marston/ Peter Golden Age issues, with the consequence of magnifying the Amazon Princess's queer erotics and wedding them to powerful female collectives, an example of which might be lesbian audiences for the comics themselves. Moreover, the comic's camp crusading does not end with Etta's erasure from the stories during the Silver Age but merely intensifies its association with Wonder Woman herself and her troubled (and troubling) relationship to normative gender and sexuality. Yet, in both ages of *Wonder Woman*, it is also clear that its superheroine and the feminist and queer utopia she has come to represent have at their foundations a white supremacist ideology.

Mission to Planet Eros: Etta Candy as Wonder Woman's Lesbian Camp Confidant

Taking into account the recent comprehensive biographical work on creator William Moulton Marston in historian Jill Lepore's much-lauded *The Secret History of Wonder Woman* (2014), as well as Noah Berlatsky's exhaustive scholarship in *Wonder Woman: Bondage and Feminism in the Marston/Peter Comics, 1941–1948* (2015) and popular accounts such as the film *Professor Marston and the Wonder Women* (Robinson 2017), it seems fairly safe to say that the lesbian or queer female *subtext* of the Amazon Princess's adventures has vividly moved into manifest *text*. As Berlatsky establishes through details from Marston's life, research, and popular writings, Wertham, with all his sensationalism and questionable methodology, stumbled onto the truth. It is worth quoting Berlatsky here in full: "Marston may not have meant 'Holliday' to be a pun on 'gay', but he certainly fully intended the Holliday girls to participate in and model erotic same-sex play. Wertham saw this as sinister, and Marston adamantly did not. They disagreed about lesbianism. But I think they would have agreed that it was lesbianism they were disagreeing about."[9] Critics and commentators have long hinted at the sexually subversive erotics of the Marston/Peter Golden Age *Wonder Woman*, as the overwhelming presence of bondage scenarios was fairly hard to ignore and, in fact, a point of contention for comics watchdogs from the very beginning.[10] Yet, naming this nonconforming sexuality specifically "lesbian," as Wertham notoriously did, has been remarkably rare. With the notable exceptions of Berlatsky and Tim Hanley (whose 2014 history *Wonder Woman Unbound* argues that her creator was strongly supportive of "female love relationships," as he termed them, reproducing them both in kinky sorority rituals and in the exclusionary lesbitopia of Paradise Island), most critics and even feminist champions of the comic since Gloria Steinem have reticently skirted around the issue of Wonder Woman's lesbian promise.[11]

Yet Berlatsky's recent revisionary intervention could not be more direct or expansive in its case for a "lesbophilia" on Marston's part that seems to have

directed major threads in the *Wonder Woman* story world and undergirded his feminist political agenda for the comic.[12] In his chapter "Candy You Can Eat," Berlatsky meticulously outlines the textual and biographical evidence to establish that the "female love relationships" long relegated to whispers about sexual subtext in the comic were in fact fundamental not just to Marston's professional work but also to his personal life in the household he shared with (at least) two queer women, Elizabeth Holloway Marston and Olive Byrne—his polyamorous partners and the mothers of his children.[13] In his professional and personal lives, as well as in his popular writing, Marston wove together different threads into a clear endorsement of lesbian sexuality. For example, his early research at Tufts University on sorority initiation rituals—where he (and Olive Byrne) observed "Baby Parties" at which freshman pledges dressed up as infants and received "stimulating" punishments, resulting in erotic pleasure for both the paddled and the paddler—led to his queer findings in *Emotions of Normal People*, as well as, of course, the portrayal in the Marston/Peter comics of the Beeta Lambda bondage-style initiations and "parties."[14] Moreover, the presence of Olive Byrne in this story reminds us of Marston's intimate knowledge and personal approval of female love relationships as "normal, natural, healthy for women themselves, healthy for society, and ideologically and spiritually 'perfect,'" which led him, according to Berlatsky, to positively portray "lesbian romance and lesbian play," in hopes that the comic's young readers would be equally stimulated themselves and come to embrace same-sex female relationships as a path to his whitewashed utopian dream that "matriarchal feminine love would save the world."[15]

Following in the wake of Berlatsky's truly persuasive scholarship, I can, in some respects, take for granted the lesbian aspects of Golden Age *Wonder Woman*, but a brief exploration of *how* that lesbian sexuality or subjectivity is performed by her powerful pint-size sidekick, Etta Candy, I believe, will establish the comic specifically as a model for lesbian camp, as well as camp reading practices. Etta Candy and the other girls from Holliday College for Women, who are predominantly also members of the Beeta Lambda sorority, play a major role in the comic in this era, rivaled perhaps only by Steve Trevor for frequency of appearances and significance in storylines.[16] The standard-issue Holliday Girl is unremarkable as a type—an attractive, usually white, thin-waisted, and well-dressed coed, not unlike the appealing Amazon girls Diana leaves behind on Paradise Island—but as a group they are notable for their activity, resourcefulness, physical strength and aggression, and, predictably, their penchant for orchestrating bondage-like scenarios. They are, in short, the Amazon Princess's own all-female army, with Etta Candy as their undisputed general and Wonder Woman's most trusted lieutenant.

But Etta, of course, is no standard issue. After her first few appearances, she is typically figured as at least a head shorter than Diana but perhaps twice her size, with a generous bust, thick, stout thighs, and an ample rear end. At times

Harry Peter depicts her as large and muscular like the oversize adversaries and tough masculinized women to whom he contrasts Wonder Woman's svelte, feminine strength; at other times she is made to grotesquely resemble an overgrown baby like the children in *Sensation Comics #31*'s notorious "Grown Down Land" (1944). Clearly intended to serve as Wonder Woman's corpulent comedic sidekick, replete with a catchphrase ("Woo! Woo!") that was lifted from Warner Brothers funnyman Hugh Herbert, Etta also just defies explanation: Les Daniels ultimately brands her the "strangest sidekick in comics," which he seemingly illustrates with full-color inserts of her as the dominating mistress on a "raised throne" in two different panels "lording" over Beeta Lambda initiation exploits, one of which directly reproduces the Baby Parties that Marston and Byrne observed at Tufts.[17] Moreover, although few commentators frame it this way, her strangeness can be largely attributed to a complicated gender performance, which is certainly punctuated by moments of masculine drag (or, cowboy camp) but might be better understood as an almost defiant gender nonconformity, which the adoption of fey comedian Hugh Herbert's catchphrase suggests.[18]

For his part, Berlatsky certainly hints at this recognition of Etta as lesbian camp, but his argument is more focused on the metaphor of the closet and camp's evocation of it than on the irrepressible female camping he lets through the door. In a close reading of one panel from *Wonder Woman #1* (1942), Berlatsky briefly zeroes in on Wonder Woman's favorite sidekick, most trusted comrade in arms, and Beeta Lambda mistress, Etta Candy, who responds to Diana Prince's fatshaming, "But Etta, if you get too fat you can't catch a man," with a saucy piece of double entendre: "Who wants to? When you've got a man, there's nothing you can do with him—but candy you can eat!" Noting how Etta's "insouciantly, even flamboyantly butch" figure dominates the frame and how the "large, swaggering delicacy" of her hand strategically holds up a piece of candy directly in line with Diana's proverbial box, Berlatsky ultimately asserts a sexual knowledge on Marston's part that makes him both *in* on the joke and relatively deliberate in constructing both Etta's "masculinity" and "desire."[19] Yet, despite his reliance on the concept of camp here to initiate a discussion of Marston's queer intentionality and the epistemology of Wonder Woman's closet, Etta—*the* camp at the center of it all—does not return in any significant way in Berlatsky's chapter.[20] Etta's butch swagger in her ten-gallon hat and insouciant play with Diana, naughtily propositioning her in a public train car to eat some "candy," is nothing short of campily flamboyant, deliciously teasing drag—an amusing, erotic, and suggestive lesbian burlesque.

From her paddle-wielding debut in *Sensation Comics #2* until her deliberate erasure by Robert Kanigher after 1950, Etta Candy is quite simply camping out in Wonder Woman's Golden Age.[21] Dressed in her enormous orange cowboy hat, green suit, and horseshoe-pinned white cravat in the episode from *Wonder Woman #1*, with which Berlatsky begins, Etta brags about being "born in the saddle" as a way to induce Diana Prince to come home with her to Texas, but it

is Wonder Woman whom she ends up mounting—gleefully shouting "Woo! Woo! Ride 'em, Cowgirl!" when she later hitches a ride on Wonder Woman's back.[22] Yet, Etta is not all ribald humor, bravado, and unbridled appetite. In one panel in the same issue (after an inexplicable outfit change into red, fringed short-shorts and a purple tank top), we learn of her "yearning" and restlessness that only song and strolling through the desert with Diana can cure, where her refined femme companion Di complements her perfectly in tailored, full English riding gear. To be sure, Etta is not camping out on this lonesome prairie *alone*; she shares her intimacies with one of the most notable and significant companions in the comic universe. As if to underscore their camaraderie and common humor, toward the end of their adventure Etta responds to a near-death incident with confusion and gratitude for her "angel" savior, but the Amazon Princess knows Etta too well to slip into indulgent sentimentality, drolly retorting, "Wake up, Etta. You're not dead and I'm not an angel." (Etta's phrasing here almost exactly echoes Steve Trevor's recurrent wakening response after yet another rescue by his "beautiful angel" Wonder Woman.) It is also worth noting that this episode begins with Etta reaching Diana through her Amazon-invented "mental radio," singling her out as the only non-Amazon to communicate with the princess telepathically.

In other words, I believe this first issue of *Wonder Woman* establishes quite clearly that not only is Etta the comic's most recognizable and wonderfully irrepressible lesbian camp, but she is also undeniably Diana's most significant, and consistent, female relationship during the Marston/Peter era. Whether you want to think of her as Diana's favorite gay gal pal away from Paradise Island, or, as I frankly do, as Diana's best ex-girlfriend, Etta Candy stands, big thighs spread and arms akimbo, as without a doubt the Amazon Princess's foremost intimate in the "warring world of men"—alongside, of course, Steve Trevor. If you doubt me, look no further than one of my favorite panels of the Golden Age (in *Sensation Comics #11*) where the "astral bodies" of Steve, Wonder Woman, and cowgirl butch Etta glide hand-in-hand in a sunburst night sky toward Planet Eros, answering the call of a butterfly-winged Queen Desira through the clouds. With psychedelic splendor, they are represented here as a polyamorous threesome drawn almost magnetically by their desires, as Etta says before their departure, "Try and stop me!" That this "Mission to Planet Eros" begins in Etta's bedroom at Holliday College, ostensibly to protect Wonder Woman's secret identity as she leaves her body for the astral plane, should be neither surprising nor any less affirming for queer female readers winked at by the comic and its creators from the very first issues.

But, let me reiterate, the convivial, amused, and easygoing companionship between Etta and Diana is not lacking in erotic frisson and sexual currents. Wonder Woman and Etta are clearly not just "friends" or innocent "sisters," and, furthermore, Etta proves more than willing to play the sapphic field over her countless appearances in the Marston/Peter era.[23] Despite their relatively

FIGURE 9 The psychedelic splendor of the polyamorous threesome—Diana, Etta, and Steve—beckons the queer audience to Planet Eros.

frequent physical contact and embraces, as, for example, in the provocative number of times they dive behind one another's backs and chew each other out of hand restraints (see *Wonder Woman #10* or *Sensation Comics #13*), Diana is not the only target of Etta's flirtatious double entendre and amatory attentions. Although she may insist in *Wonder Woman #11* that "you're all the candy I want Etta" (11B), Diana *and* Etta frequently fail to resist the charms of other pretty girls—particularly sorority initiates, Paradise Island Amazons, and female foes. One notable example is Beeta Lambda initiate Eve, introduced early in *Sensation Comics #4* at the feet of an enthroned mistress Etta and chased down by her and the girls with "ropes and paddles" (10). Eve reappears by Etta's side many issues later (although now freed from her dog collar), and even Professor Zool's "electronic evolutionizer," which has de-evolved them into campily atavistic "cave girls," cannot stop Etta from trying to gallantly protect her girl (*Wonder Woman #9*, 11A).[24]

In fact, Etta's attachment to her paradigmatic femme Eve sets her and Diana off on what Berlatsky calls "one of the most startling sequences in the history of comics," where Etta's symbolism for unbridled appetite (for girls) is played out wildly during a visit to Paradise Island for the lesbi-surreal orgiastic feast of "Diana Day" (*Wonder Woman #3*).[25] As the first friend Diana ever brings home, Etta is assured upon landing that "Amazon girls are great candy-makers," but it is the doe hunt and feast (on naughty Amazon maidens dressed up in deer suits) that might startle even the queerest reader. Stunning (for Berlatsky) for its

hog-tying and stripping of "mouth water[ing]" girls who are served to the Amazons in a "spectacle of doe pie," the episode offers a lesbian smörgåsbord that Etta sadly misses because the prey she has lured with (of course) candy has turned the tables and snuck off to steal the queen's "magic girdle," at a moment when even Queen Hyppolyte is deeply distracted by Amazon pie (10A–11A).

In the end, while Berlatsky provides an excellent disposition of camp via Core's double sense of a secret simultaneously concealed and exploited, we neglect something significant if we read the Marston/Peter comics *as* camp without recognizing *the* lesbian camp parading through so many panels. Yes, there is play with the closet and a fabulous amount of excess and recognition of the artificiality and theatricality of identity. But, what, I ask, is the personage of *the* lesbian camp doing in these many issues, and how does her legacy carry through the postwar period? What happens when this camp—this Candy—is featured so prominently in a major text of midcentury popular culture? First, she not only provides an over-the-top enunciation of same-sex desire and ironic butch performance but also acts as a foil through which we can easily then recognize *Diana's* same-sex desires. Taking center stage in her cowgirl drag throughout the early years of the comic (again in *Sensation Comics #11, #33,* and *Comic Cavalcade #7*), Etta's camp masquerade cannot help but shine a spotlight on Diana's theatricality of self; indeed, at the masquerade ball in *Sensation Comics #33* (1944), Diana self-consciously dresses as Wonder Woman (with added cape and eye mask) to accompany Etta, who dons her most elaborate, bedazzled Western wear yet (3–4). Similarly, the coded references and lesbian inside jokes that surround Etta are often shared by Wonder Woman, at the very least through association. For instance, while it is typically the Holliday Girls and Etta who fill out the rosters of a suspicious number of all-female sports teams—from baseball and bowling to hockey and even a hulking crew team that takes on the WAVES squad (but, sadly, no softball)—Wonder Woman usually shows up in the nick of time to lead her girls to athletic glory.[26]

In other words, Etta's camping—her drag, her saucy humor, and her coded allusions to lesbian life and desires—enacts, embodies, and magnifies the camp sensibility evidenced not just in the comic but in Wonder Woman herself. It is certainly not an accident that Etta can be found at the heart of the most ironic, self-conscious, and strangely self-reflexive issues of the Marston/Peter era—not just the "startling" doe hunt but also the notoriously strange and absurdly grotesque "Grown Down Land" episode in *Sensation Comics #31* and the charming self-referential appearance of Marston and Peter themselves in the introductory panel to *Wonder Woman #5,* where they comment on the action and join "toast-mistress" Wonder Woman for whom only candy is on the menu. Indeed, we expect Etta to sign up gleefully for the queer Shangri-La of the Women's Army Auxiliary Corps (WAAC) (actually, she's appointed by Diana to guard her—you couldn't make this up—"torpedo protection apparatus" in *Comic Cavalcade #4*), but of course Diana has already joined the WAAC, swapping identities with

128 • Suffering Sappho!

Marva, wife of Dr. Psycho, and enlisting in a WAAC unit just in time for "punishment duty" (*Sensation Comics #20*, 8). Or, sometimes, at the precious few moments when Etta falters, Diana is there to keep her on queer course—intervening, for instance, to stop Etta's ill-advised wedding to secret Gestapo agent Hylo Goulash, who is ultimately knocked out cold by an embarrassed and enraged Etta, after which she throws off her bridal drag of a "sissy" wedding dress and puts on her green and purple Western wear for another "long ride with Diana" (*Sensation Comics #16*, 13). And so, we come full circle back to where we started, with Etta and Diana camping out together at the Candy homestead, inevitably named—you guessed it—the Bar-L Ranch.

So, while Etta may be the capital-L lesbian of Golden Age *Wonder Woman*, her camping does more than simply manifest the "lie that tells the truth" of the female love relationships that Marston imagined would save the world; as Core insists, her "peculiar way of seeing things" is powerful enough to "impose itself on others."[27] In other words, Etta's acts of camp creation—of herself, her butch style, her subversive wit—transform Wonder Woman and fashion, for her and innumerable all-female communities, a queer comic world. For a final paradigmatic example, one need look no further than the series of episodes centralizing Priscilla Rich / the Cheetah as one of Wonder Woman's most significant female adversaries (and provocative love interests). Introduced in *Wonder Woman #6* (1943), the volatile story of how the envious "siren" Priscilla Rich "pursues the Amazon maiden" toward destruction with both intense hatred and overwhelming admiration, "like Jekyll and Hyde" (1A), extends over the entire issue and into the next *Sensation Comics* (*#22*), although, of course, these will not be her last troubling appearances in the comic.[28] It is also, perhaps not coincidentally, the story where Wonder Woman makes her first sapphic invocation, "By Sappho's stylus."[29] An extended meditation on dual identities and the debilitating chaos, dangers, and pleasures of leading a double life, these early Cheetah installments hinge on the mechanism of the closet where secrets and women's charged experiences with each other become the central bait and catalyst for the queer action. Needless to say, Etta remains ubiquitous throughout, in the end unmasking the Cheetah, who contritely confesses to her double life with its secret room full of captive girls. In these comics, the central female players, then, become three sides of the same queer coin. The irrepressible butch camp, the predatory lesbian Cheetah, and the beloved Amazon ideal play off one another and dominate a world centered on women—their conquests, friends, and rivals. Etta may not rule this world, but her strident voice and impudent actions surely help constitute it.

Finally, and perhaps no less significantly, Etta also serves to model this "way of seeing things" as a camp spectator and audience surrogate. Sure, she has a telepathic connection to the interiority of women like Diana and Priscilla Rich, catching the frequency of their queer mental radios, but she also publicly recognizes and bears witness to what her privileged sight (and sensibility) has already shown her: their closeted identities and rousing queer erotics. It is no

FIGURE 10 Etta Candy, at the forefront of the female audience for Wonder Woman's domination games, proves a masterful camp reader.

coincidence, for example, that Etta is the one to pronounce the "unmasked" Cheetah's real identity at the end of *Wonder Woman #6*, standing confrontationally in front of Priscilla, with short legs spread, mask in hand, and an accusatory finger raised, as she outs the "glamourousest deb in America" (16C). Etta sees through the "double" identity of women like Priscilla and often makes a spectacle of their closet. In fact, Wonder Woman frequently singles out Etta for her position as a privileged observer, as she does in the early episode with Gloria Bullfinch, the socialite owner of an exploitative department store driving its overworked shopgirls into near starvation and attempted suicide.

The queer punishments and eroticized "lessons" taught to other women in *Wonder Woman* so often involve a performative apparatus or staging, like Etta's throne at Beeta Lambda, and this seems to engender a predominantly female audience, as in *Sensation Comics #8* when Gloria Bullfinch comes under Diana's control. Determined to teach this "spoiled Gloria a lesson," Wonder Woman abducts the blonde heiress from her apartment and brings her to Holliday College for a "serious experiment in reforming human character" that for once does not include paddling but does find Gloria tied up and dominated by Diana, while the girls look on. The experiment—for which Diana uses the magic lasso to hypnotize Gloria and compel her to work at Bullfinch's, where she will learn firsthand about the exploitation of the worker—must, it seems, begin at Holliday College, where Wonder Woman's physical and mental domination of Gloria plays to Etta and the girls as audience.

Indeed, the panel in which Diana hypnotizes Gloria and demands that she submit places Etta conspicuously at the illuminated forefront of that female audience. Gaping in the right foreground with candy raised like movie popcorn, Etta's eyes stare up at the spectacle of Wonder Woman, whose hands cover Gloria's eyes, demanding submission from behind (6). As Diana sidles up

to Gloria in the next panel, whispering her mesmerizing commands with lips nearly touching the blonde socialite's ear and hands tantalizingly somewhere below Gloria's opened robe neckline, the viewpoint we have is quite clearly from Etta's perspective in the previous panel. In other words, we share Etta's subjective point of view of this thinly veiled seduction scene, and to emphasize the point, the first panel on the next page reiterates Etta's role as privileged spectator when Diana implores her to keep her "eyes open" at the Bullfinch store, although Etta's eyes in the panel are actually directed down at Diana's cleavage (7). As with the Cheetah, Etta once more in this issue exposes a deviant woman—Helen Jones, the suicidal and then murderous antagonist of the Bullfinch company—while assisting Diana in her socialite reformation scheme. Candy raised and mouth agape, Etta proves the master of camp reading practices, recognizing the queerness at the heart of supposed straight culture (and women) and shouting her "Woo! Woo!" from the front of an all-female audience.

In sum, the comic's "grand mistress of spanks and slams," Etta clearly proves worthy in the Marston/Peter era of Fredric Wertham's fear and public scorn as the most impactful "gay party girl" in the Amazon Princess's crowded field of female intimates.[30] Her subversive humor, cowgirl butch drag, and camp insights repeatedly underscore and spotlight the queer erotic potential in the comic's intimate same-sex relationships and female collectives—from Paradise Island and Holliday College to Reform Island and Desira's planet Venus—and in moments of splendid revelation, she shows Wonder Woman to be in on the joke. Ultimately, Etta symbolizes and voices not just lesbian sexual pleasure (although she does that often enough) but also the presence of a queer female community, though one that is almost exclusively white, which can appreciate her burlesque and recognize its disturbance of heteronormative culture. While Wertham railed against such wicked subversion, Marston revered it. One would think, then, that with Marston's death (and our Candy's exile) the camp would ride off into the sunset, but instead, her shadow looms large over the Silver Age, as Wertham's paranoid panic about her would attest, nearly four years *after* her final appearance in the early Wonder Woman comics.

Marriage-a-La-Mode: Marital Camp and Kanigher's Silver Age Sapphism

Significantly, while she might be the most prominent one, Etta Candy is not the only sapphic sidekick of the Golden Age. We could also add Jonesie, the female crime fighter's live-in secretary in the successful *Black Cat* comic, for example, who plays a recurring queer sidekick role akin to Etta's but on a much smaller scale (and who also stunningly resembles Ann Sothern's Susie MacNamara in *Private Secretary*). A stalwart of Harvey Comics starting around the same time as Wonder Woman, "Black Cat" Linda Turner—"Hollywood's glamorous detective star"—possesses her own lesbian panache with her sizable

motorcycle and impressive Judo moves, yet it is her personal assistant / roommate Jonesie with her short cropped blonde hair, heavy black specs, and animal-print bowties who signals lesbian camp is at play: see, for instance, her solicitous attention to Linda's personal needs while also advocating for her fans in *Black Cat #6* (1947), above a panel featuring Bette Davis (of all stars!) out for dinner. In later issues, we get more evidence of Jonesie's intimate familiarity with her roommate Linda, such as in *Black Cat #10* and *#11* (in 1948), where she provocatively helps dress our gorgeous heroine, whom she refers to as "honey," and even tries to chase their beloved cat back into the house.

Along similar lines, although not enjoying the same success as Harvey's *Black Cat, Jill Trent, Science Sleuth* certainly ups the roommate game to greater queer heights.[31] Described by comics historian Mike Madrid as "the proto girl geek of comics," young scientist and crime-solving inventor Jill Trent conspicuously has no boyfriend and, instead, solves criminal cases with her "best friend and trusty assistant" Daisy, with whom she sometimes shares a bed, suggesting a "forward thinking" sexual attitude to the historian.[32] Calling up images of Etta's Bar-L Ranch, Jill and Daisy, for example, share a single hotel room on a vacation out west in *Wonder Comics #11* (1947) and are pictured in bed together (in their nighties) in *Wonder Comics #17* (April 1948) and *Wonder Comics #18* (June 1948), in which they get their own cozy cabin at a spa and Daisy looks forward to "pounding [her] pillow early" in their single bed rather than staying up to solve the mystery (2). Perhaps only their smaller circulation prevented Jill and Daisy from catching Wertham's alarmist eye as yet another tantalizing "morbid ideal" for certain female readers.

However, with the end of the war and the advancing of conservative winds across the American landscape, crime comics and superheroes, of course, were not the only casualties of Cold War retrenchment: women like Etta, Daisy, and, in some respects, Wonder Woman were no longer welcome. As most comics historians note, the era's imposition of "wholesome" values and domestic containment was not only evidenced in the infamous Comics Code of 1954 but had been dramatically altering the stories and priorities of the comics industry for years. Circumscribed and domesticated female characters and a focus on romance comics had become the order of the day, making characters like Etta anathema to the comic narrative world, and, therefore, it is hardly surprising that editor Robert Kanigher excised her (and the Holliday Girls). As Les Daniels explains it, Kanigher's Silver Age reinvention of the Amazon Princess was at least partly in response to these immediate postwar changes in the industry trending toward "romantic titles," so that *Sensation Comics* became "a weird hybrid of action and soap opera," and Wonder Woman suffered dearly, now "in danger of sinking" into the romantic "mush" that surrounded her.[33] Indeed, the idea of her conformist, conservative descent has become the overwhelming critical consensus on Wonder Woman's (usually decried) Silver Age makeover: in the words of one of her most famous champions, Gloria Steinem, Wonder Woman's

"feminist orientation began to wane" as the era's enforcement of gender tyranny told women that "recognition and status through men was the best possibility."[34] Diana became involved in ridiculously silly plots, was in constant marriage negotiations with Steve, and even found her origin story altered to include men on Paradise Island—a state of affairs so disheartening that Berlatsky refers to "anything by Robert Kanigher" as "thoroughly worthless in almost every respect."[35] But worthlessness is hardly a disqualifier for camp—quite the opposite, in fact—and Kanigher's oeuvre, despite Etta's expulsion, undeniably expresses a camp sensibility, although perhaps without the same queer, subversive, even radical, intent that drove Marston.

In other words, at least since the moment her giant figure leapt across the first issue of *Ms.* magazine in July 1972 and she was promised rescue by the *Ms. Book* devoted to her the same year, the Amazon Princess's tale has chronicled a tragic postwar fall from her heroic Golden Age zenith—with clueless or even hostile post-Marston/Peter producers betraying and belittling her, before Second Wave Feminism could mercifully swoop in to save the day. As comic historian and artist Trina Robbins asserts, being the property of DC Comics, Wonder Woman has been a "slave to whoever writes and draws her," even some who might have "felt threatened by the strongest woman in comics," and, therefore, over the years since Marston's death, they have "diminished" her "by turning her into a family show" and "by taking away her costume and powers"[36] The Cold War era, then, takes on a familiar antifeminist Dark Ages guise here, in which the changes to the comics industry and attacks from morally panicked fearmongers are situated within the established thesis of a "containment policy" where an emphasis on "traditional family and prescribed gender roles," extolling the "virtues and imperatives of domesticity," gets written into the Comics Code.[37] Wonder Woman, the "strongest woman in comics," would have to change dramatically to suit this new cultural order.

Therefore, as I have noted above, Kanigher's handling of *Wonder Woman* after Marston's death has fit neatly into this critical narrative. For instance, he is unnamed but clearly referenced by Wright when the historian finds that, from 1956 to 1967, "the men who created DC comic books were clearly uncomfortable writing stories with female stars" like Wonder Woman, whose series "languished creatively and commercially" during this time.[38] Accordingly, Kanigher is often described as the, at best, unlikely heir to Marston's mythic feminist project with his hard-boiled revenue focus and famed expertise in hypermasculine war comics (such as his DC invention Sgt. Rock); he appears not exactly hostile to the most revered superheroine of comics, but patently uninterested in Marston's feminist goals, altering her story to focus on love, if that is what would sell.[39] Yet, I would argue that Kanigher's impact as the controlling force over Wonder Woman's fate during this troubled period has been grossly oversimplified in service of this domestic containment thesis, where, as Hanley insists, she retreats into a "traditionally feminine role" as a conventional character "whose

heroic mission was a hassle that stopped her from getting married, who didn't fight real criminals, who let her boyfriend aggressively control their relationship, and who lacked any sort of metaphor or subtext other than the importance of romance and marriage."[40] Moreover, I find this oversimplification somewhat fallacious considering that the same commentators who offer it also document both the "shift to campy, fantastical stories in the Silver Age" and Kanigher's open recognition of the comic as "camp," along with his confession in later interviews that he viewed all the Amazons, including Diana, as "lesbians."[41] Of course, this disconnect *does* make sense if normative failure, lesbian identity, and camp sensibility are (predictably) viewed as incommensurate. Wonder Woman in the Silver Age, however, proves this old saw wrong, yet again.

The critical impasse—again, predictably—is that discussions and scholarly understandings of camp fail to recognize either feminist or, especially, lesbian manifestations of it. When Hanley refers to the "campy adventures" that Kanigher devises for his "rather silly" Silver Age *Wonder Woman* issues, he is pointing to ridiculous, over-the-top yet "innocuous" storylines and "fantastical creatures" like giant eagles from outer space or cannibal clams and master villains like the notorious Egg Fu of *Wonder Woman #158*, which earned the writer-editor the high camp designation of winning the only two Academy of Comic Arts and Sciences Alley Awards for worst comic book in 1961 and 1964.[42] For Robbins and Daniels, Kanigher's dalliance with camp suggests a more conscious aim on his part, such as when in 1966 he initiated a series of comics cannily imitating and resuscitating the storylines and anachronistic art nouveau style of the Marston/Peter Golden Age issues, which Harry Peter's successors Ross Andru and Mike Esposito spectacularly failed to pull off.[43] Yet Kanigher's disregard for logic, reason, and, of course, taste, along with his unbridled appreciation of ridiculous and absurd excess—what he refers to as his "weird sense of humor"—is never connected to his representations of the Amazon Princess's uncontained (and unfeminine) adventures or, more importantly, to her repeated, exaggerated failure to marry Steve Trevor, despite his increasingly frustrated demands and her nonsensical (queer) refusals.[44] Kanigher may not have intended to create marital camp, but his "weird sense of humor" via a variety of "campy adventures" cannot, I would argue, be divorced from or conveniently forgotten just at the moment when he represents the pillars of the era's domestic containment imperatives, most especially marriage and its attendant reinforcement of "prescribed gender roles" and heteronormativity.

Rather than rehash yet again how Silver Age *Wonder Woman* "became far more conservative in its sensibilities" in the persecutorial McCarthy era, I propose that we take Kanigher at his word and examine just how his "campy" comics might perform and simultaneously undermine those regressive exigencies working to contain women and put so many of them in service to white heteropatriarchy's "family ideal," as I explored in chapter 1.[45] Reminiscent of the beloved "Our Miss Brooks" from the previous chapter, Diana at the very least

134 • Suffering Sappho!

embodies the competing narratives for women at the time, outlined by comics critic Ruth McClelland-Nugent as the "conflicting interests" in Kanigher's *Wonder Woman*, giving superheroine glimpses into a "real alternative to Cold War domesticity," while at her campy best denaturalizing and subverting it.[46] In other words, Kanigher's giant eagles from outer space and diabolical, Communist Egg villains over and over again find their feminist campy counterparts in the ironically bemusing ways the Amazon Princess spectacularly *avoids* marrying Steve Trevor (or caring for normal offspring) or is herself depicted as an out-of-control force smashing her way through normative 1950s culture. The open secret of these subversions and disruptions—the queer piece that completes their bizarre, absurdist puzzle—is that Wonder Woman sabotages the era's domestic ideal because she is, alas, a Suffering Sappho—a lesbian maiden caught in the menacingly absurd "man's world" of McCarthyite postwar America.

If one issue is chosen to inaugurate *Wonder Woman*'s supposed descent into the domestic ideal and postwar containment, historians typically single out the revamped makeover issue of *Sensation Comics #94* at the end of 1949, on the cover of which a young, blushing Steve Trevor carries an equally flushed, demure Wonder Woman over a stream as if over the bridal threshold. With new promised features such as "Romance, Inc." and a softened, flowing serif font for the word "Sensation," the cover—by artist Irwin Hasen, not Peter—seems to indicate that the Amazon Princess is crossing the threshold into a new era, where gazing into his eyes and "marrying Steve Trevor" will be her calling.[47] Yet, when examined closely, the cover text, even at the outset, reveals the subtle and enduring ways in which compulsory domestication will be undermined and contradicted throughout the Silver Age issues. The featured story, "S.O.S. Wonder Woman!," promises *not* that she will marry Steve but that something ("a sudden call for help") could "prevent" her from doing so. In a pattern that will become familiar well into the 1960s, this apparently transformative issue of *Sensation Comics* establishes from the beginning the queerly suspicious storyline of a promised, coerced, or even imaginary marriage proposal followed by a series of increasingly ridiculous trials and obstacles, which prevent or effectively ruin Diana and Steve's heralded nuptial bliss. One begins to wonder, in fact, if that "S.O.S." isn't being sent out by the Amazon Princess herself, hoping someone will save her soul from suburban ennui and ironing Steve's shirts.

Written and edited by Kanigher and drawn by Harry Peter, "S.O.S. Wonder Woman!" belies Hasen's charmingly conventional, bucolic cover image with the ironic, almost foregone, conclusion that, when pushed, Diana will choose career over marriage every time. That this "most perplexing problem" is already being played for laughs is indicated on the splash page itself, where the introductory scroll warns us that she must choose between "love—and her life as a crime fighter." Yet the image below shows the "beauteous Amazon maid" snickering behind her hand as she eavesdrops on Steve—bent on one knee in front of her photograph—vowing to propose marriage and *not* "take 'No!' for an answer no

matter what reasons" she may give (1). Indeed, Steve quickly becomes the butt of the joke as his "shiny" earnestness to capture the Amazon Princess comes up against, first, her creeping doubt—her thought bubble prevaricates, "Why shouldn't I say yes?"—and then her formidable noble charge to "help others" (5). Yet, because his subsequent matrimonial scheme trades on this very sacrificial mission, by securing her promise to marry him only if a whole day passes without Wonder Woman being summoned to someone's aid, it is doomed from the start; as Diana herself cautions, "It's hardly likely." Thus, as Steve desperately attempts to silence any cries for help near their lover's picnic and takes on the overwhelming duties of gallant rescue on his own—first saving a drowning girl and then a blonde on a runaway horse—his inevitable failure feels only a panel or two away, and so, at last, "helpless to fight back," the "outcry" every reader has been expecting comes (9).[48] Steve proves unable to save a stranded climber and must cry out for Wonder Woman's help, to which she, like the *totally* straight marriage material that she is, responds, "Suffering Sappho!" and saves him (and the girl). To be sure, Steve's resignation in the final panel that he "should have known that a day couldn't pass without [her] help being needed" combined with his tragic bravado to "not give up" and "keep on asking" might evoke just the kind of ironic snickering that Wonder Woman exhibited for the reader on the story's very first page.

However, although it begins with a number of issues bringing her tantalizingly close to becoming Steve's bride, as the Silver Age progresses, Diana's "most perplexing problem"—essentially, how to keep saying no to Steve and continue her crime-fighting career—is figured more and more in terms of *suffering* and less through open laughter.[49] In fact, Hanley notes that after the infamous 1949 issue of *Sensation Comics*, Wonder Woman used the exclamation "Suffering Sappho!" nearly "three times as often" as she had before, indicating that "more romance with Steve equaled more references to a lesbian poet."[50] Pointedly, in a number of issues in the late 1950s and early 1960s, the root of her suffering is presented as malicious marital entrapment or coercion and the "impossible" dilemmas Steve (and others) forces on her—as the splash page for *Wonder Woman #101*'s "Undersea Trap!" describes it, she enters into relational wagers "impossible for her to lose" and "impossible for her to win."[51] Pushed by Steve in this October 1958 issue into yet another ruse where she must choose between rescuing and marrying, Wonder Woman barely survives his matrimonial trap—having to stop a bomb, a hail of bullets, and a crazed Great White shark just to avoid marriage—and then has to battle mind-controlling aliens only a few issues later, in *Wonder Woman #108* (1959), where they "force" her to act "contrary to her real nature," which amounts to immediately agreeing to marry Steve.[52] As her panicked face stresses in an extreme close-up in the bottom-right panel of the page, she is anguished by being turned into an alien "puppet" by the "strangest threat Wonder Woman has ever had to face" because, of course, she "can't marry Steve" since she is "still needed to fight crime and injustice on a full-time basis!" Her

136 • Suffering Sappho!

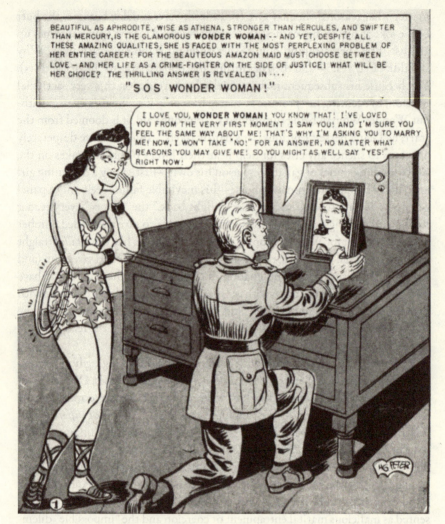

FIGURE 11 Steve's "beautiful angel" snickers behind her hand as he vows pathetically to bring her to the altar in "S.O.S. Wonder Woman!"

suppressed "*real* nature," therefore, drives her to embrace a full-time crime-fighting career and conspicuously avoid heterosexual union, which she does again in *Wonder Woman #111* (January 1960) after defeating her robot replacement, and in *Wonder Woman #118*'s "Impossible Decision" (November 1960), when she refuses to choose between Steve and her childhood friend Merman.

These matrimonial traps and trials, at times, seem amusing to her, as when she laughs off Steve's "silly" jealousy of Merman. But just as often they take on the nightmarish tenor of an unwanted and disempowering assault, which evokes, for me, the monstrous lengths to which her fiancé and the not-so-good doctor

Amazon Princesses and Sorority Queers • 137

will go to adjust Janet to marriage in chapter 3's *Daughter of Dr. Jekyll*. For instance, the aliens' telepathic mind control in issue *#108*, which hopes to make every human "powerless" by ostracizing an "outcast" superheroine forced into criminal acts (as well as marrying Steve), is presented on the cover as a "Nightmare" from which Wonder Woman cannot awaken, as she cowers terrified against a wall plastered with an enormous "Wanted" poster that bears her face and name. Over and over again, the comics represent her loss of power and control as a threat not just to the planet but to her personally, and Steve's constant pestering of her about marriage quite often symbolizes, or at least goes hand in hand with, this threat. In other words, in the age of conformity and domestic containment, *Wonder Woman*'s Silver Age issues appear consumed with marriage but hardly its blissful realization. Described by Ruth McClelland-Nugent as "optimistic" but also increasingly "belligerent" in response to his conjugal failures, Steve embodies the threat but also its comic frustration, sounding a bit like a villain when he vows in 1958's "Daily Danger" (*Wonder Woman #96*) that his "day will come, Wonder Woman! You just wait!" or losing his cool over spoiled dinner in the hallucinatory "Wonder Woman's Surprise Honeymoon" (*Wonder Woman #127*, 1962).[53]

Also strikingly reminiscent of the previous chapter's "matrimonial mirage[s]" presented in numerous episodes of *Our Miss Brooks*, Kanigher's issues of *Wonder Woman* repeatedly raise the promise of marriage only to thwart it and even extravagantly lampoon it, although in this case it is Steve's desperation and frustration played for ironic laughs rather than the spinster's illusory chances at matrimony. In "Wonder Woman's Surprise Honeymoon," Steve's concussion-induced hallucination begins happily enough with her sudden acquiescence to his marriage proposal. But almost as soon as she gets into a wedding dress, his dream turns into a nightmare, where one moment throngs of autograph seekers delay their honeymoon and the next she, still wearing her dress and veil, must stop a wayward jet. Over the course of the honeymoon mirage, his wide-eyed and shaken facial expressions become more comically exasperated, until he loses complete control, violently rejecting the (hardly) "contented" bridegroom's first meal of burnt toast, raw meat, hot Jello, and cold coffee.[54] Even though she is the one who ends up in tears after his outburst, Steve becomes a parody of bruised male pride when he angrily rejects his "restless bride" in the end, claiming "mental cruelty" in his brief fantasy marriage to the planet's heroic savior, which even in his awakened state he describes as a "horrible experience."[55] For Kanigher, it would appear, the joke is on Steve, who should, after all these years, take the queerly "restless" hint, but Wonder Woman also does not escape suffering. Compulsory heterosexuality and its marriage imperative prove a nightmare, really, for both of them.

In other words, although Silver Age *Wonder Woman* seems to comply with the period's obligatory marriage plot and family ideal through its basic subject matter, the comics themselves often present a strongly sardonic attitude toward

138 • Suffering Sappho!

domestication. Another case in point would be the small feature change, replacing "Wonder Women of History" with "Marriage a la Mode," documenting global marriage customs, which many critics cite as evidentiary of *Wonder Woman*'s Silver Age antifeminism that favored traditional heterosexual romance and matrimony.[56] However, under closer examination, these brief vignettes combining multiple "customs" from around the world can have the effect of making marriage strange or unappealing—both exoticizing it (and any foreign others) and reminding readers of its patently oppressive or nonconsensual origins and history. One "Marriage a la Mode" from *Wonder Woman #90* (1957), for instance, aligns a marriage ceremony of the Mongolian Kalmucks where the bride races away from her groom with a quaint tradition in southwest Germany where the couple's household goods ride to their new home in a "Marriage Chariot" and the practice in "old-time England" of forcing the bride to kneel at her husband's feet as testimony to the "transference of obedience from her father to her husband"; the contorted smile (almost grimace) on the kneeling bride's face in this "old-time" panel suggests that perhaps she would rather be riding swiftly away like her determined Mongolian counterpart in the panel to her left. As in "S.O.S. Wonder Woman!" or the "Undersea Trap," marriage here seems more like a battle with a Great White shark than a rewarding bargain for lifetime security and happiness.

Instead of wholeheartedly endorsing the era's idealized project of matrimony, childbearing, and the patriarchal home, the "Marriage a la Mode" feature, I would argue, works to gently mock or undermine it. Although certainly not creating the level of vicious satire that William Hogarth achieved in his landmark series of paintings entitled "Marriage A-la-Mode," this new feature of the same name in Silver Age *Wonder Woman* should be viewed, I think, with similar irony. Hogarth's scornful eighteenth-century moral critique of the upper classes and the predicament of marrying for financial solvency—with its wanton adultery, syphilitic bridegroom, and eventual murder/suicide—obviously makes a mockery of the institution of marriage far beyond its comic successor, but one could argue that in naming the feature as he does and presenting "strange" and, frankly, brutish customs, Kanigher opens *Wonder Woman* up to this resonant, subversive lineage.[57] Indeed, in the issue cited above, "Marriage a la Mode" precedes one of the strangest and most disconcerting representations of domestic obligation in his postwar collaborations with Harry Peter, "Wonder Woman, Amazon Babysitter."

Similar to when she proves overwhelmed by the job of responding to "Hopeless Hearts" letters as romance editor for the *Daily Globe* in *Sensation Comics #97* (1950), Wonder Woman is depicted here by Kanigher and Peter as bizarrely beleaguered by simple domestic life—this time in the form of child care. With a splash page featuring a smiling Amazon Princess pushing a docile Tyrannosaurus rex in a pram, prompting Daniels to ask if the comic is "endorsing or denouncing maternity," the "Amazon Babysitter" story places her in yet another

fantastic trial testing her domestic suitability and skills: in order to settle a bet between two millionaires, she must succeed as a babysitter for only twenty-four hours and the winnings will go to charity.[58] Although one of the greedy millionaires is setting her up for failure by selecting outrageous and unmanageable "babies" like a young sperm whale, a parachuting baby elephant, and the aforementioned T-Rex, whom she lassos and rides like a bucking bronco, Wonder Woman, of course, proves up to the task, even if it convinces her in the end that she has "had enough babysitting" to last her "a lifetime" (8). One of Harry Peter's last issues, "Amazon Babysitter" not only exhibits his skewed perspective and trademark "eccentric" style, which harked back to nineteenth-century art traditions and was described as "grotesque" by editor Sheldon Mayer, but also finds Wonder Woman using Kanigher's favored exclamation, "Suffering Sappho!" (when she realizes that her second Herculean labor involves a stranded circus elephant), and clearly evidences some of Kanigher's classic camp outrageousness in his selection of babies to be cared for.[59] Yet, never to be bested when a charity needs her help, the Amazon Princess sportingly accepts grateful licks from rescued baby whales and queer tail bumps from calmed dinosaurs but also, ironically, never appears interested in sticking around for a more permanent childcare obligation. Although it might not be perfectly clear if the comic is "endorsing or denouncing maternity," its attitude toward maternity could hardly be called serious, with Wonder Woman fleeing the commitment as soon as her job is done.

In sum, Kanigher's Silver Age issues establish, time and again, that the heterosexual family ideal and the prospect of domestic containment represent both untenable threats to Wonder Woman's heroic mission (her career) and dangerous, but also often ridiculous, traps for her personally. Her response to these menaces is typically forbearing, as she patiently—sometimes amusedly—goes through one contrived trial after another, but her suffering and frustration also peek through. Encapsulating the pained but ironic camp critique I have been outlining above, Kanigher ultimately provides a larger-than-life symbol of this volatile mix of steadfast duty, complicated desires, and frustrated resentment in one of his favorite fantastical figures—the giant or giantess—who comes to signify Wonder Woman's oversize needs and perhaps unbidden wish to bring down the "man's world" trying to contain her. While oversize women have long been associated with the "Amazon mythos," in this period alongside B-film cult classics like *Attack of the 50 Foot Woman* (Juran 1958), the giantess stands in (not so subtly) for dissatisfied women's unruly desires and unmanageable discontent, and in *Wonder Woman*, works as a kind of campy manifestation of the dominance and submission games of the Marston/Peter age.[60] Wertham and the Comics Code may have expunged the bondage scenarios, but the giantess brings the erotic potential of an overpowering woman storming back. Perhaps not coincidentally featured in 1957's *Wonder Woman #90*, along with "Amazon Babysitter" and "Marriage a la Mode," Wonder Woman comes to the aid of a gigantic double of herself in "Planet of Giants," the cover image for which clearly evokes

140 • Suffering Sappho!

the infamously campy *Attack of the 50 Foot Woman* with the hundred-foot-tall double holding our superheroine in her giant, well-manicured hand.[61] Yet, her giantess double takes on more pointed resonance after a familiar plot in *Wonder Woman #114* (1960) finds her manipulated by space aliens again, who animate a balloon figure of her, similar to those of the Macy's Thanksgiving Day Parade, that she must tow into space in order to detonate its "S-bomb" and avoid planetary catastrophe.[62]

Returning to almost this exact plot device a year later (in *Wonder Woman #122*), Kanigher makes "The Skyscraper Wonder Woman" less of an atomic threat, but her dilemma reveals a decidedly (hetero)domestic origin. Dodging yet another marriage proposal from Steve, who might have to compete with a "Martian invasion" in the "midst of dinner," she inadvertently brings a Trojan horse back to earth, where the giant alien double inside destroys war planes and ocean liners (with a well-placed high heel shoe) and ascends skyscrapers like Kong himself.[63] The message here seems to be that despite her best intentions, Wonder Woman can release from inside her a force of overweening desires that not only threaten the planet but also obstruct any prospective marriage to Steve. Desperate to save earth, Wonder Woman agrees to yet another set of trials against her giantess rival self and ends up strapped to an "age clock" that transforms her into Wonder Girl and then Wonder Tot, both of whom defeat the mechanical doppleganger, although it is the adult Princess in the final panel who mocks Steve again about *someday* marrying him, when her "services are no longer needed."[64] Wonder Woman's age clock might be ticking loudly, but even defeating her oversize anger, queer fear, and resentment still cannot produce an "I do" for Steve. Furthermore, the creation of Wonder Girl and then Wonder Tot, who will return through "Amazon magic" to create the "Wonder Woman Family" in a series of "impossible" logic-and-nature-defying tales where all three ages of Diana coexist in the same timeline, decidedly queers the era's family ideal with an all-female household that appears, for McClelland-Nugent, not only "complete" but "happy."[65]

By the time the 1960s are in full swing, Kanigher's not-so-subtle depictions of the Amazon's overwhelming unsuitability for the postwar world become gigantic, ridiculous, bellowing cries for help. In 1963's "Wonder Woman—The World's Mightiest Menace!" (*Wonder Woman #136*), an ever-expanding Diana pleads for Steve to help tame her uncontrollable desires, yet he is hardly qualified to help when his own date with her is offered in the next panel as the answer for the question, "What Caused Wonder Woman to Become a Human Catastrophe?"[66] Nothing can satisfy the "voracious Amazon" here, who consumes all the tiny "franks" at the fairgrounds and then drinks the entire city reservoir, but Steve is hardly the solution for this global "menace," first unable to "order the destruction" of his intended and then watching helplessly in tearful acquiescence as even the army proves no match for her skyscraper-smashing size.[67] Aliens (again) are offered as the cause for this rampage, but all of Wonder Woman's

Amazon Princesses and Sorority Queers • 141

FIGURE 12 Robert Kanigher's Silver Age "Suffering Sappho" dramatizes the Kong-sized tragic joke of the era's domestic containment.

regrets, pleas, and tears are directed at Steve and the "impossible" position he continues to put her in. The "Human Catastrophe" on display, therefore, with its unmanageable desires, unacceptable female appetite, and destructive power, is both set off and ironically unresolved by the promise of marital commitment and hetero-domesticity, and what we are left with is an awkwardly queer, giant Amazon amusingly laying waste to postwar America, which she alone can save—from herself.

With its cover image of a visibly panicked Diana crashing through two tumbling skyscrapers and pleading for Steve to "stop" her, this issue of Wonder Woman as the "World's Mightiest Menace" not only exaggerates and distorts her reactions to her growing predicament, but it also inevitably calls up for the contemporary reader that iconic cover of the first issue of *Ms.* magazine, where a dominating Amazon Princess is fired upon as she strides over a war-adjacent Main Street, for which presumably she could be the next "president." Separated by nearly ten years, these two images of Wonder Woman, I believe, work as uncanny doubles of the same idea—that female autonomy, heroism, and power

142 • Suffering Sappho!

have incredible potential to both destroy and save a conflicted (and self-destructive) American culture—but the toll this takes on the miraculous woman at its center is unmistakable. Also unmistakable, I would argue, is the earlier issue's patent employment of camp to exaggerate this toll and lay the blame for it at the feet of compulsory heterosexuality and domestic containment.

In 1963, the same year that *The Feminine Mystique* was published, Wonder Woman's unaccountable desires cannot be contained, but her consequent suffering because of their repression is represented in the comic as both a humorously over-the-top menace and a painfully borne personal experience—in other words, as camp. While I am not arguing here that Kanigher was some kind of closet feminist, I do believe his Silver Age issues create a kind of feminist camp in their expression of a "discomfort with and alienation from the normative gender and sex roles" forced on women in the period.[68] Moreover, if Kanigher, as he said in interviews, saw Wonder Woman as a lesbian, then her dangerous desires, humorously repeated avoidance of marriage to Steve, panicked and futile attempts to contain her excesses, and her unsubtle calls out to a "Suffering Sappho" signal not just queer parody but an Empire State–sized lesbian joke. In the hands of her creator's "campy" excesses, this over-the-top suffering—both Diana's and Steve's—acts out a drama with a kind of knowing laughter that corrupts the period's heterosexual family ideal and conventional gender imperatives with its wicked subversion. The Comics Code of 1954 might have sent the bondage scenarios and sacrilegious desires underground, but undercover (and yet right out in the open) is where camp thrives, striding, like a beautiful giantess, loudly and painfully over an unsuspecting 1950s Main Street.

Trouble in Paradise

On a recent episode of the *Sidedoor* podcast, "How Wonder Woman Got Her Groove Back," host Lizzie Peabody begins her investigation by describing that landmark cover of the first issue of *Ms.* magazine, with a giant Wonder Woman "taking whole blocks in a single step," and then noting how the magazine "needed" the superheroine as much as she "needed *Ms.* magazine," to pull her out of a "midlife crisis" and transform her "from comic book hero into icon."[69] With this setup, not surprisingly, the podcast goes on to chronicle a familiar story: how the *Wonder Woman* comic began with Marston's "radical" feminist vision but faltered after the war, when "cultural shifts threatened to shackle the powerful female role model" and the Comics Code and new creators focused her on romance and "Marriage a la Mode," until she ceased to be Wonder Woman at all, which is how *Ms.* magazine's editors found her when they gallantly brought her back, lobbying DC Comics for the restoration of her powers and elevating her into the symbol we know today of "female strength and power and feminism." Interviewing one of those editors, Joanne Edgar, who provided the cover essay for that first issue, "'Wonder Woman' Revisited," the podcast highlights a

major turning point in the comic's lore, where a small band of liberal feminists led the charge to rescue their childhood role model and refashion her into an icon for women's liberation.

A significant component of that restoration, as I have already mentioned, was the *Ms. Book* publication that same year of a *Wonder Woman* comics selection (all Golden Age issues) released by Warner Books and prefaced with two essays by leading liberal feminists, one semiautobiographical introduction by Steinem and an "interpretive" essay by psychologist Phyllis Chesler. While one might consider Steinem's piece a key source of the resurrection tale offered above, where this new generation of feminists promises to lift their heroine out of the "hard times" she fell into in the 1950s and restore the "feminist principles" Marston imbued in her so that she may be "born again," it also posits a deeper, underlying mythos for Wonder Woman's empowering model for women, signaled in the very title of Chesler's essay: "The Amazon Legacy."[70] Introduced in Steinem's piece as the historical and mythological "gynocracy" providing the foundation for the comic's Paradise Island, the all-female and even violently separatist Amazon societies being retheorized by twentieth-century historians and archaeologists become the central focus of Chesler's interpretive essay, which begins with a "re-created conversation" with two deceased proponents of these originary matriar-chy theories, Helen Diner and J. J. Bachofen.[71] Opening with the commonly held notion that Amazons are more patriarchal myth than historical reality—a "uni-versal male nightmare, exorcised by ridicule and disbelief"—Chesler recounts the pre- and post-Bachofen investigations of Amazon stories and, particularly, Greek and Roman historical accounts (and myths) for "proof" of actual gynoc-racies and women warriors that might have served as models for Paradise Island and Wonder Woman herself.[72] The Amazon here becomes both a way to bestow historical and cultural significance on Wonder Woman as a fictional character and a tool for grounding (and celebrating) liberal feminist ideas of female strength, empowerment, and self-reliance in a distant past of female rule.

Since the days of Herodotus and Plutarch, in Western cultures the Amazon has represented the power of physically imposing warrior women, the possibil-ity of separate and autonomous female communities, and the dangerous but sex-ually alluring obstacle for the patriarchal male hero's triumph. Chronicled by feminist scholars such as Abby Kleinbaum and Batya Weinbaum, the histori-cal, mythical, and popular figures of the Amazon in the West begin most clearly with the classical stories of Hercules's labors, the ninth of which tasked him with stealing the Amazon queen's girdle, and with Greek historians' accounts of wars with the Amazons, particularly the unsuccessful Amazon siege of Athens appar-ently undertaken to avenge the abduction of Princess Hyppolyta, as well as the sacking of their great city Themiscrya by the Greek king Theseus.[73] Considering her origin story and his descriptions of Paradise Island, Marston clearly based his superheroine on this classical version of the Amazon, but he was also working within a Western literary and cultural tradition—from portrayals in colonial

travelogues by Sir John Mandeville to recent fictional representations such as Gilman's *Herland* (1915) and Katharine Hepburn's 1932 Broadway debut in *The Warrior's Husband*—that equated Amazons with this classical notion of a ruthless, sometimes one-breasted, foreign female warrior and/or separate islands inhabited only by women and hostile to any incursions by men.[74]

While unearthing the evidentiary proof for the actual existence of bands of women warriors in western Asia, the steppes of the Black Sea, or in Africa remains an ongoing project for archaeologists and feminist historians, my concern here is with that classically founded cultural icon of the Amazon, which influenced not just Marston but all of Wonder Woman's creators, who align her with this mythic figure of female strength, combat skill, and power combined with a separate female community and nonconforming sexual practices, the most common of which was the supposed practice of seeking out neighboring men for sexual reproduction but refusing their adoption into Amazon society.[75] Indeed, Wonder Woman's elevation and restoration by feminists in the 1970s hinge on these two central features of the Amazon mythos, which also, not coincidentally, encouraged lesbian feminists of the era to adopt the Amazon as a representative symbol, although the equation of the "Amazon-as-lesbian" surely predates and lives beyond the 1970s.[76]

Venerating and looking for models of past gynocracies through the myths of Amazons served not just the women of the Second Wave but also, certainly, Marston's own proclaimed political agenda, where his separationist matriarchal "Paradise" and its most famous champion daughter could show the way for how benevolent and loving women might rule the world. Yet, this "peaceful matriarchy that Marston envisioned," along with other Progressive-era devotees to "matriarchalism," such as Charlotte Perkins Gilman and L. Frank Baum, had a fundamental failing: its feminist utopia and female "ideal," as Finn notes, were resolutely white.[77] Although the comic's obvious racism was acknowledged by Steinem and the other editors at *Ms.*, they downplayed it in service of the gynocratic promise and Amazonian feminist lineage they hoped to promote. But as scholar Keira Williams establishes in her comprehensive recent work *Amazons in America: Matriarchs, Utopians, and Wonder Women in Popular Culture*, Marston's feminist matriarchalism cannot be disentangled from the period's "scientific racism" or the white-supremacist foundations of popular and literary feminist utopias.[78]

The *Wonder Woman* comic has, of course, always featured real and metaphoric islands of women and the exalted, as well as occasionally deleterious, effects of female rule—not just Paradise Island but Reform Island, Desira's Planet Venus, or the scorned community of masculinized "Undersea Amazons" ruled by the brutal Queen Clea (*Wonder Woman #8*, 1944)—but not one of these utopian (or dystopian) matriarchies proposes anything but a white sovereign. Historian Williams argues that this is no accident, as the "feminist matriarchalism" she examines in a text like *Wonder Woman* had its roots in an

imperialist white supremacy advanced by popularizers of the idea, like African "explorer" May French Sheldon, who offered herself as a model for the kind of "White Queen" poised to lead Western colonial powers in a "better kind of imperialism" over the "savagery" of "African Amazons" at the 1893 World's Columbian Exposition in Chicago.[79] Although Progressive-era socialists like Baum sought to create fictional utopias with ethnic and racial diversity and equity, their work invariably reflects, for the historian, the "racist matriarchalism" of the period (and its suffrage movement), which imbued "white femininity" with "a special form of power" so that, for example, the "good matriarchs of Oz are always depicted as white-skinned."[80] With the Golden Age *Wonder Woman*, moreover, Williams finds an even less conflicted racism, where offensive racist characterizations, both at home and on the warfront, are scattered throughout an "almost exclusively" white world (including the "overwhelming whiteness of Paradise Island"), and Wonder Woman, "ever the adept White Queen," embodies the imperialist "white supremacy" of Marston's version of matriarchalism.[81] Perhaps not as often commented upon but clearly in line with Sheena, Queen of the Jungle (the only major female comic book character to precede her), Wonder Woman presented a racist and imperialist vision of white, female saviorhood—the pure Amazon Princess of a very particular feminist dream.

Critics and historians have long recognized, rationalized, and condemned Golden Age *Wonder Woman*'s racist characterizations, particularly of wartime villains such as her Japanese adversaries, but the white supremacy that Williams outlines depends as much on the Amazon Princess's frequent rescue or guidance of racial and ethnic others, as well as minor players dotting the background of her "noble" missions. The racist travesties employed for Marston's wartime propaganda, such as the Japanese spies, invaders, and treacherous conspirators of *Wonder Woman #1, #4,* and *#6,* while not unusual for the time, are perhaps for a contemporary reader starkly explicit, portraying these "devious" characters with heavily slanted eyes, buck teeth, and a "very yellow" complexion and painting an entire nation of people as "an evil, savage race who showed no mercy."[82] Yet, these frequently criticized enemy depictions join a host of scheming yet inept racial and ethnic others whom Wonder Woman both mocks and easily defeats—from the Mexican conspirators of *Wonder Woman #1* or *Sensation Comics #16* to the unidentified African nation allied with the Nazis in *Wonder Woman #19* (1946), which Berlatsky calls a "shameful exercise in ignorance and hate."[83] From her very beginnings, then, Wonder Woman is portrayed as a white female savior not only for her adopted (white) American nation against its dehumanized foreign enemies but also for helpless and imperiled "innocent" people of color, both at home and around the globe.

Notable issues of the comic favored by critics and, further, discussed in this chapter seemingly never fail to include both minor and major instances of racist caricature in service of Wonder Woman's larger "mission." *Wonder Woman #1,*

with which this chapter began, depicts not just sinister Mexican henchman and Japanese masterminds from whom Wonder Woman "saves Mexico" (13d) but also a hapless, overweight African American train porter (in the "candy you can eat" scene) as well as a mixed-up Mexican damsel, who is called a "black weasel" by Etta for drugging her brother (7a) but who, under Wonder Woman's benevolent attentions, turns on her Japanese tormentors to provide the location of their secret base. To be sure, although not as numerous as demonizations of foreign enemies, Marston and Peter certainly created their share of offensive caricatures of African Americans—from a befuddled elevator operator in *Wonder Woman #3* to the wise "nursemaid" named Dellie in *Sensation Comics #31*, who alerts Diana to the dangers facing Mrs. Modern's "chillun" (2). Altogether, and most significantly for me, this comic "visual imperialism," as Rebecca Wanzo terms it, uses caricatures of "racial bodies" too often as catalysts for and advancement of Wonder Woman and Etta's queer adventures to deny that lesbian camp appears clearly wed to it.[84]

Indeed, one need look no further than *Wonder Woman #2*, which contains Etta and Diana's queer triumph with an all-woman baseball team as well as Berlatsky's favored closet metaphor with dusky, exotic trickster Naha, to see how lesbian camp and imperialist racism intertwine to support Wonder Woman's white feminist Amazon mythos. With Etta embracing her in the first story, enlisting her on the all-girl baseball team in the second, and exploiting their telepathic connection to defeat the Duke of Deception in the end, with just enough time to take in a floor show of dancing hula girls whom Etta calls "hot!" (11c), this classic 1942 piece of wartime agitprop relies on the lesbian camp's queer comic role and intimacy with Wonder Woman to advance a white supremacist moral: Wonder Woman outwits and outfights the clever Hawaiian girl/deceiver Naha (ultimately spanking her into submission), in order to defeat not just the "sly little men from Nippon" (11c) but also the god Mars's evil sidekick. Moreover, as the predictable spanking reminds us, Marston's favored metaphor for his preoccupation with dominance and submission, the "bondage" scenario, points directly to a white supremacist anxiety about freedom and enslavement so often signified (and activated) by Black and Brown bodies, as do, of course, all the slave girls in captivity to female villains like the Cheetah.[85]

Although his Silver Age issues might lack the wartime inspiration for hateful depictions of certain foreign enemies and a burgeoning civil rights movement might have discouraged certain offensive, racist stereotypes, Kanigher does not fail to uphold the position of Wonder Woman as a White (Queer) Queen.[86] Through a near-total whitewashing of her world, Kanigher suggests that a "pure" Amazon queen still rules, but "alien" others come from outer space or mythical lands, not from the "exotic" earthly locales typically preserved and ruled by her "jungle girl" contemporaries, and the "quaint" customs of other cultures and times are reserved for smaller features like "Marriage a la Mode."[87] Famous and lesser jungle girl comics of the period, from *Sheena* to imitators like *Rulah*,

Jungle Goddess and *Sheena* artist Bob Powell's follow-up, *Cave Girl*, certainly offered racist, imperialist noblesse oblige and dominion over caricatured native Africans while occasionally exploring titillating single-sex antics, such as when Rulah wrestles with white girl gangs of "Harpes from Hades" (*Zoot Comics #10*, 1947) or Cave Girl saves the African "Bontos" from ruthless Greek-inspired, dominatrix-led "Amazon Assassins" in *Cave Girl #12* (1953) and *#13* (1954). But, Kanigher's Wonder Woman appeared to be avoiding Steve's marriage proposals in order to save whole cities, armies, and lands devoid of people of color, then returning to a Paradise Island and all-female Wonder Family still pristinely white.[88] In sum, this persistence of white supremacy in the stories of both the Golden Age's and the Silver Age's most famous Amazon presses the question of how the lesbian camp's representation and performances in mid-century America might depend on and yet erase racial and ethnic others from the fraught cultural discourse on gender and sexuality at the time. Whether sorority queers or Amazon Princesses, lesbian camps of the period, perhaps predictably, mirror their own white supremacist and paranoically persecutorial Cold War culture.

6

Sexual Outlaw

Disidentification, Race, and the Postwar Lesbian Rebel

Staring out sideways from a living room chair in her California home, blues icon and lauded cross-dressing performer Gladys Bentley brings the reader of *Ebony* magazine's (much remarked upon) August 1952 issue coyly into her confidence. Her smile and expression are somewhat indecipherable in the largest dominant image, but the prideful thrust of the article's introductory photographs is certainly less ambiguous: at the center of the frame, her left hand rests on an open scrapbook; set off by a contrasting background of white cloth, this hand's central position underscores (by resting below it) a key image in the scrapbook—a cutout of her younger star self in black tuxedo, tie, and top hat. This centralized, glamorous young incarnation of Bentley confidently gazes out at the viewer with a kind of butch impudence signaled by the rakish angle of her top hat and reinforced by a mirror inverse of the image that has strongly imprinted itself, though in faded pressed ink, on the opposite inside cover of the scrapbook. Facing off against the infamous title of this *Ebony* piece, "I Am A Woman Again," which promises Bentley's own testimonial on how hormone therapy corrected "her strange affliction" and enabled her heteronormative conversion, the central photograph in the article's opening spread hardly establishes confidence in her evangelical-like pronouncement.[1]

Taken along with the three other early career photos arranged below it—two of which find her posing in her more famed white tie and tails as well as in the

"mannish street garb," as the caption describes it, of her downtime—the photo spread clearly disrupts the certitude of her "I Am A Woman Again" revelation, at the very least obscuring the supposed originary identification with womanhood that the term "Again" implies. Indeed, featuring at closer distance the butch splendor of Bentley's closely cropped hair and expensive tuxedos that once admiringly attracted New York audiences, including the Prince of Wales, the smaller photo on the bottom right stakes itself more obviously as the privileged source material for the precariously converted figure reviewing her "fabulous night club career" in the top photo.

In 1920s Harlem, it is hard to imagine a more notorious *and* admired "sexual outlaw" than Gladys Bentley. Eric Garber, in fact, holds her up as "one of the most successful and notorious black women in the United States," period, in the 1920s and 1930s—a hit in the "fanciest New York nightclubs" and the "trendsetting" socialite scene, as well as a successful recording artist and subject of remarkable accounts in national newspapers and popular novels.[2] Although framed in terms of what we have come to expect as an inevitable fall *from* grace and *into* the damning closet of the postwar period, Garber's essay aims (and, one could certainly argue, succeeds) to rescue Bentley from the postwar "ruin" and obscurity to which her outspoken lesbianism condemned her: he presents a stunning rags-to-riches tale during "the era of the black female blues singer," when a teenage Bentley could make her way from modest beginnings as a "transient piano player and entertainer" to a favorite nightclub act at the Cotton Club and Connie's Inn and the main attraction at the infamous Harry Hansberry's Clam House.[3]

Publicly acclaimed by Harlem Renaissance luminaries like Langston Hughes and immortalized in best-selling novels like Carl Van Vechten's *Parties* (1930) and Blair Niles's *Strange Brother* (1931), Gladys Bentley became one of the most sought-after and well-paid blues stars of the era. The key to her success, significantly, was the combination of her facility with double entendre in her "notorious parodies," where she invented raunchy, "scandalous lyrics" set to popular tunes, and her coinciding exploitation of a defiant lesbian persona—embodying, for Garber, the "one identifiable black lesbian stereotype of the period: the toughtalking, masculine acting, cross-dressing, and sexually worldly 'bulldagger.'"[4] Indeed, while other blues icons like Ma Rainey and Bessie Smith referenced but also managed the publicity around their sexual relationships with other women, Bentley made a booming career out of her cross-dressing and pronounced lesbian persona. Confirming Garber's assertion, Lillian Faderman likewise credits this bravura performance of bulldagger identity as Bentley's central lure, making a "spectacle" of her "blatant" lesbianism (in her tuxedos and public marriage ceremony to another woman), which, apparently, "drew celebrities like flies."[5] She made her career in the 1920s and 1930s, in other words, as a personification of the Black lesbian as defiant (and attractive) sexual outlaw and masterful camp performer.

150 • Suffering Sappho!

So, how, as many commentators on the infamous 1952 *Ebony* article have asked, did she get to the point of seemingly undercutting this triumphant career as one of entertainment's most spectacular lesbians and falling into relative obscurity? The obvious answer, of course, can be found in the historical consensus about the Cold War period: confronted by the stunning conservative retrenchment and containment of the punishing postwar era, Bentley had to refute, reform, and conform in order to survive. As Garber recounts, Bentley may have continued to thrive throughout the 1930s and even into the war years by cultivating "her large homosexual following" at venues like the Ubangi Club and then transitioning to "gay-identified nightspots" like Mona's in San Francisco after her move out west, but, ironically, these steps would only seal her fate in the McCarthy era when his "anti-Communist campaign fueled anti-homosexual purges, witchhunts, and gay bar raids across the country."[6] Simply put, her signature lesbian identity, which was "once the source of her fame and prosperity," became, after the war, a "dangerous liability." And so, with an elderly mother to support and a career in precarity, she "sanitized her act," donned feminine attire, and "conformed."[7] Yet, in the end, even this apparently chastened capitulation to renewed conservative forces in the dominant white culture would only go so far, as Bentley's career waned and she faded into obscurity after her early death from a flu epidemic in 1960. A brilliant Harlem icon of the 1920s and 1930s, whose "exaggerated, larger-than-life appearances on stage and off" James F. Wilson lauds as "defiantly demand[ing] respect as an African American, a woman, and a butch lesbian," while upending "cultural ideologies associated with race, class, gender, and sexual orientation," Bentley seems to have paid a "terrific price" in the 1950s for her defiance and her bold bulldagger identity.[8] While I do not disagree with this assessment of Bentley's disciplining and tragic silencing after the Cold War period, I do want to consider more critically how, through a different iteration of camp, lesbian identity gets reframed in the era, particularly in the figure of the African American butch "rebel" whom she so clearly presages.

Evocative of the trajectory I mapped for Tallulah Bankhead in chapter 1, the rise and postwar fall of bulldagger blues icon Gladys Bentley is a powerful testament not only to lesbian camp's previously unacknowledged history but also to its adaptability to the tensions of different periods and sociopolitical conditions. In short, Bentley commands a starring role in the 1920s and even 1930s as the defiant, cross-dressing Black lesbian entertainer—camping triumphantly in her performances through her raunchy wit, flirtatious androgyny, and masterful play with popular culture. Like other iconic blues singers, such as Ma Rainey, whose "Prove It on Me Blues" is often held up as exemplary, Bentley embraced what Faderman calls "extreme lesbian stereotypes" like the "mannish lesbian image" of the "bulldyker" as part of crafting the "satirical or funny" songs in her repertoire.[9] In other words, in her songs the exaggerated Black lesbian persona, which "combines images of freakishness with a bravado that is at once laughable and

admirable," works as the fulcrum for the sexual in-joke of the teasing lyrics, undermining male sexual confidence while simultaneously allowing for self-ridicule. The bulldagger as lesbian camp, then, may be "ridiculed for her illicit and unorthodox sexuality," but her bravado, wit, and swagger also make her "an outlaw" or "a bit of a culture hero in an oppressed community."[10] She is the sexual rebel as silver-tongued, inexhaustible comic hero, and Bentley played this role to much acclaim throughout the 1920s and 1930s, and even, less prominently, into the 1940s.

Nevertheless, then come the postwar retrenchment and conservative crackdown, and what is Bentley to do? Where does this camp bravado go? My answer, not unlike in chapter 1, is to propose a camp more suited to the (backlashing) closeted era of the McCarthy age—a camp more suited for survival, more strategic, and one familiar to us now thanks to José Esteban Muñoz. What appears available to Bentley in her 1950s *Ebony* article incarnation, in other words, is a form of *disidentification*, an enactment of lesbian identity refracted through camp, as a strategy for survival.[11] Within the time and milieu of the pre-Depression Harlem entertainment district and other venues within the Theater Owners' Booking Association circuit (also known as the Black Theater Circuit or Chitlin' Circuit), Bentley's bulldyker camp performances might be viewed as what Meredith Heller terms acts of "counteridentification," professing "queer minoritarian affiliation" in a deliberate and public act of "oppositional consciousness."[12] Yet, in the postwar era, such open acts of "oppositional consciousness" and queer identity affiliation, especially for a woman of color, were hardly an avenue to acclaim and popular stardom; quite the contrary, they would be grounds for violent erasure, criminal prosecution, and loss of livelihood and even personal safety.

While I do not believe that Bentley totally capitulated to the social norms of this hostile, repressive atmosphere, as Garber suggests when he claims she "conformed" in her promotion of her hormone-induced heterosexual conversion and "repudiation of lesbian life" in the *Ebony* article, it is clear that pronouncing an openly defiant queer identity at this time would surely have had ruinous and possibly life-threatening effects.[13] But, of course, camp as mode of irony, subverting play, and coded signifiers eschews, in Muñoz's words, "direct confrontation with phobic and reactionary ideologies," achieving instead its cultural and social critique through its more strategic "disidentificatory practices," including parody and a pointed reframing of dominant and popular culture's discriminatory imagery and texts.[14] Thereby, in her *Ebony* "I Am A Woman Again" confessional article, I argue, Bentley constructs a performance of self both passably converted to heterosexuality *and* campily disruptive of such a convenient fiction.

Supported by bold pronouncements and competing photographic and descriptive narrative details, Bentley's autobiographical testimony in *Ebony*'s August 1952 issue confounds the reader with a set of defining contradictions, telling juxtapositions, and performative excesses. Described by James Wilson as

the "ultimate chameleon" and a "gifted, adaptable actor" who confuses our sense of the "real" Gladys in her revelatory confession piece, Bentley paradoxically *appears* to reform herself and renounce her "strange" ways in the article while simultaneously glorifying and cherishing the queer acts she once committed and the rewards they earned her.[15] What one commentator calls the performance "more of a trickster than a reformed B.D.," I recognize as the workings of disidentifying camp—the survival strategy of a queer woman of color adept at working "on, with, and against," as Muñoz would say, dominant culture and its most cherished foundations.[16] For example, both Wilson and Regina Jones note the evident and unflattering contrast set up between her newly reformed and "domesticated" (but relatively lifeless) current persona, represented by a number of recent photographs of her performing domestic chores in a "drab, shapeless white housedress covering her huge body," and her glamorous, lovingly described earlier life as an entertainer in New York City.[17]

Indeed, as Wilson stresses, Bentley's descriptions of her performing attire and accumulations of wealth in that earlier era are particularly diverting. As a kind of realization of the stunning promise offered in the three lower photographs of the opening spread, Bentley guides the reader through the seductive details of her rise to stardom—from her first club flourishing in "immaculate full white dress shirts with stiff collars, small bow ties and skirts" during the "era of the Black Renaissance, that lush period in Negro art," to an "elaborate mid-Manhattan club" on Park Avenue, with its $125-a-week salary and "tailor-made clothes, top hat and tails, with a cane to match each costume, stiff-bosomed shirt, wing collar tie and matching shoes," affording her an apartment on Park Avenue, servants, and "a beautiful car."[18] Yet, for aching contrast, this magnificent tale of making her "Mark in Show Business" sits ironically below two photographs of Bentley now in her "domestic role" (and drab housedress), pictured alone, conspicuously without the husband who had supposedly saved her from her doomed queer life, making up a bed and preparing dinner in, as the caption offers, her "modest, tastefully-appointed home directly in the rear of similar home she purchased for her mother." The stark disparity between a dazzling $300-a-month apartment on Park Avenue and completing chores in a renter's-like cottage behind her mother's modest house in Los Angeles is hard to miss.

Although Bentley's stated intention is to offer her "miracle" of finding the right man, receiving hormone treatments (the "magic of modern medicine"), and happily entering a "normal existence" in order to help "others who are trapped" in the "sex underworld," those "dark recesses" of her supposed queer hellscape not only fail to stay dark for long amidst the lights of Broadway and Harlem club life but also take on the unmistakably campy and absurd tone of the era's pulp fiction.[19] It is not just that Bentley's descriptions evoke for us the "doomed lesbian" of the pulp romances of the era, as Wilson proposes, but in fact, I would argue, in her "melodramatic" language and "histrionic" reversal of identity, she herself employs a camp mode of pulp exaggeration that has the potential to

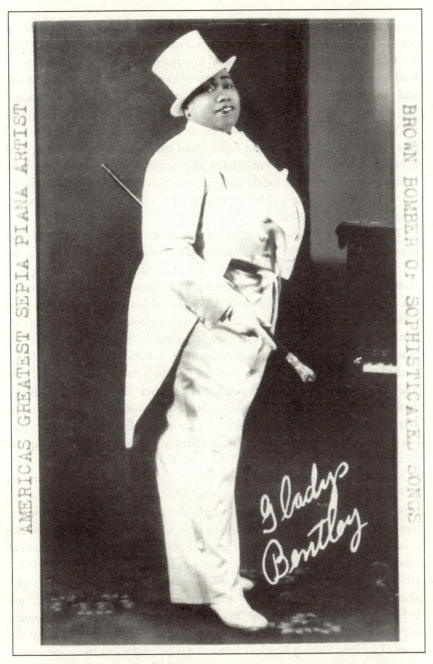

FIGURE 13 "Brown Bomber" Gladys Bentley appears here in the dazzling white top hat and tails of her Harlem heyday.

create a parodic effect.[20] Her opening paragraphs are indeed paradigmatic of the form in their apocalyptic, almost Gothic descriptions of queer life as a "personal hell" for a "legion" of "lost souls," existing in the "half shadow no man's land" of gender and sexual nonconformity—"haunted," shunned and censured, and condemned to a twisted existence of fear, "ostracism," and exploitation.[21] Yet, not only is this opening disarming in its affective appeal and prevailing on our sympathy with its first-person authenticity, as Bentley shifts from "I" to "us" to a rhythmically repeated and beleaguered queer "we" in the first several paragraphs, but its publisher-mandated pulp ending—the renunciation of the twisted twilight existence for the dawn of heterosexual union—is disrupted by troubling juxtapositions and details from Bentley's own redemption narrative, as well as future admissions.

The "brooding self-condemnation" of the personal hell of her queer life—for example, as the successful "male impersonator" Bobbie Minton—surely falters as legitimate denunciation when it leads to fame and, in her own glowing estimation, the "bright lights of storied streets in great cities." To make matters worse, her miraculous marriage to her savior sailor "Don," which should end the pulp fiction with a successful "path of normalcy," is precipitously subverted by a quick admission that the "marriage did not last."[22] In fact, both Wilson and Jones find that Bentley's supposed first groom, columnist J. T. Gibson, to whom she claims in the article she is now "happily married," publicly denied the two were ever wed.[23] Further, as already noted, suspiciously, neither "Don" nor Gibson is evidenced in the many photographs accompanying her autobiographical account, even though she appears with notable male performers like Louis Armstrong in one prominent grouping. She may "hope and pray" in the article that her (apparently) sham marriage to Gibson "will last," but knowing that it never took place to begin with certainly turns this pulp-fiction-like conclusion about her medically achieved womanhood and "happiness" into a particularly stunning example of marital camp. Indeed, one could argue that the awaited punch line for this particular inside joke comes several years later, in 1957, when *Chicago Defender* columnist Alfred Duckett, apparently spurred by Kinsey's recent publication of *Sexual Behavior in the Human Female*, revisits Bentley's conversion story in his article "The Third Sex": in this follow-up article, he finds that Bentley, "soon" after marrying a man, had in fact "returned to her old ways," which, according to him, had included playing the "man" and "husband to a number of women, both colored and white."[24] For proof of her predictable reversal, he recounts the story of a friend visiting Bentley's home and inquiring about two conspicuous photographs on her dresser, which she matter-of-factly identified as "my husband" and then "my wife," pointing to the picture of a woman "with whom the entertainer was currently embroiled." What Jones, in light of this turnaround, postulates as a kind of "mocking tribute" to her conversion therapy and its currency with the "homophobic middle-class black culture" of *Ebony*, I read as

decidedly heavy on its mockery, even as her disidentification might still work to "appease" normative society.[25]

Bentley is certainly working against (and with) powerful cultural forces here, but her disidentificatory practice exhibits a particularly resilient Black lesbian camp. Her confessional piece could be working to position itself within the narratives of "black self-improvement" that historian Gregory Conerly locates in *Ebony* (and its weekly news digest sister publication *Jet*) at the time, which spoke to the assimilationist middle-class values of its readership with a focus on "self-help, material consumption, and social and economic success"; and, thereby, we might view her overt renunciation of lesbianism as a shrewd strategy in a cultural and media milieu openly hostile to gender nonconforming and sexually "perverse" women, even as it proved more tolerant toward male homosexuality and the "drag queen balls" and other performances of Black "female impersonators."[26] This gender imbalance that Conerly locates in the treatment of same-sex desires and gender nonconformity within the two most dominant Black magazines of the 1950s—where male entertainers at nightclubs or the yearly drag balls in New York and Chicago were covered as "social events," while their "female counterparts" were presented as threatening "criminals" or in need of "treatment"—clearly leaves Bentley with a tricky terrain to navigate.[27] Yet, I would argue that there is far too much exaggeration, disruption, and incongruity in her self-improving, straightening tale for it to successfully disappear that original bulldagger swagger, especially when it is campily staring out at us, multiplied, from the very opening page. She might have to dissemble, negotiate, and work with the products of the phobic dominant cultures that wish to excise or merely discipline her in order to survive, but this does not prevent her from being an outlaw. On the contrary, she shows the way forward, obliquely, for outlaws not unlike her during an especially precarious period of queer American life.

Identity Politics, Civil Rights, and the Postwar "Rebel"

I realize, of course, that the reading I have offered above of Bentley's apparent postwar camping might be viewed as a rather (un)healthy dose of revisionist critical history. I could stand accused, as historian David Serlin reproaches others like James Wilson and Carmen Mitchell, of propping up Bentley as a "radical lesbian" icon when her *Ebony* confessional was, genuinely, repudiating her earlier queer identity and validating her new medically achieved womanhood—"a new identity that was heterosexual, feminine, and Christian, made possible by a body that materialized her to desire to enter . . . a respectable socioeconomic niche recognized by the black middle-class mainstream."[28] Am I being naive to include Bentley as "part of a transhistorical continuum of African American lesbians" when what she "desperately wanted" at the time was to be included in the Black middle-class community, which would "lend her respectability and public

legitimacy"?[29] Perhaps, but I am not entirely convinced that Bentley "desperately" wanted to assimilate into the Black middle-class community so much as find success as a performer for their spectating dollars. (To be sure, Serlin's proposal that Bentley was wholly embracing domestic, heterosexual, Christian femininity is patently undercut by her admission in 1957 that she currently shared wedded bliss with both a man and a woman.) I am, indeed, more sympathetic to the performative interpretation offered by Joana "Juba-Ometse" Clayton (also critiqued by Serlin), wherein the artist reimagines Bentley's McCarthy-era disavowal as a necessary employment of the closet for "survival" as a Black woman and lesbian: "In order to make a livin', she had to disclaim."[30] Upholding the value of the closet, Clayton critiques contemporary "privileged and white-run" gay and lesbian groups (in the 1990s) for advocating coming out when their "perception of the closet denies its positive function as a sanctuary for doubly and triply oppressed peoples and works to force African American women artists to abandon the creativity and safety of their privacy, their sanctuary, their community, that is their closet." Anticipating (or performing) Muñoz's disidentifications, Clayton complicates the closet, defining it as a set of practices where women of color can "create different realities, collect tools and strategies for healing the deep and painful wounds of our multiple oppressions, discover a voice and language that is our life, and unearth and affirm out authentic selves."[31] Indeed, this is a pretty good definition of camp—a performance (of a different reality) from within the closet that simultaneously affirms one's authentic self.

Nevertheless, as Serlin describes it, Bentley's apparent strategy in the *Ebony* article to make her gender expression and sexuality conform in order to satisfy (and join the ranks of) the magazine's bourgeois readership exposes conflicting tensions within the African American community at the time about how to best manage newfound economic and political progress. Both Conerly and Serlin view *Ebony*'s readership and editorial position as signaling the conservative thrust of a "new posture for middle-class African American identity built firmly on the foundation of both black consumerism and cultural assimilation," yet this force was met at the time with a counterdiscourse or "competing vision" for how to achieve further political and social gains.[32] The commitment to Black consumerism and integrationist policies and actions shared by mainstream periodicals like *Ebony* and organizations like the NAACP (National Association for the Advancement of Colored People) was countered by activists who advocated for more radical forms of social justice after recognizing how the vestiges of Jim Crow continued to sustain institutionalized racism and inequitable social and economic realities, which disproportionately affected the Black working class. According to Serlin, as the 1950s wore on and civil rights struggles became more acute, these conflicting political visions became almost incommensurate, with the "goals of middle-aged blacks yearning for social respectability" being scorned as "retrograde" by the "expansive vision of young black radicals."[33] In light of this

growing tension, Bentley's *Ebony* story, for Serlin, reveals the "complexities of class politics by showing black American culture at its most reactionary," but in order to do so, the article must work toward and be sincere in an assimilationist endeavor—in Bentley's case, to mimic and earnestly conform to norms of white, heterosexual (feminine) domesticity.[34] Obviously, viewing her performance as camp, I disagree with this assessment on the grounds of her confession's *lack* of sincerity.

Rather than viewing Bentley as embodying and advocating for the "reactionary" assimilationist stance, I see her as enacting a complicated tension similar to what Serlin outlines, at once supporting and subverting the normalizing discourse and cultural conservativism of an aspirational Black middle class. While I would not argue that this necessarily makes her a rebel, an identity I hope to explore further in this chapter, it does challenge both Serlin and Garber's view of her supposed "capitulation to social norms" as either tragic or strategically downplayed by later queer commentators.[35] Her disidentificatory practice can both perform social norms and subvert them, which might not be radical but hardly seems desperate for bourgeois integration. To help elaborate on this complex position and the consequent set of McCarthy-era actions and revelations necessitated by it, one might compare the postwar evolution of Bentley's outlaw status or identity with that of another lauded blues performer and star with a reputation for sexual nonconformity who also experienced career instability and then conflicted success in this same period: Ethel Waters.

In the early 1950s, Ethel Waters rose to the heights of yet another miraculous career comeback with the much-lauded publication of her best-selling autobiography, *His Eye Is on the Sparrow* (1951), at the same time that she starred in one of the great stage triumphs of her career, the Broadway production of Carson McCullers's *The Member of the Wedding* (adapted for Hollywood in 1952), and headlined a successful sitcom, *Beulah*, on ABC. Yet, she struggled not only with financial (and personal) troubles at the time but also with alienating confrontations with the ascendant, normalizing expectations of Black bourgeois organizations. Like Bentley, Waters seemed not to fit within any one community (or identity), but, contrastingly, her response was less one of disidentificatory camp and more clearly a defiant opposition—rebelling against the pressure to conform, even though it made her appear out of step with changing practices and tenets of civil rights activism and negatively impacted her career.

Reaching an almost mythic status by the 1950s, Waters defies any easy explanation. Indeed, as biographer and media scholar Donald Bogle contends, she was "an enigmatic figure, too complicated for most to fully understand," but there is no mistake about her cultural significance, as she achieved enormous star power through her success across entertainment media and eras; she was, in short, "a woman who could do everything."[36] Not unlike Gladys Bentley, emerging from a turbulent childhood of grave poverty (in inner-city Philadelphia and Chester, Pennsylvania), Waters hustled tirelessly to become a top entertainer in Harlem

158 • Suffering Sappho!

and throughout the United States in the 1920s and 1930s—singing risqué songs and dancing her way from the honky-tonks, small clubs, and tents of the Chitlin' Circuit as "Sweet Mama Stringbean" to broad acclaim through many hit recordings, which led to her ascendance to the Broadway stage and eventually to film. The list of Ethel Waters's firsts indeed beggars belief: she was the first Black female performer to star on Broadway in "an otherwise all-white cast," to have her own radio show on a major network, to headline a drama on Broadway (*Mamba's Daughters*), to have her own television show and then, ten years later, headline a nationally broadcast TV series (*Beulah*), to be nominated for an Emmy, and to receive top billing in a major Hollywood production.[37]

Yet, her beleaguered life story and professional controversies have become almost as legendary as her preeminence as a defining entertainer of the century. She became infamous for her demanding and sometimes outrageous behavior in negotiations and rehearsals and on set—most notably when her outbursts and professional resentments alienated her from her fellow cast members on the film *Cabin in the Sky* (Minnelli 1943) and apparently resulted in her being blacklisted from Hollywood for six years.[38] She suffered terrible (and well publicized) financial crises with debts and a long-lasting entanglement with the IRS, not to mention the embarrassing scandal of her fleecing by a live-in male companion who stole cash and jewelry from her home.[39] Moreover, she made no secret of her tumultuous life experiences, as her distressing childhood and personal relationship dramas, publicly with men, became part of her lore. Her sexual intimacies with a number of women, most significantly with dancer Ethel Williams, on the other hand, would remain privileged knowledge for those close to her or "in the life" until long after her death in 1977.[40] In other words, she suffered and persevered through a turbulent life seemingly drawn from the lyrics "Stormy Weather," but she could also be an unmovable and punishing force in advocating for herself or her beliefs. Labeled by one costar "the b-tch of all time," Waters possessed a fierce individuality that resulted in a series of profound contradictions, yet these conflicts demonstrate the struggles of a woman whose intersecting identities—particularly of class, race, and gender—defined her and, at times, fueled her unique rebelliousness.[41]

Indeed, on display in her own *Ebony* article in 1952 (seven months before Bentley's confessional piece appeared), details from Waters's tempestuous life, pulled from her recently published autobiography, served not only to feed her growing lore but also to distinguish her as overtly counter to or outside of Black middle-class respectability and sexual conformity. Opening the essay with characteristic frankness—"This is a story about prostitutes, thieves, pimps, dope addicts and petty hustlers"—Waters immediately anticipates the foreseeable criticism from the Black bourgeois readers of the magazine, the same "holier-than-thou people" who "condemned" her autobiography for calling "a spade a spade" and exposing truths about life "across the tracks."[42] In a pattern that is echoed in her dealings with the NAACP's campaigns against racist media stereotypes, Waters

articulates here her evident class division from the "hincty people" who supposedly look down on her, "because no matter how much I have earned, I have never been one of them," and speaks instead directly to "others" like herself, who might need inspiration for "how faith and fortitude can conquer every ugly, cruel, and squalid circumstance which the world can impose on us."[43] She goes on to recount details of her childhood among those "prostitutes, thieves, [and] pimps" that both made her sexually aware at an early age and explain her "vile tongue," "gutter vocabulary," and, perhaps most importantly, her "toughness" now. Waters's brutally honest recounting of her street and sex education sets the stage for revelations of provocative life events, such as her marriage at the age of thirteen, the physical abuse she suffered, and the ensuing affairs she had with various unreliable men (no women are mentioned), which impress upon her audience not just her disarming authenticity but also her willingness to reject "respectability" for the larger goal of helping or inspiring others.

Clearly not willing to conform to middle-class (and sexist and white supremacist) strictures of apparent modesty, chasteness, and restraint for a "lady" in sexual and romantic matters, Waters goes a step further in the latter half of the article to expose classist colorism in her own community and define herself, as a darker-skinned woman, against it. In one notable example, she uses her unromantic "buddy-pal" relationship with boxer Jack Johnson to reflect on how his preference for white women who "pamper" him teaches a lesson to "we Negro girls" (distinguished from "light-colored" Black girls) who would succeed more by "catering" to their men.[44] Yet, in short order, she contradicts this seeming concession by offering a counterdiscourse gleaned from the "pimps" and "women of the underworld" she grew up with, about the strength and independence of "we Negro girls": the "pimps" of her childhood never seemed to have "trouble" with the white girls "in their stables," who "did as they were told," but the "brown-skin prostitutes" made "all the hell, were the rebellious and independent ones and showed they had minds and wills of their own."[45] Then, as if to prove her own willfulness, Waters proceeds to recount "some unflattering things" about the "Negro men I have known romantically," including her second husband Eddie Matthews and her subsequent cheating lover Eddie Mallory. Declaring herself "no saint," Waters here defies the expectations and classist values of those "hincty people" who might judge her, and, in contrast to Gladys Bentley in her *Ebony* confessions, she vocalizes a rebellious, nonconforming sexual identity, though one not openly queer.[46] Certainly, with a title like "The Men in My Life," Waters circumscribes her defiance in the article within heterosexual borders (with a few of these men, including Jack Johnson and Mallory, pictured for emphasis), yet the *Ebony* piece also clearly emphasizes her power and righteous independence: nearly every accompanying photograph documents one of her past stage and film triumphs, with the exception of the final one, which depicts her in a moment of full-throated laughter while receiving a gold medal from the American National Theatre in honor of the publication of her autobiography.

160 • Suffering Sappho!

What becomes clear in a consideration of Waters's professional and personal choices, her sometimes controversial and complicated positions on issues of civil rights, and her enigmatic public persona is that she possessed an undeniably independent will, but one caught between intersecting identifications, loyalties, and demands. Around the same time as the release of her autobiography, Waters began to distance herself from the NAACP and, particularly, its campaigns against racist depictions in film and television. Since the early 1930s, Waters had committed herself to civil rights activism, including performing at NAACP benefit concerts, participating in fund-raisers for the Urban League and the National Defense Fund, and serving integrally on the Negro Actors Guild of America.[47] However, her participation in this civil rights work was not without controversy, and her reaction to the antiracist stratagems employed by the NAACP in Hollywood (particularly by executive secretary Walter White) could be described as, at best, circumspect.[48] Like fellow actress Hattie McDaniel, Waters straddled two different eras of opportunity for Black performers in the media industry and was divided by her dedication to civil rights and her professional ambitions and financial exigencies.[49] Out of necessity, from lack of opportunity for Black actresses in the pre–civil rights era, Waters had sometimes taken work in films with awful racist imagery, and she and McDaniel, undoubtedly owing to their darker skin and larger body type, came to symbolize for many viewers the figure of the "mammy," perhaps the paragon of outmoded racist menial types favored in Hollywood.[50] Nevertheless, during and after World War II, an increasingly empowered NAACP pushed back against these demeaning portrayals of subservient and debased African Americans on-screen and were joined by critical condemnation in the Black press and an increasingly mobilized audience discontent. Caught in the middle, of course, were Black actors and actresses trying to balance their own strong social justice convictions with professional (and monetary) needs.

Ethel Waters thereby navigated a difficult path to create more nuanced performances than perhaps her critics at the time acknowledged, but she clearly also refused to comply with or uncritically accept the normalizing currents of assimilationist Black organizations like the NAACP. Working between the "narrow range and parochial," clownish performance styles of the Chitlin' Circuit and the approach of new icons of the civil rights era such as Lena Horne, Waters infused her long-suffering but noble domestic characters with a kind of moral weight and emotional significance that belied any easy dismissal as an empty, white-serving type and, in Patricia White's terms, offered instead a "reworking of the mammy stereotype" through strength of personality and the gravitas of personal experience.[51] Still, her greatest roles—such as her Oscar-nominated turn as Granny/Aunt Dicey in *Pinky* (Kazan 1949) and her headlining triumph as family cook Berenice in *The Member of the Wedding*—were not without ideological compromises or free from antiracist critique, as when *Pinky*'s casting of a white actress in the "tragic mulatto" lead role and its white supremacist

ending drew reproach from the NAACP.[52] Therefore, when Waters agreed to star in the new television version of radio hit *Beulah*, she must have begrudgingly expected the ensuing criticism of yet another (and less substantive) domestic servant role.

A hit for CBS radio in the 1940s, *Beulah* transitioned to television in 1950 hardly seeming to acknowledge the changing postwar political atmosphere that was beginning to reckon with racial inequities and discrimination. Although no longer played by a white male voice actor in the broadest caricature and thick dialect of its vaudeville roots, prewar radio's popular "queen of the kitchen" moved to ABC television as a kind of star vehicle for headliner Waters but without revising its same basic retrograde premise and broad comedy.[53] With "queen" housekeeper and cook Beulah still loyally solving contrived problems for her bland white suburban employers, the Hendersons, the television show—also starring Butterfly McQueen as Beulah's friend Oriole and Percy "Bud" Harris as her boyfriend Bill—may have been the first to center on a Black female lead, but her wide (never complaining) smile harked back too plainly to the "all-knowing, all-seeing, all-hearing, all-understanding mammy figure."[54] As her opening cry "Did somebody bawl for Beulah?" portends, each episode revolved around her answering the call and magically rescuing the bumbling Hendersons ("Mr. Harry" and "Mrs. Alice," to her). Whether fixing a meal debacle to impress her employer's business associate (with cornbread and greens, no less), babysitting a young hellion to allow the Hendersons to have a double date, or surreptitiously catching a fish to buoy up Mr. Harry's manhood, Beulah endured the kind of outmoded scenarios, shared with other "familiar types" such as Oriole, her high-pitched "flighty" friend, and her loutish, always hungry, and inept beau Bill, that would be sure to disappoint Walter White and the NAACP, who were at the time focused on a high-profile pressure campaign against CBS's hit *Amos 'n' Andy* (1951-1953).[55]

But, again, saddled with clearly substandard, even regressive material, Waters subtly reworked the mammy type in *Beulah*, avoiding "heavy dialect and a fake hearty laugh" and instead injecting her own considerable life experience and feeling into the character.[56] The show also provided a chance, especially for its many Black viewers, to witness moments of companionship between people of color apart from the white household, which allowed Waters to complexify the character even more. In one of the few available episodes from the first season ("Bill, the Babysitter"), an early scene shows Waters's more naturalistic style and sharper wit as she sardonically chastises and teases McQueen's "mental case" Oriole over her flirtations with the ice delivery man—a kind of secreted authenticity that ironically undercuts her smiling accommodation of Mrs. Henderson shortly thereafter.[57] (She has similar unaffected and sincere interactions with boyfriend Bill as well.) Flashing in these scenes the sort of biting aside that Eve Arden's fellow spinster Miss Brooks would trade in weekly, Waters could only take this reworking so far in a white supremacist industry, and she certainly centralizes

162 • Suffering Sappho!

authentic feeling over camp parody. Regardless, and perhaps predictably, her efforts went unnoticed by the Black press, who called her out for participating in material that "defiles and desecrates colored people . . . as buffoons, slavish menials, and ne'er-do-wells."[58] Although there are some reports of Waters pushing back against the show's racist caricatures, as when she stopped one of her young costars from being put in "pickaninny braids," she ultimately chose to leave the "white folks kitchen comedy role" (as she described it in *Jet* magazine) rather than openly protest it.[59]

Although *Beulah* received far less attention in comparison with the major campaign against *Amos 'n' Andy*, it clearly placed Waters in a familiar bind as a Black performer caught between her financial concerns and political convictions, but it also might elucidate her frustrations with and resistance to the conservative, classist underpinnings of the NAACP's activism. As Thomas Cripps has documented, the significant and well-publicized protests and attempted boycotts targeting CBS's *Amos 'n' Andy* exposed a troubling class prejudice in the NAACP-led activism, with the protesters seemingly most "on edge" only about the show's ridicule of Black *middle-class* life and at odds with a large proportion of the Black viewing audience who enjoyed the show for its comedy and for its mainstream representation of "people of their own color, performing for people of every color," as the *Pittsburgh Courier* put it.[60] Waters might not have commented publicly on her own show or about the NAACP-led boycott of *Amos'n'Andy*, but she was less shy about critiquing generally what she saw as its classist double standards.[61] Toward the end of her autobiography, she declares her discomfort and, in fact, disagreement with the normalizing and assimilationist discourse of those Black bourgeois organizations with the "highest ideals," who have "done a great deal in the fight to win Negro equality," but who make a "mistake," for her, "when they protest showing colored people as they really are," as "thieves and murderers and wife-beaters," as well as "geniuses and saints."[62] Declaring herself a "blood sister" of the "Negro as he is," who has managed to "survive," she rejects campaigns for "respectable" imagery that would portray Black characters as "neat, clean Elsie Dinsmores and Little Lord Fauntleroys"—in other words, as "white" and "damn bores"—and embraces and champions instead complexity and unique identities that enact varying senses of race, class, gender, and sexuality. Unlike Bentley in her *Ebony* article, Waters here quite openly rebels against the normalizing impulses of the ascendant Black bourgeoisie and navigates her own path through an experience of multiple oppressions, but, notably, she must do so while also closeting her queer sexuality. It will be left to younger, up-and-coming performers, like Stormé DeLarverie, to forge a new defiant path to *queer* self-enunciation.

Twenty-Five Men and Girl: A Butch Outlaw for the McCarthy Age

In his expansive critical work *Rebels: Youth and the Cold War Origins of Identity*, Leerom Medovoi argues for a new understanding of the archetypal postwar rebel—the (usually white) "bad boy" of so many cultural imaginings—and his connection to the sort of identity politics that Ethel Waters seems to trouble and confound. Grounded in psychosocial theories of influential thinkers like Erik Erikson, the concept of identity, for Medovoi, becomes wedded to youth in the Cold War era and is then used to bolster the idea that young rebels represent a revolutionary "sovereign independence" or "sovereign selfhood," fighting against the debilitating standardization and compliance of Fordist mass culture, consumerism, and conformist suburban life.[63] That this "sovereign" identity was typically figured at the time as white, hypermasculine, and male makes sense to Medovoi because "it was a masculine conception of the people's sovereignty and self-determination that Fordist conformity allegedly jeopardized," and, therefore, his one chapter of female rebels typically reframes them in terms of their relationship to this originary "bad boy."[64] However, more concerning for my present argument is the way in which Medovoi posits this foundational bad boy as a model for what we have come to know as identity politics in the latter decades of the twentieth century, contending that this "rebel figure" and his "identitarianization" was "embraced and deployed" by movements for "Black liberation, women's liberation, or gay liberation" to offer a narrative of self "establishing its psychopolitical autonomy in a struggle against an authoritarian world of 'role expectations.'"[65] While he is careful to qualify his contention of influence of the Cold War bad boy on these liberation movements by recognizing their long activist histories before the midcentury, his focus on identitarianization and their adoption of it does tend to reproduce one of the central limitations of identity politics—its neglect of intersectionality.

The example of Ethel Waters, and, as I explore below, Stormé DeLarverie, suggests not only that an identity politics of a nonconformist Black female rebel existed alongside the white male examples Medovoi favors but also that women experiencing and articulating discontent with multiple oppressions would trouble his argument were they to be considered. (He chooses, for instance, Ann Bannon's lesbian pulp novel *Odd Girl Out* as his representation of the "coming out of lesbian identity," which is separated in the same sentence from Lorraine Hansberry's *A Raisin in the Sun* as it contrastingly establishes the "assertion of black female identity.")[66] The rebel girl of his configuration, then, can be white and queer or Black and female, but the queer Black girl rebel, despite the reference to Hansberry herself, remains invisible.[67] But to be fair, his disregard of Black lesbian subjectivity is hardly remarkable, since, as Lisa Walker argues, the "equation of lesbianism with whiteness" in the United States seems to ensure the "cultural invisibility of the black lesbian," particularly in popular culture of the twentieth century.[68] Although Walker focuses her analysis on the rare

164 • Suffering Sappho!

figure of the "passing" feminine Black lesbian (in Ann Allen Shockley's ground-breaking 1974 lesbian pulp *Loving Her*), I would like to consider the visibility and influence of the more common—although still markedly underrepresented—figure of the butch lesbian of color, often figured in the "black 'bulldagger,'" who, like Gladys Bentley, is typically "both dark and masculine."[69] In the stage career and Cold War experiences of camp performer and cross-dressing emcee Stormé DeLarverie, I argue, we can recognize not just a queer Black rebel girl to challenge Medovoi's formulations but a complex butch lesbian identity too rarely acknowledged in feminist criticism and queer histories.

In the increasingly well-documented, preserved, and publicized histories of influential LGBTQ+ Americans and activists of the twentieth century, few have come to embody the rebel hero quite like Stormé DeLarverie. Immortalized, despite her own reticence, as the "cross-dressing lesbian" who supposedly "threw the first punch" that helped spark the riots at the Stonewall Inn in the early hours of June 28, 1969, Stormé has become almost legendary since her death (at ninety-three) in May 2014 as a defender of the queer community and warrior for civil rights.[70] From her act of "civil disobedience" on that night, and for the next several decades, this biracial performer, bouncer, and self-appointed guardian of New York City's queer community (particularly young lesbians) cultivated a butch persona of classic rebel iconography, varying between a black motorcycle jacket, which is preserved at the New York Public Library's Schomburg Center for Research in Black Culture, and a work outfit often composed of a blue jean jacket, jeans, and boots, topped with a black cowboy hat.[71]

Completed with a permitted gun in a holster on her hip, Stormé's common presentation as the defending "Cowboy of the West Village," as she is identified in a recent podcast, seemed drawn right out of Medovoi's bad-boy era. In the words of Lisa Cannistraci (a friend and the owner of Henrietta Hudson, the lesbian bar where Stormé worked the door "with an iron fist and a pistol on her hip"), she exuded the "swagger of James Dean" when "watching out for her own," particularly her "baby girls."[72] Earning her membership in the Stonewall Veterans Association, her actions that night perhaps consolidated a strong protective and defensive inclination already present in her, encouraging her into a full-time role as a "vigilante defender of the defenseless," a rebel "warrior" for the queer community.[73] Yet, in that era dubbed "pre-Stonewall," the gender performance of this (in)famous "cross-dressing lesbian" was not yet so codified or, perhaps more importantly, so aggressive and threatening in its presentation of masculinity. In other words, before the Stonewall Rebellion, Stormé did not yet quite signify bad-boy rebel, even as her theatrical performances, I argue, can be viewed as camp defiance.

Meredith Heller, in a recent work adroitly endeavoring to redefine drag and other gender-bending practices, reads closely DeLarverie's theatrical performances, as well as her actions on that fateful June night in 1969, to argue for her particular employment of "queer butchness" in acts of *counteridentification*, from the 1950s

through the post-Stonewall era. Opposing the label "male impersonation," which was historically attached to DeLarverie's performances as emcee of the renowned Jewel Box Revue, Heller proposes instead the term "queer butchness" for her gender-bending performance that was "not designed to reveal the feminine woman or respectable lady under the stage persona," as would have been typical of earlier white male impersonators, but was meant to demonstrate "the performer's investment in being both personally and socially identified as queer."[74] This investment, which Heller aligns with earlier jazz and blues performers like Glady Bentley, Ma Rainey, and Ethel Waters, commits Stormé to engaging in acts of counteridentification, which not only signaled her same-sex attractions but also expressed her political and personal solidarity with other queer folks: "For DeLarverie specifically, queer butchness was both a celebrated professional endeavor and a means of aligning with queer family, taking pride in a queer identity, and standing in solidarity with a persecuted queer community."[75] While recognizing that the idea of "a butch" typically "names a masculine lesbian woman," with "queer butchness" Heller seeks to open up the term to be considered "a readable form of cultivated cultural masculinity" detached from medical birth assignment, and she queers it by recognizing the performer's intent to be read as "queer"—to "appear to the audience as a noncisgender identity expression."[76] In Stormé's case, her performance act "was intended to express a form of masculinity that comfortably fit with a nonman body," but it also announced itself as queer to "attract women's sexual attentions" and to profess support for her queer community.[77] Although I do not disagree with Heller that DeLarverie created a "personal queer counteridentity," I do contend, as the second half of her chapter implies, that this counteridentification is most clearly articulated *after* Stonewall and that her butch performance during her tenure at the Jewel Box Revue (from 1955 to 1969) might be more accurately termed "disidentification."

Memorialized and probed in Michelle Parkerson's influential short documentary *Stormé: Lady of the Jewel Box* (1987), the famed Jewel Box Revue both embodied and radically subverted the stifling containment culture and phobic tensions of postwar America. Introduced into the Miami club scene in 1939, Doc Brenner and Danny Brown's Revue of "Femme-Mimics" aspired to bring back the glory days of vaudevillian female (and male) impersonation with the lavishness and expanse of a great variety show. In fact, by the time Stormé joined the production in 1955, Brenner and Brown had successfully incorporated several key components from that tradition—a "performing emcee, several singing starlets, some comedy skits, burlesque stripteases, and up to three large ensemble dance numbers"—to create the only racially integrated troupe of touring female impersonators (plus the "one girl" of its advertisements) in the country. The extravagant Jewel Box Revue played clubs and theaters across the nation for over thirty years, from smaller nightclubs known to cater to gay clientele to the great theaters of the Theatre Owner's Booking Association circuit (like the Apollo), as well

as the more mainstream venues like Loew's State Theater on Broadway.[78] As the emcee of the Revue, typically dressed in a fine black-jacketed tuxedo or similarly elegant tailored suit, DeLarverie opened the show, introducing the female impersonators and transitioning into the original opening number, and continued in a unifying role throughout transitions, even joining in to sing on individual and group songs and playing bit parts (as a sailor or maharajah) in later skits.[79] In her own words in Parkerson's film, Stormé, who had been performing as a female-presenting big band singer known as Stormy Dale, now was the male impersonating master of ceremonies of the Jewel Box who "ran the show."

In many ways, the Jewel Box Revue was an *exceptional* show for its time. It aspired to be the kind of lavish performance spectacle that had gone out of fashion at least twenty years before, with seemingly no expense spared on production details like sequins, wigs, and feathers and a high live-performance standard demanded of the players. In Stormé's reminiscences with longtime friend and costar Robin Rogers (in *Stormé: Lady of the Jewel Box*), they venerate the extravagance and excellence of the show in its postwar heyday, with specialized sequin machines in use and Doc and Danny spending perhaps "$100,000 on feathers alone." A two-hour-long variety showcase of singing, dancing, comedy, and theatrical sketches (and no lip-synching), the Jewel Box featured some of the most admired female impersonators of the 1950s and 1960s, such as Rogers and (most famously) Lynne Carter, offering the height of professional quality for often three or four live shows a day, at a variety of venues across the United States, Canada, and Mexico.[80] Although their slick program books for the Revue conclude with a wink to the audience that they have just enjoyed "the World's most unusual show," producers Danny Brown and Doc Brenner (the "Boy-ological Experts" introduced in the back pages) insist upon their return to and elevation of the "true art" of female impersonation with the "very finest talent" in the country: they promise to bring back the "glories of a neglected field of entertainment"; or, as the introduction "It's an Old Mannish Custom" asserts, in a lineage going back to the "days of Elizabethan theater" when young men played "feminine roles" like Juliet, the Jewel Box Revue continues this art form in its "true and original sense."[81] As would befit such a revered and first-rate performance piece, the Jewel Box played to a broad and diverse set of audiences, to which its programs' venue lists and photographs attest—from the Fox Theatre in Detroit and the Riverside Casino in Reno to the Palomar Club in Vancouver and the El Capitan Theater in Hollywood—and even to some clubs (not listed) with primarily queer clientele, such as the Garden of Allah cabaret in Seattle, which featured the Revue on its opening night in 1946.[82]

Yet the astonishing postwar success of the Jewel Box manifests, one might say queerly, the ruling paradoxes of the era. According to Elizabeth Drorbaugh, the kind of risqué female impersonation as vaudevillian "family entertainment" that the Jewel Box produced was long past its "golden age" (in the first twenty years of the century), and since the 1930s, it was supposed to have moved

"underground" to become "adult entertainment" in night clubs, "'queer joints,' and formal drag balls," clearly no longer "family trade" but stigmatized by 1955 when Stormé joined; still, as Drorbaugh contends, almost in disbelief, "the Jewel Box Revue played on."[83] Brown and Brenner were intent on offering glorious entertainment for as wide an audience as they could get away with, which means, as it is described by Bobby Schiffman, the former manager of the Apollo Theater, that the "glamorous" Jewel Box Revue may have been "away from the normal fare of the Apollo," but it was still "good family entertainment"—a "wholesome" show involving "a lot of very talented people" who performed in a "very business-like manner."[84] While Schiffman does recognize the "gay community" as "big supporters of the show," he asserts that the "general people of the community" loved it as well. Contrary to Heller, who admits the Jewel Box and Stormé "attracted" and navigated a "variable audience base" but then focuses primarily on the reception and knowing readings by "a queer crowd or a crowd familiar with Black women's performance traditions" (i.e., blues "butch" performers like Bentley), I would argue a key to understanding the Jewel Box's unique historical significance rests in its camp path to success for both mainstream and minority audiences.[85] The Jewel Box and Stormé's "gender deception," as photographer Penny Coleman calls it, befit its time because it *could* bring its "exotic, transgressional musical theater"—its "fabulous queens in sequins and feathers, high headdresses, high heels, high camp"—straight into the mainstream as well as to the "queer crowd," at once "challenging the narrow prohibitions of the McCarthy years" and heeding them.[86]

Stormé's role in this significant example of postwar camp paradox should not be underestimated. As the crooning, debonair master of ceremonies, DeLarverie counterbalanced and (nearly) grounded all those sequins with her slim-tailored, suave masculinity. In terms of her butch presentation, one might argue that she shares commonalities with the "nelly butch" that Sue-Ellen Case describes surfacing in conjunction with "hippie" culture in 1960s San Francisco, which she counterposes to the "classic" working-class butch of the lesbian bar scene by emphasizing the softness, "gallantry," and sexual pleasure in acting like "gentlemen" with the femmes.[87] While no film recordings of the Jewel Box during this period are available, the many archived programs and booklets for the showcase offer a sense of the butch performance that emcee Stormé presented: a boyish nightclub crooner in the early days who transforms into more of a smooth "Harry Belafonte" type as the 1960s progress.[88] A handful of the Jewel Box programs include a full-page spread devoted to "Miss Storme De Laviere [sic]," the "only girl with the Jewel Box Revue," who once performed "as a female vocalist with many named bands" but who was convinced by her "deep baritone voice" and the producers to "work as a male impersonator," which is confirmed in early versions by a series of accompanying photographs (from medium to close distance) of a slight, younger Stormé with a blonde flattop and fitted black tuxedo, as well as one headshot of her with darker hair and a pencil mustache.[89]

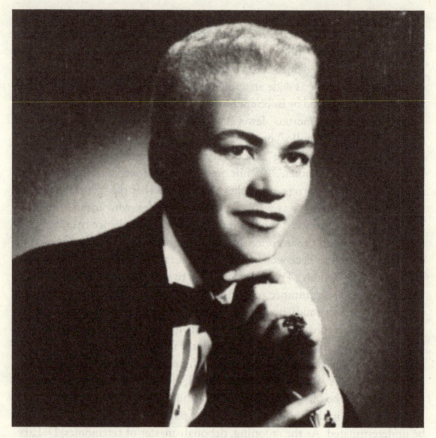

FIGURE 14 In promotional materials for the Jewel Box Revue, a young Stormé DeLarverie presents a slim-tailored, suave masculinity. Image courtesy of JD Doyle, *Queer Music Heritage*.

The later programs without the full-page spread feature at least one portrait introducing DeLarverie, who appears older and more gentlemanly now with a pronounced widow's peak and a dark, tailored men's suit, as well as some performance stills, the most prominent of which presents Stormé in full frame onstage, mid-croon. This later incarnation, perhaps most famously captured by photographer Diane Arbus for her 1961 "Full Circle" series, clearly embodies the "Harry Belafonte" butch style that director Michelle Parkerson admires so much: Stormé poses with the easy demeanor of Arbus's "the Lady Who Appears to be a Gentleman" in a broad-shouldered, fine men's suit, pencil tie, and casual hand rested on a knee (complete with pinkie ring and lit cigarette).[90] She could be a member of the Rat Pack, one feels, if she could just take some time away from the demanding schedule of the Jewel Box Revue.

In fact, at the end of Parkerson's film, we do get a sense of this particular suave butch style, as the film closes with a singing gig of Stormé's at Trivia! in New

York City. Carried over from shots of Times Square with a piano musical bridge, we first see a spotlighted Stormé from long distance fronting a three-piece band toward the back of the club; her rich baritone voice serenades the audience with the opening lines of Chet Baker's "There Will Never Be Another You." Corded silver microphone held expertly in her hand, Stormé exudes the cool confidence of a seasoned nightclub singer, dressed in a characteristic black tuxedo and with a now gray widow's peak. As Parkerson cuts to a close-up in profile, Stormé's masculine glamour (marked by a whisp of a mustache and a prominent gold ring on her right hand) and smooth performance style hint at the butch charm she once employed to oversee the Jewel Box. As if to stress this very point, Parkerson moves from an extreme close-up on DeLarverie's pitch-perfect final note and bow to the crowd at the contemporary night club to the film's credit sequence, which is essentially narrated by a rare recording of Stormé's nightly voice-off intro to the Jewel Box Revue—"the world's foremost female impersonators in the world's most unusual show"—that usually preceded the original opening number, "Can't Do a Show Without Girls." This opening number, in which the emcee did not appear, seemingly aimed to initiate the audience into the art of female impersonation, with the performers changing into their costumes, wigs, and feathers as they sang and processed across the stage, but it was Stormé's "disembodied voice of a woman being read as a man"—a voice one reviewer mistakenly likened to a bad (man's) "impersonation" of Tallulah Bankhead—that set up and concluded the show.[91] Her "slick masculinity," typical for nightclub male impersonators in the early postwar period, is thereby established as integral to the glamorous entertainment on offer.[92]

Although she was the one "girl" among twenty-five lauded female impersonator divas, Stormé DeLarverie remained central to the show's McCarthy-era camp incongruities. Like the biographical elements and headshots in the programs for the show, as well as the opening number and the "reveals" in the finale, which ground the performers in a supposedly real gender identity beneath the costumes, Stormé's verifiable sexual difference *could* reinforce a heteronormative binary by working against the ambiguity and play of the gender-bending performances. In other words, her participation, according to Drorbaugh, "rectifies the potentially unsettling gender play and alludes to heterosexual presence just by being there" and, at worst, merely serves as a mirror for the male performers: "the negative image of their impersonations, and, as a woman, her lack differentiated her and affirmed them as men."[93] In fact, Heller reproduces a photograph from several of the program booklets to affirm this sense of DeLarverie's role in creating "heterolooking romantic tableaux" with its "strong visual appearance of opposite-gender romantic interest and binary gendered coupling."[94] In it, Stormé, in a white tuxedo, poses on venue stairs with an extravagantly feathered Lynne Carter as if caught, for Heller, in a "modern prom photo," her gallant, tall masculinity magnifying Carter's sequined femininity. But, to read this image as solely reifying the heteronormative binary and the supposed

FIGURE 15 Stormé DeLarverie and Lynne Carter's prom pose both performs a "heterolooking romantic tableau" and burlesques it. Image courtesy of JD Doyle, *Queer Music Heritage*.

naturalness of gender, one must completely disregard the irony and parodic excesses of camp so evidently at play.[95] DeLarverie's tuxedo jacket appears too large for her, and her domineering position over Carter's shoulder is only achieved by standing on the step above, appearing like a child dressed up in a parent's clothes, while Carter's extravagant drag—in full makeup, platinum wig, and black-and-white feathered headdress and boa draped over a fabulous sequined jumpsuit—screams famous showgirl, not sweet prom date. In other words, the image campily both performs a "heterolooking romantic tableaux" and burlesques it.

That Stormé's butch presence can both reaffirm the heteronormative gender binary and destabilize it through camp's excesses, coded references, and pointed incongruities is further confirmed by another group of performance stills offered in the programs that document her role as the Jewel Box's resident "sailor." In spreads advertising the signature numbers of the Revue over the years, professionally composed photographs of the "Can-Can Production" and/or "Can-Can Chorus" frequently appear, with the former picturing a valorously posed young sailor in his dress white uniform at the base of an imposing elevated triangle of can-can girls, rising up the steps behind him and flanking him on the stage on his left and right. In some programs, this chivalrous attendant comes into closer view in a full-frame shot of the sailor, microphone in one hand and hat tipped rakishly askew, holding the hand of one of the chorus girls as if presenting her to the audience and serenading her at the same time; the caption reads, "Miss Storme De Larverie and Mr. Fran Novak," although the names sit below the wrong performers (Stormé's sailor is on the right of the frame).

In an early 1960s program available at the Queer Music Heritage archive, not one but two of these individual sailor images join the Lynne Carter "prom" photo as glimpses into the show, doubling the photo with Fran Novak with another pairing sailor Stormé with can-can girl and famed "male toe dancer" Mr. Jan Britton.[96] In this second image, DeLarverie's singing sailor stares admiringly down toward Britton's shapely legs as their joined hands hold up the dancer's diaphanous train and Britton looks out to the crowd from underneath an enormous, shimmering hat. Again, as with the "prom" photo, Stormé's masculine sailor's pairing with the voluptuous dancers helps fix a "heterolooking romantic tableaux" of binary gender, but the flagrant parading of queer cultural signifiers is also pretty hard to miss. As George Chauncey establishes, the sailor, "seen as young and manly, unattached, and unconstrained by conventional morality," had played a significant role in gay male subculture—for instance, as "the central masculine icon in gay pornography"—even before he became part of the "rough" trade along the waterfront and Bowery in the early years of the twentieth century.[97] Moreover, with the show touring in the aftermath of World War II, the Jewel Box's reference to military life had to carry (for some audiences) the signification of the complex gay and lesbian postwar coming-out moment in port cities that is documented by historians such as Allan Bérubé, as I discussed in chapter 1.

Signaling its debt (and tribute) to those earlier revues that made the Harlem nightspots of Gladys Bentley's heyday so chic and successful, the Jewel Box Revue also promised a lavish spectacle that could campily play to both mainstream and queer audiences. Like Bentley's 1934 "King's Terrace Revue" at Harlem's Lafayette Theater, which, despite homophobic reviews, drew ample spectators for its "dirty" numbers pairing characteristically white-tuxedo-clad Gladys with an all-Black male chorus of sailors, the Jewel Box Revue flirted with censure because of its queer splendor (and inside jokes) but continued to draw in a general

audience.[98] In the early 1960s, the recognition of its disturbing gender-bending and sexually transgressive content can be found in (unsuccessful) local attempts to ban the Jewel Box, such as in Reno, Nevada, where city council members attempted but failed to stop the show by passing an ordinance prohibiting "local shows in which one sex impersonated another," or in protests against its "dregs and drags of society" (this last quote belonging to the sign of picketers outside the Apollo Theater, where the Jewel Box was enjoying yet another standing-room-only Sunday evening show).[99] While one can certainly argue that "less restrictive norms concerning the Jewel Box Revue's gender representation occurred in the black community at the time," as Conerly shows in his work on Black popular magazine coverage of female impersonators at drag balls, the relative acceptance of its form of entertainment, touring throughout North America for decades, exceeded the apparently more tolerant Black theater circuit's audience.[100] Its appeal for queer spectators, while somewhat self-explanatory, necessitates, I believe, a closer consideration of Stormé's particular role and butch performance.

What I would ultimately argue is that Stormé's tenure in the Jewel Box Revue and her butch presentation *before* Stonewall demonstrate a distinctive form of campy gender-bending and minoritarian defiance particular to the period and underrecognized in feminist and queer criticism. The "slick masculinity" of the tuxedoed male impersonator emcees who preceded her in the Greenwich Village nightclubs of the 1940s—those "butch crooners" whom Lisa E. Davis compares to Errol Flynn, with "beautiful, androgynous faces with smooth cheeks and sculpted jaws"—clearly better fits DeLarverie's butch style in this period than the rougher masculinity of leather jackets and blue-jeaned rebellion in later years.[101] Although she might have picked up some inspiration from the Revue's "Minnie of the Golden West" number, with its white fur chaps, cravats, and small cowboy hats, Stormé's masculine presentation perhaps owes more to the white-tuxedoed and ambiguously identified "dandy 'bulldagger'" who preceded her, combining sophisticated and high-class masculine markers like the "top hat and tails" with gender queering signifiers, such as, in Gladys Bentley's case, a "heavily made up" face.[102] It is also significant, I believe, that this form of butch style enunciates and develops itself in a shared milieu with gay men and often in Black community spaces—in Bentley's case, surrounded by a gay sailor chorus onstage in Harlem, or in DeLarverie's with a troupe of the "world's foremost female impersonators."

Like Heller, who recognizes Stormé's professional adoption of masculine drag at the same historical moment when performers like Gladys Bentley were abandoning their "queer butch acts," I foreground her for creating a particular butch camp style for the McCarthy age by drawing from a complex interplay of racial, classed, and gender identities, but I understand it as a disidentificatory practice aimed at surviving in that particularly dangerous atmosphere.[103] As she recounts in Parkerson's film and in other interviews, Stormé DeLarverie "grew up hard in New Orleans with mixed blood," the child of a well-to-do white man

and a "black servant" in his household, deemed "illegitimate" because in 1920 it was illegal for a white man to marry a Black woman. Although it appears that she lived with foster parents for much of her youth and had enough means to become "an accomplished equestrienne," Stormé suffered a great deal growing up as a target of discrimination, in one instance permanently injuring her leg when classmates hung her upside down on a fence.[104] As she states in the short documentary "A Stormé Life," she grew up a "Negro with a white face," who had to learn to stop running and "fight," and who evolved into her gender presentation, moving from the femininity of her early big band days to the charismatic butch masculinity of the Jewel Box Revue.[105]

At some point around her Jewel Box days, she stopped wearing women's clothes "on the street" and in her personal life, since, as she jokes in "A Stormé Life," she "got picked up twice for being a drag queen," and fostered her own version of a nonbinary identity. She often refused questions of confirmed gender identity—for example, responding to Avery Willard's question of whether she "preferred to be called 'he' or 'she'" with a careful redirection, "Whatever makes *you* feel most comfortable."[106] Despite audiences seeing "what they wanted to see," ultimately, she felt a steadfast core identity that she defends to Parkerson: "I model myself after me. All I did was cut my hair and change. I walked the same. I talked the same. I was king of the mountain, and I intended to stay that way." In other words, DeLarverie forged a path through multiple systems of oppression and inequity that evaded normalizing binaries: growing up "hard" but keeping, as she tells Parkerson, "a touch of class"; bending both femininity and masculinity to suit her professional and personal needs; and blurring racial identity wherein she identified as Black but could be read, sometimes preservingly, as White.[107] Moreover, as Coleman notes, she "never called herself a lesbian," but she was devoted to her female partner of twenty-six years, Diana, and became a noble defender of her "baby girls" at the landmark lesbian bars the Cubby Hole and then Henrietta Hudson's in her later life.[108] She certainly came to signify "lesbian," especially after the lore of Stonewall set in, but she did not attach the term to herself, and she also maintained very close ties to the gay men she knew and performed with in the Jewel Box Revue. She was, in short, a *queer* champion, without necessarily using that term either; really, she was just Stormé.

Not unlike Ethel Waters, Stormé DeLarverie, then, constructed her own unique, complex, and defiant selfhood, eschewing easy definition but learning how to survive, queerly, with far-reaching effects. When asked at the beginning of "A Stormé Life" who she is, Stormé responds simply, "I am a human being that's survived and helped other people survive." I would argue that in the period before Stonewall she does this through camp's disidentificatory practices onstage and off that work as "public and semipublic enactments of the hybrid self"—a biracial woman of color performing an alluring butch masculinity softened by a "touch of class" and "dandy" feminine touches for queer and mainstream audiences often receptive to her multiple bendings.[109] While these performative

174 • Suffering Sappho!

disidentifications can "offer the minoritarian subject a space to situate itself in history and thus seize social agency," we cannot forget that they are, at their core, survival strategies. Stormé's tenure with the Jewel Box was during an era when she could be arrested for not wearing at least three garments of women's clothing, when the show was protested and sneered at in headlines as "Lads-in-Drag & One Mustachioed Girl, or Limp-Wrist Time on Broadway," and when male impersonators of color like her were presented as criminals or as "needing treatment" in popular magazines such as *Ebony* and *Jet*.[110] She performed a butch masculinity that when revealed as belonging to a female body would have been interpreted as the sign of an *invert*—a lesbian confused in her own gender identity and most likely an aggressive predator bent on corrupting suburban wives—and, to make matters even worse, this impersonation seemingly "parodying the attire of power and privilege," Parkerson reminds us, is "especially disconcerting when embodied by a black woman."[111] And, yet, Stormé played on, charming audiences from the Garden of Allah to the Apollo Theater.

Surviving (and indeed, at times, thriving) in the postwar period for Stormé entailed a bit of camp in her butch performance. In fact, the clever play of camp—its passing and magnificent failure to pass—might have helped make this survival possible. Yet, as Halberstam has argued, too rarely have feminist and lesbian critics connected the "understatement and cool macho" of artful male impersonations like DeLarverie's to the "ironic gender practice" of the modern drag king who campily exaggerates "for theatrical and often comic effect."[112] Halberstam argues, instead, that we might "resist making generalizations about lesbian culture based on the studies and oral histories of white lesbian communities"—such as Kennedy and Davis's influential *Boots of Leather, Slippers of Gold*, which finds "nothing really humorous or theatrical about butch artifice" for the subjects in their oral history—and perhaps look more closely at "black lesbian communities" that could have "housed and nurtured drag performances" imbued with a camp humor not fully recognized.[113] A performance like Stormé's, with its artful defiance and intersectional strategies, challenges us, I believe, to reconsider and complicate that historical record. If one views camp as "a mode of enacting self against the pressures of dominant culture's identity-denying protocols," particularly for women of color, as Muñoz does in examining the lesbian camp of *Carmelita Tropicana*, then Stormé's butch performance could be understood as a way to realize or visualize a lesbian identity in the postwar moment, although one obscured by the overdetermined equation of lesbianism with whiteness (both then and now).[114] Long before she allegedly threw that "first punch," Stormé walked the path established by queer Black female stars like Gladys Bentley and Ethel Waters and redefined the butch rebel, cut to the measure of the times.

Epilogue

At the close of the previous chapter, the life and entertainment career of Stormé DeLarverie posed a challenge, I argued, to common conceptions of the 1950s "butch" in critical discourse and queer histories where this figure is most often presented as the courageous, pugnacious white working-class defender of the isolated lesbian bars of the period, as well as of her prized femme partners. For example, although Robin Maltz distinguishes Stormé's masculine performance as "slick" and "handsome, suave, talented," like those earlier male impersonators playing to mob-run nightclubs of the 1930s and 1940s, she also identifies DeLarverie as a "stone butch," whose gender presentation (onstage and off) endangered her during the "social climate of State-sanctioned homosexual intolerance" in the 1950s, when "butch/femme communities" and bars experienced violent persecution, and her rebellious nonconformity made her a "risk-taking provocateur."[1] Significantly, Maltz then goes on to differentiate the "dangerous persona" of a "handsome 'he-she'" male impersonator like Stormé from "contemporary US drag king performers" (in the late 1990s) whose "parodic" performance of "manliness" had "lost a certain edge of decadence and risk" and seemed more suited for "trendy urban magazines" and "lurid TV talk shows." What Maltz is referring to, of course, is the more recent (and relatively mainstreamed) popularity of campy drag king performances that became a staple of 1990s queer nightlife and lesbian entertainment venues. It is, in fact, this more recent drag phenomenon that encouraged Halberstam, whom I quote at the end of the last chapter, to examine the racial dynamics of drag king performance and male impersonators like Stormé to propose "different traditions of cross-dressing and drag for different lesbian communities."[2] But in order to do so, Halberstam must address the relative "lack of a lesbian drag culture" historically and the conclusion by theorists such as Esther Newton that "camp has not worked for

'kings'" in the past when "lesbian appropriation of camp" was rare and politically unsuccessful owing to "asymmetries of masculine and feminine performativity within a male supremacist society."[3] That is, until the 1990s.

During queer theory's rapturous engagement with camp in the 1990s, the idea of lesbian camp, although still much less frequently considered, gained prominence, as I mentioned in the introduction, largely due to Sue-Ellen Case's widely cited and queried "Towards a Butch-Femme Aesthetic." Case's postmodern and winning "dynamic duo" of the butch-femme lesbian couple "playfully inhabiting the camp space of irony and wit, free from biological determinism, elitist essentialism, and the heterosexist cleavage of sexual difference" inspired academics (and drag kings) to embrace camp and its apparent gender-bending and denaturalizing effects, but certainly not all feminist and lesbian readers were so moved.[4] In perhaps one of the most thorough essays to consider the question of whether lesbians, in fact, do camp, Esther Newton builds on her landmark ethnographic work in *Mother Camp* to counter Case's theorizing with a bit of historically and socially grounded accounting: beginning with her experience of none other than Stormé DeLarverie's performance as the "one girl" in the Jewel Box Revue, Newton answers her own question ("Did lesbians do drag?") with a definitive rebuttal: "Yes, but not as often as gay men, and with far less impact."[5] The "utterly serious" butch-femme culture and experiences of lesbian communities in the 1950s and 1960s, for Newton, were definitely not "ironic," humorous, or prone to light theatrical "parody" as in gay male culture, with its "fabulous and bittersweet excesses of the camp drag queen," and, worse, to conflate the butch with the drag queen heedlessly disregards "the greater power of gay men than lesbians within every socioeconomic class and ethnic group" and the privilege this affords them to define social space (as in Cherry Grove) and cultural production (in camp performance).[6] Without the same financial and cultural dominance, she recounts, the lesbians of the beach community of Cherry Grove, who "could and did deploy camp humor informally," remained on the "edges of queen-centered camp" performance until about the mid-1990s when a larger lesbian presence (and power) tipped the scales; accordingly, Case's camp argument, for Newton, should be read as more of a contemporary "manifesto" than a study, calling forth an expansion of "lesbian power" in the "synthesis of lesbian traditions—butch-femme and feminism—with gay male culture (queer identity, camp theatricality, and modes of sexual behavior and imagery)."[7] In sum, "white urban" lesbians of the 1990s, then, might adopt camp culture but only as a sign of access to certain (gay) male privileges.

Yet, the manifestation of postwar lesbian camp (and camping) that I have examined in this book was, of course, the product of an earlier historical moment and often-shared community spaces for gay men and lesbians—a closeted existence producing perhaps the high-water mark of camp in the United States before Stonewall and "pride" utterly changed it. Although many commentators have insisted that its presumed "death" has been largely (and repeatedly) exaggerated,

the camp I have been describing in these pages was discredited and checked on many fronts before its queer return in the 1990s. Not only was there an abandonment or plain rejection of a certain kind of gay male camp after Stonewall as gay liberation replaced the closet with a political investment in identity, pride, and open civil rights activism so that, for example, "gay diva worship" became for younger men the "degrading and politically repugnant fantasy of the self-loathing pansy whose dependence on the escapism of cinema must be ritually purged from our system"; but, what I have identified as lesbian camp also met its own particular challenges over the next twenty years of feminist thought and activism.[8] First, and perhaps most obviously, connections between lesbians and camp practices that were cultivated predominantly by gay men would be severed by many feminists in the 1970s who viewed them as fostering an apparent self-annihilating alignment with the "culture, practices and principles of male-supremacy," in Marilyn Frye's words, which should place lesbian feminists and gay men in "antithetical" relation to each other politically.[9] But also, as many feminist historians have documented, lesbian feminism in the 1970s and 1980s harshly critiqued and disciplined butch-femme identities that seemed to reemerge (with a difference) in queer camp glory in the 1990s.

A central factor in what one might call the disappearing act of lesbian camp after Stonewall surely must be found in the contestations within Western feminisms around same-sex desires, gender, and essentialist notions of "women's" liberation. Specifically, the rejection of butch-femme as a "heterosexist imitation of the oppressive gender roles" was, according to Roof, central to lesbian feminists' "necessary political tactic" at the time of "championing women" and relationships between women-identified women, but it was also "limited by the idea of the truth of binary gender which would lead only as far as separatism and equal rights."[10] The emergent political identity of the lesbian feminist fought against "male supremacist" culture and renounced the heterosexual oppression evident in "regressive and anti-political practices" like butch-femme identifications, as well as alliances with gay men—a political stance partly evidenced in Newton's history of camp on Cherry Grove.[11] Yet the essentialism at the heart of this "necessary political tactic," which even tied it to homophobic liberal feminists of the Second Wave, became, of course, its central flaw according to the ascendant gender theorists of the 1990s, when, Roof recognizes, "a shift" in political tactics moved away "from a model of identity oppression . . . to strategies of play, performance, in-your-face revelation, and the reaffirmation that sex and gender are not as aligned as we thought."[12] In another turnabout, then, the antiessentialist tactics of parody and performance in a world of gender trouble brought camp back to center stage, but within a "queer" (not necessarily lesbian-identified) frame.

Writing nearly thirty years after the queer 1990s resurgence of camp and its progressive mainstreaming by media sensations like *RuPaul's Drag Race,* I find myself still struck by the questions of lesbian identity and privilege that troubled

178 • Suffering Sappho!

Newton and Case all those years ago. Ultimately, I have sought to pursue a middle way, perhaps a bit more like Case, where I look back to a time *before* the "queer ascension" of camp, when, for her, a bit of "revisionist history" burned up ties to the old "lesbian body" and valorized "gay male practices" so that the "new queer dyke is out to glue on that gay male mustache and leave those dowdy, gynocentric habits behind."[13] But, the lesbian camp that I locate in that postwar moment also counters a lesbian feminist revisionist history (or just incomplete history) that, I believe, disappeared this earlier camp in service of a favored mythic narrative of the Cold War era—what I explored in chapter 1 as the "bad gay past" that preceded Stonewall, which, for Love, grounds the "linear, triumphalist view" of queer history that she hopes to confront.[14] In fact, in the autobiographical essay "Making Butch," Case herself attempts to fill in a bit of this incomplete history by reasserting a "common" lesbian practice of camp in her own San Francisco youth when the "King and Queen of North Beach" were crowned at an annual "joint event," "boys bars" hosted "some wonderful women entertainers" (as well as, of course, Sunday brunches), and the "practice of drag and the enjoyment of multiple sexual partners circulated between gay and lesbian bar cultures," along with the "clipped, ironic, playful travesties" of camp.[15] Citing a practice that "probably did not play in, say, Buffalo," Case elevates a lesbian history too rarely glimpsed and one that might allow us not just a richer view of the past but also a stronger sense of a lesbian identity in the present. Hence, the idea of lesbian camp as a part of our history deepens not just our understanding of so-called liberation and identification but also the enduring drive for survival.

Acknowledgments

This book was brought to fruition only through the generous support, time, and efforts of many individuals and key institutions. Without two different awards from the College of Arts and Sciences at the University of Alabama, I never would have been able to hold Stormé DeLarverie's leather jacket or read through Tallulah Bankhead's Scotland Yard file, much less have the funds for the cover image I so desperately wanted. Yet, these travel and research endeavors were only possible once we could all actually travel again, and so I must express my enormous gratitude for those individuals who took pity on us researchers during the long period of COVID closures. Particularly, I would like to thank the staff at the Schomburg Center for Research in Black Culture for their support during the shutdown by giving me access to digital scans of a large portion of Stormé DeLarverie's collected papers, and to single out one particular reference librarian, Malea Walker in the Serial and Government Publications Division of the Library of Congress, who pulled and scanned rare issues of *Wonder Woman* at a time when even *her* access to the library was restricted to every other week. You all were a lifeline. Much of chapter 2 was published as "Voyage to Camp Lesbos: Pulp Fiction and the Shameful Lesbian 'Sicko,'" in the collection *Sontag and the Camp Aesthetic: Advancing New Perspectives*, edited by Bruce Drushel and Brian Peters (Lanham, MD: Lexington Books, 2017), and an abbreviated version of chapter 3 was published as "'A Strange Desire That Never Dies': Monstrous Lesbian Camp in the Age of Conformity," in *Discourse: Journal for Theoretical Studies in Media and Culture* 38, no. 3 (Fall 2016): 356–389. With these two publications, I recognize the kind and steady support of Bruce Drushel, who not only embraced a work that no one else seemed to want but also always found a place for my lesbian camp excursions in many LGBTQ studies panels at the PCA/ACA National Conference over the years. Likewise, I would be remiss if I didn't acknowledge the timely and insightful guidance of Pam Wojcik, who

180 • Acknowledgments

may feel it is a small thing to talk down an anxious scholar during her lunch break but who, in fact, kept this big boat moving through a moment of perilously icy waters. To my colleagues in New College at Alabama (past and present), I must thank you so much for nurturing a work and learning environment that not only encourages interdisciplinary play but also commits wholeheartedly to social justice and community change, and without leadership like that provided by Natalie Adams and Julia Cherry, none of us would be successful at either. Special thanks go to Nicole Solano at Rutgers University Press for steering this project through the challenging twists and turns of the pandemic publishing moment and for her expert responses to what must have seemed like a million nervous questions. Finally, I want to acknowledge my beloved crew of COVID companions: Henry and Maisie, who seem to take everything in such brilliant and inspiring stride—from global health crises and school closures to having two moms in semirural west-central Alabama. You make your moms so proud. And, at last, so much gratitude for my Lucy, who is always asked to play the straight man to my lesbian camp antics and yet still seems to love me anyway.

Notes

Introduction

1 David M. Halperin, *How to Be Gay* (Cambridge, MA: Belknap Press of Harvard University Press, 2012), 179.

2 Elly-Jean Nielsen, "Lesbian Camp: An Unearthing," *Journal of Lesbian Studies* 20, no. 1 (2016): 121. See also Annamari Vänskä, "Bespectacular and Over the Top: On the Genealogy of Lesbian Camp," *SQS: Queer Mirror Perspectives* 2, no. 7 (2008): 66–80.

3 Katrin Horn's *Women, Camp, and Popular Culture: Serious Excess* (Cham: Palgrave, 2017) includes a chapter on lesbian camp, but she focuses on two films (*But I'm a Cheerleader* [Babbit 1999] and *D.E.B.S.* [Robinson 2004]) from the late-1990s and early 2000s, when "lesbian chic" and New Queer Cinema might realize B. Ruby Rich's "Great Dyke Rewrite" of popular culture (37). See Mikaella Clements, "Notes on Dyke Camp," *The Outline*, May 17, 2018, https://theoutline .com/post/4556/notes-on-dyke-camp?zd=1&zi=t47oqckh, for a theorization of a contemporary "dyke camp." The term "pre-Stonewall" refers, of course, to the time period before the series of civil rights rebellions, protests, and riots in the late 1960s that are most famously represented by the Stonewall uprising in June of 1969 when LGBTQ+ protestors confronted police outside the Stonewall Inn in New York City.

4 Sue-Ellen Case, "Towards a Butch-Femme Aesthetic," rpt. in *The Lesbian and Gay Studies Reader*, ed. Henry Abelove, Michele Aina Barale, and David Halperin (New York: Routledge, 1993), 305. Cleto expresses concern that Case's work has been so influential that other analyses of lesbian camp have failed to emerge in its shadow. Fabio Cleto, "Introduction: Section II, Flaunting the Closet," in *Camp: Queer Aesthetics and the Performing Subject, a Reader*, ed. Fabio Cleto (Ann Arbor: University of Michigan Press, 1999), 94. José Esteban Muñoz, *Disidentifications: Queers of Color and the Performance of Politics* (Minneapolis: University of Minnesota Press, 1999), 136.

5 Pamela Robertson, *Guilty Pleasures: Feminist Camp from Mae West to Madonna* (Durham, NC: Duke University Press, 1996), 9; Nielsen, "Lesbian Camp," 131.

6 Andrea Weiss, *Vampires and Violets: Lesbians in Film* (New York: Penguin, 1992), 4.

182 • Notes to Pages 2–5

7 Allan Bérubé, *Coming Out under Fire: The History of Gay Men and Women in World War II, Twentieth Anniversary Edition* (Chapel Hill: University of North Carolina Press, 2010), 86. See also George Chauncey, *Gay New York: Gender, Urban Culture, and the Making of the Gay Male World, 1890–1940* (New York: Basic Books, 1994), especially chapter 10.

8 Steven Cohan, *Incongruous Entertainment: Camp, Cultural Value, and the MGM Musical* (Durham, NC: Duke University Press, 2005), 13, 16.

9 See Daniel Harris, "The Death of Camp: Gay Men and Hollywood Diva Worship, from Reverence to Ridicule," *Salmagundi* 111 (Fall 1996), 166–191, for an influential instance of the postmortems on camp.

10 Richard Dyer, "It's Being So Camp as Keeps Us Going," in *Camp: Queer Aesthetics and the Performing Subject, a Reader*, ed. Fabio Cleto (Ann Arbor: University of Michigan Press, 1999), 110.

11 Esther Newton, *Mother Camp: Female Impersonators in America* (Chicago: University of Chicago Press, 1979), 105–106, 110–111.

12 Newton, *Mother Camp*, 100. In a later essay, Newton clarifies that from her experience, "camp style" was centered on the "figure of the queen" and, therefore, belonged to a "gay male sensibility" and culture "not easily appropriated by lesbians" and particularly not by butch-femme identities that "lacked the element of humor and light theatricality" that camp requires; lesbians might appropriate "gay male practices," but their lack of privilege and subordinate position as women would typically have denied them access. Esther Newton, "Dick(less) Tracy and the Homecoming Queen: Lesbian Power and Representation in Gay-Male Cherry Grove," in *Inventing Lesbian Cultures in America*, ed. Ellen Lewin (Boston: Beacon Press, 1996), 164–165.

13 Sue-Ellen Case, "Tracking the Vampire," in *Writing on the Body: Female Embodiment and Feminist Theory*, ed. Katie Conroy, Nadia Medina, and Sarah Stranbury (New York: Columbia University Press, 1997), 381; see also Sue-Ellen Case, "Making Butch: An Historical Memoir of the 1970s," in *Butch/Femme: Inside Lesbian Gender*, ed. Sally R. Munt (London: Cassell, 1998), 43, for her assertion that camp was very much a part of "lesbian bar discourse" in San Francisco, in an often shared "social intercourse" with gay men.

14 Kennedy and Davis acknowledge camp as a survival strategy of resistance through "wit, verbal agility, and sense of theater" but find it not "adequate to meet the challenges lesbians faced," where the butch, for example, "carried the burden of twentieth-century women's struggle for the right to function independently in the public world." Elizabeth Kennedy and Madeline Davis, *Boots of Leather, Slippers of Gold: The History of a Lesbian Community, 20th Anniversary Edition* (New York: Routledge, 2014), 383.

15 Newton, *Mother Camp*, 106.

16 Susan Sontag, "Notes on 'Camp,'" in *Against Interpretation and Other Essays* (New York: Farrar, 1966), 277. Cleto makes a persuasive case for not getting hung up on this defining "opposition" of camp since both "deliberate" and "naive" camp are "inextricably intertwined under the aegis of *performance*." Fabio Cleto, "Introduction: Queering the Camp," in *Camp: Queer Aesthetics and the Performing Subject, a Reader*, ed. Fabio Cleto (Ann Arbor: University of Michigan Press, 1999), 24.

17 Christopher Isherwood, "From *The World in the Evening*," in *Camp: Queer Aesthetics and the Performing Subject, a Reader*, ed. Fabio Cleto (Ann Arbor: University of Michigan Press, 1999), 51.Sontag, "Notes on 'Camp,'" 275.

18 Sontag, "Notes on 'Camp,'" 280.

19 Sontag, "Notes on 'Camp,'" 275.

Notes to Pages 5–9 • 183

20 Philip Core, *Camp: The Lie That Tells the Truth* (London: Plexus, 1984), 9.

21 Chuck Kleinhaus, "Taking Out the Trash: Camp and the Politics of Parody," in *The Politics and Poetics of Camp*, ed. Moe Meyer (London: Routledge, 1994), 188, 189.

22 Kleinhaus, "Taking Out the Trash," 185.

23 Dyer, "It's Being So Camp," 112–113; Harris, "Death of Camp," 167–168.

24 For Doty's admirable attempt to open up "camping in culture" to all sorts of spectators, specifically lesbians in his second chapter, see his *Flaming Classics: Queering the Film Canon* (New York: Routledge, 2000).

25 Roberston, *Guilty Pleasures*, 15. I find it significant that Robertson's most stunning example of lesbian camp, "riddled with double entendre" and "butch-femme role-play," is found right in the middle of the 1950s—Ray's technicolor "failed" Western *Johnny Guitar* (1954) (112).

26 See the comments above by lesbian feminists such as Kennedy and Davis, who corroborate this serious disposition for many lesbians (esp. note 14). However, anyone who would deny lesbians a devastating camp sense of humor should perhaps take in Hannah Gadsby's 2018 tour-de-force *Nanette*. Rox Samer's recent "Introduction" to their book *Lesbian Potentiality and Feminist Media in the 1970s* (Durham, NC: Duke University Press, 2022) provides an excellent overview of the long history of lesbians, particularly lesbian feminists, being portrayed as humorless, or what Sara Ahmed terms a "killjoy." Sara Ahmed, *Living a Feminist Life* (Durham, NC: Duke University Press, 2017), 222.

27 See the remembrances of one lesbian pensioner in Sasha Gregory Lewis's *Sunday's Women: A Report on Lesbian Life Today* (Boston: Beacon Press, 1979), 58, for an account of lesbian friends gathering to listen to Bankhead's radio show "every Sunday afternoon."

28 Audre Lorde, *Zami: A New Spelling of My Name* (Berkeley, CA: Crossing Press, 1982), 177.

29 Quinlan Miller, *Camp TV: Trans Gender Queer Sitcom History* (Durham, NC: Duke University Press, 2019), 89.

30 Jack Babuscio, "The Cinema of Camp (AKA Camp and the Gay Sensibility)," in *Camp: Queer Aesthetics and the Performing Subject, a Reader*, ed. Fabio Cleto (Ann Arbor: University of Michigan Press, 1999), 126–128.

31 Moe Meyer, "Introduction: Reclaiming the Discourse of Camp," in *The Politics and Poetics of Camp*, ed. Moe Meyer (London: Routledge, 1994), 1 (my emphasis).

32 Michael Bronski, *Culture Clash: The Making of Gay Sensibility* (Boston: Sound End Press, 1984), 43. Bronski insists on a "political" purpose for camp as a "means of communication and survival" for "gay people." He finds it not just political but "progressive"; yet at the same time, he denies camp to most women who rarely have "the privilege or the power to take the prevailing culture and turn it around to their own advantage" (107).

33 Dyer, "It's Being So Camp," 111, 114.

34 Robertson, *Guilty Pleasures*, 16.

35 Terry Castle, introduction to *The Literature of Lesbianism: A Historical Anthology from Ariosto to Stonewall*, ed. Terry Castle (New York: Columbia, 2003), 6.

36 Castle, introduction, 7, 11, 17.

37 Castle, introduction, 18.

38 Terry Castle, *The Apparitional Lesbian: Female Homosexuality and Modern Culture* (New York: Columbia University Press, 1993), 3.

39 Nancy Adair and Casey Adair, *Word Is Out: Stories of Some of Our Lives* (New York: Dell Publishing, 1978), 56; Lorna Gufston, "Butch," *Sequel* 15 (1980): 8–10. See

184 • Notes to Pages 9–11

Veronika Koller, "Butch Camp: On the Discursive Construction of a Queer Identity Position," *Gender and Language* 3, no. 2 (2009): 249–274 for a reading of Gufston's essay as camp.

40 In yet another example of her own camp writing, Case unabashedly admires the "colossus" of Harris's wicked camping in "Toward a Butch-Feminist Retro-Future," in *Cross-Purposes: Lesbians, Feminists, and the Limits of Alliance*, ed. Dana Heller (Bloomington: Indiana University Press, 1997), 206–207. Bertha Harris, *"What We Mean to Say*: Notes toward Defining the Nature of Lesbian Literature," *Heresies* 3 (1977), 5–6.

41 Muñoz, *Disidentifications*, 1–5.

42 The essay is reprinted in Terry Castle, *The Professor: A Sentimental Education* (New York: Harper Perennial, 2010).

Chapter 1 The Big "Lesbian" Show in Postwar American Culture, a History

1 As early as July 24, the press was already anticipating the August release of the impending K-Bomb, a momentous, even atom-splitting, occasion expected to have an "explosive effect" on America. John Geiger, "Kinsey's Second Book Called a 'K-Bomb,'" *Atlanta Daily World*, July 24, 1953, 4.

2 James H. Jones, *Alfred C. Kinsey: A Public/Private Life* (New York: W. W. Norton, 1997), 700. *Time* magazine reported on the ballyhoo created by Kinsey's book release stratagem as the "biggest and raciest commotion the world's press had seen in years." "K-Day," *Time*, August 31, 1953, 52.

3 Bingham's work documents how the British press devoted "acres" of coverage to the second volume's release, with no fewer than eight of the largest national Sunday papers featuring Kinsey. Adrian Bingham, "The 'K-Bomb': Social Surveys, the Popular Press, and British Sexual Culture in the 1940s and 1950s," *Journal of British Studies* 50, no. 1 (January 2011): 171–172.

4 Sarah Igo, *The Averaged American: Surveys, Citizens, and the Making of the Mass Public* (Cambridge, MA: Harvard University Press, 2007), 237. Igo notes that, additionally, an abridged condensation costing a quarter sold nearly 750,000 copies.

5 Jones, *Alfred C. Kinsey*, 574.

6 Igo finds that discussions of the Kinsey Report went as far afield as a Town Hall Lecture Series in Beaumont, Texas, to the Council of Jewish Women in Birmingham, Alabama. *Averaged American*, 238. Popular culture produced Mae West's "Open Letter" to Kinsey in *Cosmopolitan* magazine and Martha Raye's controversial, flirtatious light comic hit "Ooh, Dr. Kinsey," which some radio stations banned, while fashion designers used the report as inspiration for dresses. Albert Deutsch, "The Kinsey Report and Popular Culture," in *Sexual Behavior in American Society: An Appraisal of the First Two Kinsey Reports*, ed. Jerome Himelhoch and Sylvia Fleis Fava (New York: W. W. Norton, 1955), 384–385.

7 Kinsey earned the sort of celebrity reserved for "a flock of Hollywood starlets," replete with autograph seekers and global name recognition, even joining Joe DiMaggio and Tyrone Power on *Focus* magazine's list of the "10 Sexiest Men in the World." Igo, *Averaged American*, 238. For comparisons with scientific forebears, see "All About Eve: Kinsey Reports on American Women," *Newsweek*, August 24, 1953, 68, 70–71.

8 John D'Emilio and Estelle R. Freedman, *Intimate Matters: A History of Sexuality in America* (New York: Harper and Row, 1988), 285.

Notes to Pages 12–15 • 185

9 Journalist Amram Scheinfeld likened the experience to the extraordinary safe-guards of "an atom-bomb project," where he had fallen into "soundproofed chambers" like an "Alice in Wonderland." "A Social Scientist's Evaluation: Kinsey's Study of Female Sexual Behavior," *Cosmopolitan*, September 1953, 29.

10 Grace Naismith, "The Great Kinsey Hullabaloo!," *Los Angeles Times*, August 9, 1953, J6-7.

11 Geiger, "Kinsey's 2nd Book Called a 'K-Bomb,'" 4.

12 See the Jones biography for discussion of the critiques of the first volume raised by the likes of Lionel Trilling and psychologist Lewis Terman, questioning his skewed sampling methods and supposed disregard for the psychological complexity of human relationships, especially pages 588–594.

13 Quote from *U.S. News and World Report*, cited in Jones, *Alfred C. Kinsey*, 703.

14 Billy Graham, "The Bible and Dr. Kinsey," in *I Accuse Kinsey*, ed. E. J. Daniels (Orlando, FL: Christ for the World Publishers, 1954), 104, 106; John S. Wimbish, "Kinsey in the Light of the Bible," in *I Accuse Kinsey*, ed. E. J. Daniels (Orlando, FL: Christ for the World Publishers, 1954), 113, 118.

15 Millicent C. McIntosh, "I Am Concerned," in *An Analysis of the Kinsey Reports on Sexual Behavior in the Human Male and Female*, ed. Donald P. Geddes (New York: E. P. Dutton, 1954), 140. Democrat Louis B. Heller famously demanded a postal ban and called for a congressional investigation into the female volume even though he had not read it, claiming it contributed to "the depravity of a whole generation." "Post Ban Urged on Kinsey's Book: Heller, Brooklyn Democrat Asks Action Pending Inquiry into Text by Congress," *New York Times*, August 30, 1953, 78.

16 "All About Eve," 71. The *New York Times* waited a day before releasing its bloodless summary, taken from the Associated Press. "Kinsey Releases Report on Women," *New York Times*, August 21, 1953, 15. See also Alton Bakeslee, "Dr. Kinsey Reveals Data on Women," *Los Angeles Times*, August 21, 1953, 2.

17 Scheinfeld, "Kinsey's Study," 30, 32; Albert Deutsch, "How Kinsey Studies the Sexual Behavior of American Women," *Women's Home Companion*, August 1953, 36.

18 "Medicine: 5,940 Women," *Time*, August 24, 1953, 53; Lena Levine, "A Woman Doctor Interprets What Kinsey's Report Means to Women," *Woman's Home Companion*, August 1953, 30. See also Wilton Krogman, "The Kinsey Report: Lifting Sex above Half-Truth Level," *Chicago Daily Tribune*, September 13, 1953, B3. Several critics, as well as biographer Jones, also recognize how Kinsey's focus on heterosexual marriage encouraged these responses and showed how he mirrored the "values" of the times. See Amanda Littauer, *Bad Girls: Young Women, Sex, and Rebellion before the Sixties* (Chapel Hill: University of North Carolina Press, 2015), 86.

19 Jones, *Alfred C. Kinsey*, 706–707, 708–709.

20 Jones, *Alfred C. Kinsey*, 709.

21 Elaine Tyler May, *Homeward Bound: American Families in the Cold War Era* (New York: Basic Books, 1988), 16–18.

22 May, *Homeward Bound*, 90–91.

23 May, *Homeward Bound*, 107–108.

24 For example, Meyerowitz contends that, for women, "domestic ideals co-existed in ongoing tension with an ethos of individual achievement." Joanne Meyerowitz, "Beyond the Feminine Mystique: A Reassessment of Postwar Mass Culture, 1946–1958," *Journal of American History* 79, no. 4 (March 1993): 1458.

25 Marilyn E. Hegarty, *Victory Girls, Khaki-Wackies, and Patriotutes: The Regulation of Female Sexuality during World War II* (New York: New York University Press, 2008), 158.

186 • Notes to Pages 15-17

26 Hegarty, *Victory Girls*, 162. As Littauer establishes with ample evidence of wartime and postwar "female sexual agency" and other challenges to gender hypocrisies, the "intense contradictions in postwar sexual culture" hardly went uncontested, specifically by women and girls. *Bad Girls*, 12, 17.

27 Donna Penn, "The Sexualized Woman: The Lesbian, the Prostitute, and the Containment of Female Sexuality in Postwar America," in *Not June Clever: Women and Gender in Postwar America, 1945–1960*, ed. Joanne Meyerowitz (Philadelphia: Temple University Press, 1994), 360, 361.

28 Penn, "Sexualized Woman," 361, 359.

29 In fact, the evidence Penn cites for the uproar created by the publication of Kinsey's studies largely focuses on the male volume. "Sexualized Woman," 378. For the impact of Kinsey's revelations about sexual activities between men, see Miriam G. Reumann, *American Sexual Character: Sex, Gender, and National Identity in the Kinsey Reports* (Berkeley: University of California Press, 2005), 165.

30 Kinsey notoriously did not break down his data by race even though he interviewed a number of African American women. Claiming too small a sample size of nonwhite respondents, he chose to merge his white and nonwhite interviews and to admit that his findings really only applied to white American women, even though they were often viewed as applicable to the average American woman—implying, of course, as Reumann argues, that the "average American woman, in the Kinsey Report as in the popular media, was white." *American Sexual Character*, 114–115. For reaction to this disparity, see Leisa Meyer, "'Strange Love': Searching for Sexual Subjectivities in Black Popular Print Culture," *Feminist Studies* 38, no. 3 (Fall 2012): 625–657.

31 Alfred C. Kinsey, Wardell Pomeroy, Clyde Martin, and Paul Gebhard, *Sexual Behavior in the Human Female* (Philadelphia: W. B. Saunders, 1953), 474–475.

32 The *New York Times*'s abridgement of the AP coverage did not even mention Kinsey's findings on female homosexuality. The *Washington Post* chose to include one small bullet point but noted the findings paled in comparison with the male study, where the numbers were "three times as great." "Kinsey Releases Report," 15; Nate Haseltine, "Dr. Kinsey Reports on Study of Women's Sexual Behavior," *Washington Post* (August 21, 1953), 1.

33 A dwarfing 70 percent of the females involved in homosexual experiences reached orgasm 90–100 percent of the time, as compared with their heterosexual sisters. Kinsey, *Sexual Behavior*, 467.

34 For example, Littauer's work establishes a clear response from lesbians and other queer women in their private letters to Kinsey at the institute, both commending his work and seeking his advice. Littauer, *Bad Girls*, 97–101.

35 Reumann, *American Sexual Character*, 126. Locating competing views on Kinsey's work, Reumann suggests, ultimately, that the surfeit of varied postwar sexual expertise confounded any hope to contain sexuality or come to easy conclusions about what constituted normal or abnormal behavior, for example, blurring the line between heterosexuality and homosexuality (104).

36 "Statistician of Sex," *Time*, September 3, 1956, 64; Lyn Pederson, "A Tribute to Dr. Kinsey," *ONE*, August–September 1956, 7.

37 Peterson, "A Tribute to Dr. Kinsey," 8–9For an account of Kinsey's meetings with and advice to the members of the Mattachine Society, see Jones, *Alfred C. Kinsey*, 674–677.

38 "Dr. Alfred Kinsey—in Memoriam," *The Ladder* 1, no. 1 (October 1956): 11.

39 In addition to the flood of letters from gay men that Kinsey received (and dutifully answered), lesbians also voiced their debt to him. See Jones, *Alfred C. Kinsey*, 708.

Notes to Pages 17–21 • 187

40 D'Emilio and Freedman, *Intimate Matters*, 291–292.
41 D'Emilio and Freedman, *Intimate Matters*, 294.
42 Allan Bérubé, *Coming Out under Fire: The History of Gay Men and Women in World War Two* (New York: Free Press, 1990), 228.
43 John D'Emilio, *Sexual Politics, Sexual Communities: The Making of a Homosexual Minority in the United States, 1940–1970*, 2nd ed. (Chicago: University of Chicago Press, 1998), 100.
44 Lillian Faderman, *Odd Girls and Twilight Lovers: A History of Lesbian Life in Twentieth-Century America* (New York: Penguin, 1991), 126–127. For all these reasons, D'Emilio and Freedman name World War II as "something of a nationwide 'coming out' experience." *Intimate Matters*, 289.
45 Angela Weir and Elizabeth Wilson, "The Greyhound Bus Station in the Evolution of Lesbian Popular Culture," in *New Lesbian Criticism: Literary and Cultural Readings*, ed. Sally Munt (New York: Columbia University Press, 1992), 97.
46 Reumann, *American Sexual Character*, 173–174.
47 Faderman, *Odd Girls*, 157. Similarly, Franzen's study of autonomous lesbians at midcentury paints a desperate picture of the postwar "backlash" against lesbians, who found "uniformly negative images of twisted and pathetic lives." Trisha Franzen, *Spinsters and Lesbians: Independent Womanhood in the United States* (New York: New York University Press, 1996), 134, 135.
48 David K. Johnson, *The Lavender Scare: The Cold War Persecution of Gays and Lesbians in the Federal Government* (Chicago: University of Chicago Press, 2004), 80. Johnson shows that after months of investigating the security threat of homosexual governmental employees, the congressional committee did not find "a single example of a homosexual American citizen who had been blackmailed into revealing state secrets" (114); yet, gays and lesbians were surveilled by the FBI, questioned, fired, or forced to resign, and excluded from employment (159).
49 D'Emilio and Freedman, *Intimate Matters*, 293–294. In the wake of the arrest of three men in Boise for supposed sexual acts with teenagers, the area went into a panic, including a curfew for youths, hundreds of stories in the press, and the police questioning of 1,400 residents. See John Gerassi, *The Boys of Boise: Furor, Vice, and Folly in an American City* (New York: Macmillan, 1967).
50 Faderman, *Odd Girls*, 119.
51 Amy Villarejo, "Forbidden Love: Pulp as Lesbian History," in *Outtakes: Essays on Queer Theory and Film*, ed. Ellis Hanson (Durham, NC: Duke University Press, 1999), 330.
52 Robert J. Corber, "Cold War Femme: Lesbian Visibility in Joseph L. Mankiewicz's *All About Eve*," *GLQ: A Journal of Lesbian and Gay Studies* 11, no. 1 (2005): 3.
53 Villarejo, "Forbidden Love," 333, 331. See also Regina Kunzel, *Criminal Intimacy: Prison and the Uneven History of Modern American Sexuality* (Chicago: University of Chicago Press, 2008).
54 Heather Love, *Feeling Backward: Loss and the Politics of Queer History* (Cambridge, MA: Harvard University Press, 2007), 3.
55 Love, *Feeling Backward*, 27.
56 Faderman, *Odd Girls*, 67.
57 Faderman, *Odd Girls*, 68, 94, 101.
58 Faderman, *Odd Girls*, 113.
59 Faderman, *Odd Girls*, 119, 120. Faderman begins her chapter on the World War II period with an epigraph from the now often-cited interview with WAC sergeant Johnnie Phelps where she describes General Eisenhower's pragmatic response to her

188 • Notes to Pages 21–24

self-disclosure as a lesbian in a successful unit filled with other lesbians: he immediately rescinds the order to find and "ferret out" lesbians in the battalion.

60 Faderman, *Odd Girls*, 133, 138.

61 Faderman, *Odd Girls*, 139–140.

62 Faderman, *Odd Girls*, 180–181.

63 Faderman, *Odd Girls*, 155.

64 Faderman quotes a lesbian writer to *ONE* in 1955 who declares that the lesbian "has a very easy time of it" compared with her gay male peer so long as she does not "advertise her anomaly," being "allowed to live a reasonably normal life, without constant fear of exposure and the ensuing ridicule, ostracism, and legal persecution." While one might rightly challenge this writer's possible class privilege and closeted acquiescence to normative culture, Faderman's dismissal of her "optimism" as "surely" overstated effectively silences this rare counterdiscourse. *Odd Girls*, 185.

65 Faderman, *Odd Girls*, 158.

66 Lauren Jae Gutterman, *Her Neighbor's Wife: A History of Lesbian Desire within Marriage* (Philadelphia: University of Pennsylvania Press, 2020), 7. Gutterman examines psychoanalyst Caprio's popular warnings about the "fantasies and nightmares" of "lesbian wives" in chapter 4.

67 Gutterman, *Her Neighbor's Wife*, 9, 10. Gutterman finds that at least in the postwar "private sphere of marriage and the family," husbands and the state "remained largely unconcerned" with women's homosexual behavior so long as it did not "disrupt men's access to their sexual, reproductive, or domestic labor."

68 Gutterman, *Her Neighbor's Wife*, 9.

69 Bérubé, *Coming Out*, 28, 128. Even with the large number of around 350,000 women who served, their numbers were a fraction of the millions of enlisted men. Margot Canaday, *The Straight State: Sexuality and Citizenship in Twentieth-Century America* (Princeton, NJ: Princeton University Press, 2011), 178.

70 Female workers made up two out of ninety-one proven "homosexuals" first fired. Johnson, *Lavender Scare*, 12. Canaday adds to this assessment by citing the navy's 1957 Crittenden Report conclusion that "female employees of the DOD were terminated for homosexuality far less often than male civil servants." Canaday, *Straight State*, 175.

71 Canaday, *Straight State*, 174.

72 After extensive research on different state statutes, Kinsey found "practically no females seem to have been prosecuted or convicted anywhere in the United States under these laws," and only a handful of women were punished in institutions like the armed forces. *Sexual Behavior in the Human Female*, 484–485.

73 Bérubé, *Coming Out*, 29. Bérubé even finds that unlike male effeminacy, which was considered a "disqualifying defect" for male enlistees, female masculinity was not necessarily used against recruits who might work well in physically demanding military environments.

74 Bérubé, *Coming Out*, 31. For a detailed accounting of the investigation into the Fort Oglethorpe incident, see Leisa D. Meyer, *Creating G.I. Jane: Sexuality and Power in the Women's Army Corps during World War II* (New York: Columbia University Press, 1996), 173–177; and M. Michaela Hampf, "'Dykes' or 'Whores': Sexuality and the Women's Army Corps in the United States during World War II," *Women's Studies International Forum* 27 (2004): 22–25. Foreshadowing future McCarthy-era purges, the Fort Oglethorpe investigators coerced witnesses into naming other "lesbians," but Hobby protected the corps, again, by having WAC staff directors

Notes to Pages 25–29 • 189

"quietly inquire" into the conduct of those on the list of names serving at new posts. Hampf, "Dykes," 23.

75 Bérubé, *Coming Out*, 30–32.

76 This technical bulletin, "WAC Recruiting Station Neuropsychiatric Examination," was notable since it "explicitly established homosexuality as a category of disqualification from the Women's Army Corps." Bérubé, *Coming Out*, 32.

77 Meyer, *Creating G.I. Jane*, 159. In accounting for the WAC's more "tolerant" practices, Meyer cites a policy prohibiting "witchhunting," established to protect the corps from "rumor and innuendo" about lesbians stirred up by investigations (160).

78 Meyer, *Creating G.I. Jane*, 36–37. For a history of the long-recognized practice of cross-dressing women who pass as male combatants, see Julie Wheelwright, *Amazons and Military Maids: Women Who Dressed as Men in the Pursuit of Life, Liberty and Happiness* (London: Pandora, 1989).

79 Meyer, *Creating G.I. Jane*, 33. Costello's historical account of the controversy surrounding the passage of the WAAC bill includes several instances of sensational press coverage of the women's military units, including the "queer damozels" comment from the *Miami News*. John Costello, *Virtue under Fire: How World War II Changed Our Social and Sexual Attitudes* (Boston: Little, Brown, 1985), 43.

80 Wheelwright, *Amazons and Military Maids*, 153.

81 Quoted in Meyer, *Creating G.I. Jane*, 43.

82 Mattie Treadwell, *United States Army in World War II: Special Studies, the Women's Army Corps* (Washington, DC: Office of the Chief of Military History, 1954), 625.

83 Treadwell, *United States Army in World War II*, 625–626.

84 Department of the Army, *Handbook for the Women's Army Auxiliary Corps* (Fort Des Moines, IA: WAAC, 1943), 7, accessed through Falvey Memorial Library, Villanova University, https://digital.library.villanova.edu/Item/vudl:14573.

85 Described and reproduced in Meyer, *Creating G.I. Jane*, 154.

86 Bill O'Malley, cartoon, The Saturday Evening Post Cartoon Collections, World War II, "WAC Jobs: Women in World War II," November 16, 2016, https://www .saturdayeveningpost.com/2016/11/wac-jobs-women-world-war-ii/.

87 Meyer, *Creating G.I. Jane*, 156, 26.

88 Herman's "Winnie the WAC" cartoons were collected in a short book, *Winnie the WAC* (Philadelphia: David McKay, 1945), in 1945 and republished in a new edition in 2002, without page numbers.

89 Wonder Woman historian Tim Hanley notes that Marston's postwar successor, Robert Kanigher, was almost obsessed with her "Suffering Sappho!" invocation. Hanley, *Wonder Woman Unbound: The Curious History of the World's Most Famous Heroine* (Chicago: Chicago Review Press, 2014), 140–141.

90 D'Emilio argues that "popular stereotypes, army policy, and the special conditions of military life" might account for the "unusually large proportion of lesbians" in the WAC. D'Emilio, *Sexual Politics*, 27.

91 See Bérubé, *Coming Out*, chapter 3, "G.I. Drag: A Gay Refuge."

92 Bérubé, *Coming Out*, 80–82.

93 Pat Bond's accounting of her time in the WAC has become a significant piece of testimony for historians of gay and lesbian wartime experiences, appearing at several points in Bérubé's history, Faderman's *Odd Girls*, and Meyer's *Creating G.I. Jane*. See also Marcy Adelman, *Long Time Passing: Lives of Older Lesbians* (Boston: Alyson Publications), 164.

94 Nancy Adair and Casey Adair, *Word Is Out: Stories of Some of Our Lives* (New York: Dell Publishing, 1978), 57.

190 • Notes to Pages 29–34

95 Adair and Adair, *Word Is Out*, 58.

96 Adair and Adair, *Word Is Out*, 60–61. For other firsthand accounts of purges of lesbians from other branches of the armed forces, see Zsa Zsa Gershick, *Secret Service: Untold Stories of Lesbians in the Military* (Los Angeles: Alyson Books, 2005), 75–76; and Mary Ann Humphrey, *My Country, My Right to Serve: Experiences of Gay Men and Women in the Military, World War II to the Present* (New York: Harper Perennial, 1990), 10–18.

97 Steven Cohan, *Incongruous Entertainment: Camp, Cultural Value, and the MGM Musical* (Durham, NC: Duke University Press, 2005), 17.

98 Goodman Ace was a stalwart of radio by 1950 as writer and costar of *Easy Aces* (1930–1945), and Selma Diamond had been a longtime writer for Groucho Marx before her tenure at *The Big Show*, after which she moved to television to write for Milton Berle, Sid Caesar, and Imogene Coca. John Dunning, *On the Air: The Encyclopedia of Old-Time Radio* (Oxford: Oxford University Press, 1998), 85–86.

99 Rosemary Counter, "Cruella de Vil Is Wicked—but Tallulah Bankhead Was Even Wilder," *Vanity Fair*, May 25, 2021, https://www.vanityfair.com/hollywood/2021 /05/real-cruella-de-vil-tallulah-bankhead.

100 Philip Core, *Camp: The Lie That Tells the Truth* (London: Plexus, 1984), 25–26.

101 Denis Brian, *Tallulah, Darling: A Biography of Tallulah Bankhead* (New York: Macmillan, 1980), 1.

102 Bérubé, *Coming Out*, 86.

103 Faderman, *Odd Girls*, 182.

104 Sasha Gregory Lewis, *Sunday's Women: A Report on Lesbian Life Today* (Boston: Beacon Press, 1979), 58.

105 Joel Lobenthal, *Tallulah! The Life and Times of a Leading Lady* (New York: Harper Collins, 2004), 206. The incident involving friend Tony Wilson's younger brother at Eton, wherein they snuck his brother out for a meal, was investigated by Scotland Yard and blown up in the tabloids to hint at Tallulah's "un-natural practices" (Lobenthal, 142). Indeed, the investigators in her classified Scotland Yard file assert confidently that she "is both a lesbian and immoral with men," having "'kept' a negress in America" before coming to England, where she currently "'keeps' a girl" in London. File in The National Archives (TNA): HO 382/9: Bankhead, Tallulah.

106 Judith Mackrell, *Flappers: Six Women of a Dangerous Generation* (New York: Farrar, Straus and Giroux, 2013), 432. See also Lobenthal, *Tallulah!*, 199, 225.

107 David Bret, *Tallulah Bankhead: A Scandalous Life* (London: Robson Books, 1996), 98; Lobenthal, *Tallulah!*, 224.

108 Bret, *Tallulah*, 25.

109 Bret, *Tallulah*, 7.

110 Lobenthal, *Tallulah!*, 43. Writing in the new millennium, Lobenthal is much more at liberty to document Bankhead's various same-sex affairs and nonconforming relationships (114, 127, 153, 185, 190, 441).

111 Defining her own intimate same-sex relationships on the model of the romantic friendships of the late nineteenth century, Crothers did not publicly identify as a lesbian, although she shared her home in Connecticut with her female partner Eula Seeley Garrison for decades. J. K. Curry, "Rachel Crothers: An Exceptional Woman in a Man's World," in *Staging Desire: Queer Readings of American Theater History*, ed. Kim Marra and Robert A. Schanke (Ann Arbor: University of Michigan Press, 2001), 55–57.

112 Mackrell, *Flappers*, 132.

Notes to Pages 35–38 • 191

113 Lobenthal documents her "virtual adoption by some of the most prominent gay women in London." *Tallulah!*, 72–74.

114 Mackrell, *Flappers*, 132. Tallulah's public debut as an "up-and-coming wit" in New York was famously achieved by a (later admitted) misspoken line, as she leaned over to critic Alexander Woolcott during a play and loudly exclaimed, "There's less to this than meets the eye!" Woolcott repeated her comment in his column the next day to her immediate acclaim. Bret, *Tallulah*, 23–24.

115 Faderman, *Odd Girls*, 70–72. Faderman includes Bankhead in a group of white bisexual or lesbian female "celebrities" such as Libby Holman and Lucille Le Sueur (i.e., Joan Crawford), who frequently traveled to Harlem to attend the "spectacle" of Bentley's performances where she would "flaunt lesbianism." *Odd Girls*, 72. Israel asserts that Bentley, upon hearing the news of Bankhead's nuptials, is supposed to have performed "an anatomically absurd lesbian song about the fact that the notorious Tallulah had married a man." Lee Israel, *Miss Tallulah Bankhead* (New York: G.P. Putnam's Sons, 1972), 176.

116 Lobenthal, *Tallulah!*, 43; Mackrell, *Flappers*, 128.

117 Lobenthal, *Tallulah!*, 8.

118 Lobenthal documents a number of incidents where Tallulah "corrected" assumptions that she was a lesbian, such as the time she supposedly seduced columnist Walter Winchell to end his homophobic baiting in the press that the "Less-bian" said about her, the better. *Tallulah!*, 254. Keith Stern notes Tallulah herself preferred the term "ambisextrous" to describe her sexual appetites. Stern, *Queers in History: The Comprehensive Encyclopedia of Historical Gays, Lesbians, Bisexuals, and Transgenders* (Dallas: Benbella Books, 2009), 39.

119 Bret, *Tallulah*, 25, 35. Bret recounts how Tallulah was "introduced" to London society in 1923 at the Bright Young Things Costume Ball, where she and her capricious bisexual lover Napier "dressed as twin brothers from the Versailles court of Louis XIV."

120 Mackrell, *Flappers*, 252 (citing Israel, *Miss Tallulah*, 94); Lobenthal, *Tallulah!*, 75.

121 David Bret credits her role in the 1922 play *The Exciters* in New York with earning Tallulah her earliest devotion from the flapper Gallery Girls, apparently "most" of whom were "lesbians." Bret, *Tallulah*, 29.

122 Bret, *Tallulah*, 38–39.

123 Israel, *Miss Tallulah*, 107–108.

124 Bret, *Tallulah*, 59.

125 Bret, *Tallulah*, 64.

126 Lobenthal, *Tallulah!*, 156.

127 Bret, *Tallulah*, 51.

128 Bret, *Tallulah*, 52, 59; Israel, *Miss Tallulah*, 218. Bret relates elsewhere that Fat Sophie could also use her power as head of the Sapphic Sisterhood (i.e., London's "uncloseted lesbian community") to attack Tallulah's rivals, setting the girls on actress Sara Sothern, for example, to cut her hair like Tallulah's. David Bret, *Elizabeth Taylor: The Lady, the Lover, the Legend, 1932–2011* (Vancouver: Graystone Books, 2011), 14.

129 Israel, *Miss Tallulah*, 119.

130 Bret recounts how she publicly slapped friend Hannen Swaffer supposedly for printing her truthful confession that the answer to the "gallery enigma" was that "they just *love* to see me in my underclothes, darling!" *Tallulah*, 64.

131 Bret, *Tallulah*, 55. Lee Israel calls known lesbian Smith Tallulah's "live-in right hand." Israel, *Miss Tallulah*, 109.

Notes to Pages 39–42

132 Tallulah Bankhead, *Tallulah: My Autobiography* (New York: Harper & Brothers, 1952), 301. It is commonly accepted now that Tallulah enjoyed liaisons with many fellow actors and actresses in Hollywood, even pursuing the elusive Garbo, but her relationship with Dietrich seemed special. Described by Lobenthal as similarly amused by their "boasts of lesbian seductions," he recounts how the two women schemed together to spread rumors of their own affair, which Tallulah evidenced by exposing her own pubic hair on set "powdered in gold," a makeup touch that Dietrich was known to use to highlight her own hair. *Tallulah!*, 190. Similarly, Bret describes a meeting with Louis B. Mayer where Tallulah tried to gain leverage on the studio boss by threatening to out six leading MGM actresses with whom she had had "lesbian affairs," including Dietrich, as well as Barbara Stanwyck and Joan Crawford. *Tallulah*, 92. See also Diana McLellan, *The Girls: Sappho Goes to Hollywood* (New York: St. Martin's Press, 2000).

133 Lobenthal, *Tallulah!*, 426–427, 451.

134 Bret, *Tallulah*, 246.

135 Israel, *Miss Tallulah*, 94. Tallulah was not alone in the period for having to closet her affairs with women in her autobiography. Infamous lesbian hostess Elsa Maxwell and blues icon Ethel Waters both wrote successful autobiographies in the period but remained coy about their nonconforming sexual identities: Waters even mentions that "gorgeous yam from Alabam'," as well as Radclyffe Hall and Josephine Baker, but can hardly put into print her own actual intimacies with women such as Ethel Williams. Ethel Waters, *His Eye Is on the Sparrow: An Autobiography by Ethel Waters with Charles Samuels* (New York: Doubleday, 1951), 207–208, 211. See also Elsa Maxwell's *I Married the World* (Melbourne: William Heinemann, 1955).

136 Bankhead, *Tallulah*, 312–313.

137 Bankhead, *Tallulah*, 319. Never one to shrink, she also refers to Joseph McCarthy as "our sewer Senator" (200).

138 Ann Aldrich, *We Walk Alone* (New York: Fawcett, 1955), 5. Meaker also includes a comic episode in the follow-up Aldrich nonfiction pulp when two friends become entangled with a theatrical star called "Mimosa" at a party in the Hamptons, where the actress seduces one of the girls, repeatedly calling her "darling." Ann Aldrich, *We, Too, Must Love* (New York: Fawcett, 1958), 77–78.

Chapter 2 Voyage to Camp Lesbos

1 Susan Stryker, *Queer Pulp: Perverted Passions from the Golden Age of the Paperback* (San Francisco: Chronicle Books, 2001), 8.

2 Forrest, *Lesbian Pulp Fiction*, xviii. Forrest also reads the pulps as reflecting the "hypocrisy of the times," where the public moralizing about sexual norms was followed in the next breath with titillating thrills (x).

3 For critical works offering this argument about the role of the pulps in lesbian identity formation and pre-Stonewall political awakening, see Lillian Faderman, *Odd Girls and Twilight Lovers: A History of Lesbian Life in Twentieth-Century America* (New York: Penguin, 1991); Yvonne Keller, "'Was It Right to Love Her Brother's Wife So Passionately?' Lesbian Pulp Novels and U.S. Lesbian Identity, 1950–1965," *American Quarterly* 57, no. 2 (June 2005): 385–410; Diane Hamer, "'I Am a Woman': Ann Bannon and the Writing of Lesbian Identity in the 1950s," in *Lesbian and Gay Writing: An Anthology of Essays*, ed. Mark Lilly (Philadelphia: Temple University Press, 1990): 47–75; Suzanna Danuta Walters, "As Her Hand

Crept Slowly Up Her Thigh: Ann Bannon and the Politics of Pulp," *Social Text* 23 (Autumn-Winter 1989): 83–101; and Stephanie Foote, "Deviant Classics: Pulps and the Making of Lesbian Print Culture," *Signs: Journal of Women in Culture and Society* 31, no. 1 (Autumn 2005): 170–190. For accounts of lesbians in the period discovering the pulps and finding themselves there, see Lee Lynch, "Cruising the Libraries," in *Lesbian Texts and Contexts: Radical Revisions*, ed. Karla Jay and Joanne Glasgow (New York: New York University Press): 39–48; Alison Hennegan, "On Becoming a Lesbian Reader," in *Sweet Dreams: Sexuality, Gender, and Popular Fiction*, ed. Susannah Radstone (London: Lawrence & Wishart, 1988): 165–190; Donna Allegra, "Between the Sheets: My Sex Life in Literature," in *Lesbian Erotics*, ed. Karla Jay (New York: New York University Press, 1995): 71–81; and Susanna Benns, "Sappho in Soft Cover: Notes on Lesbian Pulp," in *Fireworks: The Best of Fireweed*, ed. Makeda Silvera (Toronto: Women's Press, 1986): 61–68. The documentary *Forbidden Love: The Unashamed Stories of Lesbian Lives* (1992), directed by Aerlynn Weissman and Lynne Fernie, was financed by the National Film Board of Canada.

4 Barbara Grier, *Lesbiana: Book Reviews from The Ladder, 1966–1972* (Reno, NV: Naiad Press, 1976), 195.

5 Martin Meeker, "A Queer and Contested Medium: The Emergence of Representational Politics in the 'Golden Age' of Lesbian Paperbacks, 1955–1963," *Journal of Women's History* 17, no. 1 (Spring 2005): 165, 171. As Meeker summarizes, the DOB faulted Meaker for an imbalance between her "strategies of demystifying as well as pathologizing the lesbian." Meeker, "Queer and Contested," 171.

6 Ann Aldrich, *We Walk Alone* (New York: Feminist Press, 2006), 6. By the time Meaker publishes the last book in her nonfiction series, *Take a Lesbian to Lunch* (1972), Damon can allude archly to the late 1950s conflict, as she calls the author "our old nemesis," yet cannot avoid the same conflicted assessment of her writing, which is at once "poisonous, but entertaining." Grier, *Lesbiana*, 272.

7 These quotes come from the DOB's avowed "Aims and Purposes" in *ONE's* 1956 compendium on the homophile movement, *Homosexuals Today*. Cited in Martin Meeker, *Contacts Desired: Gay and Lesbian Communications and Community, 1940s–1970s* (Chicago: University of Chicago Press, 2006), 82–83.

8 Obviously, as I note in chapter 1, I am indebted to a number of queer theorists—from Amy Villarejo to Heather Love—for this recognition of "continuities between the bad gay past and the present." Heather Love, *Feeling Backward: Loss and the Politics of Queer History* (Cambridge, MA: Harvard University Press, 2007), 27.

9 Many commentators marveled at the incredible popularity of the pulps at the end of the twentieth century as beloved camp commodities, with the pulps being reissued with newly saturated covers whose lurid images adorned everything from magnets to T-shirts. Nealon, for example, identifies the lesbian pulps as a recently reclaimed part of "US queer heritage" but wonders if the reclamation honors the courage of the past writers (and readers) or shows a complex emotional retrospection, a "camp pleasure we feel, reading them now, that we can recycle earlier forms of pain at an ironic distance." Christopher Nealon, "Invert History: The Ambivalence of Lesbian Pulp Fiction," *New Literary History* 31, no. 4 (Autumn 2000): 745. More often, critics mention recent camp pleasures in the pulps as part of a contemporary "postmodern camp" and "hip marketing scheme" that come to signify ironic consumption. Melissa Sky, "Cover Charge: Selling Sex and Survival in Lesbian Pulp Fiction," in *Judging a Book by Its Cover: Fans, Publishers, Designers and the Marketing of Fiction*, ed. Nicole Matthews and Nickianne Moody (London: Ashgate, 2007), 143.

194 • Notes to Pages 44–46

10 Christopher Nealon, *Foundlings: Lesbian and Gay Historical Emotion before Stonewall* (Durham, NC: Duke University Press, 2001), 144. Bonnie Zimmerman briefly raises the possibility of resistant readings from within the pre-Stonewall era in her exhaustive study of lesbian fiction, *The Safe Sea of Women, 1969–1989* (New York: Beacon Press, 1991). However, while she recognizes that some women at the time "may have read against the grain," discovering "in the excesses and distortions of the text an ironic and amusing affirmation of their membership in a hidden and special subculture," she resists naming this ironic amusement "camp" (9).

11 Nealon, *Foundlings*, 149.

12 For Corber, through the anxiety over the femme's femininity and, thereby, her invisible threat, the era constructs a central queerness at the heart of gender and sexuality: "Discourses of national security, in highlighting the ability of gays and lesbians to pass for straight, inadvertently called attention to the mobility of sex, gender, and sexuality in relation to each other." Robert J. Corber, "Cold War Femme: Lesbian Visibility in Joseph L. Mankiewicz's *All About Eve*," *GLQ: A Journal of Lesbian and Gay Studies* 11, no. 1 (2005): 3.

13 Alexander Doty, *Flaming Classics: Queering the Film Canon* (New York: Routledge, 2000), 82.

14 As shown above, beginning with contemporary reactions from the DOB, a consistent concern about lesbian pulp fiction was focused on its stereotypical and negative portrayal of lesbians as pathological. As Roberta Yusba argues, "Psychiatric notions of lesbianism being caused by rape, trauma, or demented or sexually abusive parents find their way into most lesbian pulps. Even the best of pulp authors were unable to keep from including them." Roberta Yusba, "Twilight Tales: Lesbian Pulps 1950–1960," *On Our Backs*, Summer 1985, 43. Yusba immediately turns to discuss the works of Ann Bannon, whose Beebo Brinker novels have received the vast majority of critical attention since the 1980s, much of which acknowledges what Suzanna Danuta Walters calls the "psychological determinist" voice in even Bannon's positive portrayals of lesbian life after the war. Walters, "Her Hand Crept," 89. See also Hamer, "'I Am Woman,'" 53, 70.

15 "Report of the Select Committee on Current Pornographic Materials," U.S. House of Representatives, 82nd Cong., December 31, 1952 (Washington, D.C.: United States Government Printing Office, 1952), 3. Despite its blustering about pornographic literature's "serious menace to the social structure of the Nation," the committee could not pursue the publishers for the actual content within the covers due to First Amendment rights and the notorious difficulty of pinning down "obscenity." For a detailed account of the inner workings of this Select Committee, see Amy Villarejo, "Forbidden Love: Pulp as Lesbian History," in *Outtakes: Essays on Queer Theory and Film*, ed. Ellis Hanson (Durham, NC: Duke University Press, 1999), 325–330.

16 Keller, "Was It Right to Love Her Brother's Wife So Passionately," 388. After its best-selling success with *Women's Barracks*, Fawcett became one of the most significant publishers of lesbian paperback originals, or original works first released in paperback and distributed through nontraditional venues (such as drugstores, bus stations, and newsstands), publishing Packer's *Spring Fire* in 1952 and then other major works by lesbian pulp icons like Ann Bannon and Valerie Taylor. Keller notes that by 1975, *Women's Barracks* had sold at least 2.5 million copies (389).

17 Tereska Torrès, *Women's Barracks* (New York: Feminist Press at City University of New York, 2005), 86.

18 Torrès, *Women's Barracks*, 88. Relations full "of jealousies, of quarrels, of petty intrigue," true lesbianism is a love that "dies of its own sterility between brief flashes of passion." 88.

19 Torrès, *Women's Barracks*, 133–134.

20 Kate Adams, "Making the World Safe for the Missionary Position: Images of the Lesbian in Post-World War II America," in *Lesbian Texts and Contexts: Radical Revisions*, ed. Karla Jay and Joanne Glasgow (New York: New York University Press, 1990), 262.

21 Adams, "Making the World Safe," 269.

22 Adams, "Making the World Safe," 265.

23 Donna Penn, "The Sexualized Woman: The Lesbian, the Prostitute, and the Containment of Female Sexuality in Postwar America," in *Not June Cleaver: Women and Gender in Postwar America, 1945–1960*, ed. Joanne Meyerowitz (Philadelphia: Temple University Press, 1994), 359.

24 Penn, "Sexualized Woman," 359. Perhaps not coincidentally, *Women's Barracks* includes a strange Gothic scene in which Ursula witnesses Claude in a nude, fireside embrace with another servicewoman (promiscuous femme protégé Mickey) and mistakes her red firelit eyes for those of a "demon." Torrès, *Women's Barracks*, 98.

25 Penn, "Sexualized Woman," 364.

26 Adams, "Making the World Safe," 267.

27 Adams, "Making the World Safe," 267–268.

28 Adams, "Making the World Safe," 268.

29 Ellis Hanson, "Lesbians Who Bite," in *Outtakes: Essays on Queer Theory and Film*, ed. Ellis Hanson (Durham, NC: Duke University Press, 1999), 201. Hanson's Hollywood Freudian camp of the period is "usually recognizable at a hundred paces by the heavy-handed use of word-association games, hokey dream sequences, silly jargon, and magical epiphanies that lead invariably to marriage and motherhood." 201.

30 My work here is indebted to Ann Cvetkovich's claims of an "archive of lesbian culture" that preserves "affect" rather than just "positive images"—one that includes mainstream cultural texts that are homophobic or "that leave lesbians sad, lonely, or dead," as well as "campy reworkings" of these texts by groups like Five Lesbian Brothers. Ann Cvetkovich, *An Archive of Feelings: Trauma, Sexuality, and Lesbian Public Cultures* (Durham, NC: Duke University Press, 2003), 253.

31 David Halperin, *How to Be Gay* (Cambridge, MA: Belknap Press of Harvard University Press, 2012), 186.

32 Halperin, *How to Be Gay*, 194.

33 Halperin, *How to Be Gay*, 200.

34 In the Cleis Press reissue of *Spring Fire*, Packer's introduction claims that "1,463,917 copies sold in its first printing," outstripping Cain and Daphne du Maurier's *My Cousin Rachel* that year. Vin Packer, introduction to *Spring Fire* (San Francisco: Cleis Press, 2004), viii. Meaker includes the detail about outselling Erskine Caldwell in her introduction to the 2006 edition of *We Walk Alone*. Marijane Meaker, introduction to *We Walk Alone* (New York: Feminist Press, 2006), ix.

35 Jaye Zimet, *Strange Sisters: The Art of Lesbian Pulp Fiction, 1949–1969* (New York: Viking Studio, 1999), 46.

36 In her introduction, Packer describes meeting with her boss and the new editor of paperback originals at Fawcett, Dick Carroll, who encouraged her to write up her own tale of boarding school sapphism, but to tailor it with the censors in mind so that the book could pass postal inspection, insisting "you cannot make homo-sexuality attractive." Packer, introduction, vi.

37 Packer, *Spring Fire*, 96.

38 Packer, *Spring Fire*, 1.

39 Packer, *Spring Fire*, 4.

40 Packer, *Spring Fire*, 95, 103, 101.

41 Packer, *Spring Fire*, 96.

42 Packer, *Spring Fire*, 160.

43 Frank S. Caprio, *Female Homosexuality: A Psychodynamic Study of Lesbianism* (New York: Citadel, 1954), 121. Besides Caprio, Edmund Bergler was perhaps the most influential postwar popularizer of the "psychogenic theory" for homosexuality, which countered Kinsey's research with a strongly homophobic pathologization based in psychoanalytic theories. See Jennifer Terry, *An American Obsession: Science, Medicine, and Homosexuality in Modern Society* (Chicago: University of Chicago Press, 1999), 308, 310.

44 Packer, *Spring Fire*, 56, 59.

45 Terry, *American Obsession*, 316, 318. See also Sigmund Freud, "The Psychogenesis of a Case of Female Homosexuality," in *The Standard Edition of the Complete Psychological Works of Sigmund Freud*, ed. James Strachey (London: Hogarth Press, 1953), 18:146–172. To be sure, fathers did not escape blame either, as the perverse father turns up in the "psychic trauma" section of Caprio's work as an actual abuser. Caprio, *Female Homosexuality*, 121–131.

46 Packer, *Spring Fire*, 61.

47 Packer, *Spring Fire*, 76.

48 Michelle Ann Abate, "From Cold War Lesbian Pulp to Contemporary Young Adult Novels: Vin Packer's *Spring Fire*, M.E. Kerr's *Deliver Us from Evie*, and Marijane Meaker's Fight against Fifties Homophobia," *Children's Literature Association Quarterly* 32, no. 3 (Fall 2007): 241. Abate also argues for a "critique" of homophobia in Meaker's work, asserting "elements of subversion" in the "preposterous" ending of *Spring Fire*, but she locates the camp elements of that critique squarely in the 1990s, when *Deliver Us from Evie* is published—a "campy" and ironic "retrospection" of the 1950s (234).

49 Packer, *Spring Fire*, 83, 146.

50 Packer, *Spring Fire*, 103, 8–9.

51 Packer, *Spring Fire*, 113.

52 Packer, *Spring Fire*, 148.

53 Packer, *Spring Fire*, 146.

54 Packer, *Spring Fire*, 146. Dean Paterson, who almost single-handedly saves Mitch's college career and, apparently, her psyche, might have reason to doubt: the implication is that Paterson, as a single, middle-aged professional woman with short hair and a "frayed copy of Proust" on her desk, is queer herself, and her allowing Mitch to sleep in her own bedroom (while she strokes a white china poodle) certainly might offer another of Packer's subversive jokes.

55 Packer, *Spring Fire*, 67.

56 Packer, *Spring Fire*, 142.

57 Packer, *Spring Fire*, 151.

58 Philip Core, *Camp: The Lie That Tells the Truth* (London: Plexus, 1984), 5. However, the disapproval and even sense of shame at camping already existed in the period, as Craig Loftin documents in the firsthand accounts in letters written to *ONE* magazine. See, for example, the letters complaining about campy essays by

Notes to Pages 55–59 • 197

James Barr Fugate and a short story entitled "Jingle, You Belles You!" or the letters demanding an end of "swish" in favor of a proud homophilia. Craig Loftin, *Masked Voices: Gay Men and Lesbians in Cold War America* (Albany: State University of New York Press, 2012), 215–219, 208.

59 Steven Cohan, *Incongruous Entertainment: Camp, Cultural Value, and the MGM Musical* (Durham, NC: Duke University Press, 2005), 19.

60 In her account of ruined self-regard, Lee Lynch refers to the characters in these novels as "more miserable than Sartre's and despised as well." Lynch, "Cruising," 40. Alison Hennegan's account articulates well the complex affect produced in a young person yearning for representation no matter how "sordid," noting "panic," "bewilderment," "fear," and, most importantly, an "angry sense of shame, unbidden, resented, and uncomprehended." Hennegan, "On Becoming," 165, 166. See also Benns, "Sappho," 68; Forrest, *Lesbian Pulp Fiction*, xiv.

61 George Chauncey argues powerfully for a reconsideration of shame, particularly in the pre-Stonewall period, since "queer culture of the 1950s was more complex and diverse than the usual portrayal allows," so that assuming gays and lesbians in this period were all "governed or even incapacitated by an overwhelming sense of shame" is to fundamentally "misunderstand" them. George Chauncey, "The Trouble with Shame," in *Gay Shame*, ed. David Halperin and Valerie Traub (Chicago: University of Chicago Press, 2009), 282.

62 "Pulp Legacy: Marijane Meaker Interview by Martin Meeker," *Lambda Book Report* 13, nos. 6–8 (January–March 2005): 10, 11.

63 Marijane Meaker, "Writer Marijane Meaker," *Fresh Air*, NPR, August 25, 2003. When asked by Fresh Air's Terry Gross how she felt when she was writing the "phony ending" to *Spring Fire*, Meaker responded, "I laughed."

64 Cohan, *Incongruous Entertainment*, 18.

65 Aldrich, *We Walk Alone*, 154.

66 Marijane Meaker, "Introduction to the 2006 Edition," in *We Walk Alone* (New York: Feminist Press at City University of New York, 2006), xii (my emphasis).

67 Stephanie Foote, afterword to *We Walk Alone*, by Ann Aldrich (New York: Feminist Press at City University of New York, 2006), 159.

68 Foote, afterword, 161, 171.

69 Foote, afterword, 177–178.

70 Aldrich, *We Walk Alone*, 90. Foote, afterword, 161

71 Aldrich, *We Walk Alone*, 1–2.

72 Aldrich, *We Walk Alone*, 3–5. As noted in chapter 1, this litany also includes the "poor people's Tallulah Bankhead."

73 Aldrich, *We Walk Alone*, 6.

74 Aldrich, *We Walk Alone*, 15–16.

75 Aldrich concludes her second work, *We, Too, Must Love*, with a poignant and contrite story of the cruel (and jealous) mistreatment of two of her boarding school dormmates, whose *"grande passion"* was cut short by a petition sent to the headmistress and signed by seventy-five of their peers, who seemed driven by internalized homophobia to object to these "real Lesbians." Ann Aldrich, *We, Too, Must Love* (New York: Feminist Press, 2006), 153–156.

76 Aldrich, *We Walk Alone*, 90.

77 Aldrich, *We Walk Alone*, 128–130.

78 Aldrich, *We Walk Alone*, 132.

79 Aldrich, *We Walk Alone*, 132.

80 Aldrich, *We, Too, Must Love*, xiii. Meaker writes in her introduction to the 2006 edition that Aldrich received more letters than even Vin Packer after the publication of *Spring Fire*, which persuaded her and editor Dick Carroll to keep going with the Aldrich books (Aldrich, viii).

81 Aldrich, *We, Too, Must Love*, 46.

82 Aldrich, *We, Too, Must Love*, 126. Unfortunately, I do not have space here to address her fascinating depictions of relationships between gay men and lesbians in the 1950s, as she presents an endearing camaraderie and friendship yet also clear tensions between the two persecuted queer groups, with some of her lesbian characters professing disapproval of apparent gay male promiscuity and yet having even minor gay male characters critique their queer sisters in return: as one says in the "Hands-Around" chapter, "The Lesbians are always criticizing us because of our one- and two-night stands. They pride themselves on the fact that they stay together for a year or two. All I can say is, they're playing the same we are, only they stretch out their innings" (Aldrich, 129).

83 Meeker, "Queer and Contested," 170. Meeker details how the DOB responded to Aldrich's work early on with a contentious public forum, some of which was captured on the pages of the organization's magazine, *The Ladder*.

84 Meeker, "Queer and Contested," 161.

85 Meeker, "Queer and Contested," 175.

86 Meeker, "Queer and Contested," 177.

87 Kaye Mitchell, "'Who Is She?' Identities, Intertextuality and Authority in Non-Fiction Lesbian Pulp of the 1950s," in ed. H. Bauer and M. Cook, *Queer 1950s: Genders and Sexualities in History* (London, Palgrave, 2012) 152, 163.

88 Amanda Littauer, *Bad Girls: Young Women, Sex, and Rebellion before the Sixties* (Chapel Hill: University of North Carolina Press, 2015), 172.

89 Lynch, "Cruising," 40.

90 As Eve Kosofsky Sedgwick has argued in her foundational reevaluation of shame, it is, importantly, both "peculiarly individuating" and "peculiarly contagious" in that it compels you toward "uncontrollable relationality" with another, even one of whom you are ashamed or who recalls your own shame. Sedgwick, "Shame, Theatricality, and Queer Performativity: Henry James's *The Art of the Novel*," in *Gay Shame*, ed. David Halperin and Valerie Traub (Chicago: University of Chicago Press, 2009), 50, 51. Shame, therefore, can create a "controllable relationality" between contemporary readers and the pre-Stonewall past that can be "productive" (Sedgwick, 57).

91 Love, *Feeling Backward*, 30, 28.

92 Love, *Feeling Backward*, 51.

93 In my argument for lesbian camp's utility, I am encouraged by Cvetkovich's work, where complex affect can "serve as the foundation for public cultures." Cvetkovich, *Archive of Feelings*, 11. See, for example, her reading of Lisa Kron's *2.5 Minute Ride* (Cvetkovich, 25).

94 Angela Weir and Elizabeth Wilson, "The Greyhound Bus Station in the Evolution of Lesbian Popular Culture," in *New Lesbian Criticism: Literary and Cultural Readings*, ed. Sally Munt (New York: Columbia University Press, 1992), 97.

95 Meeker, "Queer and Contested," 175, 177.

96 In her work on the postwar "lesbian wives," Gutterman recounts a story from Highsmith's diary wherein the author of the period's most critically favored novel about lesbians, *The Price of Salt* (1955), cheekily describes the other wives in her group therapy with a Freudian psychoanalyst as "better latent than never" and

Notes to Pages 63–68 • 199

threatens to "amuse" herself by seducing a few of them (488). For Meaker's account of their two-year relationship, see Marijane Meaker, *Highsmith: A Romance of the 1950s* (New York: Cleis Press, 2003).

97 Quoted in Littauer, *Bad Girls*, 173.

98 Bertha Harris, "*What We Mean to Say*: Notes toward Defining the Nature of Lesbian Literature," *Heresies* 3 (1977): 5.

99 For a brief biography of Harris, see Ann Wadsworth's encyclopedia entry, "Bertha Harris (1937–2005)," *GLBTQ Literature* (2011): 1–2.

100 Dorothy Allison, *Skin: Talking about Sex, Class & Literature* (Ithaca, NY: Firebrand Books, 1994), 201–203.

101 Sue-Ellen Case, "Toward a Butch-Feminist Retro-Future," in *Cross-Purposes: Lesbians, Feminists, and the Limits of Alliance*, ed. Dana Heller (Bloomington: Indiana University Press, 1997), 207.

102 Bertha Harris, *The Lover* (New York: New York University Press, 1993), xix.

103 In Allison's description of her at Sagaris, she very clearly differentiates the irreverent Harris from herself and other earnest "good girls" of lesbian feminist politics of the time: "Playful, passionate, she was the living example of a lesbian who was trying to enjoy her life, not give it over to the revolution." Allison, *Skin*, 203.

104 Annamarie Jagose, *Inconsequence: Lesbian Representation and the Logic of Sexual Sequence* (Ithaca, NY: Cornell University Press, 2002), 125, 187n.

105 W. D. Sprague, *The Lesbian in Our Society: Detailed Case Histories of the Third Sex* (New York: Tower Publications, 1962), 42.

Chapter 3 A Strange Desire That Never Dies

1 Like the proliferation of pulp fiction, exploitation films directed at teenagers and satisfying the new drive-in market overwhelmed the film industry after the 1948 Paramount Decision that forced the studios to divest themselves of their theaters. Among the hundreds of these cheaply produced sensational films, which Thomas Doherty famously termed "teenpics," there were a large number focused on female teens, supposedly for a female audience. Indeed, Corman's *Sorority Girl* joins a number of films in a female subcycle within the "j.d." teenpics, portraying troubled female teens either as members of all-female gangs, or denizens of juvenile detention centers, or girls in other single-sex environments like the sorority; in nearly all of these female groupings, one of the members is often portrayed as queer, although of course in veiled ways consistent with the Production Code era. For examples, see *So Young, So Bad* (Vorhaus 1950), *Girl Gang* (Dertano 1954), *Teenage Devil Dolls* (Price, Jr.1955), *Teenage Crime Wave* (Sears 1955), *Girls in Prison* (Cahn 1956), *Swamp Women* (Corman 1956), *Reform School Girl* (Bernds 1957), *Teenage Doll* (Corman 1957), *High School Hellcats* (Bernds 1958), and *Girls Town* (Haas 1959).

2 Alain Silver and James Ursini, *Roger Corman: Metaphysics on a Shoestring* (Los Angeles: Silman-James Press, 2006), 80.

3 In his co-introduction to *Out in Culture*, even Doty, who most consistently championed an opening up of camp practice and theory to queers of all stripes, reaffirms the common divide between the "many gay men committed to camp" and the lesbian audiences who *sometimes* relate to popular culture "through strategies of camp" but who typically employ the reading strategies of "identification . . . and erotics." Corey Creekmur and Alexander Doty, introduction to *Out in Culture: Gay, Lesbian, and Queer Essays on Popular Culture*, ed. Corey Creekmur and Alexander Doty (Durham, NC: Duke University Press, 1995), 5.

200 • Notes to Pages 68–71

4 Andrea Weiss, *Vampires and Violets: Lesbians in Film* (New York: Penguin, 1992), 107.

5 Weiss, *Vampires and Violets*, 4.

6 Bonnie Zimmerman, "*Daughters of Darkness*: The Lesbian Vampire on Film," rpt. in *Dread of Difference: Gender and the Horror Film*, ed. Barry Keith Grant (Austin: University of Texas Press, 1996), 386. While Tanya Krzywinska's approach to lesbian vampire films argues for a queer reading by a spectator who can employ irony, it does not view that irony as camp. Tanya Krzywinska, "Le Belle Dame Sans Merci?," in *A Queer Romance: Lesbians, Gay Men and Popular Culture*, ed. Paul Burston and Colin Richardson (London: Routledge, 1995), 101, 109. See also Sue-Ellen Case, "Tracking the Vampire," in *Writing on the Body: Female Embodiment and Feminist Theory*, ed. Katie Conroy, Nadia Medina, and Sarah Stranbury (New York: Columbia University Press, 1997), 380–400, for lesbian camp as critical practice, although it does not provide a reading of campy lesbian vampires on-screen.

7 Alexander Doty, *Flaming Classics: Queering the Film Canon* (New York: Routledge, 2000), 82.

8 Alexander Doty, *Making Things Perfectly Queer: Interpreting Mass Culture* (Minneapolis: University of Minnesota Press, 1993), 89; Ellis Hanson, "Lesbians Who Bite," in *Outtakes: Essays on Queer Theory and Film*, ed. Ellis Hanson (Durham, NC: Duke University Press, 1999), 197.

9 Yvonne Tasker, "Pussy Galore: Lesbian Images and Lesbian Desire in the Popular Cinema," in *The Good, the Bad, and the Gorgeous: Popular Culture's Romance with Lesbianism*, ed. Diane Hamer and Belinda Budge (London: Pandora, 1994), 181. See also Stella Bruzzi, "Mannish Girl: k.d. lang—from Cowpunk to Androgyny," in *Sexing the Groove: Popular Music and Gender*, ed. Sheila Whiteley (London: Routledge, 1997), 191–206; and Patricia Juliana Smith, "'You Don't Have to Say You Love Me': The Camp Masquerades of Dusty Springfield," in *Camp Grounds: Style and Homosexuality*, ed. David Bergman (Amherst: University of Massachusetts Press, 1993), 185–205.

10 Patricia White, *UnInvited: Classical Hollywood Cinema and Lesbian Representability* (Bloomington: Indiana University Press, 1999), 30.

11 Paula Graham, "Girl's Camp? The Politics of Parody," in *Immortal Invisible: Lesbians and the Moving Image*, ed. Tamsin Wilton (London: Routledge, 1995), 174.

12 Graham, "Girl's Camp?," 180. See the epilogue in this book for further consideration of lesbian feminist responses to camp.

13 Mindful of stereotypes about lesbian humorlessness, I still suspect this criticism for taking the irony out of *The Importance of Being Earnest* and just being, well, earnest. Doty, in a much more generous spirit, names humor of a different kind for lesbians: "When queers and comedy come together, most people think of camp and 'b-tchy' wit" as gay and "sociopolitical humor" as lesbian. *Flaming Classics*, 79.

14 Susan Sontag, "Notes on 'Camp,'" in *Against Interpretation and Other Essays* (New York: Farrar, 1966), 279.

15 Gary Morris, "Edgar Ulmer's *Daughter of Dr. Jekyll* on DVD," *Bright Lights Film Journal* 30 (October 2000): 1–2.

16 Morris, "Edgar Ulmer's *Daughter*," 2.

17 Thomas Doherty, *Teenagers and Teenpics: The Juvenilization of American Movies in the 1950s*, revised and expanded ed. (Philadelphia: Temple University Press, 2002), 119.

18 From 1956 to 1958, we have titles such as *Blood of Dracula, Daughter of Dr. Jekyll, Love Slaves of the Amazons, Attack of the Crab Monsters, Frankenstein's Daughter, The Viking Women and the Sea Serpent, It! The Terror from Outer Space, Satan's Satellites, The Curse of the Faceless Man*, and the instructional *How to Make a Monster*. Not surprisingly, the she-demons in these films are rarer than their male counterparts, but the numbers are not nearly as out of proportion as the critical discourse indicates.

19 Doherty, *Teenagers and Teenpics*, 119.

20 While Ulmer might have exaggerated his legend a bit, since his early work was largely uncredited, it is hard to know the extent of his complete filmography. The claims reproduced here are from Bogdanovich's interview with him where the interviewer's preface sets the stage for Ulmer's larger-than-life autobiography: "Edgar went from the Olympian heights of picture making to the absolute lowest depths." Peter Bogdanovich, *Who the Devil Made It: Conversations with Robert Aldrich, George Cukor, Allan Dwan, Howard Hawks, Alfred Hitchcock, Chuck Jones, Fritz Lang, Joseph H. Lewis, Sidney Lumet, Leo McCarey, Otto Preminger, Don Siegel, Josef von Sternberg, Frank Tashlin, Edgar G. Ulmer, and Raoul Walsh* (New York: Knopf, 1997), 559.

21 Robert Singer acknowledges the film's "playful sense of camp" and in fact references Lamont's *Abbot and Costello Meet Dr. Jekyll and Mr. Hyde* (1953), but he only focuses on the campy potential of the male fiend, Dr. Lomas. Robert Singer, "Nothing to Hyde: Reading *The Daughter of Dr. Jekyll*," in *Edgar G. Ulmer: Detour on Poverty Row*, ed. Gary D. Rhodes (Lanham, MD: Rowman & Littlefield, 2008), 247.

22 John Belton, *The Hollywood Professionals*, vol. 3, *Howard Hawks, Frank Borzage, and Edgar G. Ulmer* (London: Trantivy Press, 1974), 154.

23 Agar's obituary describes a life trajectory eerily similar to Ulmer's tale of mythic heights and precipitous falls, with a Hollywood romance to America's sweetheart (Temple), sanctioned by David O. Selznick himself, that goes terribly wrong when his own weakness—alcoholism—ends the marriage and, for all intents and purposes, his career, sending him first into exploitation film purgatory before the ultimate hell of selling insurance. "John Agar, 81, Actor Once Wed to Shirley Temple," *New York Times*, April 10, 2002, http://www.nytimes.com/2002/04/10/arts/john-agar-81-actor-once-wed-to-shirley-temple.html.

24 Talbott has speculated that the producers used a stand-in for the nightmare scenes because they did not believe that she "could turn into that rather sexy, demonic-looking creature." Tom Weaver, *Interviews with B Science Fiction Horror Movie Makers: Writers, Producers, Directors, Actors, Moguls and Makeup*, rpt. in *Return of the B Science Fiction and Horror Heroes: The Mutant Melding of Two Volumes of Classic Interviews* (Jefferson, NC: McFarland Press, 2000), 337. This interesting supposition, while distancing Talbott herself from the "sexy" actions of the creature, also recognizes the sexually charged atmosphere of those attacks on women, most likely intended by the filmmakers.

25 Singer, "Nothing to Hyde," 245.

26 In discussing lesbian vampire films, Zimmerman finds damning stereotypes in service of a vicious containment narrative: "The function of the lesbian vampire is to contain attraction between women within the same boundaries of sexual violence. . . . By showing the lesbian as a vampire-rapist who violates and destroys her victim, men alleviate their fears that lesbian love could create an alternate model." Zimmerman, "*Daughters of Darkness*," 381–382.

27 Pamela Robertson, *Guilty Pleasures: Feminist Camp from Mae West to Madonna* (Durham, NC: Duke University Press, 1996), 105. Robertson deftly shows how *Johnny Guitar*'s heavy-handed strategies to contain the two women as its center (through exaggerations of psychoanalytic stereotypes and gender inversions such as Crawford's "psychotic mannish lesbian") result in a campy excess that "subverts the film's strategies of containment and weakens the terms of the film's phallic economy" (109).

28 Singer, "Nothing to Hyde," 247.

29 Singer, "Nothing to Hyde," 243. Singer does not locate sexual confusion in her identity crisis or in the vaguely termed "psychological issues" that are brought on by being "infantilized by these men" and goes so far as to list "repressed *heterosexual* desire" as a major feminist issue of the film (242; my emphasis). Although he joins Janet and her double in the phrase "hysterical Ms. Hyde," he separates their actions in service of his own compulsory heterosexual reading.

30 Qtd. in Edith Becker, Michelle Citron, Julia Lesage, and B. Ruby Rich, "Lesbians and Film," *Jump Cut* 24–25 (March 1981): 17–21.

31 Doty, *Flaming Classics*, 54, 59.

32 For a foundational theorization of the historical connections between lesbian sexuality and criminal violence, see Lynda Hart's *Fatal Women: Lesbian Sexuality and the Mark of Aggression* (New York: Routledge, 1994).

33 Philip Core, *Camp: The Lie That Tells the Truth* (London: Plexus, 1984), 9.

34 Doty, *Flaming Classics*, 82.

35 As Sue-Ellen Case notes, "The butch, who represents by her clothing the desire for other women, becomes the beast—the marked taboo against lesbianism dressed up in the clothes of that desire." Sue-Ellen Case, "Towards a Butch-Femme Aesthetic," rpt. in *The Lesbian and Gay Studies Reader*, ed. Henry Abelove, Michele Aina Barale, and David Halperin (New York: Routledge, 1993), 302.

36 Laura Mulvey, "Afterthoughts on 'Visual Pleasure and Narrative Cinema' Inspired by King Vidor's *Duel in the Sun* (1946)," in *Visual and Other Pleasures* (Bloomington: Indiana University Press, 1989), 33. It is, of course, in "The Psychogenesis of a Case of Homosexuality in a Woman" where Freud most clearly establishes the idea of a "masculinity complex" that leads to an abnormal path for female sexuality wherein the mother returns as primary object of erotic attachment. Sigmund Freud, "The Psychogenesis of a Case of Homosexuality in a Woman," in *The Standard Edition of the Complete Psychological Works of Sigmund Freud*, ed. and trans. James Strachey, 24 vols. (London: Hogarth, 1955–1974), 18:169.

37 While I agree with Andrew Tudor's claims that the subjective camera does not "necessarily place the viewer in a position of vicarious participation" in the monster's actions, such an identification does remain a possibility and a potential source of pleasure (and pain). Andrew Tudor, *Monsters and Mad Scientists: A Cultural History of the Horror Movie* (Oxford: Basil Blackwell, 1989), 201. See also J. P. Telotte's "Through a Pumpkin's Eye: The Reflexive Nature of Horror," rpt. in *American Horrors: Essays on the Modern American Horror Film*, ed. Gregory A. Waller (Urbana: University of Illinois Press, 1987), 114–128.

38 Doherty, *Teenagers and Teenpics*, 123. Doherty holds up the *I Was a Teenage Frankenstein / Blood of Dracula* double bill to illustrate these divided-gender audiences as "an adolescent monster (male) and an adolescent vampire (female)," with the intended audience in parentheses.

39 Zimmerman, "*Daughters of Darkness*," 380. Although neither critic explores the camp potential of the film, Zimmerman and Benshoff position *Blood of Dracula*

between the infamous studio horror of *Dracula's Daughter* (U.S., 1936) and the "more explicit lesbian vampire boom of the early 1970s." Harry Benshoff, *Monsters in the Closet: Homosexuality and the Horror Film* (Manchester: Manchester University Press, 1997), 149.

40 Benshoff, *Monsters in the Closet*, 150, 149.

41 For examples of the boarding school / sorority girl trope in lesbian pulp fiction, see chapter 2's discussion of Vin Packer's *Spring Fire* (New York: Fawcett Gold Medal, 1952). Others include R. V. Cassill's *Dormitory Women* (New York: Lion, 1954); Jordan Parker's *Sorority House* (New York: Lion, 1956); Orrie Hitt's *Girls' Dormitory* (New York: Beacon, 1958); J. C. Priest's *Private School* (New York: Beacon, 1959); and, of course, Ann Bannon's *Odd Girl Out* (New York: Fawcett Gold Medal, 1957), which initiated the Beebo Brinker series.

42 Complaints by the film's makeup artist Harry Thomas indicate that the filmmakers themselves were unsure how to create a female monster, incongruously "having a man do that female part" when Thomas might have made up the actress Sally Todd (Suzie). Weaver, *Interviews with B Science Fiction Horror Movie Makers*, 364.

43 Benshoff, *Monsters*, 145.

44 Robertson, *Guilty Pleasures*, 16.

45 Judith Mayne, *Cinema and Spectatorship* (London: Routledge, 1993), 102. Mayne recognizes the neglect of camp reading practices in her own lesbian film criticism in *Cinema and Spectatorship* (169), also later admitting to the guilty pleasure when watching women-in-prison films for their "strong doses of camp and irony." Judith Mayne, "Caged and Framed: The Women-in-Prison Film," in *Framed: Lesbians, Feminists, and Media Culture* (Minneapolis: University of Minnesota Press, 2000), 115.

46 Certainly, the critical contestation between Jackie Stacey and Teresa de Lauretis is exemplary here. See Jackie Stacey, "Desperately Seeking Difference," *Screen* 28, no. 1 (1987): 48–61; and Teresa de Lauretis, *The Practice of Love: Lesbian Sexuality and Perverse Desire* (Bloomington: Indiana University Press, 1994), especially 116–120. At contention, the terms "identification" and "desire" have directed the lesbian intervention into feminist film theory's work on spectatorship since the "Lesbian Special Section" in *Jump Cut* in 1981. Edith Becker, Michelle Citron, Julia Lesage, and B. Ruby Rich, "Lesbians and Film," 17–21.

47 Within the psychoanalytic discussion, perhaps Rhona Berenstein's theorization of "spectatorship-as-drag" comes closest to my own reading of *Daughter of Dr. Jekyll* with its obvious ties to camp performance and practice for the viewer and its recognition of multiple positions and pleasures for lesbian spectator of horror. Rhona Berenstein, *Attack of the Leading Ladies: Gender, Sexuality, and Spectatorship in Classic Horror Cinema* (New York: Columbia University Press, 1996), 56.

48 Mayne, *Cinema and Spectatorship*, 166. It is notable that in her final attempt to illustrate the different notions of critical spectatorship, Mayne admits to *her* neglect of camp in her original readings of Fassbinder (169).

49 Mayne, *Cinema and Spectatorship*, 166, 165. Like Amy Villarejo in her work on lesbian pulp fiction, I am wary of a romanticized or universalized view of the 1950s and the lesbian reception of the era's popular culture. Amy Villarejo, *Lesbian Rule: Cultural Criticism and the Value of Desire* (Durham, NC: Duke University Press, 2003), 163. Examining the film *Forbidden Love: The Unashamed Stories of Lesbian Lives*, Villarejo stresses that "participation in subcultural leisure activities does not guarantee a politics." *Lesbian Rule*, 188.

204 • Notes to Pages 91–95

Chapter 4 Spinsters, Career Gals, and Butch Comedy in 1950s Television

1 Nina Auerbach, *The Woman and the Demon: The Life of a Victorian Myth* (Cambridge, MA: Harvard University Press, 1982), 110. Sheila Jeffreys notes in *The Spinster and Her Enemies* that by the late Victorian period in the UK "almost one in three of all adult women were single and one in four would never marry" (London: Pandora Press, 1985), 86.

2 For a reading of the recent phenomenon of the "new spinster," see Hannah Rosefield, "Barbara Pym and the New Spinster," *New Yorker*, April 3, 2015. Rosefield cites Kate Bolick's contemporary best seller, *Spinster: Making a Life of One's Own* (New York: Broadway Books, 2015), and Rebecca Traister's equally popular *All the Single Ladies: Unmarried Women and the Rise of an Independent Nation* (New York: Simon and Schuster, 2016) as touchstones for this new phenomenon. See also Gina Fattore's novel, *The Spinster Diaries* (Altadena, CA: Prospect Park Books, 2020), where she advocates for "The Spinster Way."

3 See Moya Luckett, "Sensuous Women and Single Girls: Reclaiming the Female Body on 1960s Television," in *Swinging Single: Representing Sexuality in the 1960s*, ed. Hilary Radner and Moya Luckett (Minneapolis: University of Minnesota Press, 1999), 280, for a consideration of the 1960s period.

4 Judith Roof, *All About Thelma and Eve: Sidekicks and Third Wheels* (Urbana: University of Illinois Press, 2002).

5 Lynn Spigel, *Make Room for TV: Television and the Family Ideal in Postwar America* (Chicago: University of Chicago Press, 1992), 153.

6 Nina Auerbach, forward to *Old Maids and Radical Spinsters: Unmarried Women in the Twentieth Century Novel*, ed. Laura Doan (Urbana: University of Illinois Press, 1991), ix.

7 Qtd. in Auerbach, forward to *Old Maids and Radical Spinsters*, ix. See also Martha Vicinus, *Independent Women: Work and Community for Single Women, 1850–1920* (Chicago: University of Chicago Press), 3–4, for an account of Greg's infamous article "Why Are Women Redundant?"

8 Laura L. Doan, ed., *Old Maids to Radical Spinsters: Unmarried Women in the Twentieth-Century Novel* (Urbana: University of Illinois Press, 1991), 1.

9 Doan, *Old Maids to Radical Spinsters*, 5, 15.

10 Doan cites Mary Daly's reinterpretation of the spinster in *Gyn/Ecology* as a terrifying "whirling dervish" or dangerous witch who powerfully disturbs the "natural" order (2), and, of course, Auerbach's *Woman and the Demon* works as an extended meditation on this very demonizing of the threat of female power in the Victorian age.

11 Vicinus, *Independent Women*, 6.

12 Auerbach, *Woman and the Demon*, 118–119, 121.

13 Jeffreys, *The Spinster*, 4.

14 Virginia Woolf, *Mrs. Dalloway* (Ware, UK: Wordsworth Classics, 1996), 58. I am indebted to Kathryn Simpson's work "'Queer Fish': Woolf's Writing of Desire between Women in *The Voyage Out* and *Mrs. Dalloway*," *Woolf Studies Annual* 9, part 1 (2003): 55–82, for drawing attention to this appellation by Woolf's judgmental lifelong bachelor Walsh.

15 Jeffreys, *The Spinster*, 112.

16 Alison Oram, "'Embittered, Sexless, or Homosexual': Attacks on Spinster Teachers, 1918–1939," in *Not a Passing Phase: Reclaiming Lesbians in History, 1840–1985*, ed. Lesbian History Group (London: Woman's Press, 1989), 99. Due to the marriage

Notes to Pages 95–98 • 205

bar in teaching in the first half of the twentieth century, the vast majority of U.S. teachers were technically spinsters: sociologist Donovan calculates in her 1938 study *The Schoolma'am* (New York: Frederick A. Stokes, 1938) that 82 percent of the nearly one million public school teachers in the United States were women, and in the 1931 census, 77.3 percent of all female teachers were single women (32). In the UK, Oram cites the 1931 census, revealing 85 percent of all female teachers were unmarried. "'Embittered, Sexless, or Homosexual,'" 100.

17 Jackie M. Blount, *Fit to Teach: Same-Sex Desire, Gender, and School Work in the Twentieth Century* (Albany: State University of New York Press, 2005), 45. Blount contends that the shifting perception after the 1920s of spinster teachers from "upstanding members of their communities" to "sinister, deviant women who corrupted children" eventually led to policy changes (including the lifting of the marriage bar) that would result in the shift "from a profession of spinsters to one dominated by married women" (61). See also Sheila L. Cavanagh, "Spinsters, Schoolmarms, and Queers: Female Teacher Gender and Sexuality in Medicine and Psychoanalytic Theory and Tistory," *Discourse: Studies in the Cultural Politics of Education* 27, no. 4 (December 2006): 421–440.

18 Jeffreys, *The Spinster*, 100.

19 Laura Doan's collection, for example, tracks the spinster late into the twentieth century but does not focus specifically on the immediate post–World War II era. Doan, *Old Maids to Radical Spinsters*, 10.

20 May argues that for those who came of age after World War II, marriage was essentially a foregone conclusion, with 96.4 percent of all women and 94.1 percent of all men in this cohort marrying. Elaine Tyler May, *Homeward Bound: American Families in the Cold War Era* (New York: Basic Books, 1988), 23, 6.

21 Joanne Meyerowitz, "Beyond the Feminine Mystique: A Reassessment of Postwar Mass Culture, 1946–1958," *Journal of American History* 79, no. 4 (March 1993): 1458.

22 Meyerowitz, "Beyond the Feminine Mystique," 1465. Drawing a similar conclusion about competing narratives, Lisa Parks recognizes a competing discourse in 1950s television featuring single, female secretaries in the programs *My Friend Irma*, *Meet Millie*, and Sothern's *Private Secretary* that pointed to a contemporaneous demand from industry forces to meet a rapidly growing "need of a larger secretarial work-force," directly countering the dominant imperative for middle-class women to eschew work outside the domestic sphere. Lisa Parks, "Watching the 'Working Gals': Fifties Sitcoms and the Repositioning of Women in Postwar American Culture," *Critical Matrix* 11, no. 2 (June 1999): 42.

23 Meyerowitz, "Beyond the Feminine Mystique," 1461, 1470.

24 Meyerowitz, "Beyond the Feminine Mystique," 1462.

25 May, *Homeward Bound*, 5, 6.

26 Tim Brooks and Earle Marsh, *The Complete Directory to Prime Time Network and Cable TV Shows, 1946–Present*, 9th ed. (New York: Ballantine Books, 2007), 1680–1681.

27 For an examination of the rise of the idealized family sitcom in the second half of the 1950s, see Mary Beth Haralovich's influential article "Sit-coms and Suburbs: Positioning the 1950s Homemaker," *Quarterly Review of Film and Video* 11 (1989): 61–83.

28 Rick Mitz, *The Great TV Sitcom Book* (New York: Richard Marek Publishers, 1980), 59.

29 Mitz, *Great TV Sitcom Book*, 84, 85.

30 Mitz, *Great TV Sitcom Book*, 117. I have singled out more prominent examples, but Mitz's sitcom catalog includes many more less successful instances of this single

206 • Notes to Pages 98–102

working-girl phenomenon of 1950s television, including *Honestly Celeste!, Those Whiting Girls, Willy, It's Always Jan, Oh! Susanna,* and *Tugboat Annie* (116–117, 131–132, 146, 152).

31 Mitz, *Great TV Sitcom Book*, 192.

32 Qtd. in Jim Cox, *The Great Radio Sitcoms* (Jefferson, NC: McFarland, 2007), 221.

33 Jeremy G. Butler, *The Sitcom* (New York: Routledge, 2020), 65–66.

34 Butler, *The Sitcom*, 65–66. See also David C. Tucker, *The Women Who Made Television Funny: Ten Stars of 1950s Sitcoms* (Jefferson, NC: McFarland, 2007), 24.

35 Jack Gould, "Two Video Shows, 'Our Miss Brooks' and 'Hollywood Opening Night,' Receive Critical Treatment," *New York Times*, October 8, 1952, 44. Gould, in fact, never really warmed to the show, even as he continued to praise Arden for her "brittle, caustic style and stinging delivery of a wisecrack." Jack Gould, "TV's Top Comediennes," *New York Times Magazine*, December 27, 1953, 16–17.

36 Gerald Nachman, *Raised on Radio: In Quest of the Lone Ranger, Jack Benny, Amos 'n' Andy, The Shadow, Mary Noble, The Great Gildersleeve, Fibber McGee and Molly, Bill Stern, Our Miss Brooks, Henry Aldrich, The Quiz Kids, Mr. First Nighter, Fred Allen, Vic and Sade, Jack Armstrong, Arthur Godfrey, Bob and Ray, The Barbour Family, Henry Morgan, Our Gal Sunday, Joe Friday and Other Lost Heroes from Radio's Heyday* (New York: Pantheon Books, 1998), 218; Tucker, *Women Who Made Television Funny*, 26.

37 "Eve Arden: One-Man Woman," *TV Guide*, April 2, 1954, 6–7.

38 "Eve Arden," 6.

39 Roof, *All About Thelma and Eve*, 160.

40 Roof, *All About Thelma and Eve*, 161.

41 Spigel, *Make Room for TV*, 153.

42 Michael Bronski, *Culture Clash: The Making of Gay Sensibility* (Boston: South End Press, 1984), 102.

43 Roof, *All About Thelma and Eve*, 16.

44 Bronski, *Culture Clash*, 102; Roof, *All About Thelma and Eve*, 17. While Roof finds the comic second "may be lesbian and may be many other things" (16), White argues for a clear lesbian representation in this "type," whose "lack of romantic attachment to men," masculinity, and "sarcastic, flippant, or superior resistance to male values" can mark her as "lesbian." Patricia White, *UnInvited: Classical Hollywood Cinema and Lesbian Representability* (Durham, NC: Duke University Press, 1999), 146.

45 White, *UnInvited*, 147.

46 Stephen Tropiano recognizes the gender trouble created by "independent-minded" female characters in early television sitcoms, such as "wisecracking Connie Brooks," but he asserts definitively that "gay, lesbian, bisexual, and transgender characters didn't appear in situation comedies until the early 1970s," referring to open representation rather than subtext or the "gay appeal" of camp TV of the 1960s. Stephen Tropiano, *The Primetime Closet: A History of Gays and Lesbians on TV* (New York: Applause Theatre and Cinema Books, 2002), 185. See also Ron Becker, *Gay TV and Straight America* (New Brunswick, NJ: Rutgers University Press, 2006), 3.

47 Amy Villarejo, *Ethereal Queer: Television, Historicity, Desire* (Durham, NC: Duke University Press, 2014), 59.

48 Villarejo, *Ethereal Queer*, 62.

49 Villarejo, *Ethereal Queer*, 63. As Villarejo cautions before her reading of this one episode, which she viewed through a fan's VHS copy, access to television texts

continues to expand and alter critical readings of the medium. Currently, there are various formats for viewing the entire first season of *Our Miss Brooks*, and most of the later seasons are available through internet streaming sites (see archive.org/). Obviously, access to more material has enabled me to establish both repetition and a pattern over the seasons.

50 Villarejo, *Ethereal Queer*, 64.

51 See Joanne Morreale, "Dreams and Disruptions in the Fifties Sitcom," *Journal of e-Media Studies* 4, no. 1 (2015), https://journals.dartmouth.edu/cgi-bin /WebObjects/Journals.woa/1 /xmlpage/4/article/453, for an interpretation of dream sequences in 1950s sitcoms as a "way to speak the unspoken and undermine the harmonious image of the family."

52 Associating cats with the old maid has a long history: as Lahad asserts, the "unmarried woman is regularly stereotyped as lonely, miserable, and with no alternative but to fill her life with cats." Kinneret Lahad, *A Table for One: A Critical Reading of Singlehood, Gender, and Time* (Manchester: Manchester University Press, 2017), 55. It is less clear when this connection was tied specifically to lesbians, but the curator of a recent exhibit, "The Wide World of Lesbian Cats" (Rachel Corbman), asserts that by the 1970s the association had become "quite ingrained" since cats have long been "connected with deviant forms of femininity like witches, spinsters, and lesbians." Qtd. in Megan Wallace, "Why Cat Imagery Is So Significant in Lesbian Pop Culture," *Dazed Digital*, August 5, 2019, https://www.dazeddigital.com/art -photography/article/45498/1/this-show-traces-the-significance-of-cat-images-in -lesbian-communities.

53 Christine Becker, *It's the Pictures That Got Small: Hollywood Film Stars on 1950s Television* (Middletown, CT: Wesleyan University Press, 2008), 162.

54 For instance, when Walter unknowingly excludes Connie from the category of "girls," she responds with mock incredulity, "Girls? What do you think *I* am?" at which point the loud sound of Minerva's "meow" answers on the soundtrack.

55 See Alexander Doty's *Making Things Perfectly Queer* for a reading of Jack Benny's queer star persona and the "far-ranging network of gay connotation on the radio and television programs over the years," where Benny and his "manservant" Rochester's relationship became akin to a domestic sitcom. Alexander Doty, *Making Things Perfectly Queer: Interpreting Mass Culture* (Minneapolis: University of Minnesota Press, 1993), 73.

56 Proof of her place as the "patron saint of the teaching profession," as John Crosby dubbed her in the *Washington Post*, numerous articles mention hundreds of fan letters a week for Arden from appreciative women and particularly teachers, for whom she often advocated. John Crosby, "Maybe It Would Be Nice to Just Go Back to School," *Washington Post*, February 25, 1953, 31. See also Wayne Oliver, "Miss Brooks Just Tops with Teacher," *Washington Post*, October 11, 1953, L5; and Hyman Goldberg, "'Our Miss Brooks,' America's Favorite Schoolmarm," *Cosmopolitan*, June 1953, 70–75.

57 Steven Cohan, *Incongruous Entertainment: Camp, Cultural Value, and the MGM Musical* (Durham, NC: Duke University Press, 2005), 9.

58 The "Citizen's League" episode aired on January 7, 1955, just over six months after the Army-McCarthy hearings were televised. Capsuto argues that it was these hearings that "ultimately brought the subject of homosexuality into living rooms nationwide," with millions of viewers witnessing accusations of homosexual corruption by both sides. Steven Capsuto, *Alternate Channels: The Uncensored Story of Gay and Lesbian Images on Radio and Television* (New York: Ballantine Books, 2000), 30.

208 • Notes to Pages 106–109

59 Again, in his examination of Jack Benny's queer comic persona as "America's favorite effeminate straight man," Doty singles out bandleader Phil Harris as "Jack's most overtly gay compatriot and rival" on the show, marked by his vanity, lisped lines, and male jealousies. Doty, *Making Things Perfectly Queer*, 71, 72.

60 In *Camp TV*, Miller centralizes Kulp as a "camp icon" of the 1950s and 1960s. Quinlan Miller, *Camp TV: Trans Gender Queer Sitcom History* (Durham, NC: Duke University Press, 2019), 9, 90. Similarly, White relies on Kulp's example to counter Bronski's insistence that the old maid is represented as "asexual." White, *UnInvited*, 173–174.

61 Capsuto, *Alternate Channels*, 3–4. Indeed, Capsuto's first chapter focusing specifically on lesbians on news and information programs in the 1960s is *still* entitled "The Invisible Lesbian" (43).

62 Capsuto, *Alternate Channels*, 17–18.

63 Capsuto, *Alternate Channels*, 15.

64 Miller, *Camp TV*, 23. Miller seeks not only to demonstrate, contrary to critical consensus, how camp was "ubiquitous" in early television but also to open up definitions of camp itself that traditionally privilege sexuality and specifically the practices of gay men (3, 61–62).

65 Miller, *Camp TV*, 162, 12.

66 Miller, *Camp TV*, 28, 118, 71.

67 Miller, *Camp TV*, 109.

68 Miller, *Camp TV*, 54, 103. In examining industry practices, Miller works to expand our notion of camp practitioners to a "broad contingent of industry producers" such as writers, directors, producers, and performers "fluent in queer vernaculars" (62–63). With *Our Miss Brooks*, I would suggest that head writer Joseph Quillan, who wrote nearly every episode of the series and was solely responsible for season 4, could be identified as one of these "industry producers." Part of a family vaudeville act in his youth, he was a playwright, screenwriter, and radio/television writer for *The Eddie Cantor Show* (1955) and *Our Miss Brooks* and was briefly married to notorious "party girl" Ronnie Quillan, who was famous for being a source for Robert Harrison's vicious scandal magazine *Confidential*, where she was apparently used to entrap actress Lizabeth Scott into revealing she was a lesbian. Neal Gabler, "*Confidential*'s Reign of Terror: Inside the Magazine That Catalyzed the Celebrity Tabloid Culture," *Vanity Fair*, April 1, 2003. See also Henry E. Scott, *Shocking True Story: The Rise and Fall of Confidential, "America's Most Scandalous Scandal Magazine"* (New York: Pantheon, 2010).

69 Ball certainly manifests features of Kathleen Rowe's carnivalesque "unruly woman" of comedy, whose bodily excesses and ability to dominate create "an ambivalent figure of female outrageousness and transgression." Kathleen Rowe, *The Unruly Woman: Gender and Genres of Laughter* (Austin: University of Texas Press, 1995), 10. See also Lori Landay's *Madcaps, Screwballs, and Con Women: The Female Trickster in American Culture* (Philadelphia: University of Pennsylvania Press, 1998).

70 Gould, "TV's Top Comediennes," 17.

71 Gerard Jones, *Honey, I'm Home! Sitcoms: Selling the American Dream* (New York: Grove Press, 1992), 85. See also Harry Castleman and Walter Podrazik's *Watching TV: Four Decades of American Television* (New York: McGraw Hill, 1982), 76, which praises Arden for creating "a wise-cracking tough gal with a heart of gold," performing in a setup that worked like "an effective reversal" of *I Love Lucy*'s.

72 Nachman, *Raised on Radio*, 218–219.

73 Mitz, *Great TV Sitcom Book*, 75.

Notes to Pages 109–113 • 209

74 Cohan, *Incongruous Entertainment*, 12–13.

75 The "Reunion" episode surely ranks as one of the high-water marks of the show's lesbian camp with WAC Sergeant Connie entertaining her two married war buddies and reacting to their supposed envy of her "career," "freedom," and "independence" with bitter sarcasm. The comic view of Connie's spinster status vacillates between her friends' initial surprise that she is still single and then their winking recognition of its foregone conclusion, as Ellie says at one point, "Connie's just been kidding me about wanting to meet someone and get married too."

76 Jim Cox recounts how most episodes of the radio show found Arden's Brooks speaking out to the audience to ostensibly "help the announcer" with the narration, which he likens to a "paradigm George Burns perfected." Jim Cox, *The Great Radio Sitcoms* (Jefferson, NC: McFarland, 2007), 222.

77 Arden's continual use of overtly sexual quips (or "leering double entendres") was incredibly rare for female performers at the time and surely aligned her more with male vaudevillians like Marx and Milton Berle than with other successful female comedians. "The Working Girls," *Time*, February 8, 1954, 49.

78 Jones, *Honey, I'm Home*, 12. See also David Marc, *Comic Visions: Television Comedy and American Culture*, 2nd ed. (Oxford: Blackwell Publishers, 1997), 22.

79 Butler, *The Sitcom*, 203–204.

80 Doty, *Making Things Perfectly Queer*, 68. Married to Benny, Mary Livingstone did not play his wife on the show, occupying instead a supporting role where she sometimes dated Jack but more often sarcastically berated him, along with a number of other supporting women such as his "butch 'he-women'" dates. Doty highlights playwright Imamu Amiri Baraka's description of Mary as a TV/radio-dykey (69).

81 As in the "Magic Tree" episode, Connie's female impersonation in this episode spurs its own inverted double in the series' male leads, who come in at the end butched up as costumed "playboy" paramours: for example, confirmed bachelor Munsey sports a ridiculous toupè and nautical getup, and even Conklin joins the drag race in a swashbuckling outfit, complete with flaccid sabre. Connie's final queer comic rejoinder about *The Desert Song* refers to the popular operetta adapted for television only a few months before "Reunion" aired. This over-the-top desert romance is known for including an odd queer couple, the classic "pansy" character Bennie Kidd and his moll Susan, the male partner of which is clearly "coded as homosexual." Dominic McHugh, *The Oxford Handbook of Musical Theatre Screen Adaptations* (Oxford: Oxford University Press, 2019), 454.

82 Patricia Mellencamp, "Situation Comedy, Feminism, and Freud: Discourses of Gracie and Lucy," in *Critiquing the Sitcom: A Reader*, ed. Joanne Morreale (Syracuse, NY: Syracuse University Press, 2003, 42.

83 Mellencamp, "Situation Comedy," 43, 48.

84 Mellencamp, "Situation Comedy," 51.

85 It must be noted, of course, that this is true of the radio and television versions of *Our Miss Brooks*, not the film. The Warner Brothers film adaptation (Lewis, 1956) allows Connie to finally catch her man with Boynton's long-awaited marriage proposal coming at last, although Connie and Philip never actually reach the altar and a chimpanzee at the zoo absconds with the engagement ring.

86 Mellencamp, "Situation Comedy," 46.

87 Mellencamp, "Situation Comedy," 48, 51.

88 Jones, *Honey, I'm Home*, 85.

89 Mary M. Dalton and Laura Linder single out the "more feminine silhouette of soft shoulders, cinched waists, and flowing skirts" of Connie's wardrobe, usually

210 • Notes to Pages 113–118

accented by a "flopping bowtie" as the show's "silent signifier of her 'schoolmarm' status." Dalton and Linder, *Teacher TV: Sixty Years of Teachers on Television* (New York: Peter Lang, 2008), 26.

90 Crosby, "Maybe It Would Be Nice," 31; Cox, *Great Radio Sitcoms*, 229.

91 Discussing Nancy Kulp's performances on *The Bob Cummings Show*, for example, Miller finds her character Pamela "queerly effeminate," reading her assertive sexual pursuit of Bob as parodic, or a "campily masculine, effeminate gender expression" by an actress whom most commentators read simply as "masculine" and thereby "asexual" and "unattractive," rather than as capable of "gender crossing." Miller, *Camp TV*, 72, 73.

92 Miller, *Camp TV*, 73.

93 Faderman and Timmons document the often underhanded tactics used by the notorious Vice Squad of the Los Angeles Police Department to harass and entrap gays and lesbians in the era, noting that these tactics drove most "middle-class lesbians" with professional reputations to protect, such as teachers, into private homes for socializing. Lillian Faderman and Stuart Timmons, *Gay L.A.: A History of Sexual Outlaws, Power Politics, and Lipstick Lesbians* (Berkeley: University of California Press, 2006), 90.

94 Steven Cohan, "Queering the Deal: On the Road with Hope and Crosby," in *Outtakes: Essays on Queer Theory and Film*, ed. Ellis Hanson (Durham, NC: Duke University Press, 1999), 41.

95 Becker, *It's the Pictures*, 162–163.

96 Becker, *It's the Pictures*, 163.

97 Becker notes that Sothern received a mountain of letters weekly from female office workers praising her and seeking her advice. *It's the Pictures*, 164. Indeed, in a 1959 profile, Sothern boasts that she receives "nearly 1,500 letters a week," and about "80 percent come from women." Richard G. Hubler, "A Belle Named Sothern," *Coronet* 43, no. 8 (June 1959): 92.

98 See Christopher Anderson, *Hollywood TV: The Studio System in the Fifties* (Austin: University of Texas Press, 1994), 220. David C. Tucker contends that she left the show after Chertok seemed to negotiate a deal without her for new episodes. *Women Who Made Television Funny*, 131.

99 Tucker, *Women Who Made Television Funny*, 126.

100 Tucker, *Women Who Made Television Funny*, qtd. on 126; Mitz, *Great Sitcom Book*, 81.

101 Gould, "TV's Top Comediennes,"; Tucker, *Women Who Made Television Funny*, 130. The focus on Sothern's signature "husky contralto" should certainly be highlighted here as integral to her form of campy comic performance and her sardonic wisecracks. Hubler, "Belle Named Sothern," 96.

102 Becker, *It's the Pictures*, 163.

103 Steven Cohan singles out "show business" in-jokes as key examples of knowing material offering itself up for camp reading during the 1950s when "more covert coding of a gay subculture" became camp's semiotic register. Cohan, "Queering the Deal," 41. See also Miller, *Camp TV*, 110–111.

104 Although Garbo's affairs with women were kept in the closet by both a protective Hollywood studio system and her own notorious demands for privacy, the rumors of her queer sexuality and gender nonconformity that existed in the 1950s have been brought into the open by both Garbo's and Mercedes D'Acosta's recent biographies. See Diana McClellan, *The Girls: Sappho Goes to Hollywood* (New York: St. Martin's Press, 2000).

Chapter 5 Amazon Princesses and Sorority Queers, or the Golden Age(s) of Comic Lesbians

1 Bradford W. Wright describes Wertham's attacks on the comic book industry as rife with "conspiracy rhetoric" and paranoia. Wright, *Comic Book Nation: The Transformation of Youth Culture in America* (Baltimore: Johns Hopkins University Press, 2001), 162.

2 Fredric Wertham, *Seduction of the Innocent* (New York: Rinehart, 1954), 190–191.

3 Wertham, *Seduction of the Innocent*, 192.

4 Wertham, *Seduction of the Innocent*, 192–193. In a recent article, Carol Tilley shows that, in fact, Wertham's published claims in *Seduction of the Innocent* were tempered from his earlier drafts of the manuscript, which forcefully accused the *Wonder Woman* comic of contributing to young female readers' "later Lesbian guilt complexes." Carol L. Tilley, "A Regressive Formula of Perversity: Wertham and the Women of Comics" Journal of Lesbian Studies 22, no. 4 (2018): 362.

5 Tim Hanley highlights this quote as a prime example of Wertham's frequent "unsubstantiated claims"; failing to locate the quote in any editorial in *Psychiatric Quarterly* between 1941 and 1954, Hanley asserts that his reading of Wonder Woman as lesbian was "pure supposition." Hanley, *Wonder Woman Unbound: The Curious History of the World's Most Famous Heroine* (Chicago: Chicago Review Press, 2014), 130–131.

6 Wertham, *Seduction of the Innocent*, 193.

7 Wertham, *Seduction of the Innocent*, 34.

8 Wertham, *Seduction of the Innocent*, 193.

9 Noah Berlatsky, *Wonder Woman: Bondage and Feminism in the Marston/Peter Comics, 1941–1948* (New Brunswick, NJ: Rutgers University Press, 2015), 152.

10 For example, comics historians note the immediate alarm raised by EC Comics's in-house watchdog Josette Frank, who strongly cautioned publisher Gaines about "the sadistic bits showing women chained, tortured, etc." Qtd. in Les Daniels, *Wonder Woman: The Complete History* (San Francisco: Chronicle Books, 2004), 61. See also Richard Reynolds, *Super Heroes: A Modern Mythology* (London: B. T. Batsford, 1992), 34; and Douglas Wolk, *Reading Comics: How Graphic Novels Work and What They Mean* (New York: De Capo Press, 2007), 98.

11 Hanley, *Wonder Woman Unbound*, 133–142. Daniels has much to say about bondage and Etta Candy's "strange" partnership with Wonder Woman but little about the Marston household (*Wonder Woman*, 35), while Lepore's expansive work concludes with a 1985 photo of Elizabeth Marston and her by-then lifelong companion Olive Byrne but fails to pursue the obvious conclusions. Jill Lepore, *The Secret History of Wonder Woman* (New York: Knopf, 2014), 297. See also Trina Robbins's essay "Wonder Woman: Lesbian or Dyke? Paradise Island as a Woman's Community," originally presented at WisCon in May 2006, for a noncommittal hedging of "whether Wonder Woman's creator really intended any hidden lesbian agenda in his comics, or whether suspicions of Sapphism were simply products of Wertham's McCarthyist mentality" (unpublished paper available at https://web .archive.org/web/, accessed 03/31/2021). For the rare recognition, see Brian Mitchell Peters, "Qu(e)erying Comic Book Culture and Representations of Sexuality in Wonder Woman," *CLCWeb: Comparative Literature and Culture* 5, no. 3 (2003).

12 Berlatsky, *Wonder Woman*, 151. See also the recent "Introduction" to a special issue of *Journal of Lesbian Studies* focusing on queer female characters in comics that posits Wonder Woman as a paradigmatic example of the "long history" of comics

Notes to Pages 123–125

"featuring female same-sex attraction, relationships, and identity." Michelle Ann Abate, Karly Marie Grice, and Christine N. Stamper, "Introduction: 'Suffering Sappho!': Lesbian Content and Queer Female Characters in Comics," *Journal of Lesbian Studies* 22, no. 4 (2018): 329.

13 Berlatsky, *Wonder Woman*, 148. Marston's *Emotions of Normal People*, originally published in 1928 (London: Routledge, 1999), includes several passages describing sexual acts between well-adjusted women (and girls), including tribadism, oral sex, and use of hands to reach orgasm, which he argues are not only good for the women involved but also for all of society).

14 Berlatsky, *Wonder Woman*, 144. As Hanley notes, in just the second appearance of the Holliday Girls in 1942, we have a vivid portrayal of these BDSM-like sorority initiations with pledge Eve blindfolded, on all fours, being paddled and teased with a swinging piece of candy, held by none other than the "grand mistress of spanks and slams," Etta Candy. *Wonder Woman Unbound*, 137–138.

15 Berlatsky, *Wonder Woman*, 150–151. See Keira Williams, *Amazons in America: Matriarchs, Utopians, and Wonder Women in Popular Culture* (Baton Rouge: Louisiana State University Press, 2019), for a detailed examination of the white supremacist ideology undergirding Marston's dream of a "matriarchalist" utopia.

16 Hanley documents that the Holliday Girls appear in every issue of the Golden Age *Wonder Woman* until Marston's death, after which his successor Kanigher's tenure as writer-editor "brought a speedy decline" to their presence. Hanley, *Wonder Woman Unbound*, 143.

17 Daniels, *Wonder Woman*, 35.

18 In his early films, Herbert, who came from vaudeville, perfected a physical comedy persona punctuated by a trademark high-pitched giggle and "Woo! Woo!" catch-phrase. Typically absentminded, flustered, and nervous, his characters eschewed normative masculinity, performing instead a fey gender expression in their gestures, which included fluttered fingers, closed eyes, and clapping in a delicate manner, all accompanied by his high-pitched giggle. Annette Bochenek, "Hugh Herbert," *The Classic Movie Hub* (blog), August 11, 2020, https://www.classicmoviehub.com/blog/classic-movie-travels-hugh-herbert/. See also "Woo-Woo! Man of Movies for Many Years Dies," *New York Times*, March 13, 1952, 29.

19 Berlatsky, *Wonder Woman*, 128–129.

20 Berlatsky, *Wonder Woman*, 136.

21 When questioned why he "got rid" of the Holliday Girls and Etta Candy, Kanigher at first denied being their "executioner" but then offered a passionate four-word judgment: "Etta Candy! Jesus Christ!" Daniels, *Wonder Woman*, 100.

22 Etta's flamboyant and colorful Western wear recalls nothing so much as the reviewer's astute description of Joan Crawford's camp appearance in *Johnny Guitar* (U.S., 1954) as looking like "a cowtown Liberace." Qtd. in Pamela Robertson, *Guilty Pleasures: Feminist Camp from Mae West to Madonna* (Durham, NC: Duke University Press, 1996), 107.

23 Although he recognizes Marston's "sexual kinkiness" in the bondage scenarios, DiPaolo's article joins the scores of others who downplay or ignore the strong lesbian features of the comic, finding the Holliday Girls to be a representation of "female friendship." Marc DiPaolo, "Wonder Woman as World War II Veteran, Camp Feminist Icon, and Male Sex Fantasy," in *The Amazing Transformed Superhero! Essays on the Revision of Characters in Comic Books, Film and Television*, ed. Terrence R. Wandtke (Jefferson, NC: McFarland, 2007), 171, 156–157.

Notes to Pages 126–132 • 213

24 Wonder Woman's potential paramours or unresolved ex-girlfriends are perhaps too many to count, but certainly notable story time is devoted to the reformed Paula (previously Baroness Von Gunther), Paradise Island go-to and scientific genius Mala, and the ultimately irredeemable Priscilla Rich.

25 Assessed by Berlatsky as the "most dispositive evidence" of the comic's lesbian content, the doe feast of costumed and stripped girl-prey is depicted by Peter as a kind of lesbian buffet/ banquet, with trussed up girl-does on a platter for a table of eager Amazon diners. Berlatsky, *Wonder Woman*, 142–143.

26 Etta plays for the "All-Woman" baseball team in *Wonder Woman #2*, proves an avid bowler in *Sensation Comics #13*, and nearly throws the hockey contest against the Hale University men in *Wonder Woman #11*; and as coxswain for the All-College-Girls against the WAVES boat in *Comic Cavalcade #3*, Etta teases her stroke, Bee Strong, who shows up late to the contest because they "stroked me so hard last night at the Beeta Lambda initiation, I can't sit down" (5).

27 Philip Core, *Camp: The Lie That Tells the Truth* (London: Plexus, 1984), 9.

28 Priscilla Rich proves queerly unwilling to reform her ways. Later escaping her Amazon prison, Transformation Island, she joins a super league of villainesses known as Villainy Incorporated, which includes some of Wonder Woman's queerest adversaries, including the Blue Snow Man (Byrna Brilliant) and fellow drag kings Dr. Poison and Hypnota, who twirls her mustache at their first gathering while instigator Eviless announces, "Good—not a sissy in the lot" (*Wonder Woman #28*). Qtd. in Michael Fleisher, *The Encyclopedia of Comic Book Heroes, Vol. 2: Wonder Woman* (New York: Collier Books, 1976), 188.

29 Hanley, *Wonder Woman Unbound*, 139.

30 Hanley, *Wonder Woman Unbound*, 138.

31 This "roommate" innuendo colors female groups as well, like the Girl Commandos team of heroine "War Nurse" Pat Parker, who find themselves suggestively sharing a sparse hotel room in "The Devil's Sister" as they battle sexy Axis agent Madame Intrigue in *Speed Comics #33* (1944). For an account of even earlier (brief) instances of potentially "lesbian" comic strip characters, such as in *Lucy and Sophie Say Goodbye*, *Terry and the Pirates*, and *Brenda Starr, Reporter*, see Caitlin McGurk, "Lovers, Enemies, and Friends: The Complex and Coded Early History of Lesbian Comic Strip Characters," Journal of Lesbian Studies 22, no. 4 (2018): 336-353.

32 Mike Madrid, *Divas, Dames, and Daredevils: Lost Heroines of Golden Age Comics* (Minneapolis, MN: Exterminating Angel Press, 2013), 106.

33 Daniels, *Wonder Woman*, 93–97. See also Craig This, "Containing Wonder Woman: Fredric Wertham's Battle against the Mighty Amazon," in *The Ages of Wonder Woman: Essays on the Amazon Princess in Changing Times*, ed. Joseph J. Darowski, (Jefferson, NC: McFarland, 2014), 37.

34 Gloria Steinem, introduction to *Wonder Woman: A Ms. Book* (New York: Holt and Warner Books, 1972), 6. See also Trina Robbins, *The Great Women Superheroes* (Northampton, MA: Kitchen Sink Press, 1996), 107, as well as a recent foreword where Robbins admits to abandoning a "boring" Wonder Woman around the time of Kanigher's takeover because "all she cared about was whether or not she should marry Steve Trevor." Trina Robbins, "Foreword: The Lasso and the Pendulum," in *Wonder Woman Psychology: Lassoing the Truth*, ed. Travis Langley and Mara Wood (New York: Sterling, 2017), xv.

35 Berlatsky, *Wonder Woman*, 187.

36 Robbins, "Foreword," xvi. See also Lepore, *Secret History*, 271–272.

214 • Notes to Pages 132–137

37 Wright, *Comic Book Nation*, 127. Wright notes the Comic Code statement that the romance titles should "emphasize the value of the home and the sanctity of marriage" (172–173).

38 Wright, *Comic Book Nation*, 185.

39 See Andy Mangel's introduction to DC's recent collection *Wonder Woman in the Fifties* (Burbank, CA: DC Comics, 2020), where he asserts that "Kanigher wasn't terribly fond of Marston's feminist ideals about the superiority of women" (5).

40 Hanley, *Wonder Woman Unbound*, 147.

41 Hanley, *Wonder Woman Unbound*, 146. Hanley cites a Trina Robbins 1996 interview with Kanigher as the source for his declaration that "all of the Amazons were lesbians," including Wonder Woman (140), which Robbins confirms in her paper "Wonder Woman: Lesbian or Dyke?"

42 Hanley, *Wonder Woman Unbound*, 99, 105.

43 Daniels, *Wonder Woman*, 118. Daniels refers to these failed Golden Age retreads as "Kanigher's attempt at camp" and notes a not insignificant fact that the timing of these issues in 1966 coincided exactly with the premiere of the parodic *Batman* series on ABC now synonymous with the mainstreaming of camp in the United States (118–120).

44 Daniels, *Wonder Woman*, 117.

45 DiPaolo, "Wonder Woman as World War II Veteran," 161; Elaine Tyler May, *Homeward Bound: American Families in the Cold War Era* (New York: Basic Books, 1988), 16–18.

46 Ruth McClelland-Nugent, "The Amazon Mystique: Subverting Cold War Domesticity in *Wonder Woman* Comics, 1948–1965," in *Comic Books and the Cold War: Essays on Graphic Treatment of Communism, the Code and Social Concerns*, ed. Chris York and Rafiel York (Jefferson, NC: McFarland, 2012), 126. See also This, "Containing Wonder Woman," 38, for recognition of Kanigher's portrayal of her "struggle with the tension of choosing between career and family."

47 Daniels describes Hasen's "makeover" cover image of Wonder Woman as a "role reversal," where she becomes "weak and helpless" (and carried by Steve for a change). Daniels, *Wonder Woman*, 95.

48 Even casual readers of the comic since its introduction of "the oft-rescued Steve" would have little faith in his aspirations to take on the rescuer role, knowing in the end that he always defers to and depends on his beautiful angel's superheroine abilities. DiPaolo, "Wonder Woman as World War II Veteran," 160. DiPaolo cites this imbalanced status, as well as her "anxiety about male-female romance," as one of the reasons "her relationship with Steve Trevor has always been a non-starter." 160.

49 McClelland-Nugent cites a cluster of Kanigher/Peter issues in the 1950s that propose "Wonder Woman could indeed marry," but this would force her to "retire from crime fighting"—from "Wonder Woman's Wedding Day" (*Wonder Woman #70*) in November 1954 to "Daily Danger" (*Wonder Woman #96*) in February 1958. "Amazon Mystique," 117.

50 Hanley, *Wonder Woman Unbound*, 141, 140. Hanley totals the "Suffering Sappho!" exclamations at more than 160, or "almost 2.5 times an issue" from 1948 to 1958.

51 Reprints of these Silver Age issues were published by DC Comics in its "Archive Editions," but the reproductions do not have page numbers. *Wonder Woman #101's* "Undersea Trap!" appears on pages 86–96 in *Showcase Presents* Wonder Woman, vol. 1 (New York: DC Comics, 2007), which I will cite here.

52 *Showcase Presents*, 1:273.

53 McClelland-Nugent, "Amazon Mystique," 117.

54 *Showcase Presents* Wonder Woman, vol. 2 (New York: DC Comics, 2008), 263.

55 *Showcase Presents*, 2:267.

56 Daniels, for instance, uses the example of the change to "Marriage a la Mode" as proof that "Kanigher's Wonder Woman was more traditionally feminine than William Moulton Marston's, both in her fascination with marriage and in her attitude toward conflict." *Wonder Woman*, 102.

57 For a full historical account of Hogarth's painting series, see Robert L. S. Cowley, *Hogarth's Marriage A-la-Mode* (Ithaca, NY: Cornell University Press, 1983).

58 Daniels, *Wonder Woman*, 98.

59 Daniels, *Wonder Woman*, 24.

60 Dominique Mainon and James Ursini note in *The Modern Amazons: Warrior Women On-Screen* (Pompton Plains, NJ: Amadeus Press, 2006) that the "giantess motif has long been interwoven with the Amazon mythos, as Amazon women were rumored to be taller than average, not to mention strong and commanding" (236).

61 Tony Williams argues that the cult classic *Attack of the 50 Foot Woman* functions as a "camp" enunciation of a "patriarchal nightmare about the female threat which has to be put down," figured in the "erotic" giant's "excess" emotion and in the film's B-grade failures such as her "giant hand obviously made of plaster." "Female Oppression in Attack of the 50-Foot Woman," *Science Fiction Studies* 12, no. 3 (November 1985): 265, 264.

62 *Showcase Presents*, 1:438–440.

63 *Showcase Presents*, 2:114.

64 *Showcase Presents*, 2:137.

65 McClelland-Nugent, "Amazon Mystique," 124. McClelland-Nugent understatedly notes how this family "differed from the Cold War American ideal," but an all-female household where queer out-of-time versions of Wonder Woman call each other "sister" and the Amazon Princess resembles a husband coming home to the "suburbia" of Paradise Island after work is "different" in a very specific way: it models a lesbian domestic situation (122–124). See, for example, "The Impossible Day!" adventures in *Wonder Woman #124*.

66 *Showcase Presents*, 2: 479.

67 *Showcase Presents*, 2: 489-498.

68 Robertson, *Guilty Pleasures*, 10.

69 Lizzie Peabody, "How Wonder Woman Got Her Groove Back," *Sidedoor*, podcast audio, January 13, 2021, https://www.si.edu/sidedoor/ep-1-how-wonder-woman-got-her-groove-back.

70 Steinem, introduction, 6, 4.

71 Phyllis Chesler, "The Amazon Legacy," in *Wonder Woman: A Ms. Book* (New York: Holt and Warner Books, 1972), 10. Nineteenth-century Swiss historian J. J. Bachofen is often considered the originator of modern theories of a primary matriarchal social system in past Mediterranean cultures that was usurped by the current patriarchal one, primarily established in his work *Mother Right* (1861). George Boas's preface to *Myth, Religion, and Mother Right: Selected Writings of J.J. Bachofen* notes that Bachofen called the "extreme form" of the matriarchal second stage "Amazonism" (Princeton, NJ: Princeton University Press, 1967), xvii. Helen Diner championed these ideas of a foundational matriarchy in her 1930 work *Mothers and Amazons: The First Feminist History of Culture*, ed. and trans. John Phillip Lundin (New York: Anchor Books, 1973).

72 Chesler, "Amazon Legacy," 11.

216 • Notes to Pages 143–146

73 Abby Wettan Kleinbaum, *The War against the Amazons* (New York: McGraw Hill, 1983), 8. See also Batya Weinbaum, *Islands of Women and Amazons: Representations and Realities* (Austin: University of Texas Press, 1999).

74 Kleinbaum concludes that the "Amazon who became the star of stage, screen, and television" (including Wonder Woman) was based on a patriarchal wish-fulfillment story of a "splendid Amazon queen whose hatred of and opposition to men melted away before the superior military and sexual prowess of a true hero." *War against the Amazons*, 201.

75 See, for example, the recent exhaustive chronicling by historian Adrienne Mayor, *The Amazons: Lives and Legends of Warrior Women across the Ancient World* (Princeton, NJ: Princeton University Press, 2014).

76 Kleinbaum, *War against the Amazons*, 225, 2. The association of Amazons with lesbianism long predates the 1970s—Chesler notes that Herodotus proposes an affliction of "sexual aberration" for the female warriors ("Amazon Legacy," 18)—but also lives on. For just one example, in her first collection of the landmark lesbian comic *Dykes to Watch Out For*, Alison Bechdel organizes the book as a kind of lesbian alphabet, the last entry of which reframes it through the "Amazon's Bedside Companion." Alison Bechdel, *Dykes to Watch Out For* (New York: Firebrand Books, 1986), 78. Or, see Audre Lorde's invocation of "our sister Amazons" of the "kingdom of Dahomey" in *Zami: A New Spelling of My Name* (Berkeley, CA: Crossing Press, 1982), 176.

77 Michelle R. Finn, "William Marston's Feminist Agenda," in *The Ages of Wonder Woman: Essays on the Amazon Princess in Changing Times*, ed. Joseph J. Darowski (Jefferson, NC: McFarland, 2014), 11, 15.

78 Williams, *Amazons in America*, 67. In an analysis of *Terry and the Pirates*'s character Sanjak, dubbed the "first lesbian character in U.S. comics," Michelle Ann Abate argues for the villainess's influence on Wonder Woman but laments both comics' racist caricatures, particularly pointing out the racism and white supremacy central to Marston's "brand of feminism." Michelle Ann Abate, "'You are Een the House of Sanjak!': *Terry and the Pirates*, the First Lesbian Character in U.S. Comics, and the Roots of Wonder Woman," *ImageTexT* 9, no. 3 (2018).

79 Williams, *Amazons in America*, 50–51.

80 Williams, *Amazons in America*, 90, 89.

81 Williams, *Amazons in America*, 144.

82 Mia Sostaric, "The American Wartime Propaganda during World War II," *Australasian Journal of American Studies* 38, no. 1 (July 2019): 32. For example, *Wonder Woman #4* (1942) contains the brutal tale of Chinese damsel Mae Wu, whose village was attacked by "the monkey men" of Japan and their "Jap-nats" with sinister ruthlessness (14a). In *Wonder Woman #1*, a Japanese spy accompanies racist depictions of the Burmese, and offensively sibilant Japanese commanders are assisted by the Cheetah in *Wonder Woman #6*.

83 In his blog, Berlatsky analyzes the racist depictions of African people as "subhuman, animalistic blackface monsters." "The Enduring Racism of Wonder Woman," *Medium* (blog), April 29, 2016, https://medium.com/the-establishment/the-enduring-racism-of-wonder-woman-c76dde61f080.

84 Rebecca Wanzo, *The Content of Our Caricature: African American Comic Art and Political Belonging* (New York: New York University Press, 2020), 4. In her history of racist caricature in comics, Wanzo finds it is no accident that the tradition of caricature and "scientific racism" began in "roughly the same period," where racist

Notes to Pages 146–150 • 217

travelogues and the "science" of phrenology would employ racist imagery as "tools in justifying colonialism."

85 Like Superman, Wonder Woman is portrayed as, in Wanzo's words, a "caricature of ideal citizenship" premised on whiteness but not able to totally excise the racial others upon whom this heroic identity depends—represented not just in the women of color she conquers (and rescues) but also in the bondage scenarios that depend on what Toni Morrison famously called the "Africanist presence" to bear their ultimate meaning. Wanzo, *Content of Our Caricature*, 10, 17.

86 As Qiana Whitted shows in *EC Comics: Race, Shock, and Social Protest* (New Brunswick, NJ: Rutgers University Press, 2019), postwar comics *were* beginning to openly address the struggle for civil rights by African Americans, as exemplified in EC Comics's social issue subgenre called preachies.

87 At her foundations considered "racist and imperialist, as the local Africans need the protection of a white girl," *Sheena, Queen of the Jungle* spawned many, many imitators and "jungle girls," both during the war and after. Valerie Estelle Frankel, *Wonder Women and Bad Girls: Superheroine and Supervillainess Archetypes in Popular Media* (Jefferson, NC: McFarland, 2020), 8.

88 As Hanley contends in his review of the hardcover collection of issues #98–110, "people of color just disappeared" during Kanigher's Silver Age tenure, as his *Wonder Woman* became "almost entirely whitewashed." Tim Hanley, "America's Silver Age," *Los Angeles Review of Books*, April 12, 2014, https://lareviewofbooks.org/article/americas-silver-age/.

Chapter 6 Sexual Outlaw

1 Gladys Bentley, "I Am A Woman Again," *Ebony*, August 1952, 92–93.

2 Eric Garber, "Gladys Bentley: Bulldagger Who Sang the Blues," *Out/Look: The National Gay and Lesbian Quarterly* 1 (Spring 1988): 53.

3 Garber, "Gladys Bentley," 56. Elsewhere, Garber describes Harry Hansberry's Clam House as "perhaps the most famous gay-oriented club of the era," standing out in a fairly crowded field of speakeasies and clubs running up and down Lenox and Seventh Avenues. Eric Garber, "A Spectacle of Color: The Lesbian and Gay Subculture of Jazz Age Harlem," in *Hidden from History: Reclaiming the Gay & Lesbian Past*, ed. Martin Duberman, Martha Vicinus, and George Chauncey Jr. (New York: Meridian Books, 1990), 324.

4 Garber, "Gladys Bentley," 55, 58.

5 Lillian Faderman, *Odd Girls and Twilight Lovers: A History of Lesbian Life in Twentieth-Century America* (New York: Penguin, 1991), 72. As I mentioned in chapter 1, one of those "celebrities" drawn to Bentley's performances was, of course, Tallulah Bankhead. In contrast with other blues icons, Garber notes, the "homosexuality that others hid, Bentley exploited to its full advantage." "Gladys Bentley," 58.

6 Garber, "Gladys Bentley," 59.

7 Garber, "Gladys Bentley," 60.

8 James F. Wilson, *Bulldaggers, Pansies, and Chocolate Babies: Performance, Race, and Sexuality in the Harlem Renaissance* (Ann Arbor: University of Michigan Press, 2010), 183. Garber concurs, arguing simply that the "United States cold war society could not tolerate a strong, uncompromising, Afro-American bulldagger." "Gladys Bentley," 61.

218 • Notes to Pages 150–155

9 Faderman, *Odd Girls*, 77. For a discussion of Ma Rainey's "Prove It on Me Blues" as "an assertion and an affirmation of lesbianism," see Hazel V. Carby, "It Jus Be's Dat Way Sometime: The Sexual Politics of Women's Blues," *Radical Amerika* 20, no. 4 (1986): 18. Also, Angela Y. Davis, "I Used to Be Your Sweet Mama: Ideology, Sexuality and Domesticity in the Blues of Gertrude 'Ma' Rainey and Bessie Smith," in *Sexy Bodies: The Strange Carnalities of Feminism*, ed. Elizabeth Grosz and Elspeth Probyn (New York: Routledge, 2013), 219–220.

10 Faderman, *Odd Girls*, 77. James F. Wilson provides a close reading of several of Bentley's recordings, such as "Worried Blues" and "Big Gorilla Man," but concludes that their heterosexual lyrics do not "fit the image of the cross-dressed butch lesbian, which one normally associates with the performer." *Bulldaggers*, 170, 171. Therefore, I would argue, Bentley's bulldyker lesbian camp persona was produced predominantly in *live* performances at the clubs and Harlem rent parties that established her reputation and where she could get away with salacious material. See Garber, "Gladys Bentley," 55, 58. Although Regina Jones notes the disappointment expressed by fans, like Langston Hughes, who viewed her move to nicer clubs as having a stifling effect on her outrageous charm, one reviewer in 1944 finds the singer still donning "a Ted Lewis top hat and mannish attire" in order to set fans "on fire with her risqué songs and fancy piano-plucking." Qtd. in Jones, "How Does a Bulldagger Get Out of the Footnote," *ninepatch: A Creative Journal for Women and Gender Studies* 1, no. 1 (2012): 8–9; "Alvin Moses Says," *Chicago Defender*, December 30, 1944, 13.

11 My argument here is in no small part indebted to Meredith Heller's chapter "The First Punch at Stonewall: Counteridentification Butch Acts," in *Queering Drag: Redefining the Discourse of Gender-Bending* (Bloomington: Indiana University Press, 2020), where she connects both Bentley's and Stormé DeLarverie's performances of butchness to her concept of "counteridentification," which asserts a process of aligning the "bent aspect of the identity expression" of butch queerness with an oppositional "minoritarian group identity" (119). I will discuss in more depth below how I differ from Heller's reading of Stormé.

12 Heller, "First Punch at Stonewall," 126–127, 35.

13 Garber, "Gladys Bentley," 60, 61.

14 José Esteban Muñoz, *Disidentifications: Queers of Color and the Performance of Politics* (Minneapolis: University of Minnesota Press, 1999), 119.

15 Wilson, *Bulldaggers*, 188.

16 Jones, "How Does a Bulldagger," 11; Muñoz, *Disidentifications*, 12.

17 Wilson, *Bulldaggers*, 188.

18 Bentley, "I Am A Woman Again," 94.

19 Bentley, "I Am A Woman Again," 94.

20 Wilson, *Bulldaggers*, 189.

21 Bentley, "I Am A Woman Again," 93. Music scholar Carmen Mitchell aptly describes this opening confessional by Bentley as a "harrowing, Dante-esque account." Carmen Mitchell, "Creations and Fantasies/Constructions of Identities: The Oppositional Lives of Gladys Bentley," in *The Greatest Taboo: Homosexuality in Black Communities*, ed. Delroy Constantine-Simms (Los Angeles: Alyson Books, 2001), 211.

22 Bentley, "I Am A Woman Again," 98.

23 Jones, "How Does a Bulldagger," 12; Wilson, *Bulldaggers*, 189.

24 Alfred Duckett, "The Third Sex," *Chicago Defender*, March 2, 1957, 7.

25 Jones, "How Does a Bulldagger," 13.

Notes to Pages 155–160 • 219

26 Gregory Conerly, "Swishing and Swaggering: Homosexuality in Black Magazines during the 1950s," in *The Greatest Taboo: Homosexuality in Black Communities*, ed. Delroy Constantine-Simms (Los Angeles: Alyson Books, 2001), 391, 386. See also Leisa Meyer, "'Strange Love': Searching for Sexual Subjectivities in Black Print Popular Culture during the 1950s," *Feminist Studies* 38, no. 3 (Fall 2012) for further analysis of how "discussions of gender inversion related to women were often more critical" than those of men (645).

27 Conerly, "Swishing and Swaggering," 389, 392.

28 David Serlin, *Replaceable You: Engineering the Body in Postwar America* (Chicago: University of Chicago Press, 2004), 155, 156.

29 Serlin, *Replaceable You*, 156, 142.

30 Joana "Juba-Ometse" Clayton, "Closet Ain't Nothin' but a Dark and Private Place for . . . ?," *Art Journal* 55, no. 4 (Winter 1996): 53.

31 Clayton, "Closet Ain't Nothin'," 53.

32 Serlin, *Replaceable You*, 147, 146.

33 Serlin, *Replaceable You*, 149.

34 Serlin, *Replaceable You*, 150.

35 Garber, "Gladys Bentley," 61.

36 Donald Bogle, *Heat Wave: The Life and Career of Ethel Waters* (New York: Harper Collins, 2011), xii, xi.

37 Axel Nissen, *Mothers, Mammies and Old Maids: Twenty-Five Character Actresses of Golden Age Hollywood* (Jefferson, NC: McFarland, 2012), 191–192. She also recorded over twenty charted singles and had two chart-topping hits ("Am I Blue?" and "Stormy Weather").

38 Bogle notes that her "mean-spirited" paranoid treatment of the up-and-coming ingenue Lena Horne was "frankly appalling." *Heat Wave*, 389.

39 See Bogle, *Heat Wave*, 399–406.

40 Bogle's recent biography is perhaps the first time any writer has dealt so openly with Waters's queer sexuality, documenting not just the "steady stream of men" who came in and out of her life but also the gorgeous female "lovers" who "sometimes appeared in her shows, sometimes worked as her 'secretaries' and assistants, sometimes stayed in her homes." *Heat Wave*, xi.

41 Nissen, *Mothers*, 191. One might note, for example, that Waters was a devout Christian woman whose obscenity-filled cussing out of directors, producers, and costars was renowned, as well as a consummate performer who dominated on stage and screen but who was also plagued with paranoid fears and doubts.

42 Ethel Waters, "The Men in My Life," *Ebony*, January 1952, 24.

43 Waters, "Men in My Life," 25.

44 Waters, "Men in My Life," 32.

45 Waters, "Men in My Life," 34.

46 Waters, "Men in My Life," 38.

47 She even participated as one of the Black homeowners of the Sugar Hill neighborhood in Los Angeles who successfully sued to end racist restrictive covenants in California in 1945. See Bogle, *Heat Wave*, 193, 299, 324, 348, 419–421.

48 For example, there was some controversy when she asked to be one of the only performers paid to appear in a National Defense Fund benefit in 1934. Bogle, *Heat Wave*, 240–241.

49 When the NAACP's secretary White met with studio heads in 1942 to argue for a "new treatment" of African Americans on-screen as more than shameful stereotypes and comic figures, Bogle describes "nervous, in some cases frantic," responses by

220 • Notes to Pages 160–162

established Black actors like McDaniel, Waters, and Eddie Anderson, who feared for "their basic livelihoods" and felt stung by criticisms and picketing of their films. Bogle, *Heat Wave*, 377.

50 Particularly during the Depression era—what Bogle calls the "Age of the Negro Servant"—the stereotyped "mammy" figure offered to actresses such as McDaniel a desexualized, appeasing, and "prehumanized black domestic" role meant to serve as "the true and trusted companion out to aid the white world," yet Bogle contends that in the hands of formidable performers such as McDaniel (and Waters), these "cheerful aunt jemima[s]" were infused with the "rebellious spirit" of a "quick-tempered, outspoken black woman, not about to take any nonsense." Donald Bogle, *Toms, Coons, Mulattoes, Mammies, & Bucks: An Interpretive History of Blacks in American Films* (New York: Continuum, 1989), 83.

51 Thomas Cripps, *Making Movies Black: The Hollywood Message Movie from World War II to the Civil Rights Era* (New York: Oxford Press, 1993), 81; Patricia White, *UnInvited: Classical Hollywood Cinema and Lesbian Representability* (Bloomington: Indiana University Press, 1999), 157.

52 Walter White described Waters's role as Granny as demonstrative of "worn out stereotypes of the domineering old mistress of the plantation and the blindly faithful servant." Qtd. in Bogle, *Heat Wave*, 444.

53 Donald Bogle, *Primetime Blues: African Americans on Network Television* (New York: Farrar, Straus and Giroux, 2002), 20. For the popular radio show, Beulah was originally voiced by Marlin Hurt and Bob Corley but transitioned to Hattie McDaniel in 1947. Bogle argues that even amid postwar changes, the show almost "seemed oblivious to current social/political realities" (22).

54 Bogle, *Primetime Blues*, 22.

55 J. Fred MacDonald, *Blacks and White TV: African Americans in Television since 1948*, 2nd ed. (Chicago: Nelson Hall, 1992), 23–24.

56 Bogle, *Primetime Blues*, 25.

57 This early episode is included in a *Beulah* DVD/digital collection available on various streaming services (as *The Beulah Show, Vol. I*) and is also streaming on YouTube. It is the only episode in the DVD collection starring Waters.

58 Qtd. in Bogle, *Heatwave*, 460. This review from the *Pittsburgh Courier* went so far as to say Waters personally deserved "condemnation" for her role in the show.

59 Bogle, *Heatwave*, 460, 461. Her costar Bud Harris was more vocal in his criticism at the time. While Christine Becker argues that Waters "departed *Beulah* in anger at its degrading scripts," Bogle finds discontent with the racist material but also that she just felt the acting role was below her standards. Christine Becker, *It's the Pictures That Got Small: Hollywood Film Stars on 1950s Television* (Middletown, CT: Wesleyan University Press, 2008), 148.

60 Pointing to the Black middle class specifically, Cripps insists, "It was *their* taste, sensibility, and identity that CBS violated in its narrow depiction of blacks as urban riffraff, tricksters, Falstaffs, and snarling matriarchs." Thomas Cripps, *"Amos 'n' Andy* and the Debate over American Racial Integration," in *American History / American Television: Interpreting the Video Past*, ed. John E. O'Connor (New York: Frederick Unger, 1983), 35, 42.

61 Bogle documents the controversy caused by Waters's refusal to admit membership in the NAACP in her 1956 interview with Mike Wallace, responding characteristically, "I do my own thinking," which made her appear "shockingly out of touch at a time when the civil rights movement was on the rise." Bogle, *Heat Wave*, 485–486.

However, with *Beulah* she might have suspected, as one critic argued, that the NAACP was not "much bothered" about the show because she was just a "domestic servant" and not representative of the aspiring Black middle class. Gerard Jones, *Honey, I'm Home! Sitcoms: Selling the American Dream* (New York: Grove Weidenfeld, 1992), 59.

62 Ethel Waters, *His Eye Is on the Sparrow: An Autobiography by Ethel Waters with Charles Samuels* (New York: Doubleday, 1951), 258.

63 Leerom Medovoi, *Rebels: Youth and the Cold War Origins of Identity* (Durham, NC: Duke University Press, 2005), 23.

64 Medovoi, *Rebels*, 45.

65 Medovoi, *Rebels*, 47.

66 Medovoi, *Rebels*, 49.

67 A similar division problematizes his male examples as well, where Little Richard stands as the sole example of Black male queerness in the first chapter among a plethora of white nonconforming gay male rebels who are clearly distinguished from civil rights advocates. Medovoi, *Rebels*, 47, 50. Medovoi's selection of primary texts for analysis in chapter 7, focusing on *Girls Town, Imitation of Life, Gidget, Tomboy*, and *Odd Girl Out*, works to reinforce his division between challenges to heterosexism and challenges to white supremacy when figuring the girl rebel (312–315).

68 Lisa Walker, *Looking Like What You Are: Sexual Style, Race, and Lesbian Identity* (New York: New York University Press, 2001), 129. For another example, one might consider the lack of Black lesbian characters in comics for most of the twentieth century, where for instance, according to historian Sheena Howard, no "Black lesbian superheroine" can be found until the release of Jimmie Robinson's *Cyberzone* in 1994. Sheen Howard, "Situating *Cyberzone*: Black Lesbian Identity in Comics," *Journal of Lesbian Studies* 22, no. 4 (2018): 402.

69 Walker, *Looking Like What You Are*, 128.

70 William Yardley, "Stormé DeLarverie, Early Leader in the Gay Rights Movement, Dies at 93," *New York Times*, May 30, 2014, B16. While there has been some disagreement about whether she was the reported "lesbian" whose punch of an arresting officer sparked the rush of violence on that June night, Hinds confirms what Stormé only occasionally admitted—that she came to the Stonewall Inn after work and resisted a beating and arrest by an officer when she was trying to help a male patron outside the bar's entrance. Patrick Hinds, "Uncovering the Stonewall Lesbian: Stormé DeLarverie Was There That Infamous Night. Now She's Coming Clean about It All," *Curve* 18, no. 1 (January–February 2008): 64. She further elaborated to Charles Kaiser and then for an episode of *In the Life: Documentary Stories from the Gay Experience* ("A Stormé Life," 2001) that the cop hit her and she "hit him back."

71 Charles Kaiser, *The Gay Metropolis: The Landmark History of Gay Life in America* (New York: Grove Press, 1997), 200. Included in her collected papers at the Schomburg Center is a promotional card for a tribute to and fundraiser for Stormé held at the Henrietta Hudson bar in November 2010, where she is pictured in her sheriff-like attire: a high-contrast photo of an almost-ninety-year-old DeLarverie in aviator glasses and slim-brimmed black cowboy hat, staring coolly off into the distance with her thumbs looped into a black braided belt (box 2, folder 2).

72 Brittany Luse, "The Cowboy of the West Village," *The Nod* (podcast), October 16, 2017, https://gimletmedia.com/shows/the-nod/wbh8ab. Penny Coleman similarly describes Stormé as having the "vulnerable defiance of the young James Dean." Coleman, *Village Elders* (Urbana: University of Illinois Press, 2000), 14.

222 • Notes to Pages 164–167

73 Coleman, *Village Elders*, 14. For reference to Stormé as a warrior, see Erin M. Drinkwater, "Remembering Stormé DeLarverie," *GO! Magazine: The Cultural Roadmap for City Girls Everywhere*, June 14, 2014, 52.

74 Heller, "First Punch at Stonewall," 119. Jack Halberstam, on the other hand, does situate Stormé's performance in the tradition of "male impersonation," suggesting that she takes over from blues icons such as Bentley, Waters, Ma Rainey, and Bessie Smith in a storied cross-dressing and/or "bulldagger" singing tradition where "black butch women" performed a kind of "lesbian drag." Jack Halberstam, "Mackdaddy, Superfly, Rapper: Gender, Race, and Masculinity in the Drag King Scene," *Social Text* 52/53 (Autumn-Winter 1997): 114.

75 Heller, "First Punch at Stonewall," 138.

76 Heller, "First Punch at Stonewall," 119. Heller cites Marlon Bailey's excellent ethnographic work *Butch Queens up in Pumps: Gender, Performance, and Ballroom Culture in Detroit* (Ann Arbor: University of Michigan Press, 2013) as her foundation for extending the term "butch" for a broader definition.

77 Heller, "First Punch at Stonewall," 118.

78 Mara Dauphin, "'A Bit of a Woman in Every Man': Creating Queer Community in Female Impersonation," *Valley Humanities Review,* Spring 2012, 1; Elizabeth Drorbaugh, "Sliding Scales: Notes on Stormé DeLarverie and the Jewel Box Revue, the Cross-Dressed Woman on the Contemporary Stage, and the Invert," in *Crossing the Stage: Controversies in Cross-Dressing*, ed. Leslie Ferris (London: Routledge, 1993), 132–133.

79 Heller, "First Punch at Stonewall," 133.

80 As Revue performer Kurt Mann confirms in an interview on the Queer Music Heritage show and archive, Danny and Doc only hired "acts that worked live. You had to really sing or speak. No lip-synching allowed." JD Doyle, "The Kurt Mann Story," *Queer Music Heritage*, accessed June 7, 2022, https://www.queermusicheritage.com/fem-mann1.html.

81 Several of the Jewel Box Revue programs are archived in the Stormé DeLarverie papers in the New York Public Library's Schomburg Center for Research in Black Culture. The one cited here, the "25th Anniversary (30th Edition)—It's Been a Pleasure," is located in box 1, folder 16. Digital copies are also available on Queer Music Heritage's site.

82 Don Paulson, *An Evening at the Garden of Allah: A Gay Cabaret in Seattle* (New York: Columbia University Press, 1996), 80.

83 Drorbaugh, "Sliding Scales," 134–135.

84 Qtd. in *Stormé: Lady of the Jewel Box* (Parkerson, 1987).

85 Heller, "First Punch at Stonewall," 130.

86 Coleman, *Village Elders*, 14.

87 Sue-Ellen Case, "Making Butch: An Historical Memoir of the 1970s," in *Butch/Femme: Inside Lesbian Gender*, ed. Sally R. Munt (London: Cassell, 1998), 42.

88 Michelle Parkerson, "Beyond Chiffon: The Making of *Stormé*," in *Blasted Allegories: An Anthology of Writings by Contemporary Artists*, ed. Brian Wallis (Cambridge, MA: MIT Press, 1987), 377.

89 See the early program "Show Sensation of a Nation" and later "It's been a pleasure" programs featuring "star" Mr. Lynne Carter archived in the Stormé DeLarverie papers at the Schomburg Center and online at the Queer Music Heritage Archives, http://www.queermusicheritage.com/fem-jewl.html.

Notes to Pages 168–173 • 223

90 Similar portraits in this "gentlemanly" vein appear in photographer Avery Willard's book *Female Impersonation* (New York: Heritage, 1971), in which Stormé is the only featured male impersonator.

91 Drorbaugh, "Sliding Scales," 133–134.

92 Robin Maltz, "Real Butch: The Performance/Performativity of Male Impersonation, Drag Kings, Passing as Male, and Stone Butch Realness," *Journal of Gender Studies* 7, no. 3 (November 1998): 281. Maltz references Lisa E. Davis's work (1992) on the 1940s impersonation shows in mob-run Greenwich Village nightclubs that featured popular male impersonators "in tux and slicked back cropped hair," crooning tunes for "adoring" female fans.

93 Drorbaugh, "Sliding Scales," 143.

94 Heller, "First Punch at Stonewall," 133. The promotional shot of Stormé and Lynne Carter can be viewed in the "It's been a pleasure" program booklet digitally archived at https://queermusicheritage.com/fem-jewl.html.

95 To be fair, although Heller does not discuss camp in this context, she *does* argue that Stormé's insistence on her own butch queerness—her reinforcement of the still masculine gender-bending "girl" underneath—disrupts the norms of the "hegemonic cisgender" system. "First Punch at Stonewall," 137.

96 Doyle suggests, without an exact date, that this blue and pink "It's been a pleasure" program dates from the early 1960s owing to the featuring of Lynne Carter as the "star."

97 George Chauncey, *Gay New York: Gender, Urban Culture, and the Making of the Gay Male World, 1890–1940* (New York: Basic Books, 1994), 78.

98 Wilson, *Bulldaggers*, 177. Having been locked out of the actual King's Terrace in Midtown by the police, Bentley's musical revue moved back to Harlem and continued to draw patrons despite and certainly because of its "homosexual content" both onstage and referenced in publicity materials naming Bentley as a "King" and featuring the sailors.

99 Drorbaugh, "Sliding Scales," 141. Parkerson notes that the "demise" of the Jewel Box in the 1970s was precipitated by "violent homophobic boycotts staged by black nationalist groups, which claimed the Jewel Box undermined the black male and the black family." Parkerson, "Beyond Chiffon," 378.

100 Parkerson, "Beyond Chiffon," 142.

101 Lisa E. Davis, "The Butch as Drag Artiste: Greenwich Village in the Roaring Forties," in *The Persistent Desire: A Femme-Butch Reader*, ed. Joan Nestle (Boston: Alyson Publications, 1992), 45.

102 Jones, "How Does a Bulldagger," 10.

103 Heller, "First Punch at Stonewall," 127.

104 Avery Willard, *Female Impersonation* (New York: Heritage, 1971), 60; Stormé DeLarverie, "NYC in Focus," interview by Kirk Kocke, Columbia University Graduate School of Journalism, Fall 2009, http://vimeo.com/41947368.

105 Stormé DeLarverie, "A Stormé Life," episode of *In the Life: Documentary Stories from the Gay Experience* (2001), http://www.inthelifetv.org.

106 Willard, *Female Impersonation*, 62.

107 As the Committee to Support the Lesbian Herstory Archives reports in its coverage of DeLarverie's comments at a fund-raising benefit, Stormé rejected the idea of passing but had been safeguarded from "ignorant sheriffs who presumed she was white as well as male." "A Home of Our Own," *Gay Community News*, June 23, 1991, 18, no. 47, 5.

224 • Notes to Pages 173–176

108 Coleman, *Village Elders*, 15.

109 Muñoz, *Disidentifications*, 1.

110 Parkerson includes this headline in *Stormé: Lady of the Jewel Box*; Conerly, "Swishing and Swaggering," 392.

111 Qtd. in Betsy Pisik, "In Search of a Lost Legacy," *Washington Blade*, May 1, 1987, 13. Penny Coleman artfully sums up her complex identity politics: "She is a black woman with a white face who dresses like a man and loves women." *Village Elders*, 16.

112 Halberstam, "Mackdaddy," 115–116. Although Halberstam is careful to note that "drag king" is not a term Stormé would "use to describe herself," others have attached it to her; for example, see Ed Hamilton, *Legends of the Chelsea Hotel: Living with Artists and Outlaws of New York's Rebel Mecca* (Cambridge: De Capo, 2007), 54.

113 Halberstam, "Mackdaddy," 117. Elizabeth Kennedy and Madeline Davis, *Boots of Leather, Slippers of Gold: The History of a Lesbian Community, 20th Anniversary Edition* (New York: Routledge, 2014), 383. Additionally, Amanda Littauer has documented the presence (and even defiance) of teenage Black lesbians in the 1950s who boldly declared their same-sex desires to interviewers despite the censure that might come from the "rise of the middle-class African American civil rights discourse." Littauer, *Bad Girls: Young Women, Sex, and Rebellion before the Sixties* (Chapel Hill: University of North Carolina Press, 2015), 169. See also Audre Lorde's biomythographical depiction of black lesbian life in the mid-1950s in *Zami: A New Spelling of My Name* (Berkeley, CA: Crossing Press, 1982), 241–242, where she defines a particular style for Black lesbian butches and femmes of the "dyke-chic scene" in Brooklyn and Queens.

114 Muñoz, *Disidentifications*, 120.

Epilogue

1 Robin Maltz, "Real Butch: The Performance/Performativity of Male Impersonation, Drag Kings, Passing as Male, and Stone Butch Realness," *Journal of Gender Studies* 7, no. 3 (November 1998): 281.

2 Jack Halberstam, "Mackdaddy, Superfly, Rapper: Gender, Race, and Masculinity in the Drag King Scene," *Social Text* 52/53 (Autumn-Winter 1997): 107. Halberstam is, of course, not the only critic to propose a diversifying of the concept of the butch figure in lesbian culture; for example, see Gayle Rubin, "Of Catamites and Kings: Reflections on Butch, Gender, and Boundaries," in *The Persistent Desire: A Femme-Butch Reader*, ed. Joan Nestle (Boston: Alyson Publications, 1992), 469, for a call to recognize the "range of lesbian masculinity" beyond the typical model of the butch style of "white working-class youthful masculinity."

3 Halberstam, "Mackdaddy," 115–116.

4 Sue-Ellen Case, "Towards a Butch-Femme Aesthetic," rpt. in *The Lesbian and Gay Studies Reader*, ed. Henry Abelove, Michele Aina Barale, and David Halperin (New York: Routledge, 1993), 305.

5 Esther Newton, "Dick(less) Tracy and the Homecoming Queen: Lesbian Power and Representation in Gay-Male Cherry Grove," in *Inventing Lesbian Cultures in America*, ed. Ellen Lewin (Boston: Beacon Press, 1996), 162.

6 Newton, "Dick(less) Tracy," 164–165. Kennedy and Davis concur with Newton's assessment entirely, locating little "campy sense of humor" in the "old-time butches" they interviewed in Buffalo and concluding that the "butch persona, unlike that of the queen, carried the burden of twentieth-century women's struggle for the right to

Notes to Pages 176–178 • 225

function independently," a task "camp was not designed" to satisfy. Elizabeth Kennedy and Madeline Davis, *Boots of Leather, Slippers of Gold: The History of a Lesbian Community, 20th Anniversary Edition* (New York: Routledge, 2014), 383.

7 Newton, "Dick(less) Tracy," 188, 177, 192.

8 Daniel Harris, "The Death of Camp: Gay Men and Hollywood Diva Worship, from Reverence to Ridicule," *Salmagundi* 111 (Fall 1996): 180.

9 Marilyn Frye, *The Politics of Reality: Essays in Feminist Theory* (Trumansburg, NY: Crossing Press, 1983), 144–145.

10 Judith Roof, "1970s Lesbian Feminism Meets 1990s Butch-Femme," in *Butch/Femme: Inside Lesbian Gender*, ed. Sally R. Munt (London: Cassell, 1998), 27.

11 Roof, "1970s Lesbian Feminism," 29. On the other hand, Jeffreys cautions historians whose "romanticizing" of the butch-femme "roleplaying" might posit an "authentic" lesbian identity found in the pre-Stonewall era that conceals the diversity of identities and experiences. Sheila Jeffreys, "Butch and Femme: Now and Then," in *Not a Passing Phase: Reclaiming Lesbians in History, 1840–1985*, ed. Lesbian History Group (London: Women's Press, 1989), 160, 163.

12 Roof, "1970s Lesbian Feminism," 34.

13 Sue-Ellen Case, "Toward a Butch-Feminist Retro-Future," in *Cross-Purposes: Lesbians, Feminists, and the Limits of Alliance*, ed. Dana Heller (Bloomington: Indiana University Press, 1997), 210. Elsewhere, Stein recognizes this divide in the 1990s as a clash between "lipstick" lesbians and the passé "crunchies" as lesbian feminism gave way to "lifestyle lesbianism." Arlene Stein, "All Dressed Up, but No Place to Go? Style Wars and the New Lesbianism," in *The Persistent Desire: A Femme-Butch Reader*, ed. Joan Nestle (Boston: Alyson Publications, 1992), 435.

14 Heather Love, *Feeling Backward: Loss and the Politics of Queer History* (Cambridge, MA: Harvard University Press, 2007), 3.

15 Sue-Ellen Case, "Making Butch: An Historical Memoir of the 1970s," in *Butch/Femme: Inside Lesbian Gender*, ed. Sally R. Munt (London: Cassell, 1998), 43.

Selected Filmography

Amos'n'Andy, created by Charles Correll and Freeman Gosden (CBS, 1951–1953; Seattle, WA: Victory Video Production, 2005), DVD.

Attack of the 50 Ft. Woman, directed by Nathan Juran (1958; Los Angeles, CA: Warner Archives, 2011), DVD.

Beulah, "Bill the Babysitter," directed by James Tinling (ABC, 1950) https://tubitv.com/series/300009188/the-beulah-show.

The Big Show, produced and directed by Dee Engelbach (NBC radio, 1950–1952), https://archive.org/details/OTRR_The_Big_Show_Singles.

Blood of Dracula, directed by Herbert L. Strock (American International Pictures, 1957), 1:09.21, https://tubitv.com/movies/496373/blood-of-dracula.

Daughter of Dr. Jekyll, directed by Edgar G. Ulmer (1957; Chatsworth, CA: Image Entertainment, 2000), DVD.

Dracula's Daughter, directed by Lambert Hillyer (1936; Universal City, CA: Universal Pictures Home Entertainment, 2007), DVD.

Cabin in the Sky, directed by Vincente Minnelli (1943; Los Angeles, CA: Warner Archives, 2016), DVD.

Frankenstein's Daughter, directed by Richard E. Cunha (Astor Pictures,1958), 1:25:04, https://tubitv.com/movies/536482/frankensteins-daughter-the-original-schlock-classic.

The George Burns and Gracie Allen Show, directed by Frederick De Cordova, Ralph Levy, and Rod Amateau (CBS, 1950–1958; Walnut, CA: Diamond Entertainment, 2003), DVD.

I Love Lucy, directed by Marc Daniels, James Kern, and William Asher (CBS, 1951–1957; Hollywood, CA: Paramount Pictures Home Entertainment, 2020), DVD.

The Jack Benny Show, directed by James Kern and Ralph Levy (CBS, 1950–1966; West Conshohocken, PA: Alpha Video, 2022), DVD.

Johnny Guitar, directed by Nicholas Ray (1954; Chicago, IL: Olive Films, 2012), DVD.

The Member of the Wedding, directed by Fred Zinnemann (1952; Culver City, CA: Sony Pictures Home Entertainment, 2008), DVD.

Mildred Pierce, directed by Michael Curtiz (1945; Burbank, CA: Warner Bros., 2006), DVD.

228 • Selected Filmography

Our Miss Brooks, directed by Al Lewis, John Rich, John Claar, and Phil Booth (CBS, 1952–1956; New York: CBS Home Entertainment, 2021), DVD.

Pinky, directed by Elia Kazan (1949; Century City, CA: 20th Century Fox, 2006), DVD.

Private Secretary, directed by Oscar Rudolph and Christian Nyby (CBS, 1953–1957; West Conshohocken, PA: Alpha Video, 2007), DVD.

The Snake Pit, directed by Anatole Litvak (1948; Century City, CA: 20th Century Fox, 2004), DVD.

Sorority Girl, directed by Roger Corman (American International Pictures, 1957), 1:01:43, https://tubitv.com/movies/493008/sorority-girl.

Stormé: Lady of the Jewel Box, directed by Michelle Parkerson (1987; New York: Women Make Movies, 2009), DVD.

The Wizard of Oz, directed by Victor Fleming (1939; Studio City, CA: Studio Distribution Services, 2014), DVD.

Word Is Out: Stories of Some of Our Lives, directed by Nancy Adair, Peter Adair, Lucy Massie Phenix, Veronica Selver, Andrew Brown, and Rob Epstein (1977; Harrington Park, NJ: Milestone Films, 2010), DVD.

Index

Agar, John, 74, 77–78, 201n23
Ahmed, Sara, 183n26
Aldrich, Ann, 5, 40, 42, 56–60, 63, 192n138, 193n6, 197n75, 198n82
All About Eve, 6, 38–39, 64, 194n12
Allen, Gracie, 108, 112
Allison, Dorothy, 63–64, 199n103
Amazons, 21, 25, 133, 143–145, 214n41, 216n76
Amos'n'Andy, 161–162, 220n60
androgyny, 26, 36, 150, 172
Apollo Theater, 167, 172, 174
Arden, Eve, 6, 8, 29, 92, 98–101, 106–108, 110–115, 206n35
Arthur, Bea, 9
Attack of the 50 Foot Woman, 139–140, 215n61

Babuscio, Jack, 7, 183
Ball, Lucille, 92, 97–100, 108, 112
Bankhead, Tallulah, 3, 8, 31–40, 104, 169, 179, 190–192, 197n72, 217n5
Bannon, Ann, 61, 86, 163, 194n14
bar culture, 2, 21, 150, 164, 178, 182n13
Batman, 40, 121–122, 214n43
Batman and Robin, 121–122
Bechdel, Alison, 216
Becker, Christine, 103, 115–116, 220n59
Belafonte, Harry, 167–168
Benny, Jack, 105–107, 111, 114, 117, 207n55, 209n80
Bentley, Gladys, 4, 8, 35, 148–157, 171–172, 191n115, 217n8, 218n10, 223n98

Bergler, Edmund, 47, 196
Berlatsky, Noah, 122–124, 126–127, 132, 145–146, 213n25, 216n83
Bérubé, Allan, 2, 18, 23–25, 29–30, 32, 37, 171
Beulah, 92, 118, 157–158, 161–162, 220n53
Big Show, The, 6, 31, 38–40, 190n98
Black Cat, The, 72, 130–131
Blood of Dracula, 6, 68, 72, 85–86, 89–91, 202n38, 203n39
Bogle, Donald, 157, 158, 219n40, 220n50
Bond, Pat, 9, 29–30, 189n93
Bride of Frankenstein, The, 90
Bronski, Michael, 101, 183n32, 208n60
Brooks, Connie, 97–99, 101–102, 108–109, 112–113, 115, 206
bulldagger/bulldyker, 149–151, 155, 164, 172, 217n8, 222n74
Burns, George, 109–113, 209n76
butch comedy, 6, 9, 38, 93, 107–109, 111–115, 118–119
butch-femme, 2, 57, 60, 176–177, 182n12, 183n25, 225n11
Byrne, Olive, 123–124, 211n11

Cabin in the Sky, 158
camp: associated with gay men, 1–3, 32, 40, 55, 69, 176, 177, 199n3, 208n64; as form of critique, 45, 52, 54, 139; history of, 2–3, 7, 29–30, 32, 171, 197n61; humor, 3, 68, 105, 174, 176; sensibility, 4–5, 7, 68, 72, 127, 132–133

229

230 • Index

camp TV, 107–108, 114, 117, 206n46, 208n64, 210n91
Canaday, Margot, 23, 188n69
Candy, Etta, 121–127, 129–130, 212n14, 212n21
Caprio, Frank, 22, 47, 51, 188n66, 196n45
Carter, Lynne, 166, 169–171, 222n89, 223n96
Case, Sue-Ellen, 2–3, 9, 55, 64, 88, 167, 176, 202n35
Castle, Terry, 7–9, 184n42
cats (associated with spinsters), 102–103, 105, 117, 131, 207n52
Chauncey, George, 2, 171, 197n61
Cheetah, The, 128–130, 146, 216n82
Cherry Grove, 176–177, 182n12
Chitlin' Circuit, 151, 158, 160
Classical Hollywood, 92, 192n132
closet (workings of), 2, 53–55, 59, 80–82, 105–107, 114, 127–129, 156
Cohan, Steven, 2, 30, 55–56, 105, 115
Cold War era, 14–17, 21–22, 44, 50, 131–134, 150, 163, 215n65
Comics Code, 120, 131–132, 139, 142
Conerly, Gregory, 155–156, 172
containment, 14–16, 47, 79, 96, 131–134, 139, 142, 150, 202n27
Corber, Robert, 20, 44, 50, 194n12
Core, Philip, 5, 31, 82, 128
Corman, Roger, 66–67, 199n1
cowboy, 124, 164, 172, 221n71
Crawford, Joan, 1, 92, 191n115, 192n132, 212n22
Cripps, Thomas, 162, 220n60
Crothers, Rachel, 34–35, 190n111

Daniels, Les, 124, 131, 211
Daughter of Dr. Jekyll, 3, 68, 70–85, 88–89, 137, 203n47
Daughters of Bilitis (DOB), 6, 17, 43, 60, 63, 193n5, 194n14, 198n83
Davis, Bette, 1, 39, 69, 92, 131
Davis, Madeline, 3, 182n14, 225n6
DC Comics, 132, 142
Dean, James, 164, 221n72
DeLarverie, Stormé, 4, 8, 163–176, 221n70, 222n74, 223n90
D'Emilio, John, 11, 17–18, 184, 187, 189
Dietrich, Marlene, 34, 38, 69, 192n132
disidentification, 8–9, 151, 155–157, 165, 172–174

diva worship, 5, 177, 182n9
Doty, Alexander, 5, 7, 45, 69, 82–83, 183n24, 199n3, 200n13, 207n55, 208n59, 209n80
drag: in dress, 30, 38, 82–83, 87–88, 104, 106–108, 124, 127–128, 130, 172; kings, 82, 174–176, 222n74, 224n112; in performance, 5, 29, 64, 103, 117, 167, 174, 209n81; queens, 3, 109, 155, 170, 173, 176
Dyer, Richard, 3, 5, 7

Ebony, 148, 150–151, 154–159, 162, 174
EC Comics, 120, 211n10, 217n86
Ellis, Havelock, 17, 46, 95
exploitation film, 3, 6, 8, 68, 70, 72, 86, 89–90, 199n1, 201n23

Faderman, Lillian, 18–19, 149, 187, 192, 210n93
Father Knows Best, 96–97
Fawcett Gold Medal, 46, 192, 194n16, 195n36
female impersonator, 155, 165–166, 169, 172
female masculinity, 82–83, 164–169, 172–174, 188n73
Feminine Mystique, The, 96, 142
femininity, 101–103, 145, 156, 169, 173, 194n12, 207n52
feminism, 64, 91, 97, 132, 142, 176–177, 216n78, 225n13
femme, 21, 44, 50, 69, 82, 108, 115, 126, 167, 175, 194n12, 195n24, 224n113
flapper, 33–36, 191n121
Freedman, Estelle, 11, 17–18, 187n44
Freud, Sigmund, 11, 17, 48–49, 51, 57–58, 83, 112, 202n36
Frye, Marilyn, 177

Gallery Girls, 36–38, 40, 191n121
Garber, Eric, 149–151, 157, 217n3
Garbo, Greta, 8, 69, 117–118, 192n132, 210n104
giantess, 139–140, 142, 215n60
Golden Age of comics, 122–125, 130, 133, 145–146, 212n16
Golden Girls, The, 9, 92
Great Depression, 21, 151, 220n50
Greenwich Village, 20, 57, 60, 172, 223n92

Halberstam, J., 174–175, 222n74, 224n112
Hall, Radclyffe, 36, 61, 192n135

Index • 231

Halperin, David, 1, 48–49
Hanley, Tim, 122, 132–133, 135, 189, 211n5, 212n16
Hanson, Ellis, 48, 69, 195n29
Harlem, 6, 21, 35, 149–153, 157, 171–172, 191n115, 218n10, 223n98
Harris, Bertha, 9, 63–64, 68, 82, 184n40, 199n103
Heller, Meredith, 151, 164, 218n11
Hepburn, Katharine, 92, 144
Herbert, Hugh, 124, 212n18
heteronormativity, 7, 48, 53–54, 79–81, 100, 104, 133
Highsmith, Patricia, 63, 198n96
His Eye Is on the Sparrow, 157, 192n135
Hobby, Oveta Culp, 24, 26–27, 29, 188n74
Holliday Girls, 121–123, 127, 129, 131, 212n14

I Love Lucy, 98, 111, 208n71
incongruous juxtapositions, 1, 4, 76, 78, 151, 154
invert, 46, 50, 174

Jeffreys, Sheila, 94–96, 204n1, 225n11
Jet, 155, 162, 174
Jewel Box Revue, 165–174, 176, 222n81, 223n99
Johnny Guitar, 79, 183n25, 202n27, 212n22

Kanigher, Robert, 124, 131–134, 137, 140–142, 189n89, 212n21, 214n39
Kennedy, Elizabeth, 3, 182n14, 225n6
kiki lesbians, 21, 32, 38
Kinsey, Alfred, C., 10–18, 22–23, 40, 42, 57, 154, 184n7, 186n30
Krafft-Ebing, Richard von, 25, 46
Kulp, Nancy, 106, 108, 208n60, 210n91

Ladder, The, 17, 43, 198n83
Lang, k.d., 2, 69
Lepore, Jill, 122, 211n11
lesbian feminism, 177, 225n13
Littauer, Amanda, 61, 185n18, 186n26, 224n113
Lorde, Audre, 6, 216n76, 224n113
Love, Heather, 20, 61, 193n8

male impersonator, 154, 165, 167, 169, 172, 174–175, 223n90
Maltz, Robin, 175, 223n92

mannish lesbian, 25, 27, 150, 202n27
Marston, William Moulton, 28, 121–124, 127–128, 130, 132, 142–144, 211n11, 212n15
Marx, Groucho, 31, 110, 190n98
masculinity, 50, 52, 77–79, 101, 103, 113–114, 202n36, 206n44, 212n18, 224n2
matriarchy, 143–144, 215n71
Mattachine Society, The, 17, 186n37
May, Elaine Tyler, 14, 96–97, 205n20
Mayer, Louis B., 192n132
Mayne, Judith, 88–89, 203n45
McCarthy era, 19, 21–22, 76, 95, 105, 133, 150, 157, 167, 169, 188n74, 207n58
McDaniel, Hattie, 160, 220n50
McNamara, Susie, 93, 115–116
McQueen, Butterfly, 161
Meaker, Marijane, 4–8, 42–43, 45, 54–56, 60–65, 193n5, 196n48, 198n80
Medovoi, Leerom, 163–164, 221n67
Meeker, Martin, 43, 60, 63, 193n5, 198n83
Mellencamp, Patricia, 112–113
Member of the Wedding, A, 157, 160
Meyer, Leisa, 24–26, 186n30, 188n74, 219n26
Meyerowitz, Joanne, 15, 96, 185n24
Mildred Pierce, 101, 109
momism, 51–52
Mother Camp, 3, 176
Ms. magazine, 81, 132, 141–144
Mulvey, Laura, 83, 88
Muñoz, José Esteban, 9, 151–152, 174

NAACP, 156, 158, 160–162, 219n49, 221n61
Newton, Esther, 3–4, 175–178, 182n12, 224n6
Nightingale, Florence, 94

Odd Girl Out, 86, 163, 203n41, 221n67
Odd Girls and Twilight Lovers, 3, 20, 32, 192n3
ONE, 17, 186n36, 196n58
Our Miss Brooks episodes: "The Christmas Show," 101; "Citizen's League," 105–106, 111, 207n58; "Conklin's Love Nest," 100, 104, 109–111; "Connie and Bonnie," 106; "June Bride," 100, 104, 108, 112; "The Magic Tree," 102–103, 111, 209; "Reunion," 29, 106, 109, 112, 209n75; "Trying to Pick a Fight," 99; "The Wrong Mrs. Boynton," 97, 99, 108, 111–112

232 • Index

Packer, Vin, 3, 5, 42, 49, 61–62, 67, 80, 194n16, 195n36, 198n80

Paradise Island, 29, 121–123, 126, 130, 132, 143–145, 147, 215n65

Parkerson, Michelle, 165–166, 168–169, 172, 174, 224n110

Penn, Donna, 15–16, 47, 186n29

Peter, Harry, 124, 133–134, 138–139

Pinky, 160

post-Stonewall period, 3, 8–9, 20–21, 29, 63, 165, 173, 177

pre-Stonewall period, 2–4, 8, 20–21, 42–45, 55–56, 65, 164, 172, 178, 181n3, 194n10, 197n61

Private Secretary, 6, 92, 97, 115–119, 130, 205n22; "Elusive," 117–118; episodes: "Cat in a Hot Tin File," 117; "Her Best Enemy," 116–117

psychoanalytic discourse, 17, 19, 21, 25, 44–48, 50–52, 54, 59, 88,194n14, 196n43

psychological diagnosis, 57–59, 194n13

pulp fiction, 3, 5, 8, 41–45, 47–49, 55, 62–63, 152, 154, 179, 193n9, 194n13, 203n49

Queer Music Heritage, 168, 170–171, 222n80, 222n89

queer theory, 2, 176

racism, 7, 118, 120–121, 144–147, 156, 158–160, 162, 216n78, 216n82, 217n87, 219n47

Rainey, Ma, 149–150, 165, 218n9, 222n74

rebel, 3, 40, 150–151, 157, 162–164, 172–174, 221n67, 224

Robbins, Trina, 132–133, 211n11, 213n34, 214n41

Robertson, Pamela, 2, 5–7, 70, 79, 88, 202n27

romantic friendships, 20, 92, 190n111

Roof, Judith, 92, 100–101, 177, 206n44

Ru Paul's Drag Race, 1, 177

San Francisco, 3, 18, 150, 167, 178, 182n13

Scooby Doo, Where Are You!, 73

Scotland Yard, 33, 179, 190n105

Second Wave Feminism, 91, 97, 132, 144, 177

Sedgwick, Eve Kososfky, 198n90

Sexual Behavior in the Human Female, 10–17, 23, 42, 154

Sexual Behavior in the Human Male, 11, 17, 42

sexual outlaw, 36, 149

Sheena, Queen of the Jungle, 145–147, 217n87

Shields, Arthur, 73–74, 89

"sicko," 3, 5, 8, 19, 22–24, 44–45, 48

Silver Age of comics, 122, 130–135, 137–139, 142, 146–147, 217n88

situation comedy (sitcom), 3, 92–93, 98–100, 103–108, 110, 112, 114, 205n27, 207n55

Smith, Bessie, 149, 222n74

Snake Pit, The, 48–49

Sontag, Susan, 3–5, 9, 68, 70, 182n16

sororities, 49–54, 66–67, 85, 121–123, 126, 147, 199n1, 203n41, 212n14

Sorority Girl, 49, 66–68, 85, 89, 199n1

Sothern, Ann, 6, 8, 92, 97, 115, 117, 130

spectatorship, 83–84, 86–89, 203n45

Spigel, Lynn, 93, 100

spinster: as "career gal," 91–93, 97–98, 115–119, 137, 205n22; history of, 91–97, 187n47, 204n10; as lesbian, 22, 95–97, 101, 103, 106, 205n17, 207n52; teachers, 91, 95, 97, 99–100, 105, 204n16, 205n17

Steinem, Gloria, 122, 131, 143–144

Stonewall rebellion, 8, 164, 176, 221n70

Stormé: Lady of the Jewel Box, 165–166, 224n110

Streetcar Named Desire, A, 39

suffrage movement, 91, 95, 145

Talbott, Gloria, 74

teenpics, 71, 86, 199n1

Trevor, Steve, 121, 123, 125, 133–134, 213n34, 214n48

Tropiano, Stephen, 107, 206n46

Ulmer, Edgar, 68, 70, 72–73, 81, 201n20

vampire (lesbian), 48, 68–70, 75, 77, 85–86, 200n6, 201n26, 202n38

vaudeville, 12, 110–112, 161, 165–166, 208n68, 212n18

Villarejo, Amy, 20, 101–102, 106, 193n8, 203n49, 206n49

voyeurism, 81, 83–84

WAAC, 25, 27, 29, 127–128, 189n79

WAC, 18, 21, 24–30, 106, 109, 187n59, 188n74, 189n77, 189n90, 209n75

Wanzo, Rebecca, 146, 216n84, 217n85
Waters, Ethel, 8, 92, 118, 157–163, 173, 192n135, 219nn40–41, 220n50, 220n59
WAVES, 18, 21, 29, 127, 213n26
We, Too, Must Love, 43, 58–59, 192n138, 195n34, 197n75
weirdies, 71–72, 85
Weiss, Andrea, 2, 68–70, 88
Wertham, Frederic, 120–122, 130–131, 139, 211n4
We Walk Alone, Through Lesbos Lonely Groves, 5, 43, 56, 58–59, 64
White, Patricia, 69, 88, 101, 160, 206n44
White, Walter, 160–161, 220n52
white supremacy, 7, 92, 118, 122, 144–147, 159–161, 212n15, 216n78, 221n67
Williams, Keira, 144–145, 212n15

Wilson, James F., 150–152, 154–155, 218n10
Winnie the WAC, 27–28, 189n88
Wizard of Oz, The, 69, 82
Women's Barracks, 28, 45–47, 49–50, 194n16, 195n18, 195n24
Wonder Woman issues: "Amazon Babysitter," 138–139; "Diana Day," 126–127; "Marriage a la Mode," 138–139, 142, 146, 215n56; "S.O.S. Wonder Woman!" 134–136, 138; *Wonder Woman #1*, 124–125, 145–146, 216n82; "World's Mightiest Menace," 140–141
Word Is Out: Stories of Some of Our Lives, 9, 29–30
World War II, 4, 14, 18, 23–30, 187n44, 187n59, 189n79, 205n20

About the Author

BARBARA JANE BRICKMAN is an associate professor of media and gender studies at the University of Alabama. She is the author of two books, *New American Teenagers: The Lost Generation of Youth in 1970s Film* and *Grease: Gender, Nostalgia and Youth Consumption in the Blockbuster Era*, and is the founder and director of Druid City Girls Media.